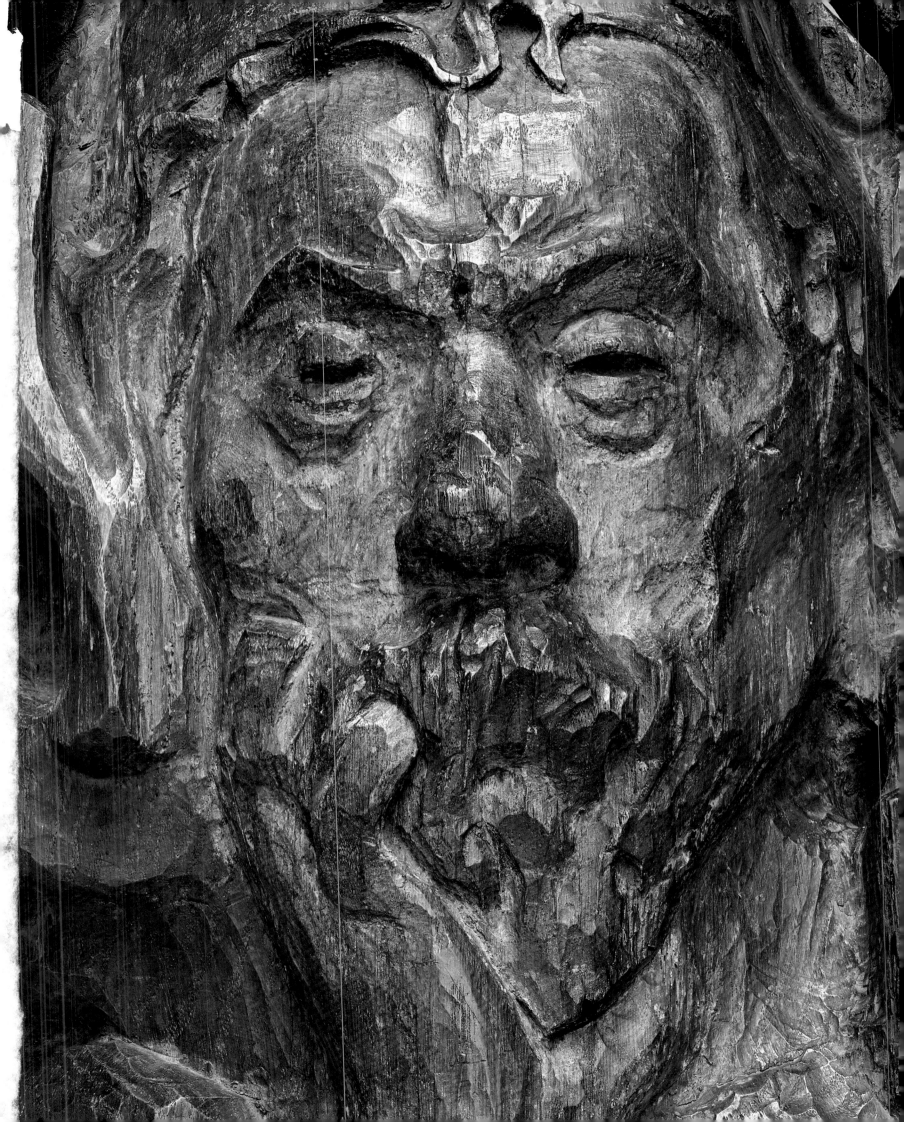

GAUGUIN
PORTRAITS

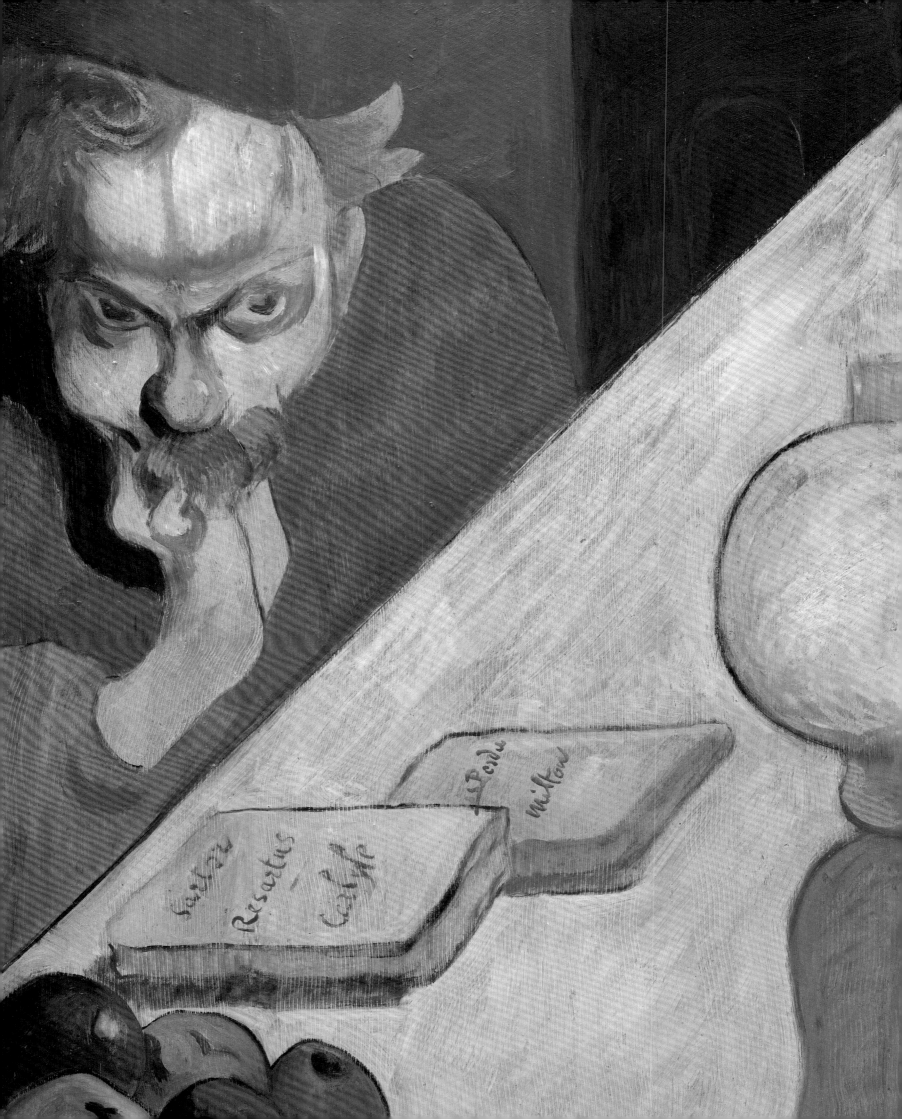

Edited by
CORNELIA HOMBURG
CHRISTOPHER RIOPELLE

with contributions by

ELIZABETH C. CHILDS

DARIO GAMBONI

LINDA GODDARD

CLAIRE GUITTON

JEAN-DAVID JUMEAU-LAFOND

ALASTAIR WRIGHT

GAUGUIN
PORTRAITS

National Gallery of Canada, Ottawa
The National Gallery, London
Distributed by Yale University Press,
New Haven and London

1 *Interior with Aline*, 1881

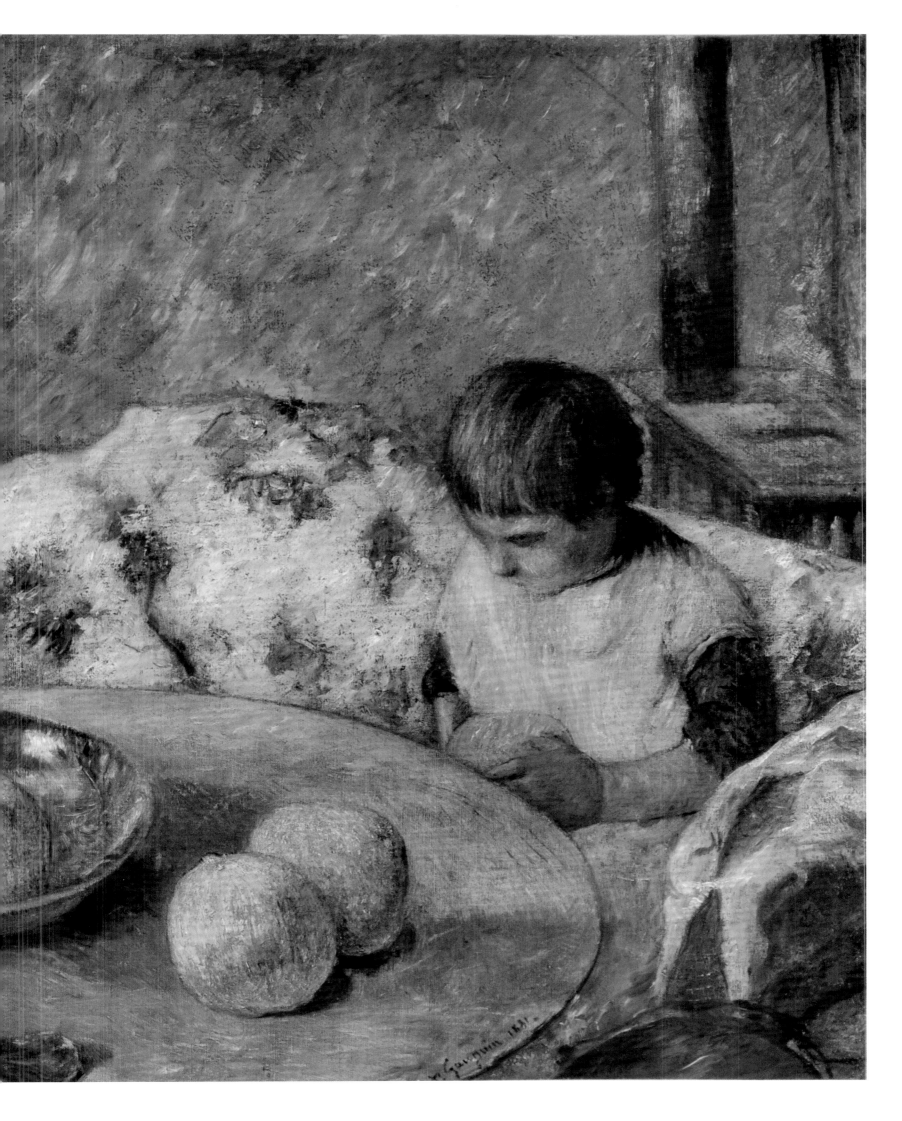

Published in conjunction with the exhibition *Gauguin: Portraits*, organized by the National Gallery of Canada, Ottawa, and the National Gallery, London.

Itinerary
National Gallery of Canada, Ottawa, from 24 May to 8 September 2019
The National Gallery, London, from 7 October 2019 to 26 January 2020

National Gallery of Canada
Chief, Publications and Copyright: Ivan Parisien
Editor: Caroline Wetherilt
Picture Editors: Anne Tessier and Andrea Fajrajsl
Production Manager: Anne Tessier
Translators: Judith Terry and Jane MacAvock

Designed and typeset in Adelle and Gotham by Réjean Myette
Printed in Italy on GardaMatt by Conti Tipocolor
Also published in French under the title *Gauguin. Portraits*

Cover: *Melancholic (Faaturuma)* (detail), 1891 (ill. 78)
Back cover: *Self-portrait with Yellow Christ* (detail), 1890–91 (ill. 103)
p. 1: *Portrait of Meijer de Haan* (detail), 1889–90 (ill. 50)
p. 4: *Portrait of Meijer de Haan* (detail), 1889 (ill. 43)
pp. 16–17: *Still Life with Apples, a Pear and a Ceramic Portrait Jug* (detail), 1889 (ill. 112)
pp. 20–21: *Portrait of Madame Roulin* (detail), 1888 (ill. 65)
pp. 250–251: *Clovis Asleep* (detail), 1884 (ill. 122)
p. 269: *Nirvana: Portrait of Meijer de Haan* (detail), 1889–90 (ill. 49)

Catalogue © National Gallery of Canada, Ottawa, 2019
"Seeking Oneself Through Others" © Cornelia Homburg

Cataloguing data available from Library and Archives Canada,
https://bac-lac.on.worldcat.org/discovery.

ISBN 978-0-300-24273-7
Library of Congress Control Number: 2019931688

Distributed by
Yale University Press
302 Temple Street
P.O. Box 209040
New Haven, CT 06520-9040
www.yalebooks.com/art

Supported by the Government of Canada

CONTENTS

10 FOREWORD

12 LENDERS TO THE EXHIBITION

13 ACKNOWLEDGEMENTS

18 **INTRODUCTION**
CORNELIA HOMBURG and CHRISTOPHER RIOPELLE

23 **GAUGUIN'S SELF-PORTRAITS:**
EGOS AND ALTER EGOS
ALASTAIR WRIGHT

57 **HEAD OF A SAVAGE, MASK**
JEAN-DAVID JUMEAU-LAFOND

65 **SEEKING ONESELF THROUGH OTHERS:**
GAUGUIN'S PORTRAITS OF HIS COLLEAGUES AND FRIENDS
CORNELIA HOMBURG

103 **GAUGUIN IN BRITTANY**
CHRISTOPHER RIOPELLE

121 **PORTRAIT VASE, MADAME SCHUFFENECKER**
JEAN-DAVID JUMEAU-LAFOND

129 **GAUGUIN'S PORTRAITURE IN TAHITI:**
LIKENESS, MYTH AND CULTURAL IDENTITY
ELIZABETH C. CHILDS

165 *NOA NOA* **AS SELF-PORTRAIT**
LINDA GODDARD

189 **SOYEZ SYMBOLISTE:**
PORTRAIT OF JEAN MORÉAS
JEAN-DAVID JUMEAU-LAFOND

197 **ANIMATION AND PERSONHOOD:**
GAUGUIN'S STILL LIFES AS PORTRAITS
DARIO GAMBONI

227 **GAUGUIN AND PORTRAITURE**
IN THE LATE NINETEENTH CENTURY
CLAIRE GUITTON

253 **LIST OF ILLUSTRATIONS**

260 **SELECTED BIBLIOGRAPHY**

270 **INDEX**

FOREWORD

Paul Gauguin's extraordinary sculpture of Meijer de Haan in the collection of the National Gallery of Canada was the starting point for the present in-depth investigation into the fascinating ways the French artist explored portraiture. The first exhibition dedicated to this topic, it allows for a fresh look at an artist whose oeuvre is well known and at the same time continues to generate interest and inquiry. By focusing on a specific genre and the question of how to define a portrait in Gauguin's work, our project highlights how his multi-media approach to art – from painting, drawing and printmaking to sculpture, pottery and writing – informed his ideas and channelled his evocative thinking and continuous search for new expression. The exhibition aims to demonstrate the inventiveness with which Gauguin tackled the traditional genre of portraiture within the context of his deep interest in non-Western cultures inexorably linked to his understanding of Western art.

The exhibition, conceived by Cornelia Homburg, guest curator at the National Gallery of Canada and a specialist of late-nineteenth-century art, is co-organized by the National Gallery of Canada, Ottawa, and the National Gallery, London. We are grateful to Cornelia Homburg and co-curator Christopher Riopelle, the Neil Westreich Curator of Post-1800 Paintings at the National Gallery, for their dedication to this extraordinary project, and applaud their thorough scholarship. We appreciate their fruitful collaboration with an international team of scholars who generously shared their knowledge in order to characterize Gauguin's portraiture in the wider context of his oeuvre. We wish to thank in particular the authors of this catalogue for their insightful contributions: Elizabeth Childs, Dario Gamboni, Linda Goddard, Claire Guitton, Jean-David Jumeau-Lafond and Alastair Wright. The exhibition was further enriched by the in-depth investigation by the National Gallery of Canada's Restoration and Conservation Laboratory into the materials and techniques that Gauguin used for his sculpture of Meijer de Haan.

The National Gallery of Canada in Ottawa and the National Gallery in London have a long history of collaboration and scholarly exchange, in particular our partnership on the *Renoir Landscapes, 1865–1883* exhibition in 2007, which was presented at both venues.

We sincerely thank the many staff and collaborators at both of our institutions who worked tirelessly to bring this remarkable project to fruition.

In Ottawa, we are grateful to the National Gallery of Canada Foundation for its encouragement and assistance.

In London, we are indebted to Credit Suisse, Partner of the National Gallery, for their continuing and generous support of our educational and exhibition programme.

Finally, we extend our immense gratitude to the lenders from around the world, both private and public. Without their generosity, this exhibition, and the new window it has opened on Gauguin's achievement, would not have been possible.

MARC MAYER
Director and Chief Executive Officer
National Gallery of Canada, Ottawa

GABRIELE FINALDI
Director
The National Gallery, London

LENDERS TO THE EXHIBITION

Art Institute of Chicago
Baltimore Museum of Art
Bibliothèque littéraire Jacques Doucet, Paris
La Boverie, Liège
Dallas Museum of Art
Fine Arts Museums of San Francisco
Galerie Talabardon & Gautier, Paris
Hammer Museum, Los Angeles
Harvard Art Museums / Fogg Museum, Cambridge, MA
Indianapolis Museum of Art at Newfields
Institut national d'histoire de l'art, Paris
The J. Paul Getty Museum, Los Angeles
Kelton Foundation, Santa Monica
Kimbell Art Museum, Fort Worth
Kröller-Müller Museum, Otterlo
Kunstmuseum Basel
McNay Art Museum, San Antonio
Musée d'Art moderne et contemporain de Strasbourg
Musée départemental Stéphane Mallarmé, Vulaines-sur-Seine
Musée d'Orsay, Paris
Musée Léon Dierx, Saint-Denis
Museu de Arte de São Paulo Assis Chateaubriand
Museum Folkwang, Essen
The Museum of Modern Art, New York
National Gallery of Art, Washington, D.C.
National Gallery of Canada, Ottawa
National Museum of Art, Architecture and Design, Oslo
National Museum of Western Art, Tokyo
The Nelson-Atkins Museum of Art, Kansas City, MO
Norton Museum of Art, West Palm Beach
Petit Palais, Musée des Beaux-Arts de la Ville de Paris
Pola Museum of Art, Hakone
Private collection, courtesy Museums Sheffield
Private collection, courtesy Portland Museum of Art
The Pushkin State Museum of Fine Arts, Moscow
Royal Museums of Fine Arts of Belgium, Brussels
Saint Louis Art Museum
The State Hermitage Museum, Saint Petersburg
Sterling and Francine Clark Art Institute, Williamstown, MA
Dr. Richard and Astrid Wolman

And those lenders who wish to remain anonymous

ACKNOWLEDGEMENTS

CORNELIA HOMBURG
AND CHRISTOPHER RIOPELLE

Many people and institutions were most generous in helping us to succeed in our undertaking. Our deepest gratitude goes to the lenders to the exhibition – institutions as well as private individuals – who have consented to part with their treasures for the duration of the show.

We are deeply indebted to our colleagues at both our institutions. We thank our directors, Marc Mayer at the National Gallery of Canada in Ottawa and Gabriele Finaldi at the National Gallery in London, for their unflagging support.

We are grateful to the writers of this catalogue, for their thoughtful contributions, for our many inspiring conversations, and for their expertise in the field of Gauguin studies. Our project would not have been the same without the support of Claire Guitton and Kirsten Marples, whose research skills allowed us to find answers to the most improbable questions.

At the National Gallery of Canada we first and foremost recognize the extraordinary commitment of Anne Eschapasse, Deputy Director, Exhibitions and Outreach. The Exhibitions department under the leadership of Marie-Claude Rousseau and Christine La Salle has overseen the realization of the show throughout its various stages with calm efficiency, and we are particularly appreciative of the hard work of our exhibition project managers: first Karolina Skupien and then foremost Christopher Regimbal, who tirelessly met all the organizational challenges.

The exhibition space would not have been as beautiful without the direction of Junia Jorgji, and in particular the inspiration and professionalism of Ellen Treciokas, who created the evocative installation. Doris Couture-Rigert, Chief of Conservation and Technical Research, conducted an in-depth investigation into the materials and techniques Gauguin used for his sculpture of Meijer de Haan, thus greatly enriching our knowledge of the artist's working methods.

The exhibition catalogue will have a life beyond the show, and we are particularly grateful for the commitment of Ivan Parisien, Chief of Publications and Copyright, and his entire department. Caroline Wetherilt took charge as the lead editor and in her thoughtful way guided the book through its many stages, while Marie-Christine Gilbert edited the French version with seamless continuity. Anne Tessier and Andrea Fajrajsl dealt with all the images and production matters. For the stunningly beautiful design of the catalogue, we praise Réjean Myette.

Cornelia Homburg would like to express her deep appreciation for the cheerful collaboration of so many people throughout the institution, and is particularly grateful to her curatorial colleagues Sonia Del Re, Erika Dolphin, Josée Drouin-Brisebois, Anabelle Kienle Poňka, Paul Lang and Ann Thomas. She gives special thanks to François Rijk.

At the National Gallery, London, we are grateful to the indefatigable Exhibitions team headed by Jane Knowles, which worked so effectively with Ottawa colleagues on the myriad details of an international loan exhibition: Philippa Hemsley, Susan Thompson and Katherine Lucas. Jan Green, Publisher at the National Gallery, liaised with unending good cheer with Ottawa's publishing team, while Belinda Phillpot and Chris Oberon directed a splendid and subtle exhibition installation in Trafalgar Square.

Christopher Riopelle would like to give particular thanks to Caroline Campbell, Director of Collections and Research; curatorial colleagues Sarah Herring, Anne Robbins and Julien Domercq for their ongoing support amid their own considerable responsibilities; and his wife Caroline for the same, plus one unexpected and inspired flight to Ottawa in the depths of winter.

We would also like to express our gratitude to Cassandra Albinson, Scott Allan, Hope Alswang, Alex Apsis, Agustín Arteaga, Richard Aste, Rene Paul Barilleaux, Alison Beckett, Christopher Bedford, Brent Benjamin, Claire Bernardi, Giovanna Bertazzoni, Mark H.C. Bessire, Richard Brettell, Susanne Brüning, Cheryl Brutvan, Rupert Burgess, Isabelle Cahn, Thomas Campbell, Carla Caputo, Laurence de Cars, Hubert Cavaniol, Danielle Chaput, Paula Coelho, Renske Cohen Tervaert, Karen Colby-Stothart, Laura Corey, Sylvie Crussard, Sherry D'Asto Peglow, Patrick Deboeck, Marcus De Chevrieux, Patty Decoster, Nanne Dekking, Enrico De Marco, Marcello De Marco, Natasha Derrickson, C.D. Dickerson III, Maite van Dijk, Caitlin Draayer, Michel Draguet, Elise Dubreuil, Ann Dumas, Marie-Elise Dupuis, Nadine Engel, Andrew Eschelbacher, Ophélie Ferlier-Bouat, Jay Fisher, Catherine Futter, Isabelle Gaëtan, James Ganz, Davide Gasparotto, Jean-Marc Gay, Christine Gendreau, Jannet de Goede, Lily Goldberg, Peter Gorschlüter, Gloria Groom, Valérie Haerden, Hiroyo Hakamata, Tracy Hamilton, June Hargrove,

Josef Helfenstein, Chris Hightower, Ann Hoenigswald, Joost van der Hoeven, Max Hollein, Martine Hollenfeltz, Wobke Hooites, Philip Hook, Diana Howard, Nancy Ireson, Yoko Iwasaki, Kimberly Jones, Simon Kelly, Richard Kelton, Shunsuke Kijima, Teresa Krasny, Azu Kubota, Heather Lammers, Christophe Langlois, Ellen W. Lee, Eric Lee, Frederik Leen, Christophe Leribault, Bernard Leveneur, Siri Lindberg, Nicole Linderman, Marina Loshak, Glenn Lowry, Akiko Mabuchi, Lisa M. MacDougall, Daniel Malingue, Judy Mann, Julie Mattsson, Olivier Meslay, Nicole Myers, Kathleen Morris, Mary Morton, Nathalie Muller, David Norman, David Oakey, Judy Ozone, Jeanha Park, Sylvie Patry, Helena Patsiamanis, Adriano Pedrosa, Lisette Pelsers, Ann Philbin, Mikhail Piotrovsky, Remi Poindexter, Tatiana Potapova, Timothy Potts, Earl A. Powell III, Annalisa Powers, Richard Rand, Eva Reifert, James Rondeau, Lisa Rosche, Katherine Rothkopf, Annette Schlagenhauff, Jamie Sepich, George Shackelford, Caroline Shields, Atsushi Shinfuji, Lauren Silverson, Léa Simon, Sheila Singhal, Susan Alyson Stein, Sasha Suda, Tricia Taylor Dixon, Martha Tedeschi, Ann Temkin, Judith Terry, Belinda Thomson, Maya Urich, Charles Venable, Liz Waring, Malcolm Wiener and Julián Zugazagoitia.

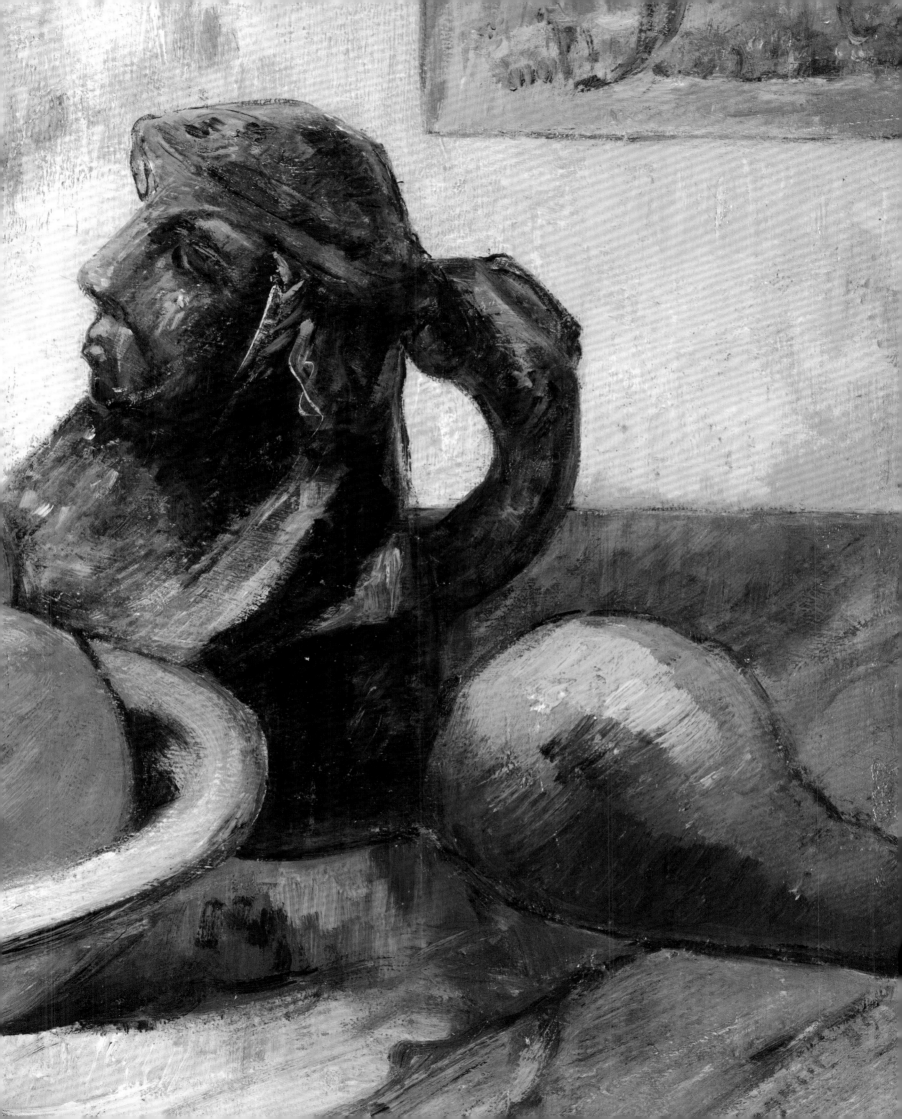

INTRODUCTION

CORNELIA HOMBURG
AND CHRISTOPHER RIOPELLE

Paul Gauguin's activities as a painter, sculptor and writer, together with his carefully constructed persona, exert an ever-increasing fascination on a vast public. The observations and ideas that he articulated in his multi-faceted oeuvre, and his incessant urge to experiment in various media offer ongoing opportunities of investigation for those interested in the late-nineteenth-century origins of modern art, an interest that is exemplified by the numerous exhibitions and publications of recent years. It is therefore astonishing that his work specifically as a portraitist has never before been the focus of a full-scale study.

Perhaps this has had something to do with the challenge of grasping what portraiture actually meant for Gauguin. In important ways, he reinvented the genre – partly within the context of the late-nineteenth-century reinvestigation of the spiritual dimension of art and the formal experimentation that accompanied it, and partly because he was committed to forging a new imagery that incorporated primitive and exotic references that reflected his travels to far-flung corners of the globe, allowing him to create a language outside of European traditions. This was carried out within the context of rampant colonialism in which Europe, not least France, was then engaged. This context coloured Gauguin's vision significantly.

Gauguin's portraits offer fascinating representations of the people he encountered – or imagined. He broke open the traditional function of the genre by deliberately disregarding the identity or social milieu of his sitters. Often he created images that reflected more on himself and his psychological relationship with his models than on the models themselves. Rather than making portraits that followed established conventions, he sought increasingly to introduce symbolic content that carried the image into new realms of meaning, a tendency that he expanded during his mature years via a syncretic primitivist or exoticist frame of reference.

At the same time, he was fully aware of traditional Western formats of portraiture, from aristocratic statements of status to intimate family scenes, reaching back as far as medieval and Renaissance examples. He employed them in part to meet expectations of what a portrait should be, in particular on the Parisian art market. He also subverted their meaning, rendering interpretation difficult, by proposing a synthetic context or an enigmatic narrative.

In many of his portraits Gauguin alluded to work by artists he admired, among them Gustave Courbet, Edgar Degas, Édouard Manet and Paul Cézanne. Friends and competitors such as Vincent van Gogh and Odilon Redon were referenced in ways that allowed Gauguin to turn a still life into a surrogate portrait. On his travels his vivid recollections of artworks he had admired or owned accompanied him just as much as the photographs and prints he brought with him. Many of these photographs, including reproductions of Delacroix's works from the collection of his former guardian Gustave Arosa or images of the friezes of the Buddhist temple of Borobudur in present-day Indonesia, served as continual inspiration for his portraits as well.

Analyzing Gauguin's extraordinary creativity has led us to focus our attention on works in which the artist addressed and expanded the parameters of portraiture. Our catalogue reflects this strategy. It is the result of extensive research by an international team of scholars and offers a first thorough investigation of the topic. We are particularly grateful to our co-authors – Elizabeth Childs, Dario Gamboni, Linda Goddard, Claire Guitton, Jean-David Jumeau-Lafond and Alastair Wright – who contributed thoughtful texts on aspects of our subject, and who were willing to engage in broader discussions with us about the character of Gauguin's portraiture.

The essays address the artist's self-portraits both in his images and his writings and the functions he assigned to them. They look as well at the inanimate objects in his still lifes that remarkably could serve as portraits and evoke absent companions. Also, his representations of his friends and colleagues, in particular the seminal role of Meijer de Haan, are investigated. Two essays analyze his portraits within their specific geographical and cultural contexts: Brittany and Tahiti. Less well-known works such as the recently discovered original drawing of Gauguin's portrait of Jean Moréas for *La Plume* benefit from detailed focus studies. And, finally, Gauguin's activities and opinions as a portraitist are placed within the context of the late-nineteenth-century fascination with portraiture.

While this catalogue accompanies our exhibition in Ottawa and London, we hope that it will contribute as well to our knowledge of Gauguin's artistic engagement and initiate further thinking about the nature of his portraiture and its fundamental influence on the twentieth and twenty-first centuries.

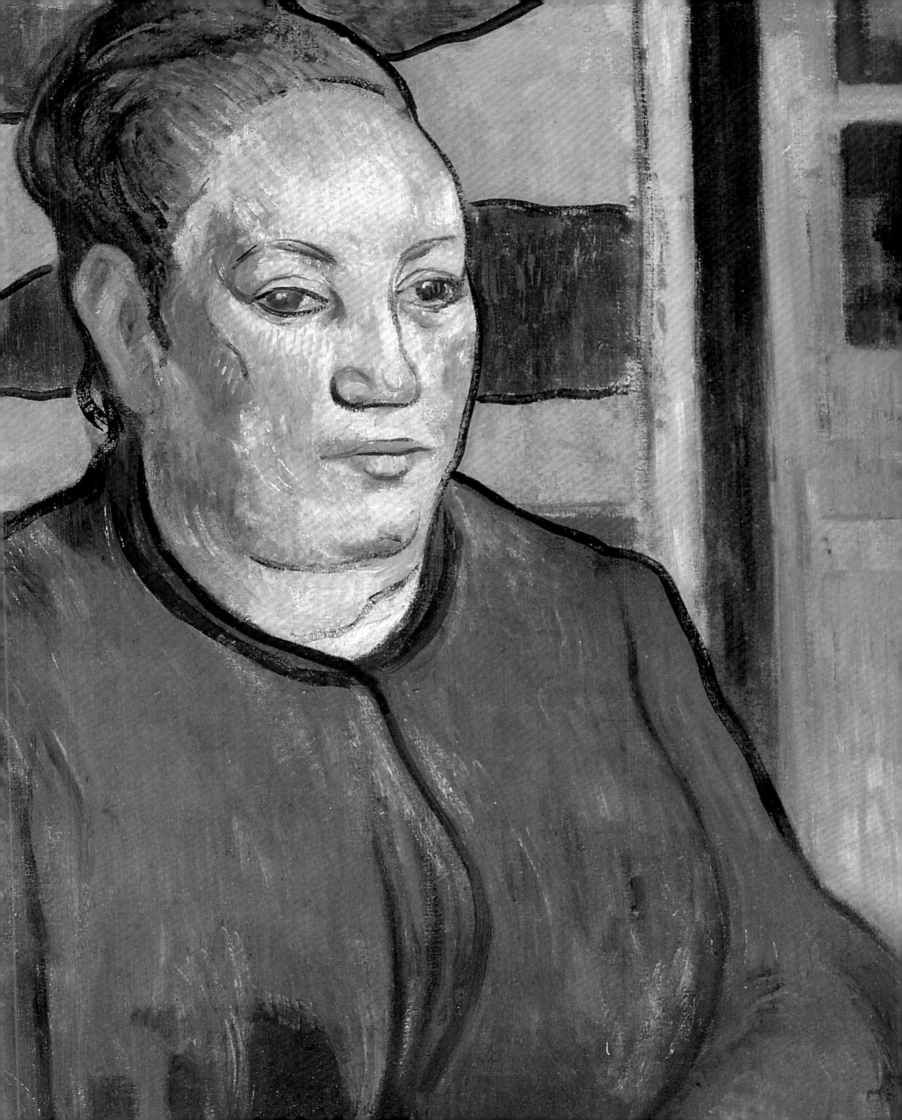

GAUGUIN'S SELF-PORTRAITS
EGOS AND ALTER EGOS

When I saw in the flash of the glaucous
and naked mirror,
Instead of my face, a face unknown...

<div align="right">Maurice Rollinat, "Le Mime"[1]</div>

ALASTAIR WRIGHT

The self-portrait is perhaps the most straight-forward and at the same time the most complex form of portraiture. Its simplicity lies in the easy availability of the model: all the artist has to do is examine his or her own features in the reflective surface of a mirror. But this apparently uncomplicated act – one that we all perform daily – raises thorny questions for the painter about identity and the ability to know oneself. What does one see, the self-portrait asks, when one gazes into the mirror? Is the gaze that emerges from the picture a projection of what the artist knows of him- or herself, or does the act of painting transform the artist into an object, a thing in the world seen from the outside? Does one see oneself more truthfully than others do, or is one always to some degree blinded by self-regard? Is the image in the mirror that of the true self or a stranger?[2]

Consider two painted eyes (see p. 24). One is all eager attention, its pupil and green iris set off against a dab of white paint that signals its orientation toward the world before it. The other, a dark void largely occluded by a swath of brown paint that spills over from the surrounding skin, seems blinded, or perhaps inwardly turned, self-absorbed rather than scanning the exterior world. Both, in fact, belong to the same face – Gauguin's – as it appears in *Self-portrait with Manao tupapau* (ill. 2). He made the picture while looking in a mirror, as we can tell by the reversal of the painting *Spirit of the Dead Watching* (*Manao tupapau*, ill. 88) on the wall behind him. In his divided gaze we sense the uncertainty of the effort to capture his self, the oscillation between experiencing his own gaze as active – as to some degree it necessarily is, for without an examination of the world of appearances

Bonjour, Monsieur Gauguin (detail, ill. 11), 1889

23

there would be no picture – and apprehending that same gaze as introverted, as though his own eye were merely a blind and unseeing orb.

We might not expect Gauguin to be troubled by such uncertainty. His contemporaries most often described a man possessed of a swaggering self-confidence, and at times his portrayal of his own features appears to confirm this view. At other times, as in *Self-portrait with Manao tupapau*, the face that looks out at us seems less sure of itself. These variations speak in part of an artist grappling with the complexity of self-portraiture, with the difficulty of capturing the gaze returned by the mirror. But we should be wary of taking the self-portraits as straightforward evidence of the artist's real state of mind. Gauguin was highly adept at promoting himself, and each version of his self – whether apparently assured or seemingly marked by hesitation – was designed to propagate a carefully crafted self-image and thus to attract attention in the competitive world of the Parisian avant-garde. It was for this reason that he began around 1885 to represent himself via a series of personae and alter egos – convict, sage, Christ – that helped to establish his position as a leading member of the Symbolist generation. (Gauguin was not alone in inventing identities: others in the avant-garde, both friends and rivals, played the same game.) Toward the end of the 1880s he refined this strategy, claiming that he was a doubled or divided self, half civilized, half savage.

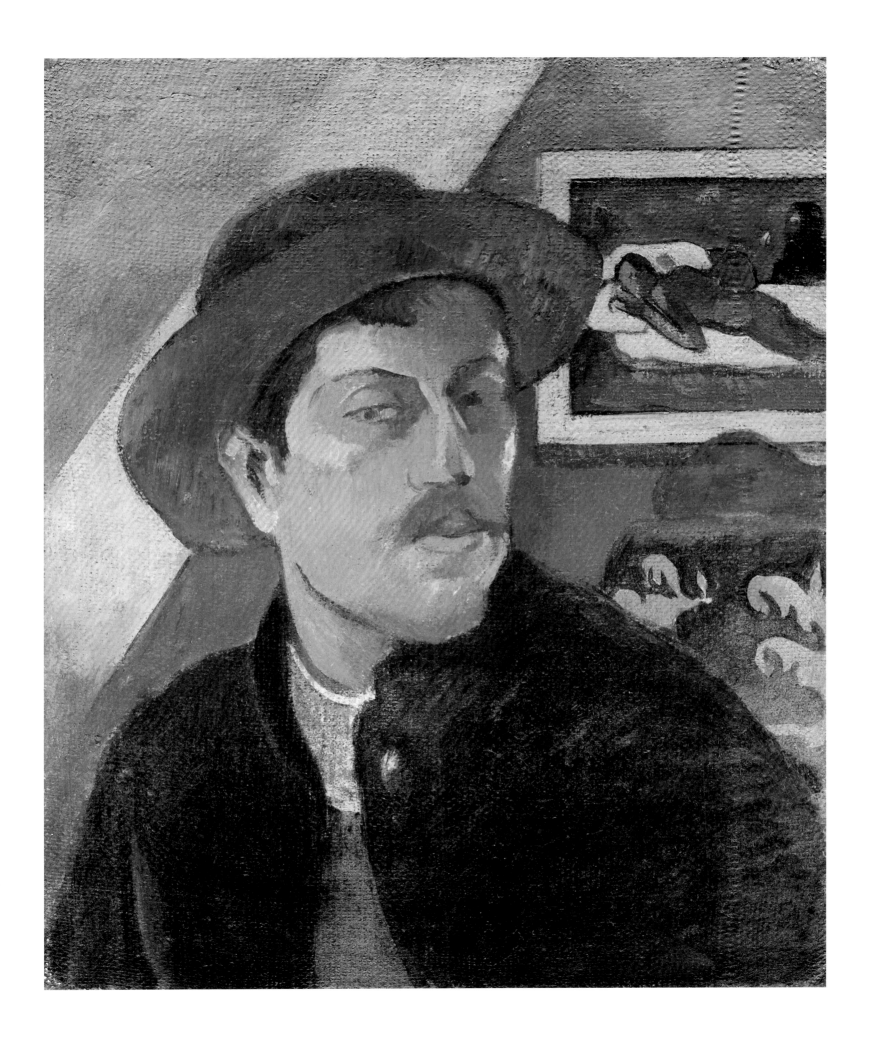

3 *Self-portrait*, n.d.

Hence Gauguin's ostensible doubt about the face in the mirror in *Self-portrait with Manao tupapau*. Which of my selves, the artist seems to ask, do I see before me? Such questions may have been heartfelt, but they also usefully aligned Gauguin's self-portraits with the interests of his Symbolist colleagues – Stéphane Mallarmé, for one, who was drawn to the idea that the self was seen at a remove "in the oblivion enclosed by the frame."[3] As we shall see, the artist's presentation of himself as a doubled being resonated equally with the later nineteenth-century belief that time spent in the colonies could result in a form of self-alienation, with the European traveller split between their homeland and their new life overseas, and thus fully at home in neither. Whether Gauguin himself believed these things – whether he genuinely saw his reflection as a stranger and as a divided colonial self or simply used these ideas to garner attention – is impossible to know. What we can state with certainty is that the compelling nature of his self-portraits derives from the way in which they bring together a sustained examination of the artist's own face and an exploration of the profound questions about identity that were being asked by his contemporaries. It was from this combination of looking and interrogation that Gauguin forged his remarkable series of self-portraits.

...you have my individual image, as well as a portrait of us all, poor victims of society, taking our revenge on it by doing good.

<div align="right">Gauguin to Vincent van Gogh, 1888[4]</div>

Apart from a rather conventional self-portrait painted early in his career (*Man with Toque*, 1876, Harvard Art Museums/Fogg Museum, Cambridge, MA, W25/W23 [2001]), Gauguin showed little inclination to depict his own features until the mid-1880s. It was then, as he sought to position himself within the rapidly evolving world of advanced painting in France, that he seems first to have felt a sustained need to propagate his image. In his 1885 self-portrait showing him at the easel (ill. 5) he signalled his allegiance to Impressionism and to his first master, Camille Pissarro, by concentrating on the fall of light through the attic window and the play of refracted colour across his jacket and face.[5] *Self-portrait Dedicated to Carrière* (ill. 6), painted about three years later, hints at new affiliations. The picture seems less interested in attempting to accurately record what the artist saw (note the unnaturally bright-green wall and the unmodelled brown of his jacket) than it is in asserting his place as head of the group of young artists working at Pont-Aven in Brittany. Gauguin shows himself in the embroidered Breton waistcoat in which he often had himself photographed at this time (see ill. 4) and wears an expression of quiet confidence appropriate to a self-declared leader.[6] His gaze, although aimed roughly in the viewer's direction, appears somewhat unseeing, as though he is lost in his own thoughts. This is Gauguin as Symbolist, attuned to the inner world of ideas and feelings.

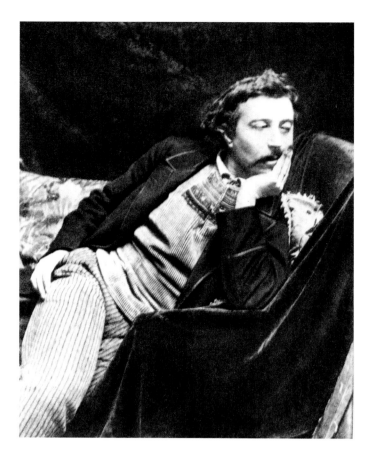

These images were crafted not for the general public (few of Gauguin's self-portraits were exhibited during his lifetime) but for a small circle of fellow painters and sympathetic critics. As examples of his work and as representations of his appearance the self-portraits were key tools in a game of self-promotion, and they were often given to colleagues to strengthen the personal ties that structured avant-garde networks. *Self-portrait for Carrière* is a good example. The canvas was originally dedicated to the painter Charles Laval, whom Gauguin befriended in Pont-Aven in 1886. When their relationship subsequently cooled as they competed for the affections of Madeleine Bernard, sister of the painter Émile (Madeleine chose Laval), Gauguin reinscribed the picture to Eugène Carrière, a leading Symbolist artist and – he presumably thought – a potentially useful ally. He received in exchange Carrière's *Portrait of Paul Gauguin* (1891, Yale University Art Gallery, New Haven).[7]

A similar wish to cement a friendship with a fellow painter and also with a potential supporter in the art market led to the first picture in which Gauguin created for himself a specific alter ego. Vincent van Gogh and his brother Theo – who worked for the Paris art dealers Goupil & Cie and who was trying to persuade his employers to sell Gauguin's work in his Montmartre branch – had for some time dreamt of assembling a collection of artists' likenesses.[8] Vincent wrote from Arles

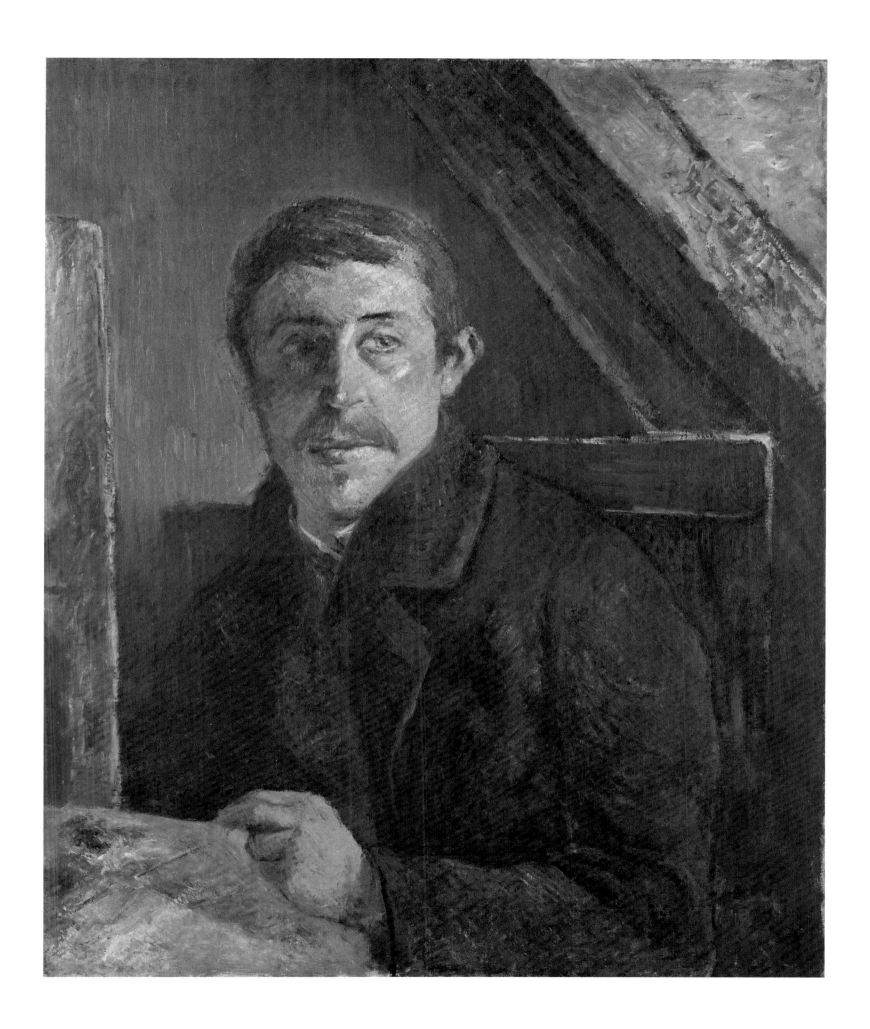

5 *Self-portrait*, 1885 **29**

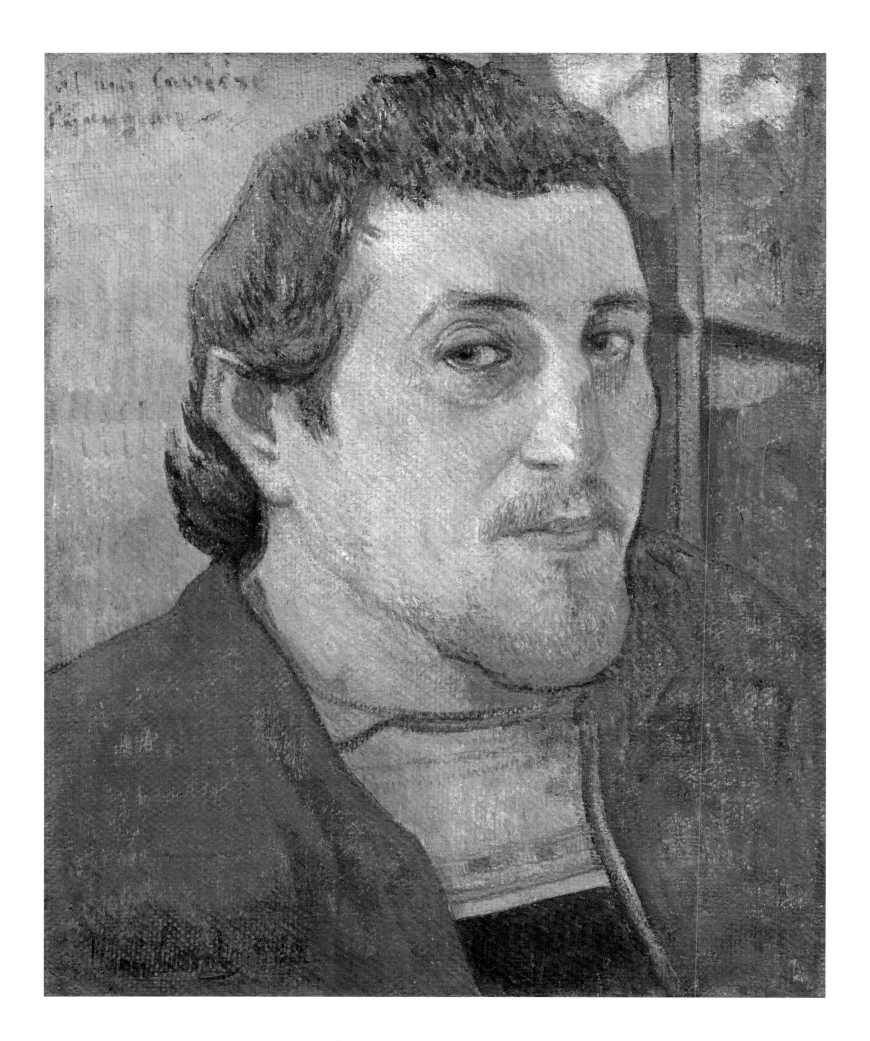

6 *Self-portrait Dedicated to Carrière*, 1888/89

in September 1888 to ask Gauguin and Émile Bernard to paint each other's portraits in exchange for two of his own self-portraits.[9] Bernard baulked at painting Gauguin, by whom he apparently felt intimidated, and the two artists opted instead for self-portraits (ills. 7, 8).[10] Both pictures are dedicated to "l'ami Vincent," and both include alongside the self-portrait a smaller portrayal of the other artist (perhaps painted by the other artist himself). But where Bernard presented himself simply as himself, Gauguin adopted a specific persona, as indicated by the inscription "les misérables" and explained in a letter to Van Gogh. The self-portrait, Gauguin wrote, was "[t]he mask of a thief, badly dressed and powerful like Jean Valjean, who has his nobility and inner gentleness."[11]

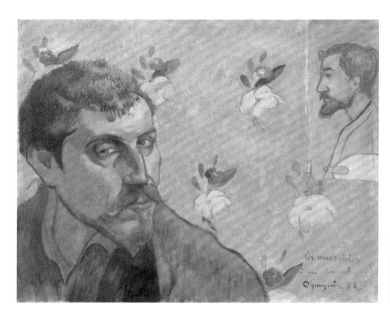 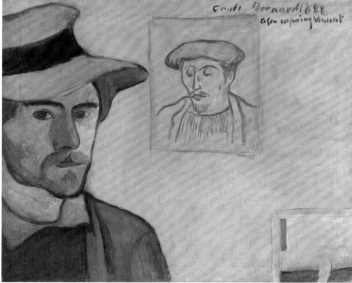

Jean Valjean is the hero of Victor Hugo's great novel *Les Misérables* (1862). Unjustly convicted as a young man for stealing a loaf of bread to feed his widowed sister's children, he thereafter lives honourably but is continually shunned as a criminal outcast. Gauguin's self-portrait implies that he believed his trajectory was similar: slighted and ignored by much of the art world, he nevertheless remained true to his artistic calling. He spelled this meaning out for Van Gogh:

> And that Jean Valjean, whom society oppresses, outlawed; with his love, his strength, isn't he too the image of an Impressionist today? By doing him with my features, you have my individual image, as well as a portrait of us all, poor victims of society, taking our revenge on it by doing good.[12]

He also explained the meaning of specific aspects of the picture. The dashes of red around the eyes were to express the intensity of artistic creation: "The rutting

7 *Self-portrait with Portrait of Bernard (Les Misérables)*, 1888
8 Émile Bernard, *Self-portrait with Portrait of Gauguin*, 1888

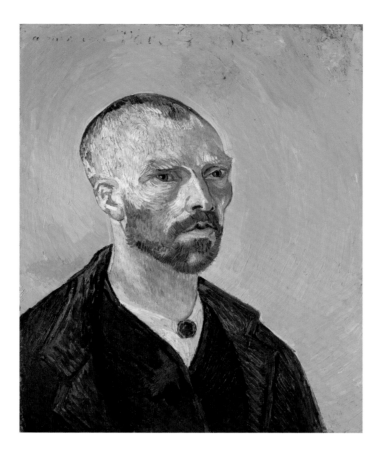

blood [that] floods the face, and the tones of a fiery smithy, which surrounds the eyes, suggest the red-hot lava that sets our painters' souls ablaze."[13] "The girlish little background, with its childish flowers," was "there to testify to our artistic virginity."[14]

This last remark perhaps reflects less Gauguin's own view of the painter's vocation – he was not much interested in high-minded purity – than his sense of what Van Gogh might have wanted to hear. His description of the self-portrait, like the painting itself, was fashioned to serve specific needs – in this case, keeping Vincent and his art-dealer brother happy. Gauguin was not, we might note, the only one carefully managing his own image. Van Gogh played much the same game in the work he offered in return, *Self-portrait Dedicated to Gauguin* (ill. 9).[15] The Dutch painter's haggard expression and shaved head allowed him to suggest that he too suffered for his art, and like his friend he created for himself an alter ego of sorts: he depicted himself, he explained to Gauguin, as a *bonze* – a Japanese Buddhist monk or priest.[16] The differences between the images, though, are equally significant. Van Gogh's invocation of the *bonze* was inspired by his hope that an artistic community might be formed in Arles where painters could coexist in simple and humble brotherhood, much as he imagined the monks of Japan had lived in the past. Gauguin's chosen alter ego was, in contrast, a solitary outsider who struggled against the unrelenting hostility of those around him.

I is another... Arthur Rimbaud, 1871[17]

Gauguin was not, of course, solitary. Valjean was a useful mask, but this was not a mask worn in isolation. Rather it operated, as I have suggested, within a network of avant-garde friendships and rivalries. The alter ego could, as Gauguin knew very well, be used in that setting with devastating force. Witness the joke he played in 1886 by circulating a collection of precepts purportedly written by Mani Vehbi-Zunbul-Zadi, a theretofore unknown Turkish artist.[18] The text included several observations that rhymed particularly well with Gauguin's own approach and that contradicted the theories of his rivals the Neo-Impressionists – not surprisingly, as Gauguin had himself written the text as an elaborate hoax (Georges Seurat, leader of the Neo-Impressionist group, was one of those who was taken in).[19]

The Zunbul-Zadi trick broadly echoed a taste for playful imposture – for playing an "other" – that was shared by many of Gauguin's artistic contemporaries. Seurat's colleague Paul Signac penned a pastiche of Émile Zola and presented it as though it were a scrap of Zola's own writing.[20] Henri de Toulouse-Lautrec had himself photographed as everything from a businessman to a Japanese geisha. And when Gauguin and his friends showed their work at the Café des Arts in 1889, Bernard exhibited two works under the pseudonym Ludovic Nemo. The invented name was a good joke: Ludovic is close to the Latin *ludere*, to play, and Nemo means "no-one."

Such jokes were one of the means by which the various factions of the avant-garde defined themselves, allowing those in the know to share a humorous wink and to laugh at rivals who remained in the dark. As such they parallel but also differ in important respects from the self-portrait alter egos. Zunbul-Zadi, Signac's "Zola," and Bernard's Nemo were played for laughs, and their force was dependent precisely on the intended audience being able to recognize the droll inauthenticity of these identities. The self-portraits, in contrast, were on the whole more serious. Their underlying claim – perhaps somewhat paradoxically – was that the adopted persona pointed toward the real self, toward the artist's true identity. "I" may be another, the pictures suggest, but that other is also the real me. This truth about the self was not, obviously enough, to be revealed in external appearances. Thus, unlike in contemporary self-portraits by Impressionist artists – Claude Monet's *Self-portrait with a Beret* (ill. 10), for example – Gauguin had little interest in a careful examination of the contours of the face. Instead, he reduced his own features to a set of somewhat caricatured traits in order to

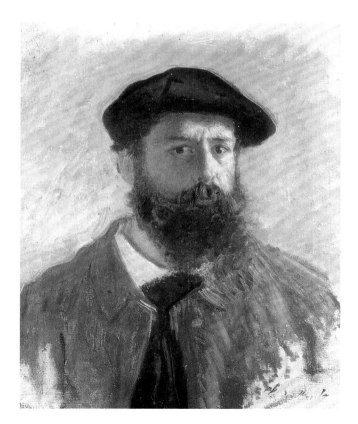

11 *Bonjour, Monsieur Gauguin*, 1889

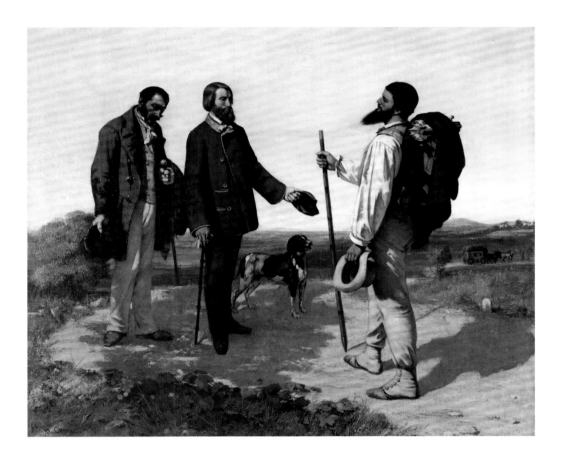

make his image instantly recognizable. In *Self-portrait with Portrait of Bernard* (*Les Misérables*, ill. 7) the hook of his nose is exaggerated, his forehead is lowered (compare, for instance, to ill. 8), his eyelids are given an emphatic weight, and his facial hair is given a reddish tinge (perhaps partly in homage to Van Gogh).

These traits would recur in the series of self-portraits that Gauguin created in late 1889 while living in Le Pouldu, an isolated village on the Brittany coast where he stayed in a small inn, La Buvette de la Plage, with two friends from his Pont-Aven days, Meijer de Haan and Paul Sérusier.[21] Like *Les Misérables*, these pictures were designed to propagate a self-serving image of the artist for a limited circle of initiates. *Bonjour, Monsieur Gauguin* (ill. 11), which hung on one of the inn's dining-room doors, aligns Gauguin with an earlier leader of the avant-garde, Gustave Courbet, whose *Bonjour, Monsieur Courbet* (ill. 12) he had seen with Van Gogh in Montpellier the previous year.[22] Borrowing some of Courbet's prestige, Gauguin also implies that he has moved beyond his predecessor. Where Courbet shows himself as the equal of the art collector Alfred Bruyas (in contrast to the collector's submissive manservant), Gauguin pictures himself as though in silent communion with a Breton peasant woman.[23] The picture suggests that, as a good Symbolist, Gauguin is attuned to the rhythms and rituals of timeless rural life. With one eye half-closed and the other hidden, he looks not at the material qualities of the world but, we are

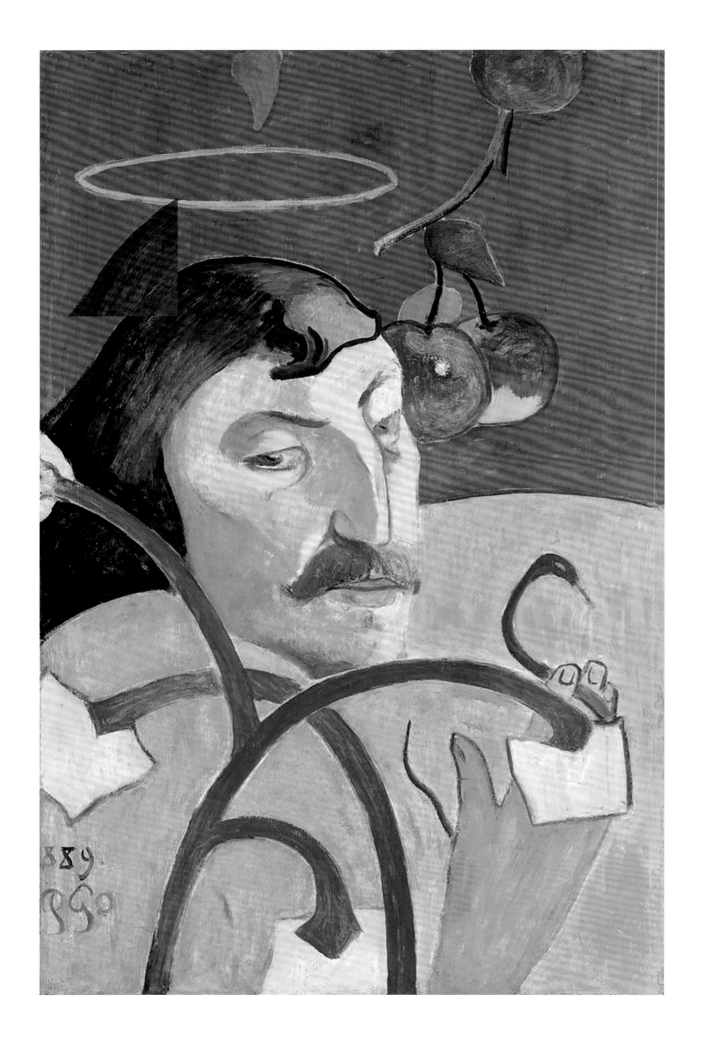

13 *Self-portrait with Halo*, 1889

to infer, into its hidden depths. A second image from Le Pouldu, *Self-portrait with Halo* (ill. 13), this one painted directly on a door in the dining room, pushes this idea further: the artist attends, we surmise, to the mysterious meanings suggested by the halo, snake and apples, which together call to mind the Biblical Fall.[24]

These paintings, like *Les Misérables*, affirm the idea of Gauguin as a man apart – a sage, a fallen angel, someone who communes with peasants. And, as with the earlier painting, they transform his face into an easily identifiable icon: *Self-portrait with Halo* in particular reduces his physiognomy to a set of schematic signs. What the artist's face actually looked like is of less import than what the self-portrait tells the viewer about the kind of man he was. This is perhaps even truer of another self-portrait of sorts, this one in ceramic: *Self-portrait in the Form of a Grotesque Head* (*Anthropomorphic Pot*, ill. 110). Were it not for a letter in which he offered the pot to Madeleine Bernard and told her that "it is meant to represent the head of Gauguin the savage," we might not think of it as a self-portrait at all, though the artist's identification with what the distorted countenance expresses is confirmed by the description he sent to Émile Bernard: "this figure calcined in this inferno [i.e. the kiln] … like the artist whom Dante had seen in the Inferno: that poor devil all shrunk to sustain the suffering."[25] The letters and the gift of the object to Madeleine are telling: as with the painted self-portraits, Gauguin used the pot to disseminate a persona (once again, that of the tortured artist) that served him well as he jockeyed for position within the Parisian avant-garde.[26]

The most ambitious self-portrait painted in Le Pouldu, though not included in the décor at the Buvette de la Plage inn, was in the form of another alter ego. *Christ in the Garden of Olives* (ill. 14) is nominally a depiction of Jesus, but the hooked nose and heavy-lidded eyes make clear that this is essentially a self-portrait. In equating the artist with Christ, the painting follows a well-trodden path: Albrecht Dürer's famous *Self-portrait* of 1500 (Alte Pinakothek, Munich) had set the ball rolling nearly 400 years earlier. But where Dürer was interested in the artist's status as a quasi-divine creator, for Gauguin the pertinent comparison was to Christ's anguish, and he orchestrated the picture's dark colours and sombre atmosphere to convey the figure's tormented isolation. Other later nineteenth-century artists were equally drawn to the parallels between painter and Christ – James Ensor, for example, whose *Ecce Homo* (*Christ and the Critics*, 1891, private collection) equates the trials of the modern artist and the scorning of Jesus before the Crucifixion.[27] For Gauguin, though, the image of Christ meditating in solitude was of particular use. Firstly, it served his ongoing promotion of himself as a martyr (thus he explained the picture to Van Gogh in terms presumably intended to appeal to the Dutch artist's religious inclinations: "There is a Road to Calvary that all we artists must tread").[28] Secondly, it allowed him to present himself – as had the figure of Valjean – as one who was rejected even by those close to him. (Van Gogh would have understood the reference: Gauguin's letters made clear his fear that the young artists who had gathered around him since the Pont-Aven days – his disciples, as it were – were beginning to desert him.)

I have two natures within myself... Gauguin, 1888[29]

We should not, of course, read *Christ in the Garden of Olives* as evidence of Gauguin's real state of mind. This self-portrait, like another work from the same year, *Jug in the Form of a Head, Self-portrait* (ill. 111), was carefully crafted to bolster the painter's image as one who suffered for his art (he included the vase in *Still Life with a Japanese Print* [ill. 113] to further disseminate this self-serving identity).[30] The extravagant astrakhan hat (see ill. 15) that attracted attention at art openings in Paris and the decorated Breton waistcoat and tight-fitting blue frock-coat that he often sported served much the same purpose of self-promotion. Many were struck by what the painter Armand Séguin recalled as the artist's "strange way of dressing."[31] The art dealer Ambroise Vollard, for example, marvelled at Gauguin's appearance at his one-man exhibition at the Durand-Ruel galleries in 1893: "with the haughty expression on his face, a fur cap on his head, a coat thrown over his shoulders, followed by a small Javanese girl dressed in luminous garments, one could have taken Gauguin for an oriental prince."[32] Not everybody approved: a caricature by Camille Pissarro's son Georges casts what we sense is an acerbic eye on the artist's posing at Durand-Ruel (ill. 16). But the fact that even Gauguin's enemies took note of his appearance points to the success of his self-advertising.

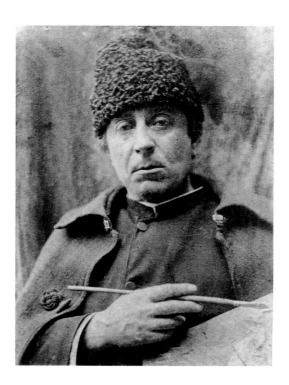

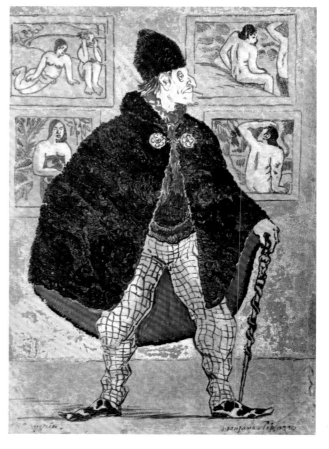

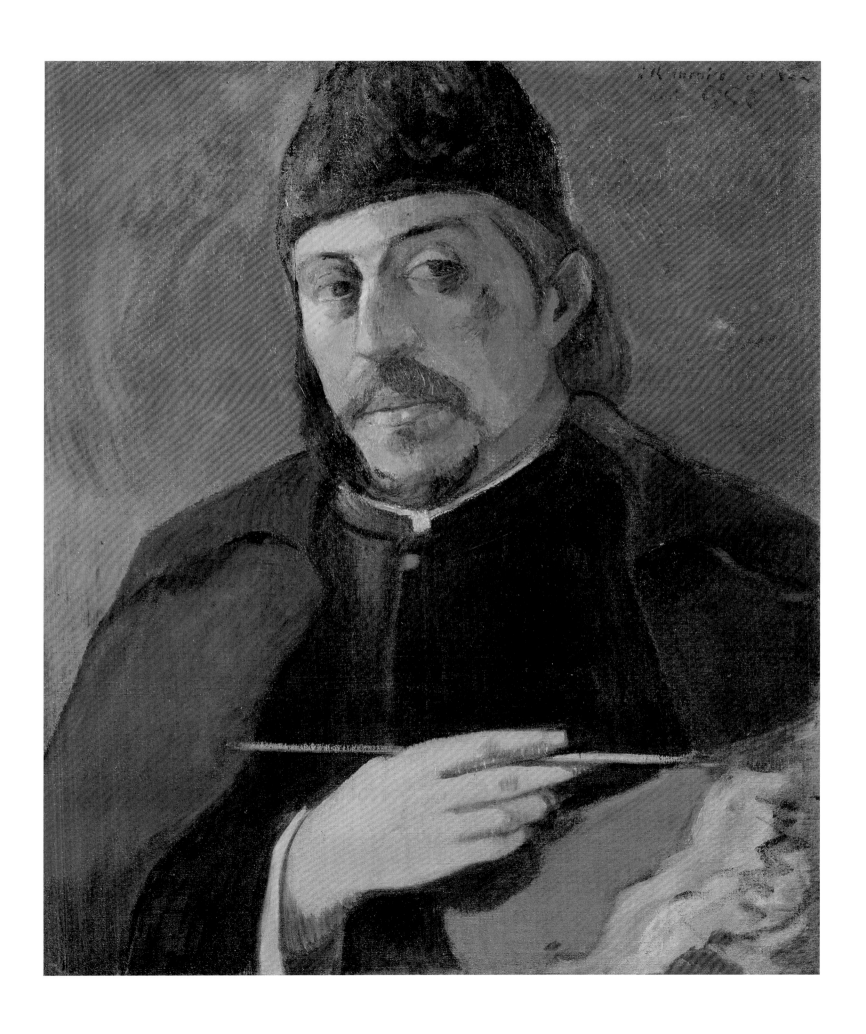

17 *Self-portrait with Palette*, c. 1894 **41**

Vollard and Georges Pissarro's responses also highlight a key aspect of Gauguin's self-mythologizing – namely, his claimed affiliation with a range of non-European cultures. His first stay in Tahiti (1891–93) and the canvases he brought back with him would cement this association, but it was one that Gauguin had already begun to cultivate in the late 1880s. Writing to his wife, Mette, in February 1888 he declared that "I have two natures within myself: the Red Indian and the sensitive [i.e. European/civilized]."[33] By the following year he maintained that this was also how others saw him: "I am staying on the beach in a fisherman's hut, near to a village of 150 inhabitants [Le Pouldu]. I live here like a peasant. They call me: the Savage."[34] A letter sent to Bernard in August 1890 added cowboys and Christ to the mix: "I walk about like a savage, with long hair … I have cut myself a few spears and, like Buffalo Bill, practise spear-throwing on the beach. That then is he, whom they call Jesus Christ."[35]

As the range of identifications (Buffalo Bill and Native Americans, peasants and Christ) indicates, Gauguin's self-fashioning as a "savage" was at this point somewhat inchoate. He clearly understood that to present himself as non-European usefully upped the ante on the assertion that he was a man apart, but this new identity was pieced together in a somewhat aleatory fashion from the culture around him. William "Buffalo Bill" Cody, for example, was on his mind because the American showman had brought his Wild West show to Paris at the time of the 1889 Exposition Universelle. Some would have seen Gauguin's scattershot adoption of different personae as a sign of his insincerity. Camille Pissarro, for one, came to suspect that the artist's habit of picking up motifs and styles here and there meant that he created merely an "art of the sailor" (as a young man Gauguin had, as Pissarro would have known, worked in the merchant marine).[36] His art – and perhaps his persona – was for Pissarro merely a kind of voyager's *bricolage* of whatever had most recently caught his eye. Pissarro's concerns would have been confirmed had he seen the letter Gauguin wrote to Émile Schuffenecker in July 1888 describing *Breton Boys Wrestling* (1888, private collection, W273/W298 [2001]); the picture, Gauguin averred, was something "completely Japanese, done by a ~~Frenchman~~ Peruvian savage."[37] Twinned with his invocation of the contemporary European fashion for things Japanese (a taste he shared with Van Gogh), Gauguin's deletion of "Frenchman" in favour of a more exotic South American identity signals the provisional status of his various selves at this time: the claim to be Peruvian was added as an afterthought as he weighed up how best to convince a fellow artist of the originality of his work and of its difference from that of other members of the avant-garde.

Camille and Georges Pissarro were not the only ones to express skepticism about Gauguin's posturing, but the artist's claim to be at least partly a "savage" proved a successful gambit in the ongoing effort to attract attention from fellow artists and critics. Thus, Gauguin gave increasing emphasis to the idea that he was in part Peruvian – as, for example, when he proclaimed in 1889 that he had

18 *Self-portrait "à l'ami Daniel,"* 1896

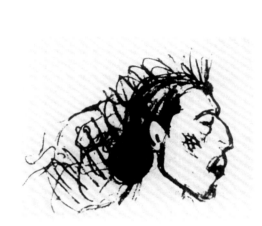 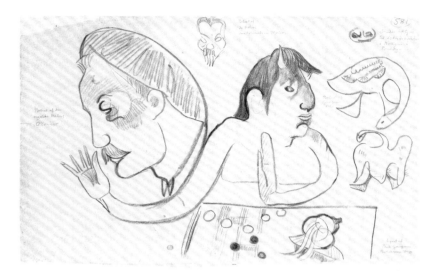

"Indian, Inca blood" (the veracity of this assertion is questionable: it is true that he had a "Peruvian" great-grandfather, but this ancestor was in fact a Spanish nobleman whose family held positions of power in the viceroyalty of Peru).[38] He also began to explore how his putatively non-European identity might be conveyed visually. In a small sketch titled *Head of a Savage* (ill. 19) he showed himself wearing what appears to be a Native American headdress. In *Self-portrait Caricature with De Haan and O'Connor* (ill. 20) his split nature is signalled even more clearly: he pictures himself partly in relation to Brittany (the stylized geese recall those seen on many of his faux-Breton ceramics) and partly as non-Western. With his hand pressed vertically against his chest, his pose repeats that of the female Cambodian dancers he had seen in Paris at the 1889 Exposition Universelle (like Toulouse-Lautrec, playing with gender roles was part of the game).[39] The caricature circulated among his friends, presumably as an amusing diversion (the annotations are by Jens Ferdinand Willumsen, a Danish artist who spent time with Gauguin in Brittany). But the message that the image conveys – namely, that the artist was part European, part other – was also in earnest.

The first suggestion of this doubled identity in a publicly exhibited work was subtle: in the wooden relief sculpture *Be in Love and You Will Be Happy* (ill. 54) Gauguin pictured himself in the upper-right corner as "a monster" (as he wrote to Bernard), behind whose shoulder we see a roughly fashioned miniature face that has been interpreted as a visual alter ego representing the primitive side of his nature.[40] *Self-portrait with Yellow Christ* (ill. 103) declares the dividedness of the artist's self more explicitly. Painted on the eve of his departure for Tahiti, the image

positions the artist between one of his best-known Brittany paintings (seen reversed, as in a mirror) and the self-portrait pot from Le Pouldu (painted from a photograph provided by Bernard).[41] This pot, described earlier by the artist as the image of a tortured artist, here takes on a second meaning: its resemblance to Pre-Columbian Mexican vessels allows it to stand as the sign of Gauguin's "primitive" half.[42]

...so was I a savage to each one of them... Gauguin, *Noa Noa*[43]

Partly inspired by the colonial displays at the 1889 Exposition Universelle, Gauguin set off for Tahiti in 1891 in hopes of further exploring the "savage" side of his nature. During his two-year stay he seems not to have created any painted self-portraits: perhaps as he was temporarily at a remove from the Parisian art world the need to disseminate his image was less pressing. (One of the few records of his appearance in Tahiti is a small drawing in which he depicted himself from behind wearing a Tahitian *pareu* that hints at his partly "other" nature.) Back in France in 1893 he resumed his public self-fashioning with *Self-portrait with Idol* (ill. 21), in which he again signals his doubled identity, this time by wearing a Breton sweater while seated before a statue of the Polynesian goddess Hina.

In Paris Gauguin also began to write *Noa Noa*, a semi-fictionalized account of his time in Tahiti with which he intended to propagate further his image as at least partly a "savage." (To his disappointment, *Noa Noa* remained incomplete when he left once more for Tahiti in 1895, in part because he fell out with Charles Morice, the Symbolist poet and critic whom he had asked for help in reworking his first draft.[44]) The text is structured around a series of episodes in which, having escaped the Europeanized culture of Tahiti's capital, Papeete, the artist establishes contact with the "real" Polynesia – a contact represented most notoriously in his account of his relationship with the thirteen-year-old Teha'amana. Yet if the text is largely devoted to convincing its intended readership that Gauguin had more fully accessed his "primitive" side, it also suggests that under the gaze of the local population he gained a richer and perhaps more melancholic understanding of what was at stake in the claim to be situated between cultures. If his Parisian colleagues could half believe in his allegedly Inca blood, he came to understand that Tahitians saw him necessarily as a European (albeit an odd one, quite unlike most other colonials they had encountered), and certainly not as one of them: "As each one of them was a savage to me, so was I a savage to each one of them."[45] To be between cultures, the text of *Noa Noa* suggests, is to be at home in neither, and perhaps to be nowhere oneself.

Gauguin figured this sense of dividedness in a double-page spread of a leather-bound notebook into which he copied Morice's amended draft of *Noa Noa* shortly before departing on his second Tahiti trip in 1895 (see ill. 100). On one page we see a caricatural portrait in profile, undoubtedly drawn by the artist himself but labelled as "Mon portrait par ma Vahine Pahura" (My portrait by my vahine Pahura).

On the opposite page he pasted a photograph of himself posing at Durand-Ruel in 1893. Placed in close proximity, the images point both to Gauguin's doubled identity – at one and the same time the elegant European artist in a Paris gallery and the savage with hooked nose and heavy-lidded eye – and to the fact that these identities are alienated from each other. The two Gauguins turn their backs to each other, forever separated by the white space of the album's gutter. The sense of alienation is underlined by the fact that neither image is framed as a self-portrait. One is ascribed (falsely) to a Tahitian hand; the other is a photograph taken *of* Gauguin by someone else. Each thus shows (or claims to show) the artist seen from the perspective of another. That the paired images bespeak a melancholy recognition of the fact that, divided between "savage" and sophisticate, the artist can never fully be either, is further suggested by the "Vers de Verlaine" transcribed on the left-hand page. In "Le ciel est par dessus le toit," written as the poet Paul Verlaine awaited his transfer to prison in 1873, the narrator weeps ceaselessly over his enforced isolation from the peaceful murmur of a nearby town.[46] Gauguin chose the poem well: it speaks concisely to the conundrum staged by the paired portraits on the same pages. Alone in Tahiti, the artist misses the artistic networks of Paris, yet his Polynesian seclusion is precisely the means by which he maintains his elevated reputation in those networks.

The trope of a melancholically divided self with which Gauguin seems to engage here was not, we might note, one that was original to his oeuvre. The colonialist's self-alienation was frequently thematized in accounts of life in the tropics and played an important role in one of the main sources for *Noa Noa*, Pierre Loti's novel *Le Marriage de Loti*.[47] (Note that Loti, like Gauguin, was drawn to the alter ego: born Julien Viaud, he lived under the name of the eponymous hero of his book following its huge success.) Early in the text "Loti," a British naval officer whose real name is Harry Grant (in art, as in life, the European acquires a Tahitian moniker), experiences the pleasures of a double identity – namely, the ability to move freely between the world of the colonists and that of the colonized (this ability is exemplified by a scene in which Loti passes back and forth between a grand ball at which he dances with Europeanized Tahitian women, and the dark gardens outside where he consorts with Rarahu, a young Polynesian relatively untouched by European habits).[48] This is a self-satisfied image of the power of the colonial male, at home both in the court and in the forest. Toward the end of the novel, however, Loti suggests that there is a price to pay for playing both sides of the colonial divide. The text closes with a series of fragmentary episodes recorded in Harry Grant's diary many years later. In one he plays his part in a light-hearted conversation with British officers in a mirrored hall where, amid the laughter and clink of glasses, he joins his colleagues in repeating the usual clichés: that, yes, the women of Tahiti are beautiful, like flowers; and that, yes, it is a place to go when you are young and then forget.[49] But subsequent fragments offer a dramatic account of the haunting of Loti's dreams by ghostly and elegiac visions of Polynesia and of Rarahu.[50]

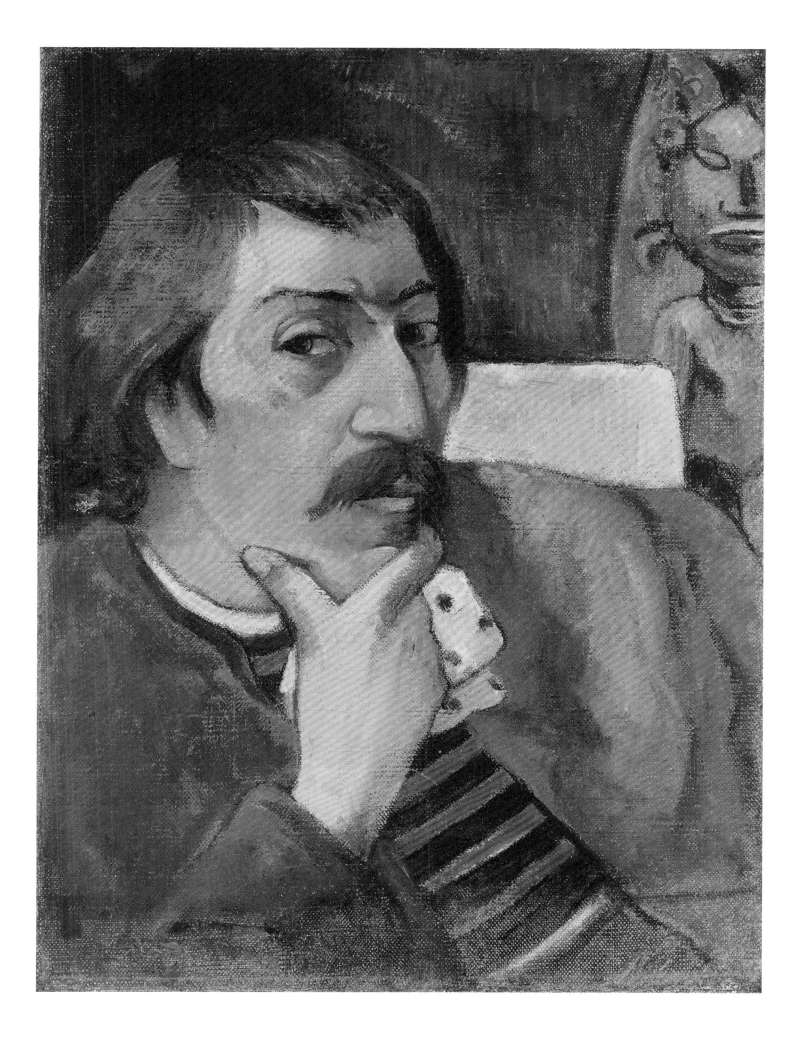

It is significant that Loti's evocation of the colonist split in two, caught between a return to European society and the memory of his time overseas, is set partly in a mirrored room. We are asked to imagine that as he discourses with his fellow officers Loti also watches himself, that he sees his own face reflected in the glass as he plays the role of the genial British officer that to the observer looks heartfelt but that is in conflict with his inner feelings. The mirror allows this doubled view, allows the reader to register the contrast between exterior appearance and inward experience and thus to understand that Loti is not one but two, irremediably divided.

...seeing himself vague and about to disappear... Stéphane Mallarmé, "Igitur"[51]

Gauguin, too, looked in the mirror. In *Self-portrait with Manao tupapau* (ill. 2) his face – like the painting on the wall – is a reflection. The painting shows the artist in his Paris studio in 1893, not long after he returned from his first Tahitian trip and at roughly the time he was planning *Noa Noa*. Below *Spirit of the Dead Watching (Manao tupapau)*, lying on a chair, is a Tahitian cloth that appears also in the picture on the wall. The yellow diagonal that matches the colour of the frame of *Spirit of the Dead Watching* is the chrome yellow with which Gauguin painted the walls of his studio in an effort to transform the mundane French setting into an exotic world.[52] And, at the centre, Gauguin's own face peers out toward the beholder. We feel that we are being scrutinized, but of course this is also an act of self-scrutiny.

Perhaps Gauguin recalled the mirrored hall in *Le Marriage de Loti*. Sitting in his Paris studio with the great Tahitian canvas behind him, he seems to wonder, as had Loti: who is the man I see before me? Is it Gauguin the French painter, ready to rejoin the day-to-day life of the Parisian avant-garde, to pass the time of day with the artist colleagues and critics whom he will soon invite to the studio to view his latest works? Or is it Gauguin the "savage," drawn irresistibly back to memories of the world depicted in *Spirit of the Dead Watching*? (Soon enough the artist would answer the siren call of that world, departing once more for Polynesia in 1895, never to return.)

When gazing at his own reflection Gauguin could equally have had in mind the Symbolist fascination with the mirrored self. As we noted at the outset, Mallarmé, with whom Gauguin became closely acquainted in the early 1890s, was drawn to the idea that the self was seen at a remove "in the oblivion enclosed by the frame."[53] Indeed, for Mallarmé, the trope of the mirror image as a sign of otherness was a recurrent theme.[54] In "Herodias" the titular character sees her reflection "like some distant shade."[55] In "Igitur" the narrator comes close to losing himself entirely in the mirror's depths: "seeking himself in the mirror become boredom, and seeing himself vague and about to disappear."[56]

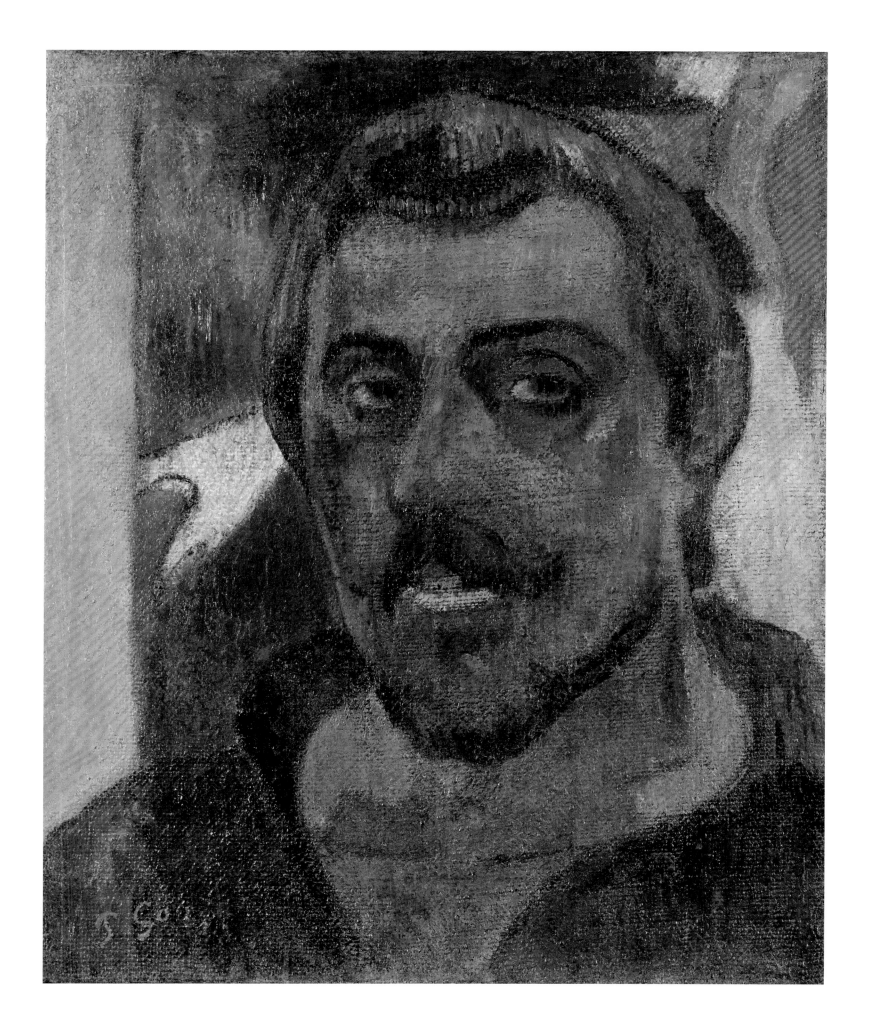

For Mallarmé, the face seen indistinctly in the mirror was the sign of an alienation from one's self. The reflected self was an estranged other, only partly recognized, only partly oneself. Others of Gauguin's generation agreed. In *Le Traité du Narcisse* (1891), André Gide worried that in gazing for too long into the mirror one risked becoming merely the reflected image and thus no longer oneself.[57] And the Symbolist Paul-Pierre Roux (known as Saint-Pol-Roux) penned a remarkable passage that echoes Gauguin's pose as Valjean. Encountering a condemned bandit in his cell, his narrator realizes that they look exactly like each other: "Suddenly the condemned greeted me thus: – I am yourself."[58]

As with the poems of Mallarmé and his colleagues, Gauguin's self-portraits suggest that one sees oneself always imperfectly in the mirror. His expression in *Self-portrait with Yellow Christ* bespeaks a certain reserve, a lack of confidence in his own presence – as though he views himself as a stranger. The same can be said of *Self-portrait with Manao tupapau*, and here the idea of dividedness, of a self not fully present to itself, resonates even more fully with his own avowedly doubled nature – part European, part savage. In this respect the inclusion of *Spirit of the Dead Watching* is particularly significant. As a Tahitian canvas it locates the artist once more between Paris and Polynesia, between the studio of a French avant-garde artist and the experiences of a colonial overseas. But more specifically it invokes a moment when Gauguin claimed to have felt himself equally divided in Tahiti. In *Noa Noa* he described how, returning one night from a trip to Papeete, he found his rural house in darkness. Striking a match he saw Teha'amana lying terrified on the bed. His account is famous for its indecent interest in the vulnerability of the girl, whose fright made her "tremulously beautiful."[59] But it also suggests a degree of uncertainty about his own place in the scene: "She looked at me, and seemed not to recognize me. As for myself I stood for some moments strangely uncertain. … How could I know what at that moment I might seem to her? Might she not with my frightened face take me for one of the demons and spectres, one of the tupapaus?"[60] The episode might well, of course, have been an invention: we should as always be wary of Gauguin's self-mythologizing. But the veracity of his account is less important than what the story tells us about how he wanted his audience to see him: namely, as one who experienced his own alterity, his own divided selfhood – man or spectre, "savage" or European – under the gaze of the other.[61]

This doubledness, and the consequent sense that the artist cannot fully be present to himself, echoes in the look in the mirror depicted in *Self-portrait with Manao tupapau*. As we noted earlier, Gauguin's self-regard in this picture is divided. Even the left eye, which at first seems to look directly out, does not quite meet our gaze – nor the artist's own as he looked at himself in the reflective glass surface before him. The image intimates that the artist cannot fully see himself, that he cannot quite grasp the face in the mirror, and his downcast gaze lends this realization a melancholy edge. This is an image of the artist both as a man caught between

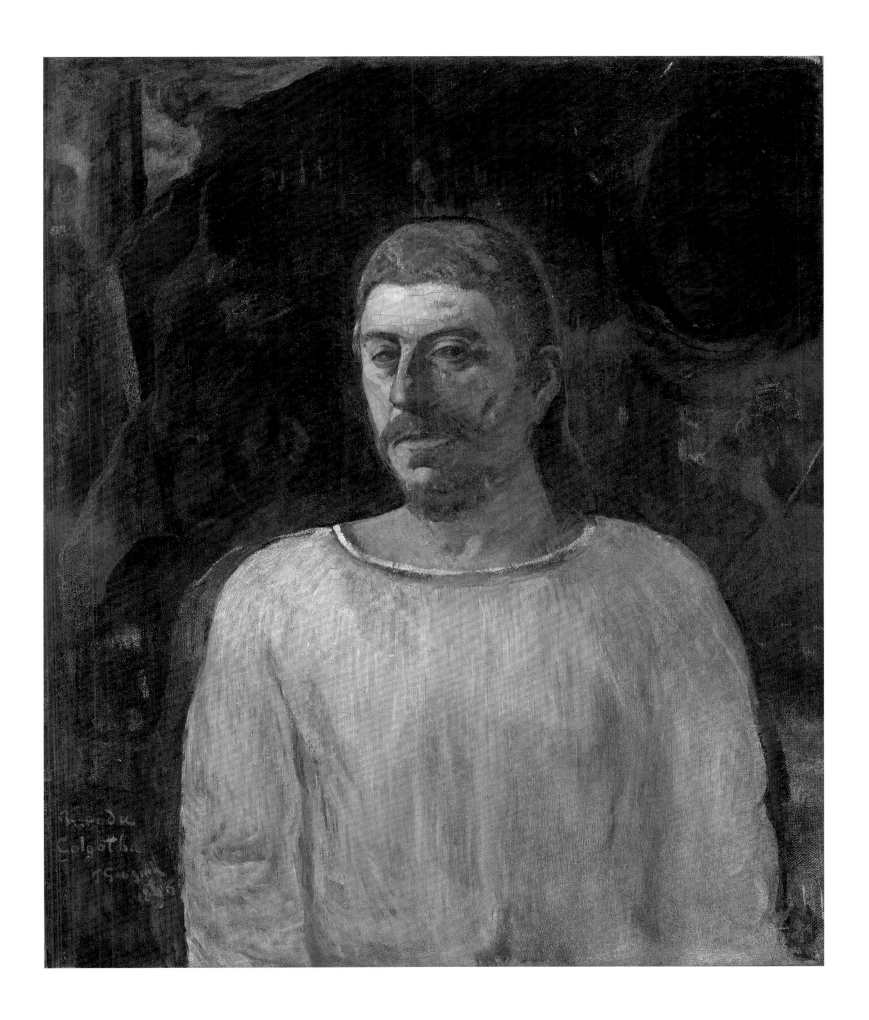

cultures – the sophisticated and knowing European painter (he wears once more his Breton waistcoat, though it is partly painted over) and the traveller who identified with the culture he had visited – and also as a self not fully present to himself.

Self-portrait with Manao tupapau is perhaps the most striking example of Gauguin's presentation of the gaze in the mirror as fundamentally divided, and of himself as a doubled and alienated self. As we have seen, this identity was crafted for the small circle of (primarily) Symbolist artists and critics whose support he craved. And, like some of his other self-portraits, this one was gifted to a close colleague – the French-Norwegian composer William Molard, whose own portrait appears on the reverse side of the canvas. In other works from the same period Gauguin – ever willing to strike a pose – put up a very different front. *Self-portrait with Palette* (ill. 17) shows him as an artist self-assuredly grasping the tools of his trade. The painting is based closely on the photograph of the artist in his astrakhan hat (ill. 15), though he has tightened up the jowly lines of his middle-aged face. We might therefore take his self-possessed air as the result of working from a photograph, which perhaps raised fewer questions about selfhood than looking in a mirror. But the picture was also, one suspects, a deliberate attempt to appear bullishly confident in the eyes of Morice, to whom the portrait was dedicated and with whom Gauguin was already starting to fall out as their collaboration on *Noa Noa* faltered.

When Gauguin left for Polynesia for the second and final time, the apparent confidence evaporated and a despondent self-pity took centre stage (I say "apparent," because we are, as ever, in the realm of the self-serving pose). *Self-portrait* (*Near Golgotha*, ill. 23) recalls the persona of the suffering artist that had dominated in the works of the later 1880s. The artist locates himself, as so often, between the old world and the new, between the base of the cross to the left and Polynesian figures – including a hooded *tupapau*, harbinger of death – to the right.[62] Clad simply in a white shirt, he is once more the martyr.

In what is probably Gauguin's last self-portrait (ill. 24) the melancholy seems more heartfelt. The austere image suggests a private meditation rather than an address to an imagined public. But again the artist's appearance is carefully managed. The cropped hair, the pseudo-antique garb, the plain background, and the narrow format all recall Roman funerary portraits.[63] Painting himself as though already beyond the grave, as though already merely a face remembered by those who mourn his passing, was perhaps a useful way to elicit sympathy. For although the artist would indeed die before his colleagues had a chance to see the image, when he painted it he was still in touch with his remaining allies in France (most notably the painter and collector Daniel de Monfreid), corresponding with them about his plans for the future and about his need for their moral and financial support.[64] Here I am, the self-portrait declares, a man whose end is near. Which might equally be to say: here is a man whose remaining friends ought to pay heed. With Gauguin, as always, it is hard to know where the posing begins and ends.

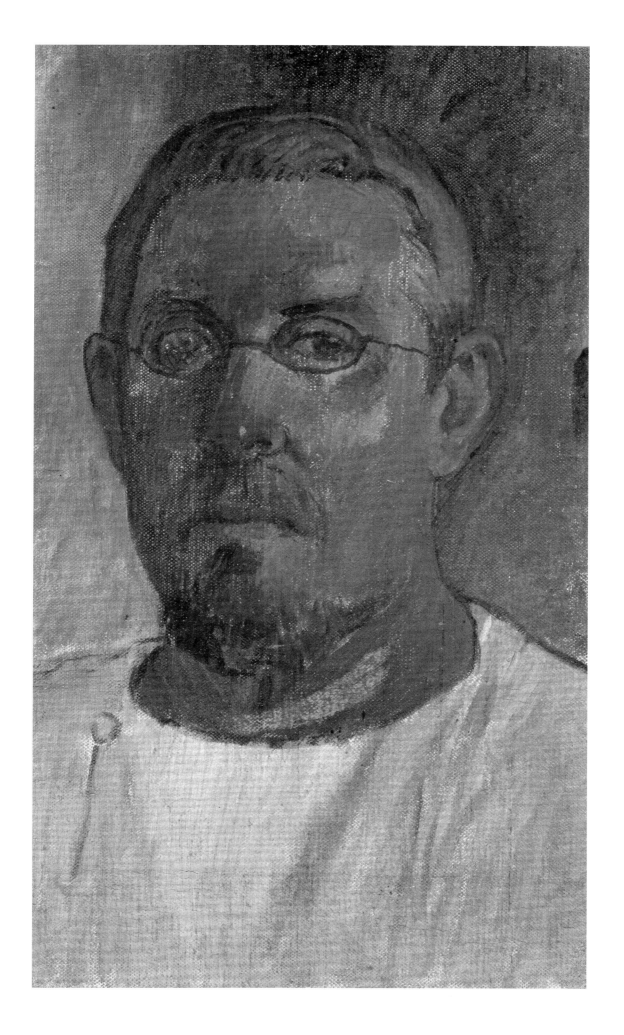

NOTES

1 Maurice Rollinat, "Le Mime," in *Les Névroses* (1883).

2 Marcia Pointon has argued that "the alterity staged by mirrors" is a persistent trope in European art (Pointon 2013, p. 199). Important explorations of self-portraiture's inherent complexity can be found in Bond and Woodall 2005; Derrida 1993; and Koerner 1993.

3 Stéphane Mallarmé, "Sonnet en –yx," in *Poésies* (1887), trans. C.F. MacIntyre, *Selected Poems* (Berkeley: University of California Press, 1957), p. 85.

4 Letter from Gauguin to Vincent van Gogh, 1 October 1888, no. 692, http://vangoghletters.org (accessed 9 August 2018).

5 On the work's debt to Impressionism, see Jirat-Wasiutyński and Newton 2000, p. 58, and Brettell and Fonsmark 2005, p. 252.

6 As Françoise Cachin has noted, "the 'Breton outfit' is one of the first signs of Gauguin's determination, from 1886 on, to treat his personal appearance as part of his work" (Françoise Cachin, "Gauguin Portrayed by Himself and Others," in Brettell 1988, p. xviii).

7 Brettell 1988, pp. 75–76.

8 On the Van Gogh brothers' interest in artists' portraits, see Cachin, "Gauguin Portrayed," pp. xviii–xx, and Alain Bonnet, "Le Musée des portraits au musée du Louvre," in Musée de l'Hôtel-Dieu, Mantes-la-Jolie 1998, pp. 56–69. On Theo van Gogh's promotion of Gauguin, see Chris Stolwijk, "Devoted to a Good Cause: Theo van Gogh and Paul Gauguin," in Lemonedes, Thomson and Juszczak 2009, pp. 75–85.

9 Van Gogh's letter is lost, but he mentioned his request in a letter to Theo on around 11 September 1888, no. 680, http://vangogh-letters.org (accessed 9 August 2018).

10 Bernard's reluctance to paint Gauguin is referred to in a letter from Van Gogh to Bernard written between 19 and 25 September 1888, no. 684, http://vangoghletters.org (accessed 9 August 2018).

11 Letter from Gauguin to Van Gogh, 1 October 1888.

12 Ibid. For a recent discussion of the painting, see Moran 2017, pp. 44–46.

13 Ibid.

14 Ibid.

15 On the *Self-portrait Dedicated to Gauguin* and Van Gogh's relations with his colleagues, see Homburg 2003, pp. 113–122.

16 Letter from Vincent van Gogh to Gauguin, October 1888, no. 695, http://vangoghletters.org (accessed 9 August 2018). For a discussion, see Silverman 2000, pp. 41–42.

17 Letter from Arthur Rimbaud to Georges Izambard, 13 May 1871, *Rimbaud: Complete Works, Selected Letters*, trans. Wallace Fowlie (Chicago and London: University of Chicago Press, 1966), p. 304.

18 Paul Gauguin, untitled MS (1885–86), Département des manuscrits Occidentaux, Bibliothèque nationale de France, Paris, NAF 14903, pp. 43–46.

19 For a discussion, see Alastair Wright, "Paradise Lost: Gauguin and the Melancholy Logic of Reproduction," in Wright and Brown 2010, pp. 66–67. In additional writings Gauguin adopted the voices of other authors both explicitly (as in in texts such as *Diverses choses* [1896–98], which he described as "Scattered notes, without order like Dreams, made up of fragments, like life. And because of the fact that several collaborate here") and, less openly, as with the notoriously plagiarized sections of *Noa Noa*. On *Diverses choses*, see Wright, "Paradise Lost," pp. 74–75; Childs 2003b, p. 73; and Goddard 2011, pp. 352–369. On *Noa Noa*'s borrowings as "plagiarism," see Solomon-Godeau 1992, pp. 118–129. For a more sympathetic recent analysis of Gauguin's textual strategies, see Linda Goddard, "Gauguin's Alter Egos: Writing the Other and the Self," in Broude 2018, pp. 15–25.

20 On Signac's pastiche, see Wright 2009, pp. 239–240.

21 On the works produced at Le Pouldu, see Robert Welsh, "Gauguin and the Inn of Marie Henry at Pouldu," in Zafran 2001, pp. 61–71; Victor Merlhès, "Labor: Painters at Play in Le Pouldu," in ibid., pp. 81–101; and Jirat-Wasiutyński and Newton 2000, pp. 172–191.

22 Van Gogh described the trip to Montpellier in a letter to Theo, 17 or 18 December 1888, no. 726, http://vangoghletters.org (accessed 9 August 2018).

23 Courbet may have been an inspiration not only for *Bonjour, Monsieur Gauguin* but also for Gauguin's practice of presenting himself via a series of personae: Courbet had shown himself as a wounded man, a suicidal man, a hunter and so forth; see Brettell and Fonsmark 2005, p. 252, and Moran 2017.

24 On Gauguin's interest in the theme of the Fall, see Alastair Wright, "Fallen Vision: Gauguin in Polynesia," in Bouvier and Schwander 2015, pp. 167–179.

25 Letter from Gauguin to Madeleine Bernard, Le Pouldu, late November 1889, in Gauguin 1949, no. 96, p. 134. Letter from Gauguin to Émile Bernard, Le Pouldu, June 1890, in ibid., no. 107, p. 145.

26 The pot appears initially to have been given to another avant-garde colleague, as its interior bears an inscription to Schuffenecker: "La sincérité d'un songe / à l'idéaliste Schuffenecker, Souvenir / Paul Gauguin" (The sincerity of a dream / for the idealist Schuffenecker, in remembrance / Paul Gauguin). See Brettell 1988, pp. 128–129.

27 On the history of artists portraying themselves as the martyred Christ (and as other martyrs), see Holsten 1978, pp. 80–83.

28 Letter from Gauguin to Vincent van Gogh, c. 10 September 1888, in Gauguin 1983, pp. 221–222, trans. Cachin, "Gauguin Portrayed" (trans. modified).

29 Letter from Gauguin to Mette Gauguin, February 1888, in Mittelstädt 1968, p. 27.

30 *Jug in the Form of a Head, Self-portrait* invited comparisons both to John the Baptist and to the convicted murderer whose execution by guillotine Gauguin had watched in late 1888 (Brettell 1988, p. 126). The vase thus rhymes both with the religious martyrdom invoked in *Christ in the Garden of Olives* and with the outlaw-status claimed in *Les Misérables*.

31 Séguin 1903, p. 160, cited in Cachin, "Gauguin Portrayed," p. xviii. For other contemporary accounts of Gauguin's appearance, see Mittelstädt 1968, pp. 41–47.

32 Cited in Mittelstädt 1968, p. 47.

33 Letter from Gauguin to Mette Gauguin, Paris, February 1888, in Gauguin 1984, no. 139, p. 170.

34 Letter from Gauguin to Mette Gauguin, Le Pouldu, June 1889, in Mittelstädt 1968, p. 27.

35 Letter from Gauguin to Émile Bernard, August 1890, in ibid., p. 28.

36 Letter from Camille Pissarro to Lucien Pissarro, 23 January 1887, in Rewald 2002, p. 97.

37 Letter from Gauguin to Émile Schuffenecker, Pont-Aven, 8 July 1888, in Gauguin 1984, no. 156, p. 198.

38 Letter from Gauguin to Theo van Gogh, 20 or 21 November 1889, in Thomson 1998, p. 80.

39 On Gauguin's fluid gender identifications in Tahiti, see Eisenman 1997, especially pp. 91–147, and, specifically with reference to the self-portraits, Irina Stotland, "Paul Gauguin's Self-portraits in Polynesia: Androgyny and Ambivalence," in Broude 2018, pp. 41–67. On his use of the Cambodian dancers, see Brettell 1988, p. 154, and Alastair Wright, "Gauguin and the Dream of the Exotic," in Friedman, Herson and Walen 2014, p. 188.

40 Gauguin described the relief in a letter to Bernard from Le Pouldu, September 1889, in Gauguin 1949, no. 89, p. 125. On the meaning of the small face, see Gray 1963, p. 44.

41 Brettell 1988, p. 129.

42 On the pot's resemblance to Pre-Columbian examples, see Groom 2017, p. 162. That Gauguin was aware of this relationship is suggested by the fact that a number of his ceramics closely resemble the Peruvian pots that his mother and his guardian Gustave Arosa collected (ibid., p. 154).

43 Gauguin 1919, p. 30.

44 For a detailed account of Noa Noa's history, see Isabelle Cahn, "Noa Noa: The Voyage to Tahiti," in Shackelford and Frèches-Thory 2003, pp. 91–113.

45 Gauguin 1919, p. 12. On Tahitian views of Gauguin in 1891, see Eisenman 1997, pp. 27–28.

46 "The sky-blue smiles above the roof," trans. Gertrude Hall, Poems of Paul Verlaine (New York: Duffield and Company, 1906), p. 67.

47 Originally published anonymously as Rarahu: Idylle Polynésienne in 1879, Loti's novel was republished the following year under the title by which it became famous, Le Marriage de Loti (The Marriage of Loti). Elizabeth C. Childs is one of several who have noted Gauguin's debt to Loti (Childs 2003b, p. 75).

48 Loti 1925, pp. 34–36.

49 Ibid., pp. 214–215.

50 Ibid., pp. 215–217.

51 Stéphane Mallarmé, "Igitur," trans. Mary Ann Caws, Selected Poetry and Prose (New York: New Directions Books, 1982), p. 98.

52 On the studio, see Wright, "Paradise Lost," pp. 49–50, 54–55.

53 Mallarmé, "Sonnet en –yx." On Gauguin's friendship with Mallarmé, see Brettell 1988, pp. 200–201. In January 1891 the artist etched a portrait of Mallarmé (see ills. 31, 32, 105) in which the poet is given a hooked nose and pointed ear that resemble the way in which Gauguin typically depicted his own features (for the pointed ear, see Self-portrait Dedicated to Carrière): which is to say that the image of Mallarmé is also a self-portrait of sorts, an indication of the artist's affectionate identification with the sitter.

54 See Gill 1959, pp. 159–181.

55 Stéphane Mallarmé, "Herodias," trans. E.H. and A.M. Blackmore, Collected Poems and Other Verse (Oxford: Oxford University Press, 2006), p. 31. See Gill 1959, p. 165, and Norman 2014, p. 27.

56 Stéphane Mallarmé, "Igitur," trans. Mary Ann Caws, Selected Poetry and Prose, p. 98. See Gill 1959, p. 165. On the association of the mirror images of "Igitur" with a loss of self, see Zachmann 2008, pp. 61–89, 175–181.

57 Michaud 1959, p. 206.

58 Saint-Pol-Roux, Les Reposoirs de la Procession: La légende individuelle, cited in Michaud 1959, p. 205.

59 Gauguin 1919, p. 33.

60 Ibid.

61 On the signalling of Gauguin's multiple identities in Self-portrait with Manao tupapau, see Stotland, "Paul Gauguin's Self-portraits," p. 55.

62 Brettell 1988, p. 405.

63 Eisenman 1997, p. 184.

64 See Gauguin 1922.

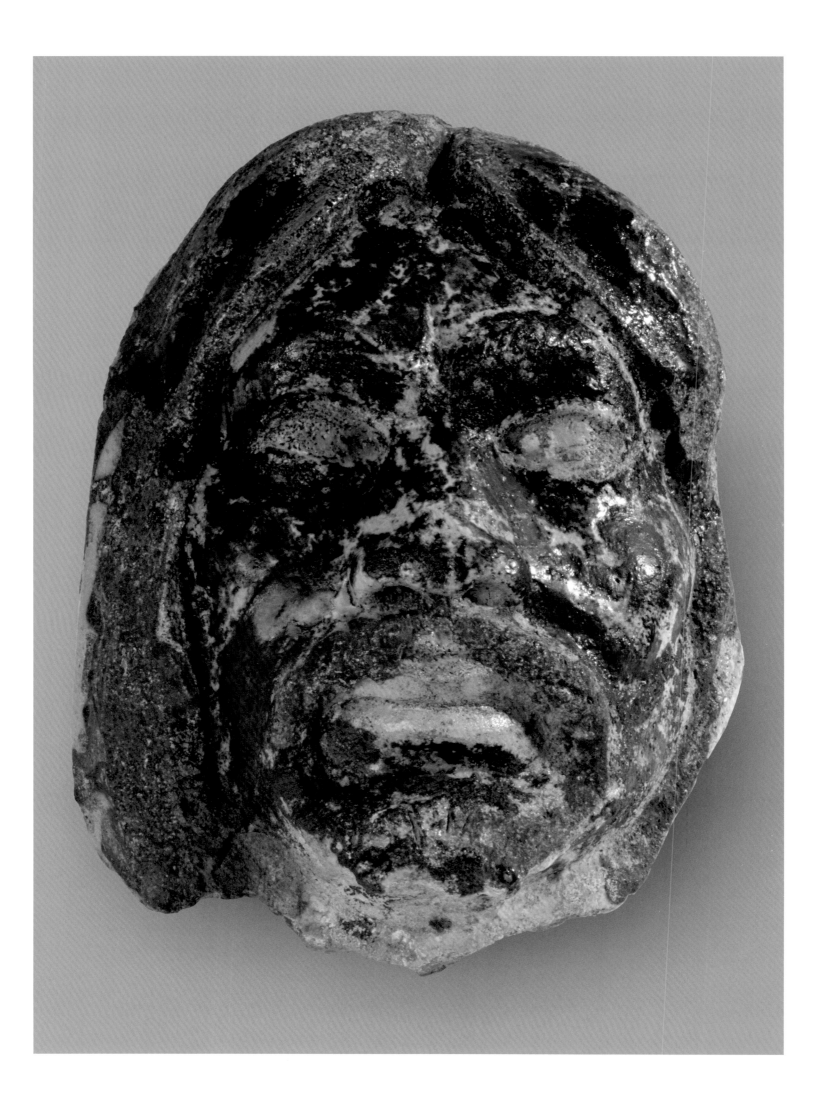

HEAD OF A SAVAGE, MASK

JEAN-DAVID JUMEAU-LAFOND

Gauguin created his last ceramic pieces during his final stay in Paris, after his return from Tahiti in July 1893 and before his permanent departure for Polynesia on 28 June 1895. The three-dimensional works he made subsequently are all in wood, probably for technical reasons (for instance, the lack of a kiln on the islands) but also, and more significantly, because the pieces modelled and fired in 1894 and 1895, which the artist described as "ceramic sculptures," are masterpieces that could not be surpassed. This very small group of objects consists of the rectangular stele-shaped vase titled *Hina and Te Fatou* (current location unknown, G96), the large figure of Oviri from 1894 (Musée d'Orsay, Paris, G113) and *Head of a Savage, Mask* (ill. 25). The precise circumstances of their execution are not known, but Gauguin may have entrusted these final pieces to Ernest Chaplet, who had been working in Choisy-le-Roi since 1888. The artist's preceding ceramics had been fired by Auguste Delaherche, proprietor since 1887 of Chaplet's former workshop on rue Blomet in Paris, but Gauguin and he had fallen out, and it is hard to imagine that the artist would have employed him again after having disparaged his stoneware works at the Exposition Universelle as "commonplace mechanical forms."[1] In any case, Gauguin was much preoccupied with the finish of these latest works.

Although the *Hina and Te Fatou* vase is technically less accomplished than the two other pieces, the three are closely linked by their striking though not entirely limpid iconography. At first view the mask seems to resemble the face of the god Fatu (which Gauguin sometimes wrote "Fatou"), associated in the Polynesian religion with the earth. As well as being the subject of the vase, this deity is also portrayed in Gauguin's 1893 painting *Hina Tefatou* (The Museum of Modern Art, New York, W499) and would reappear in 1901 in the central section of the relief

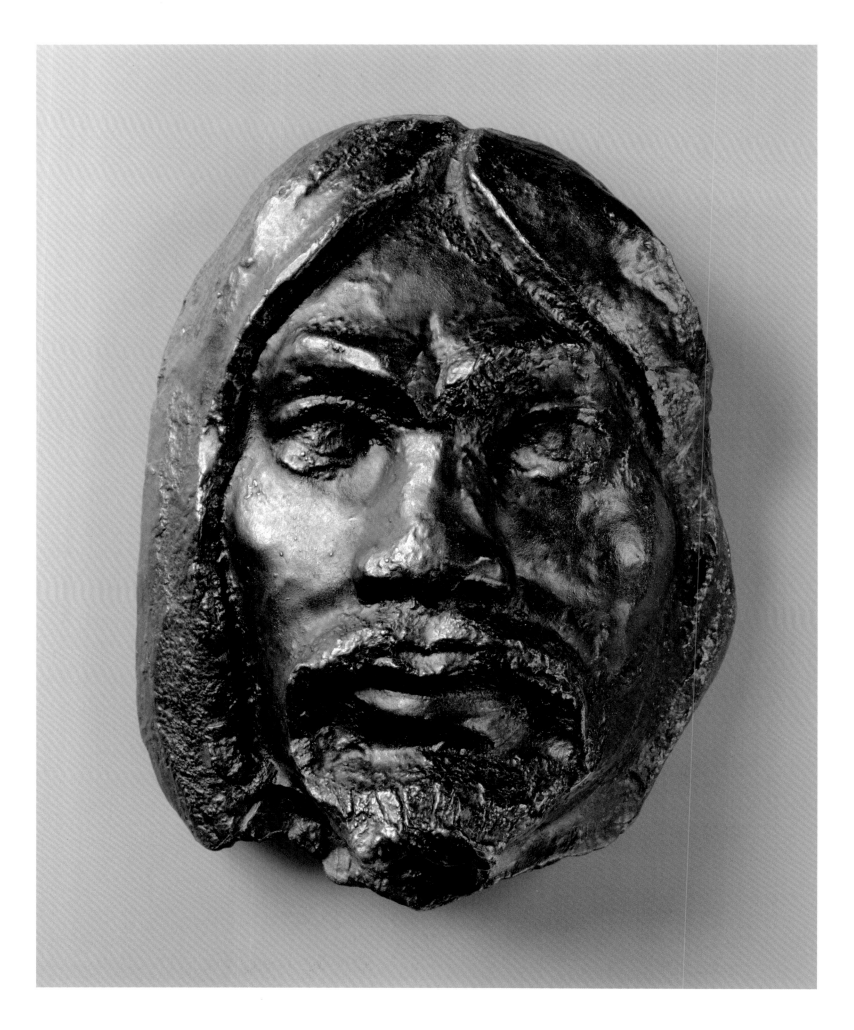

26 *Head of a Savage, Mask*, c. 1895

War and Peace (Museum of Fine Arts, Boston, G127). But Gauguin evidently made a distinction between the images, since he gave a precise title to the stoneware mask on several occasions. In 1896 he wrote to Daniel de Monfreid asking him to send the "*glazed* head of a savage (Mask)," describing it as a "unique ceramic piece."[2] And, the following year, he put a proposal to Ambroise Vollard:

> And the mask, *Head of a Savage*, what a beautiful bronze it would make, and not expensive. I am convinced that you could easily find thirty collectors who would pay 100 francs, which would mean 3,000 francs, or 2,000 after deduction of expenses. Why don't you consider this?[3]

This plan was not pursued, and only three bronze versions of the mask were produced (see ill. 26), but these references offer clear evidence that the artist was portraying the "head of a savage" and not the god Fatu. The distinction is important, for it situates the mask in the symbolic realm rather than the mythological.

The artist was working during this same period on *Oviri*, which means "savage" in Tahitian, and he inscribed the word "oviri" on a profile self-portrait he made in plaster, now lost but known from bronze versions produced posthumously (see ill. 27). This corpus is completed by the woodcut based on *Oviri*, which when he gave a copy of the print to Stéphane Mallarmé he described in an inscription as a "strange figure, cruel enigma." Far from accidental, the chronological proximity of the figure of Oviri, goddess of savagery (with which Gauguin wished to adorn his grave), the "realist" self-portrait entitled *Oviri* and the *Head of a Savage, Mask* suggests that the latter was of crucial importance to Gauguin: for it can be seen, in a sense, as the true self-portrait – not a physical likeness, but a highly symbolic and paradoxically unmasked image of the "savage" he longed to be, or to become, or to become again, both as a man and as an artist, as he embarked on his ultimate voyage.

Gauguin's allusions to the idea of savagery are too numerous to be extensively cited, and what the idea meant to him – an artist's need to be free of civilization – is widely accepted. Nevertheless, it is hard not to recall the photograph of his own "savage face" that he sent Émile Schuffenecker in 1888.[4] One is also reminded of a passage in his last letter to Vincent van Gogh, dated June 1890:

> Alas, I see myself condemned to be less and less understood, and I must hold fast to following my way *alone*, to drag out an existence without a family like a pariah. So the solitude in the woods seems to me in the future to be a new and almost dreamed-of paradise. The savage will return to savagery.[5]

The association of a "return" with the notion of a "new paradise" only appears contradictory: for Gauguin, it meant recapturing a primeval purity through contact with a culture considered immemorial and (however illusorily) savage, reminiscent of a lost paradise. The ideal future merges with a primordial golden age where everything is perfect. In his manuscript *Diverses choses*, the painter wrote: "Nourishing milk can always be found in the primitive Arts."[6] The importance of

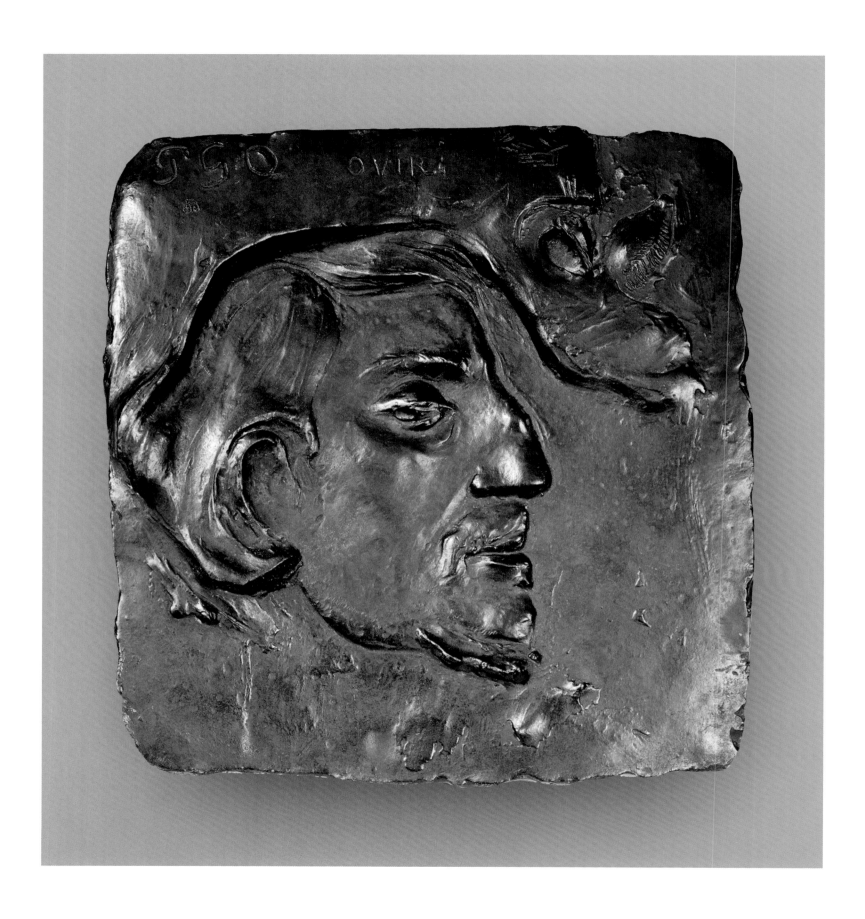

ceramics to an approach that elevates an archaic past to the level of ideal model seems evident. Gauguin stated his view in the first section of the article cited earlier, published in 1889 in Albert Aurier's magazine *Le Moderniste*:

> The ceramic art is not an idle pastime. In the most distant epochs of the past, among the Indians of America one finds that art constantly in favor. God made man with a little mud. With a little mud one can make metals, precious stones, with a little mud and also a little genius![7]

Earth, one of the four elements and symbolically the most powerful (the earth on which we walk, that we cultivate and that provides us with sustenance), is also the material from which we make pottery and sculpture. In the passage characterizing earth as mud that genius can transform into metal and precious stones, Gauguin was clearly alluding to a line by Charles Baudelaire: "You gave me your mud and I turned it into gold."[8] This picture of the artist as alchemist, creating, god-like, out of mud, resonates compellingly with the words used by the author of *Les Fleurs du mal* (1857) to introduce the section on sculpture in his review of the Salon of 1846: "The origin of sculpture is lost in the mists of time; thus it is a Carib art."[9] Baudelaire deliberately avoided any reference to Greece, China or Egypt – all too illustrious, too closely linked with modern Western thought and no doubt judged too "civilized." For the poet, though he likely drew inspiration for his line from Denis Diderot's *Salon de 1767*, Carib was synonymous with primitive, unknown, overlooked, distant. The Caribbean, the Amerindian world, the Antilles, Polynesia, it hardly mattered which – it had simply to be an *elsewhere*.

Baudelaire had captured the essence of this "elsewhere," his poetic ideal, in the famous phrase "Anywhere Out of the World," which would become a rallying cry for the entire Symbolist generation. Moreover, Gauguin responded very specifically to the author of *L'Invitation au voyage* in *Noa Noa*, where Tahiti is described as being "Somewhere, out of the world."[10] Through a remarkable semantic shift, "anywhere" had become "somewhere." This is because, unlike the poet, whose kingdom was words and whose escape could only be mental and imaginary, the painter was a man of the visible. Not content to dream about a theoretical elsewhere, he was driven to nourish his visual faculty: the promised land had to have the appearance of a real country.

For Gauguin, this world of evasion and renewal was represented first by Brittany, a still largely mythical place for a nineteenth-century Parisian but soon too popular and too tarnished by its folkloric image. Pursuing his quest, the painter opted next for Tahiti and then the Marquesas Islands – his final destination. Owing to its remoteness, its isolation, its strangeness and its "savage" culture, this "somewhere" was still "out of the world." No mere source of anecdotal exoticism, the artist saw it as an opportunity to go back to basics. It was not, for him, a matter of copying new forms, even if he drew inspiration from the landscapes and people that surrounded him, and even if these "savages," as he wrote near the end of

Noa Noa, had "taught many things to the man of an old civilization; these ignorant men [had] taught him much in the art of living and happiness."[11]

Gauguin approached his discovery of these new horizons like an artist confronting a blank canvas. Their "savagery" was in fact the true reflection of the artist who discards old models in order to invent a new form of art. Tahiti and the Marquesas were the mythicized lands where the painter could create freely by drawing upon an unsullied world. The glazed *Head of a Savage, Mask*, with is pale eyes, uneven coloration and rough surface is therefore the image the artist was striving for, the one he saw as mirroring his essential self. Gauguin had explained his approach to material in an 1890 letter to Émile Bernard:

> You have long known, and I have written it in the *Moderniste*, that I seek the character in every lump of matter. Now the character of grey pottery is the emotion of the furnace, and this figure calcined in this inferno, expresses, I think, the character pretty distinctly. Such an artist was glimpsed by Dante in his visit to the Inferno.[12]

With its mottled appearance – which in 2007 Charles Stuckey suggested Gauguin likely created, through glazing and firing, to evoke a state of weathering and decay – the mask conjures exposure to both fire and time (not the anecdotal, archaeological notion of time, but temporality in its broadest sense).[13] If the *Head of a Savage, Mask* is an image of the painter suffering the anguish of creation, it also seems to belong to a bygone age. It is thus not a self-portrait of Gauguin "as a savage," which would be simply a disguise based on a Tahitian face (either mortal or divine), but rather a symbolic self-portrait of an artist who, after a kind of initiatory voyage, had recaptured a visual virginity and a creative innocence. The "somewhere out of the world," an escape in space, had become for Gauguin also a "somewhere out of time," a journey into the symbolic past of a rediscovered purity, which he saw as the only possible future.

NOTES

1 Gauguin 1889b, p. 91. In this article Gauguin admittedly levels the same criticism at Chaplet, but the artist had collaborated much more closely with him, and since the great ceramist no longer produced stoneware, he was probably less sensitive than Delaherche, his junior by more than twenty years.

2 Letter from Gauguin to Daniel de Monfreid, December 1896, in Gauguin 1950, no. 26, p. 157.

3 Cited in Rewald 1986, p. 179.

4 Letter from Gauguin to Émile Schuffenecker, June 1890, in Gauguin 1984, no. 184, p. 291.

5 Letter from Gauguin to Vincent van Gogh, Le Pouldu, c. 28 June 1890, no. 892, www.vangoghletters.org (accessed 31 October 2018).

6 Gauguin 1896–98, p. 223.

7 Gauguin 1889a, p. 86, trans. Gray 1963, p. 29.

8 Charles Baudelaire, *Projet d'un épilogue pour l'édition des Fleurs du mal de 1861* (Paris: Gallimard, collection Bibliothèque de la Pléiade, 1975), vol. 1, p. 191.

9 Charles Baudelaire, "The Salon of 1846," in *The Mirror of Art: Critical Studies by Charles Baudelaire*, trans. and ed. Jonathan Mayne (Garden City, NY: Doubleday Anchor Books, 1956), p. 119.

10 Gauguin and Morice 1893–99, p. 12.

11 Ibid., p. 203, trans. Gauguin 1919, p. 146.

12 Letter from Gauguin to Émile Bernard, Le Pouldu, November 1889, in Gauguin 1949, no. 106, pp. 144–145.

13 Charles F. Stuckey, in Eisenman 2007, cat. 99, p. 332.

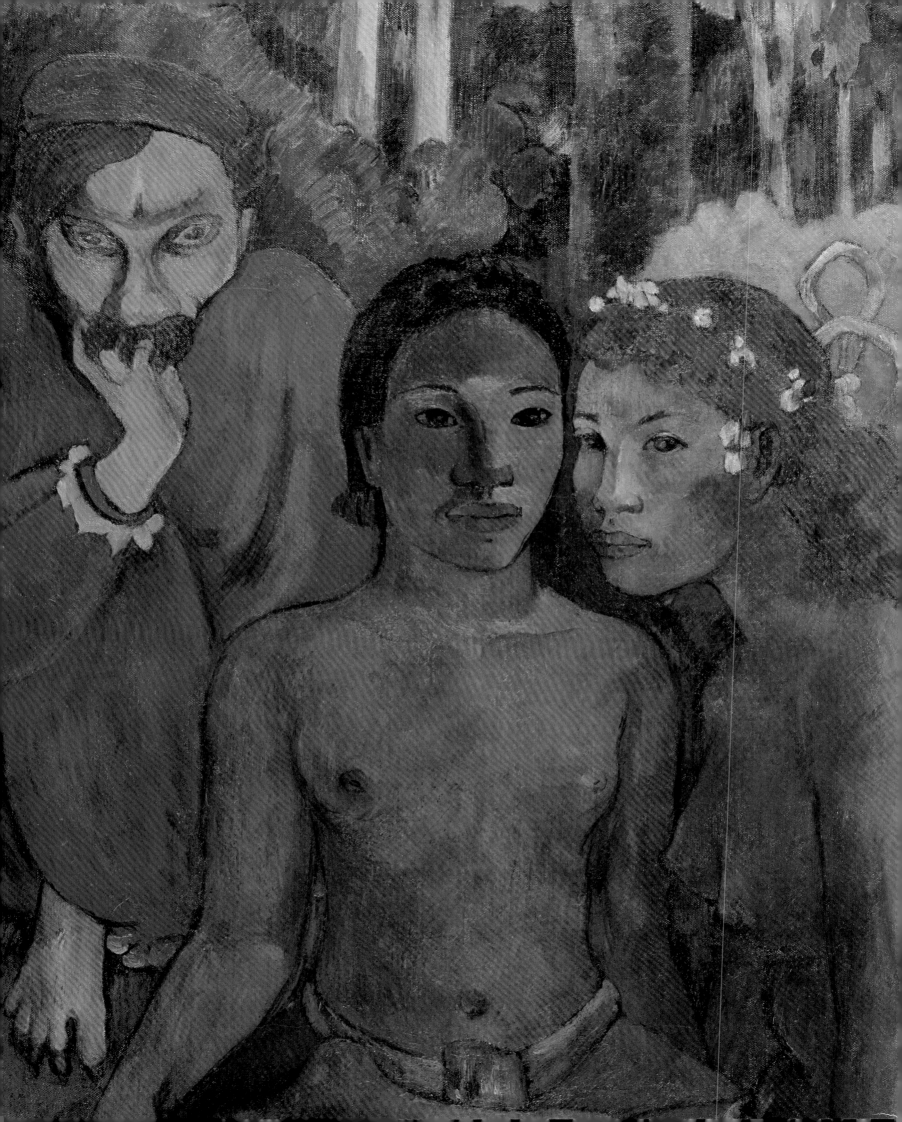

SEEKING ONESELF THROUGH OTHERS
GAUGUIN'S PORTRAITS OF HIS COLLEAGUES AND FRIENDS

The portraits Gauguin made of his friends, in particular those of other artists, constitute a fascinating group. Many of them are not very flattering for the model: Émile Schuffenecker is squeezed uncomfortably into a tight space next to his easel (see ill. 67), Charles Laval forms a sidebar as onlooker to a still life with Gauguin's own pottery (ill. 114), Vincent van Gogh looks deranged painting his sunflowers (ill. 35), and Meijer de Haan appears sly and devilish with bulging eyes he did not have (ill. 43). What was the purpose of these portraits? Do such representations tell us anything about Gauguin's relationship with his models? And what do they say about his intentions as an artist?

CORNELIA HOMBURG

Looking more closely at the people Gauguin chose to portray, it becomes evident that these works were triggered by considerations such as indebtedness, admiration and competition. The portraits also consistently show the artist's urge to comment on his own work coupled with an ambition to define his own place in history. Often Gauguin gave the portraits to his sitters – with a few notable exceptions. In some ways these images seem to have fulfilled a parallel function to the portraits of Gauguin himself, both the pictures he painted and the photographs he presented to admirers and colleagues.

Initially, Gauguin's portraits served to underscore his position and self-presentation within the circle of admirers and friends in which he wanted to be a leader. Later, when he lived in artistic isolation in Polynesia, his commemorative portraits were intended to secure his legacy, lay claims on primacy, and play a role on the larger Parisian stage of critics, potential collectors and exhibitors.

Useful Friends

Gauguin's friendships, largely with other men, were often based on a mixture of sincere liking and shared interests during a certain period of his life, combined with the friend's willingness to be useful to him. The portraits he made of these men do not characterize their relationship, but were more likely intended as gestures of gratitude. An early example is the likeness of Claude Antoine Charles Favre, a charming frontal view executed in the traditional style the artist was using at the time (ill. 28). Gauguin had probably met Favre in the early 1870s when they were both in the merchant marine, and the portrait itself dates to 1877. However, little is known

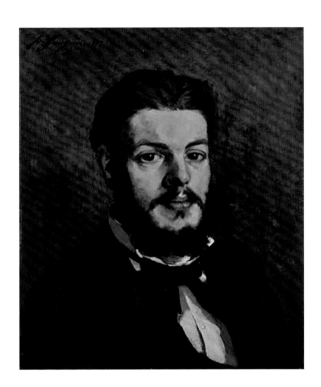

about their relationship before the 1880s, when Favre's name appears in the surviving correspondence. He offered Gauguin a roof in Paris at times, they shared help with their children and, importantly, Favre assisted the artist toward the end of 1884 to get a job with the marquise company Dillies as their representative in Denmark, when Gauguin was trying once more to generate a regular income and live in Copenhagen with his family. As several others would do later, Favre took care of Gauguin's art, stored his paintings, and acted as a go-between for possible sales and exhibitions in his absence. "Le Marsouin [Favre's nickname] remains my *chargé d'affaires* and receives my canvases," Gauguin wrote, for example, in a letter to Camille Pissarro in the fall of 1884.[1] Gauguin's early portrait of Favre remained in the latter's family until well after Favre's death, though the relationship between the two men seems to have come to an end during the 1880s.

By the mid-1890s, the musician and composer William Molard had taken on a similar role and was also rewarded with a portrait (ill. 29). Gauguin and Molard had met after Gauguin had returned to Paris from Tahiti in 1893 and moved into a building at 6 rue Vercingétorix, where Molard lived with his family. There, Gauguin created his bright yellow and extravagantly decorated studio to evoke the exotic atmosphere of the South Pacific and showed his latest canvases. He received artists, writers and musicians, several of whom he had met via Molard.[2] Gauguin and Molard's friendship was also based on their shared interest in the music and theories of Richard Wagner, which were much discussed in art circles at the time.[3]

Gauguin depicted Molard as a somewhat melancholy figure, in dark but intense hues. As with the portrait of Favre, the composition is simple and focuses exclusively on the sitter, but it was a rather special gift, as the other side of the canvas holds Gauguin's *Self-portrait with Manao tupapau* (ill. 2). The fact that Gauguin gave this double-sided canvas to Molard suggests their close relationship. Indeed, the artist was friendly with Molard's entire family: he experimented with plaster

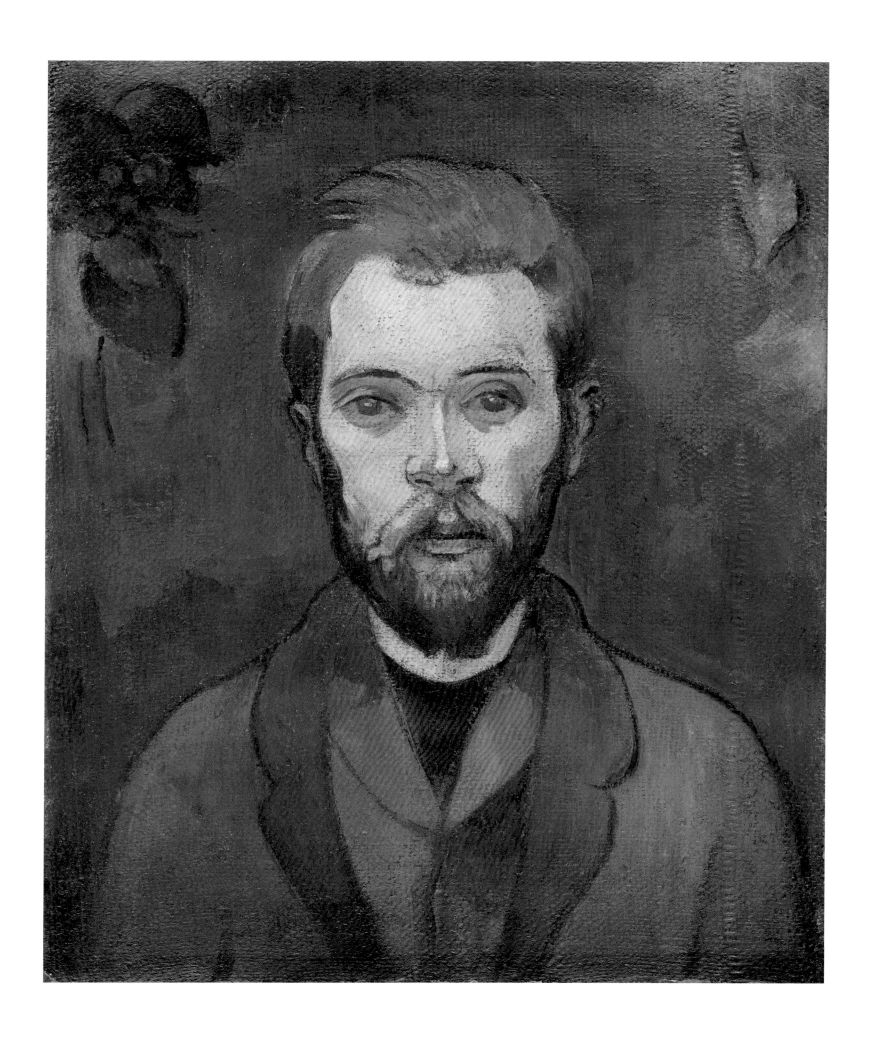

in the studio of Molard's wife, the sculptor Ida Ericson, and their daughter Judith moved freely between the two households. Gauguin and Molard continued to correspond after Gauguin's second departure to Polynesia in July 1895, and, as Favre had done before him, Molard took care of numerous business matters for Gauguin.[4]

Although Gauguin rewarded friends such as Favre and Molard with personal portraits, other faithful supporters were never honoured in quite the same way. For instance, Émile Schuffenecker, a patient and loyal longtime friend and colleague, evidently did not merit an individual portrait in Gauguin's eyes. He had to be content with a family picture in which his wife, not he, takes centre stage (ill. 67). Gauguin assigned him an insignificant corner of the canvas, making him look subservient and powerless, glancing almost fearfully at his family. Schuffenecker's role as a painter is questioned as he stands awkwardly and empty-handed before his easel, while his role as supporter has been ignored.[5] It is a powerful but exceedingly ungrateful painting in which Gauguin dismisses his friend in order to show off his own associations with the family and his obvious interest in Madame Schuffenecker. Gauguin's sexual fantasies – she seems to have rejected his possible advances – are reflected not only in her dominant pose in this composition but were also played out in the sculptures he made of her (see ill. 66).[6]

Through Émile Shuffenecker, Gauguin made the acquaintance of Louis Roy, an artist who taught at the same lyceum as his friend in Paris. Roy participated in the so-called Volpini exhibition in the summer of 1889 and seems to have become one of Gauguin's followers in Brittany.[7] As usual, Gauguin's interest in pursuing a friendship with Roy would have been triggered by the latter's efforts to find collectors for Gauguin's work and engineer sales.[8] Moreover, Roy apparently bought work from Gauguin, who in turn dedicated some small canvases to him.[9]

Gauguin portrayed Roy before his move to Tahiti in 1891, most likely during 1890 or early 1891 (ill. 30). In the intensely coloured canvas he focuses on his model's face, including references, behind the sitter, to his own work. In the background, the words "Expo/Synthe" make reference to the Volpini exhibition. A female figure appears to emanate from Roy's head, like the evolution of a thought or an idea. This figure may also have been part of an announcement for the Volpini exhibition, in a similar way to the female figure included in the background of the caricature *A Nightmare*, by Émile Bernard, also referring to the show.[10] A vessel of Gauguin's making has been placed behind Roy's shoulder, but it is seen only partially and appears almost like an ornament. It could be the elaborate handle of the *Cup Decorated with the Figure of a Bathing Girl* (1887–88, G50), a work that Gauguin had already incorporated in a still life from 1888.[11]

Gauguin gave the portrait to his sitter but must have claimed it back for the exhibition *Portraits du prochain siècle* at the gallery Le Barc de Boutteville in 1893, in which he also exhibited a self-portrait.[12] The decision to include the canvas of Roy may have been influenced by its easy availability just as Gauguin was returning

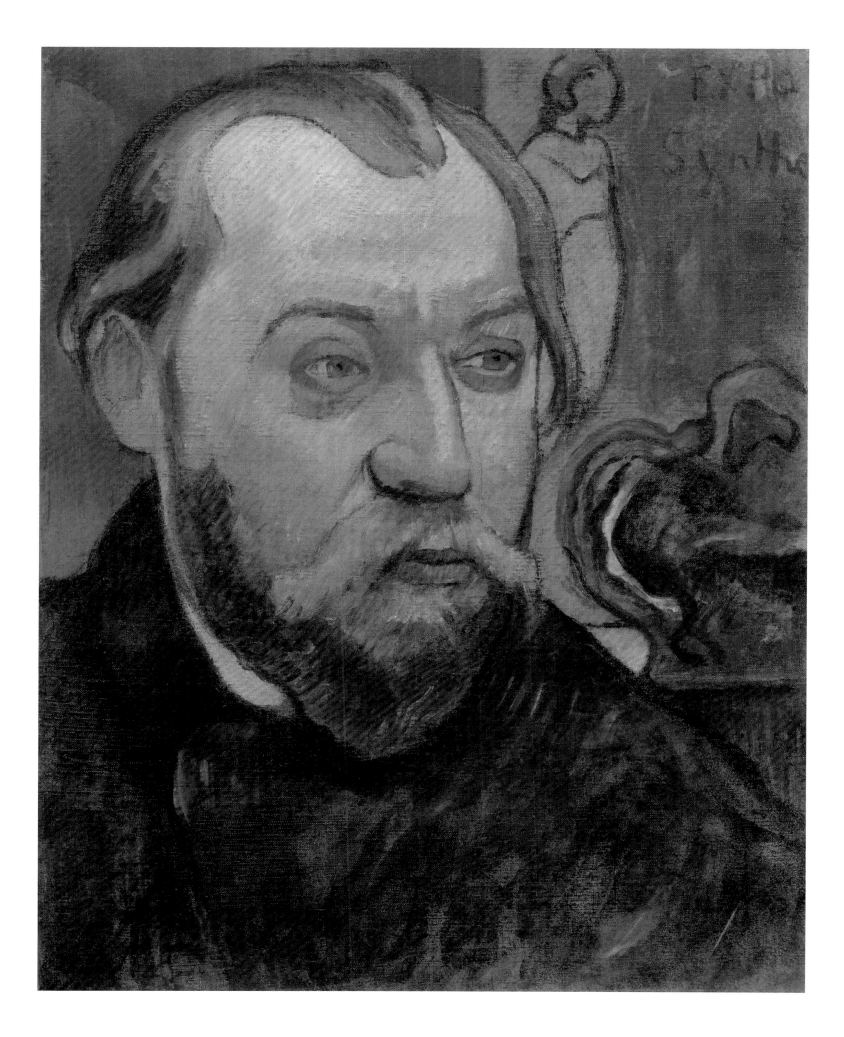

30 *Portrait of Louis Roy*, 1890–91 **69**

from Tahiti, but it could also have been a way to reconnect with Roy at a time when Gauguin needed to re-establish himself as a leading figure of the avant-garde.

The two men continued to be in contact, a friendship that may have been fuelled further by their involvement in the same literary circles, for example that of Alfred Jarry and Remy de Gourmond, who were the editors of the short-lived journal *L'Ymagier* (1894–96), to which Roy also contributed.[13] In 1894 Gauguin turned to Roy for help with the printing of his *Noa Noa* suite, most likely because he himself lacked the technical means and know-how. Roy printed an edition of twenty-five or thirty, a serial production that for obvious reasons was more trad-itional in execution than Gauguin's initial experimental sheets. The edition was never published, and we have no record of Gauguin's response to it. Some of the prints served him as a base for further elaboration and experimentation, given the fact that they did not find any buyers.[14]

Public Associations

Apart from showing works at exhibitions, such as the portrait of Roy, the print medium offered Gauguin another excellent means to reach larger audiences. Gauguin initially delved into the possibilities of printing in 1889 with the so-called *Volpini Suite*, in which he retooled scenes from Martinique, Arles and Brittany in prints on bright yellow paper.[15] His printed portraits of two major literary figures, Jean Moréas and Stéphane Mallarmé, have to be considered in this context.

Gauguin was commissioned by the avant-garde journal *La Plume* to create a portrait honouring Moréas, who had published his famous manifesto on Symbolism in literature in *Le Figaro* in 1886, and who was to be honoured in the January 1891 edition of *La Plume*. As Jean-David Jumeau-Lafond explains in this catalogue in his analysis of the original drawing (ill. 104), Gauguin's composition was carefully thought out, with the goal of establishing a position for himself vis-à-vis the poet, taking advantage of the interest in the man and his work to transfer Symbolist leadership from the poet to the painter. Gauguin's minute attention to detail and the quality of his drawing can now be appreciated in the original that has come to light after many years during which only the lithographic reproduction in *La Plume* was available for study.

Gauguin's *Portrait of Stéphane Mallarmé* from 1891 (see ills. 31, 32, 105), the only drypoint he ever executed, served several purposes: in addition to expressing his sincere admiration for the poet, it offered Gauguin the opportunity to associate himself with this leading figure of literary Symbolism as well as other artists he appreciated. Introduced by the poet Charles Morice, the two men developed a mutual liking and respect for each other's work. Mallarmé presided over Gauguin's farewell dinner before his departure for Tahiti in 1891, and Gauguin presented him with his sculpture *The Afternoon of a Faun* (ill. 33), with its reference to Mallarmé's poem of the same title, upon his return in 1893. Already in his print of Mallarmé

31 *Portrait of Stéphane Mallarmé, Dedicated to Charles Morice*, 1891
32 *Portrait of Stéphane Mallarmé, Dedicated to Daniel de Monfreid*, 1891

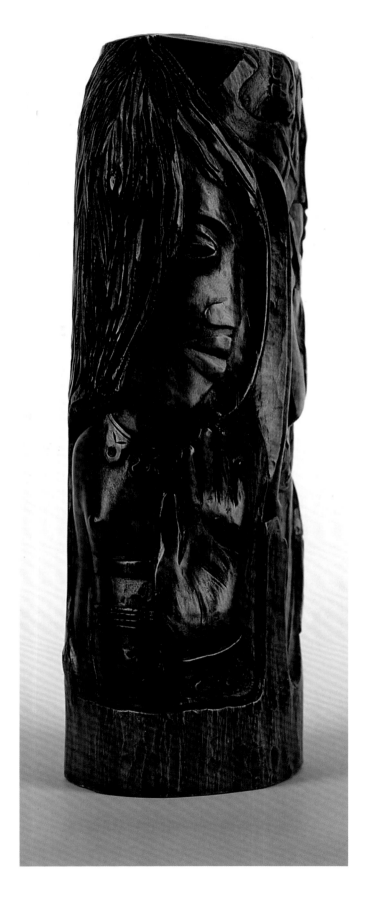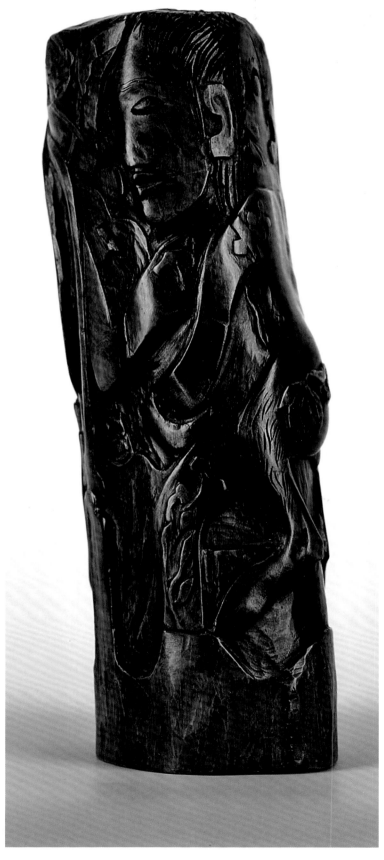

Gauguin had made subtle references to this poem by giving his model faun-like, pointed ears.[16] By further including the head of a raven, Gauguin alluded to the French poet's translation of Edgar Allan Poe's writings. Thus, he could share in the widespread admiration for Poe's writings and associate with two other artists and friends of Mallarmé: Édouard Manet and Odilon Redon.

Manet, who had illustrated Mallarmé's Poe translation of 1875, had made prominent use of the bird. Redon had created his own lithographic homage to Poe and provided a raven for the cover of Émile Hennequin's translation of Poe's stories in 1882.[17] Following Redon's example further, Gauguin used some copies of his Mallarmé portrait to create personalized gifts by adding dedications to the recipients.[18] He gave one of the first sheets to Mallarmé with expressions of deep admiration, while others were gifted to helpful friends, such as Morice and the painter Daniel de Monfreid (ills. 31, 32). In 1899, after Gauguin had learned of Mallarmé's death, he sent one of the remaining prints to the critic André Fontainas. This was a way to honour the memory of his friend, but at the same time it was part of a forceful exchange with Fontainas, editor of the *Mercure de France*, whom Gauguin was trying to convince of his own importance.[19]

Disciples

Among the group of artists that over the years constituted Gauguin's followers in Brittany, we find portraits of Charles Laval, Władysław Ślewiński and Meijer de Haan (who will be discussed later). Each of these men fulfilled distinct roles in Gauguin's life and was portrayed in a manner reflecting the artist's need to formulate and shape his artistic identity.

The 1886 portrait of Charles Laval (ill. 114), Gauguin's earliest painting of a friend from Brittany, is compositionally unusual. It unites three of Gauguin's specific interests: his exploration of pottery, which he had started under the tutelage of the ceramist Ernest Chaplet in Paris; his deep admiration for Paul Cézanne, as reflected in the stylistic treatment of a still life of apples arranged prominently on the tablecloth; and, lastly, the novel experience of having a young follower, one of a small group that year. This latter element must have been deeply gratifying for Gauguin, and a sign of growing success, as for much of the preceding period it had been Gauguin who had found himself in the role of apprentice in relation to Pissarro and Cézanne.

It is hard to determine in the portrait if Laval's eyes are open or closed, but his profile shows him obviously contemplating Gauguin's creation, serving in the role of admirer or one in awe.[20] The composition is intense, and colour is focused on the fruit on the table, while small touches of bright hues can be found in many areas, for instance in Laval's hair. It is a confident and daring canvas that reflects new directions in Gauguin's work. Laval received the portrait as a gift before the two men went off travelling together to Panama and Martinique in 1887.[21]

34 *Portrait of the Painter Ślewiński*, 1891

Another of Gauguin's followers in Brittany was Władysław Ślewiński. He arrived in Paris from Poland in 1888 and met Gauguin the next year. This encounter had such an impact on Ślewiński that he decided to become a full-time painter and adopt Gauguin as his teacher.[22] The pupil followed the master from Paris to Brittany in 1890, and from then on divided his time between the two locations for years to come. The friendship between the two men was a lasting one. Gauguin portrayed him in 1891 (ill. 34), and the Polish artist and his Russian wife, also a painter, welcomed him into their house in Le Pouldu for some time in 1894. In addition to seeking Gauguin's artistic guidance, Ślewiński also supported him financially by occasionally buying some of his canvases and apparently storing others. Even in 1902 Gauguin was still mentioning Ślewiński in this context, namely in a letter to Molard, when as usual he was trying to raise funds.[23]

Charged with references to Gauguin's own artistic preferences, the portrait of the Polish painter shows him seated next to a table on which sits a bouquet of flowers. The composition recalls similar juxtapositions by Gustave Courbet and Edgar Degas (see ill. 117), both painters with whom Gauguin wanted to be associated. Yet instead of the luxurious presentation of flowers that dominate their compositions, Gauguin chose a more constrained rendering in which the neutral tones of his model deepen the contrast of red furniture against blue walls. The simplified treatment that recalls the flatness of Japanese prints gives prominence to the brightly coloured flowers in their light paper.

Vincent van Gogh

The paintings representing Vincent van Gogh form a special group within Gauguin's oeuvre. While Van Gogh was certainly no pupil of Gauguin, it was Vincent himself who used this argument to lure Gauguin to leave Brittany and join him in Arles in 1888. He claimed in his letters that Gauguin would be the head of their Studio of the South, the master from whom he, Vincent, would learn so much.[24]

The two artists had met in Paris after Gauguin's return from Martinique in 1887. Van Gogh recognized the importance of the paintings Gauguin had conceived during his trip and awakened the interest of his brother Theo, art dealer with the renowned firm of Boussod, Valadon & Cie. The collaboration of the two artists in Arles at the end of 1888 was triggered by the two aspects that frequently guided Gauguin's friendships with others: firstly, he would receive financial support from Theo, who acted as his dealer, and, secondly, Vincent offered him the opportunity to assume the role of master to follower. If Gauguin had any doubts about the second aspect, they were confirmed from the start. Upon arriving in Arles, he was confronted with works of great maturity and expressiveness, such as Van Gogh's still lifes of sunflowers. Here was no disciple, but an equal and a competitor with a powerful vision that differed in many ways from Gauguin's own.[25]

This became apparent during their intense discussions in Arles as well as in the portraits they executed side by side. They solicited Van Gogh's friends, Madame Roulin, wife of the postman, and Madame Ginoux, owner of the Café de la Gare, to pose for them in their studio. In the case of the latter, Van Gogh dashed off a first version in oil (ill. 47), while Gauguin made a carefully drawn portrait (ill. 48), which he used as the basis for a more elaborate composition afterwards (ill. 64).

In late November Madame Roulin sat for the two artists who both portrayed her in oil. Gauguin chose a horizontal format (ill. 65), in which he placed his model to one side and added an excerpt of a recent painting, *Blue Trees* (1888, Ordrupgaard, Copenhagen, W311/W319 [2001]) as a background, thus distinguishing himself from Van Gogh's more naturalistic depiction of a view through a window (1888, Oskar Reinhart Collection, Winterthur). Disliking Van Gogh's use of impasto, Gauguin chose a very thin application of paint that recalls the brushstrokes of Paul Cézanne, whom both artists admired. Gauguin further simplified Madame Roulin's features to give her an almost mask-like appearance. While Gauguin worked on his painting in several installments, Van Gogh finished his canvas in one go. Gauguin attempted a similar quick execution a few weeks later in *Old Man with a Stick* (ill. 53), which he painted on coarse fabric, thus providing a rough surface for his composition. While the model remains unidentified, Gauguin's interpretation seems more casual than his portrait of Madame Roulin, though he used similar strong outlines for his figure.

In December Gauguin also portrayed Van Gogh, creating a composition that reflects the ambivalent attitude he had toward his friend. At a time when Van Gogh's sunflower canvases decorated the walls of his home, Gauguin, who admired them greatly, portrayed the Dutchman in the act of painting these works (ill. 35). Observing his model at his easel, and using his imagination, as sunflowers were no longer available at the end of the year, Gauguin paid homage to Van Gogh's work, identifying him

with his sunflowers – an association that Van Gogh would also make himself.[26] By choosing a high vantage point, Gauguin acknowledged their shared admiration of Japanese prints; by looking down on Van Gogh, he also assumed a superior position. Disapproving of the Dutchman's need to work directly from nature, Gauguin had tried in vain to convince him to change this manner of working. By representing his model with half-closed eyes, he introduced his own credo that one needed to dream in front of nature or see it through a veil in order to grasp its meaning. Almost like an illustration of this approach he added a painting in the background that was derived from one of his own compositions.[27] Van Gogh commented that Gauguin made him look "extremely tired and charged with electricity as I was then," while Gauguin claimed later that Van Gogh said of the work, "That is me, all right, but me gone mad."[28]

Despite the tragic end of their time together after only two months, both artists were deeply influenced by their intense exchange of ideas and by having worked side by side. And for Gauguin, Van Gogh's yellow sunflowers remained a vivid presence.[29] After returning from Tahiti, at a time when Van Gogh's fame was on the rise and his letters were published by Émile Bernard, Gauguin needed to re-establish his position in avantgarde circles. He published reminiscences of Van Gogh that reflected their daring experiments with colour and emphasized his own interest in synesthesia. His text also pointed out that Van Gogh had been mentally ill since his youth, and not as a result of their collaboration. Sunflowers play a leading role in the text:

> In my yellow room, sunflowers with purple eyes stand out on a yellow background; they bathe their stems in a yellow pot on a yellow table. In a corner of the painting, the signature of the painter: Vincent. And the yellow sun that passes through the yellow curtains of my room floods all this fluorescence with gold; and in the morning upon awakening from my bed, I imagine that all this smells very good. … When the two of us were together in Arles, both of us mad, and at constant war over the beauty of colour – me, I loved the colour red.[30]

After evoking Van Gogh's extreme behaviour as a young Evangelist in the Borinage, which was itself considered a sign of madness, the text ends with the exclamation: "Decidedly, this man was mad."[31] Apart from emphasizing Van Gogh's mental instability, the references to his Christian fervour also recall the artists' discussions

about Christian subject matter and their shared negative opinion about the Church as an institution, which became an increasingly important topic for Gauguin.

During his second stay in Tahiti, in October 1898, Gauguin asked Daniel de Monfreid to send flower seeds for his garden, among them varieties of sunflowers.[32] A few years later, when he was engaged once more in securing his own leading role in the art world while removed from the Parisian art scene, he made use of both his writings and four sunflower paintings to ensure his position vis-à-vis Van Gogh.[33] These still lifes are rightly regarded as surrogate or commemorative portraits of Van Gogh. In a parallel to his earlier portraits of his followers, Gauguin incorporated elements that proclaimed his own allegiances and artistic position; different from those compositions, here he also paid homage to his friend.[34]

Two of the paintings show a basket with sunflowers on an armchair that have been associated with Van Gogh's 1888 painting of a chair symbolizing Gauguin.[35] The casual arrangements of the flowers offer an alternative to Van Gogh's vertical

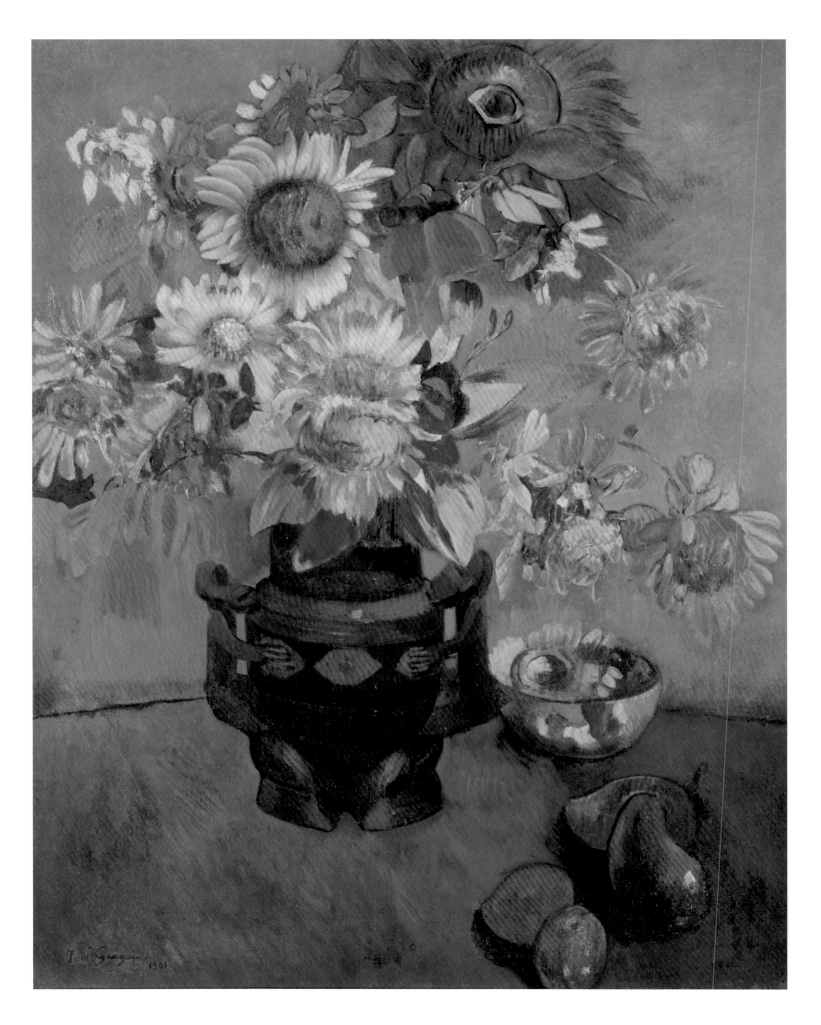

compositions of 1888 (see ill. 36), but it is worth remembering that already by late 1887 Gauguin had owned two still lifes of sunflower heads by the Dutch artist.[36] As he had done frequently, and similar to his portraits of Laval and Roy, Gauguin incorporated his own work in the composition. One canvas (ill. 37) includes the painting of a seascape, a scene of sunshine and leisure that evokes Gauguin's exotic surroundings and at the same time recalls the Western tradition of a view through an open window. In a similar composition (ill. 38), the seascape has been replaced by the head of a Tahitian woman, a portrait that introduces yet another context. Whether the Tahitian model represents a person looking in from the outside or the reproduction of another painting, she appears to be contemplating the sunflower "portrait" of Van Gogh, with its implication of Western art and culture. As such, Gauguin assimilated the associations with Van Gogh into the fabric that constituted his own imagination and unique experience.

The other two sunflower paintings also testify to Van Gogh's presence and Gauguin's intent to underscore his own identity. One of them (ill.39) shows a bouquet of sunflowers next to works by Edgar Degas and Pierre Puvis de Chavannes. Van Gogh and Gauguin had shared a deep admiration of these painters and had discussed their work at length, in particular Puvis' *Hope* (1871–72, Musée d'Orsay, Paris), of which Gauguin had a reproduction on his walls. In Gauguin's painting, this piece holds a prominent place next to the sunflowers, but contrary to the original, the head of the figure of Hope is turned away, introducing a subtle tone of melancholy, as pointed out by Douglas Druick.[37] The casual basket in the other sunflower pictures has been replaced with an elaborate exotic pot, emphasizing once more Gauguin's personal context.

The fourth painting (ill. 40) approaches the vertical format of Van Gogh's 1888 *Sunflowers*. The luxurious bouquet in an exotic vase is accompanied by local mangoes. More prominently than in two of the other compositions, Gauguin transformed one of the flowers into an eye, an image that recalls Odilon Redon's floating eyes and his eye flower from the series *Les Origines* (ill. 41). Van Gogh is represented via the yellow sunflowers, while the reference to Redon's work creates a link to its imaginary and dreamlike qualities, which Gauguin admired and sought to express in his own oeuvre.

Different from earlier portraits, these compositions were not intended for an intimate circle of admirers but for Paris, where the art dealer Ambroise Vollard had asked Gauguin for flower still lifes.[38] And while Gauguin pretended that he did not like to paint them, he produced them nevertheless as they allowed him to fulfill several ambitions: respond to the demands of the art market, present a frame of reference for his artistic identity, and publicly associate with recognized avant-garde figures of the time.

Meijer de Haan

Whereas Van Gogh's artistic impact and rising fame played a big part in Gauguin's sunflower paintings, Meijer de Haan's role as a model was quite different, though no other friend or colleague was portrayed so often, and no other model, except the artist himself, appeared in so many different media. Like Van Gogh, the Dutch De Haan had been active in the Netherlands, but unlike Vincent, who was largely an autodidact and had worked for several years in relative isolation, De Haan had followed traditional art training in Amsterdam and set up a studio with pupils.[39] Taking inspiration from his own background, he had specialized in Jewish subject matter, aiming to create a niche in the competitive art market of Amsterdam.[40]

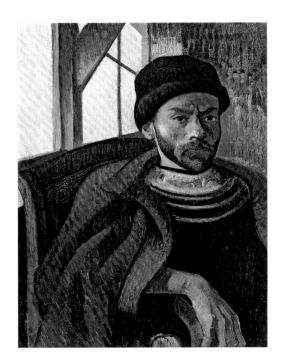

While Van Gogh went to Paris in 1886 to find a place in the international art world, De Haan left Amsterdam in 1888 for a change of scene after his ambitious history painting *Uriël Acosta* (1888, current location unknown), on which he had worked for years, was met with fierce criticism. First Van Gogh, then De Haan, stayed with Theo van Gogh in Paris. In contrast to Gauguin, both were able to pursue their artistic careers through the money available from their families. Gauguin was inclined to work with De Haan, as he had been with Van Gogh, because he offered some financial support and a connection to Theo, who could sell his work.[41]

Whereas Gauguin's collaboration with Van Gogh had been stimulating yet deeply challenging on all levels – intellectually, artistically and personally – the situation with De Haan a year later was fundamentally different. De Haan was not only easier to live with, he also actively sought the role of pupil to Gauguin and under his guidance changed his own manner of painting. The two artists worked together, in particular in the small Breton hamlet Le Pouldu, exploring the country and seaside and collaborating on the decoration of the dining room at the Buvette de la Plage inn where they stayed for some time.[42] Gauguin evidently enjoyed working with De Haan, and the Dutchman delighted in the new direction his own art was taking.[43] While Gauguin could comfortably assume a leadership role, he must have found much stimulus in De Haan's conversation and his willingness to engage in intellectual and spiritual discussions. Their exchange prompted Gauguin to develop a framework of references that remained vital until the end of his life.

For Gauguin's portraits of De Haan, the artist focused on certain elements of his model's appearance, such as his cap, moustache and tufts of hair that make him recognizable though do not capture his likeness. A comparison of these portraits with De Haan's self-portrait (ill. 42) highlights Gauguin's exaggeration and disregard of his model's features. Each time, De Haan is shown reading or in contemplation, and two drawings in particular (ills. 45, 46) indicate that Gauguin observed

42 Meijer de Haan, *Self-portrait in Breton Dress*, 1889

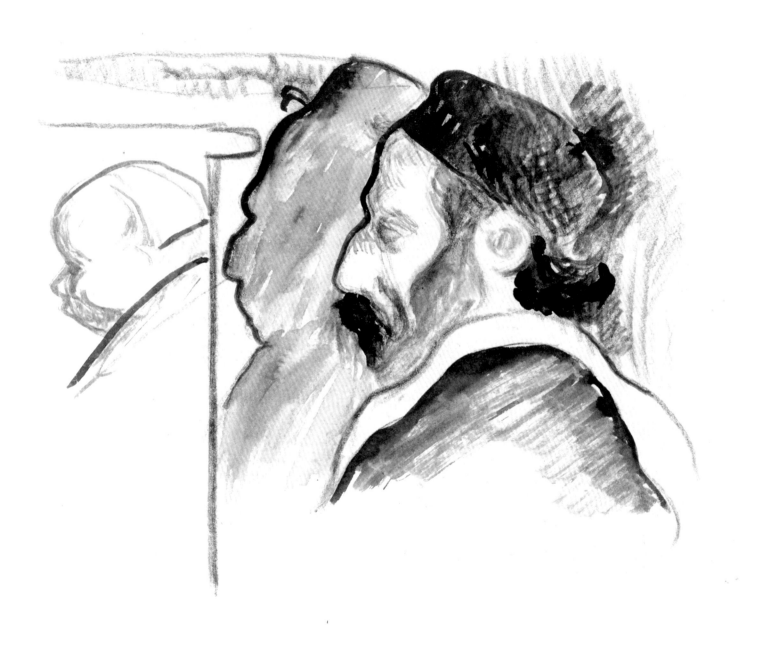

44 *Portrait of Meijer de Haan*, 1889

45 *Portrait of Meijer de Haan*, 1889–90

46 *Portrait of Meijer de Haan Reading*, 1889

his friend before portraying him in more complex compositions. The process recalls Gauguin's comments to Van Gogh in September 1888 when Gauguin and Émile Bernard were asked to paint each other's portraits (see ills. 7, 8):

> I'll do the portrait you want, but not *yet*. I'm not in a fit state to do it, seeing that it's not a copy of a face that you want, but a portrait as I understand it. I'm studying young Bernard and I don't have him yet. I shall perhaps do it from memory, but in any case it will be an abstraction.[44]

Gauguin painted his first portrait of De Haan on a wooden door in the dining room of the Buvette de la Plage to serve as a counterpoint to his own *Self-portrait with Halo* (ill. 13) on the door on the other side of the fireplace.[45] Representing

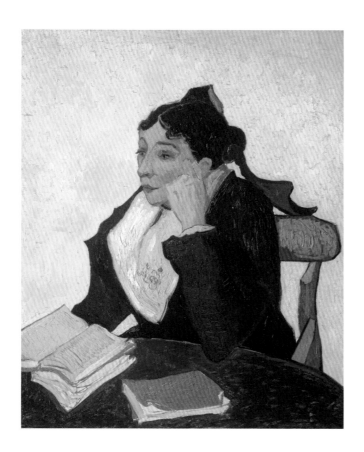

himself as a fallen angel, he depicted De Haan as a wise man or seer, with an exaggerated bulging forehead and mask-like eyes staring unseeingly as if deep in thought. Flat colours, simplified shapes and a jutting perspective recall Gauguin's interest in Japanese prints, while the apples are reminiscent of his admiration for Cézanne. Two books, Thomas Carlyle's *Sartor Resartus* (1836) and John Milton's *Paradise Lost* (1667), reflect Gauguin's and De Haan's conversations as well as the former's growing interest in spirituality and Christian subjects. Gauguin's preoccupation with the idea that the true artist was endowed with divine creative forces was a concept much *en vogue* in the nineteenth century and evocatively represented in Carlyle's text.[46] Milton's celebration of the creative power of Lucifer, which had been taken up by Charles Baudelaire, among others, may have led Gauguin to give De Haan somewhat satanic features.[47]

Many authors have insisted on the importance of De Haan's Jewishness for Gauguin, pointing in particular to his cap; but its jaunty angle and generic form in Gauguin's portraits reflect more simply the fact that De Haan customarily wore a hat, as seen in his self-portraits.[48] While it can be assumed that De Haan's education was extensive and very different from Gauguin's Catholic upbringing, his frame of reference was not orthodox but all-embracing, as Theo van Gogh noted in a letter to his sister:

> It is what you could call biblical Jews but with this difference from what one would imagine from such a label, in terms of the Bible, it is as if they go to and through the New Testament and thus have found all that is human and all the good from the new and the old. ... If it were possible, one could call them Christian-Jews.[49]

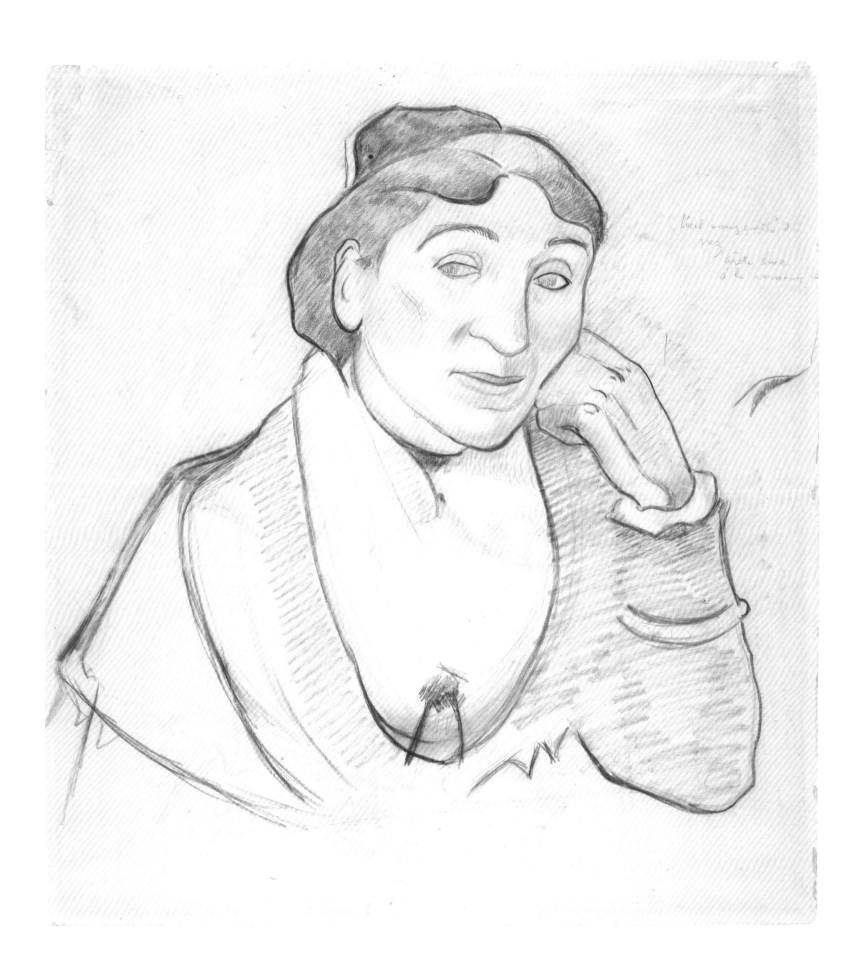

48 *L'Arlésienne, Madame Ginoux,* 1888 **89**

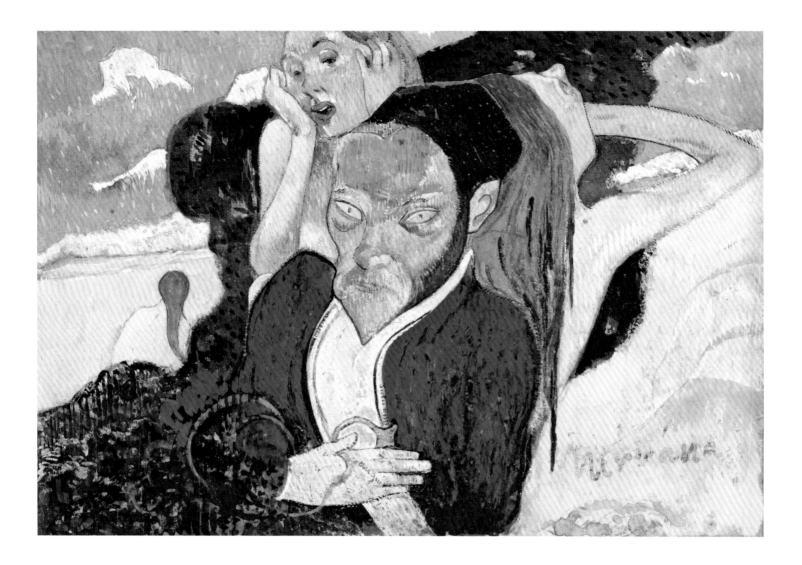

Theo also reported in the same letter that De Haan was an engaging conversationalist – a trait that Gauguin would have appreciated.

De Haan's pensive pose, with his chin resting on his hand, has a long tradition, dating back at least to Albrecht Dürer's engraving *Melancolia* from 1514, as does the inclusion of books in the composition. It is also worth recalling that only the year before, Gauguin and Van Gogh, working side by side, had portrayed Madame Ginoux in a similar pose. Van Gogh had then created a second, more worked version of his composition in which he introduced open books on the table in front of his model, as if she were contemplating what she had read (ill. 47). Later, he elaborated this concept further in a series of paintings based on Gauguin's drawing of Madame Ginoux (ill. 48).[50]

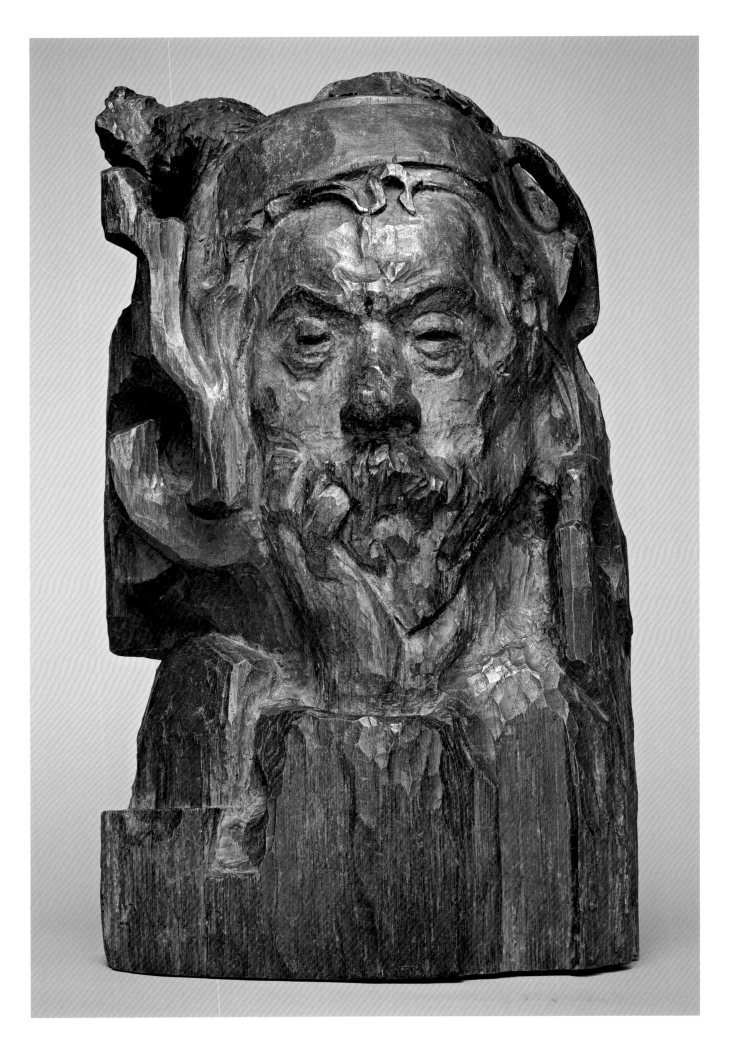

Gauguin's painting of De Haan suggests that he used his model's features as a vehicle to express ideas and thoughts relevant to his own art.[51] This is confirmed by his slightly later painting *Nirvana: Portrait of Meijer de Haan* (ill. 49), which presents De Haan as a pivotal presence in Gauguin's thinking and development of his oeuvre. Showing a masklike face staring out at the viewer, this portrait seems to hold the key to Gauguin's work, here represented by the compositions *Life and Death*, *In the Waves (Ondine)* and *At the Black Rocks*, which embody the conceptual and stylistic framework that he was forming at that point in time.[52]

Within the context of such representations, Gauguin's carved portrait bust of De Haan (ill. 50) stands out in isolated splendour. He chose a huge block of oak to chisel a vastly over-life-sized portrait of his diminutive friend, who at age eighteen had measured 1.49 metres (4.9 feet) and was considered too short for military service.[53] Gauguin used oak for several wooden reliefs in Brittany, but most of these are small pieces that differ significantly from this sculpture.[54] Why did the artist choose a piece of very hard wood that had split open? Did he find it by chance and did not mind that it could not be sculpted all around? Obviously, he intended it to be understood as a freestanding work and not a relief. Perhaps, as Robert Welsh suggests, he hacked off a piece at the back to make it fit on the mantel of the fireplace in the Buvette de la Plage.[55] One wonders if it was intended for that place from the outset or was added later to the setting.

Similar to his portrait with books (ill. 43), De Haan is shown in a contemplative pose, with his head leaning on his hand, his eyes half-closed.[56] The carving is detailed, but emphasizes the solid quality of the oak on which Gauguin used intense pigments such as blue, green and red, working the surface with wax to give it a subtle sheen, as if to soften the impact.[57] The combination of rough material and pensive pose in the bust is all the more dramatic when compared to Gauguin's relief *Be in Love and You Will Be Happy* (ill. 54) from around the same time. In that work, Gauguin applied colour and a smooth sheen to the linden wood after carving a complex story of seduction, which includes his self-portrait. The whole stands in dramatic contrast to De Haan's massiveness and calm contemplation.[58] Gauguin, who saw himself as a fallen angel or perverse seducer, portrayed his friend as a positive, intellectual life force that balanced his other incarnations. As such, the tree trunk of long-living oak and the branches growing from it support the projection of such an equilibrium.[59]

In a fascinating parallel to Van Gogh, De Haan also remained an important figure for Gauguin until the end of his life. In this case, however, it was not the colleague and competitor who was remembered but the identity that Gauguin had projected onto his friend in Brittany as an alter ego or a vital part of his own artistic persona. De Haan's reappearance in seminal works in Polynesia, when Gauguin was reflecting on his career and impact on the art of his time, underscores the essential role

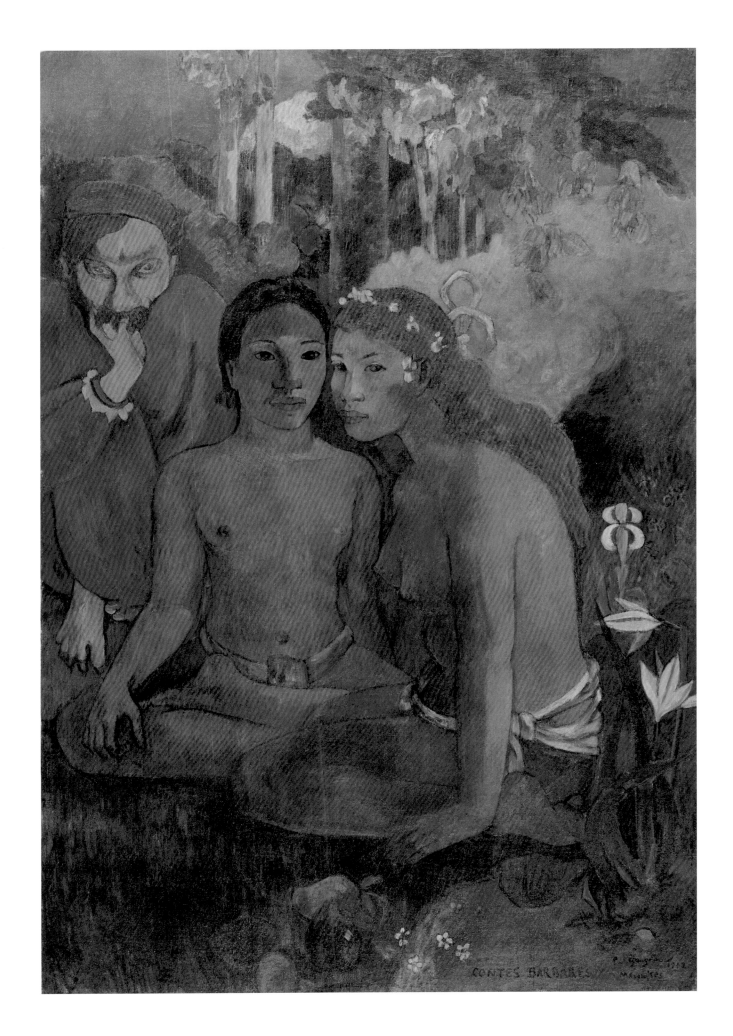

51 *Barbarian Tales*, 1902

De Haan had played in his thinking in 1889–90. While sunflowers personified Van Gogh, it was the masklike face of De Haan that reappeared. After creating a small woodcut in 1896–97 commemorating his friend, at the beginning of the next century Gauguin painted two major canvases with his likeness: *Barbarian Tales* (ill. 51) and *Bouquet of Flowers* (ill. 52).

Barbarian Tales manifests Gauguin's continued interest in Baudelairean correspondences and the ever-important issues of spirituality and artistic creativity.[60] As Elizabeth Childs has pointed out, it was at the time when Gauguin was writing *L'Esprit moderne et le catholicisme*, his view of the relationships among the world's religions, that he painted this composition in which the three figures represent different faiths: De Haan stands for the Western Judeo-Christian tradition, the androgynous figure in the centre represents Buddhism, and the woman on the right the Maori religion.[61] De Haan's strange purple attire not only creates a dramatic contrast with his red hair, but has also been identified as a missionary dress. This would imply a deliberate swipe at the Catholic Church trying to impose its rules and regulate sexuality in Polynesia, just as the luxurious locks of the Tahitian woman on the right echo De Haan's hair and as such may suggest the corruptive force of the Western man.

With the traditional role of the portrait subverted, Gauguin had recourse to De Haan's image as a personification of his own ideas and role as an artist. While De Haan symbolized for Gauguin wisdom and knowledge, the satanic creativity evoked by Milton and Baudelaire, he stands here for the artist who contemplates the unattainable vision of Buddhist balance and perfection in a Polynesian paradise that could still be tasted but was irretrievably lost. It is a projection of Gauguin's role within his own exotic setting, via the image of De Haan.

Bouquet of Flowers must have been painted not long before, as it suggests interesting parallels with Gauguin's sunflower still lifes of 1901–02. The magisterial but little-known painting shows a spectacular bouquet of flowers in a large pot placed on a chest. The massive vase has two intertwined figures affixed, recalling Gauguin's earlier pottery and also his fascination with Maori imagery.[62] The figures reflect Gauguin's preoccupation with sexuality and creative force as well as the clichés of sexual freedom in Polynesia promoted in the Western world. In contrast to the sunflower still lifes for which Gauguin used flowers that he had grown from imported seeds in his garden and recalled Van Gogh, here he depicted native flowers.

The brilliantly coloured arrangement is accompanied by De Haan's looming head behind the blooms. Despite the painterly, broadly brushed execution, his features, with slanting eyes and moustache, are easily recognizable from Gauguin's other portraits. Similar to Gauguin's *Sunflowers on an Armchair (II)* (ill. 38), it is not clear if De Haan is shown peering in through a window or if it is his portrait in a frame. In one, a Tahitian woman looks at flowers sent from Europe, while in the other a European presence is contemplating the opulence of Polynesian flora

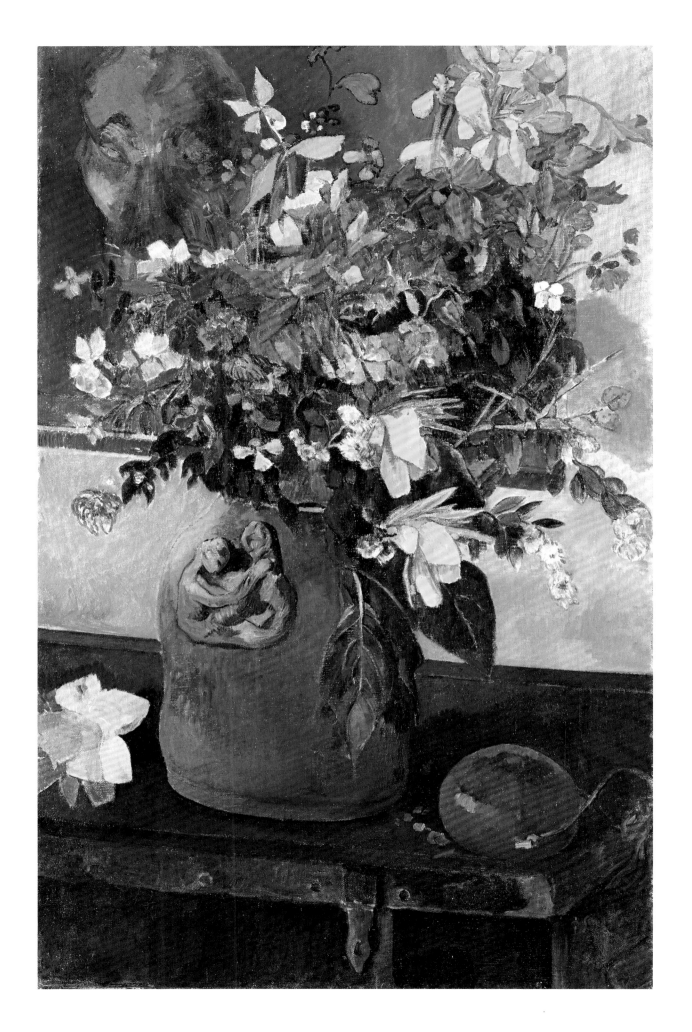

available to Gauguin. The deep-blue background suggests a tonality comparable to *Barbarian Tales*. Gauguin is employing once more the portrait of De Haan as a Western presence standing for himself, contemplating and celebrating the paradise in which he lives.

Like the terms *sauvage* or *barbare* that Gauguin used in the titles of his works, De Haan figures as a reference, a signifier for Gauguin's own Western artistic identity.[63] This became particularly important at the end of his life when Gauguin was reflecting upon his position as an avant-garde artist. With Van Gogh he needed to re-establish his eminence, whereas he could use De Haan to reinforce his own position and artistic credo.

Gauguin's portraits of his friends and colleagues, while often discussed individually, have rarely been considered as a group. When doing so, patterns emerge that point to specific functions for these works. Apart from signs of gratitude or appreciation, many portraits reflect Gauguin's evident need to identify his achievements or clarify his wide-ranging ideas and deep-seated ambitions. Toward the end of his life, when he lived far away from Paris and his colleagues, his paintings recalling Van Gogh or De Haan constituted not only spectacular celebrations of his surroundings and artistic creativity but were also intended to safeguard his legacy.

NOTES

I would like to thank Claire Guitton for her invaluable assistance during the preparation of this exhibition and in particular of this essay, support that was continued most effectively by Kirsten Marples.

1 Letter from Gauguin to Camille Pissarro, October 1884, in Gauguin 1984, no. 54, p. 70. For the information mentioned here and more details on Favre, see Sylvie Crussard's in-depth research in Wildenstein 2001/2002, pp. 42–44.
2 Allison Perelman, "The Burning Yellow Atelier," in Groom 2017, pp. 64–71.
3 For Gauguin's interest in Wagner, see for example, Lang 2005. The importance of Wagner to Gauguin's thinking is apparent in comments in many of his letters and in his manuscript "Le Texte Wagner" (1889), later recopied in "Diverses choses" (1896–98).
4 See Gauguin's letters to Molard in Gauguin 1949.
5 See in particular Françoise Cachin's thoughtful analysis in Brettell 1988, cat. 61, pp. 120–122.
6 See also Jean-David Jumeau-Lafond's discussion of Madame Schuffenecker in this catalogue.
7 See Belinda Thomson, "Gauguin Goes Public," in Lemonedes, Thomson and Juszczak 2009, p. 48. Roy, about whom still regretfully little is known, was part of Gauguin's circle. See Walter 1978, pp. 61–72; André Cariou, "Louis Roy," in Musée des beaux-arts, Quimper 1978, unpaginated; and Siberchicot 2011.
8 See, for example, the letter from Gauguin to Émile Schuffenecker, Pont-Aven, June 1890, in Gauguin 1949, no. 104, p. 141.
9 Such as *Fruit in a Bowl* (1886, private collection, W215 [2001]).
10 See, in particular, Siberchicot 2011, pp. 86–89.
11 *Still Life with Ceramic Cup*, 1888 (ill. 120); see also Groom 2017, cats. 100, 101, pp. 174–175.
12 For this exhibition, see Claire Guitton's essay in this catalogue.
13 *L'Ymagier* was published in eight issues between October 1894 and January 1896 and combined texts and images, including Épinal prints as well as prints and woodcuts by artists such as Gauguin, Roy, Émile Bernard and Charles Filiger. For Gauguin's relationship with Jarry, see Gamboni 2005, pp. 459–475.
14 Little is known about this collaboration, and consequently most authors had to speculate about the printing of *Noa Noa*. See, for example, Figura 2014, p. 24, and Barbara Stern Shapiro, "Shapes and Harmonies of Another World," in Shackelford and Frèches-Thory 2003, pp. 115–133.
15 For this series of prints, see in particular Lemonedes, Thomson and Juszczak 2009.
16 See also Pickvance 1998, cats. 69, 70.
17 Edgar Allan Poe, *Contes grotesques*, trans. Émile Hennequin (Paris: Paul Ollendorf, 1882). See also Redon's 1882 drawing *The Raven* in the collection of the National Gallery of Canada, Ottawa (no. 14847).
18 Gott 1990, pp. 48–56.
19 See Gauguin's letters to André Fontainas, 1899–1903, in Gauguin 1949.
20 See among others Gamboni 2014, p. 18, and his essay in this catalogue.

21 For the relationship between Gauguin and Laval and their visit to Martinique, see Van Dijk and Van der Hoeven 2018.
22 See Puget, Jaworska and Delouche 1989, p. 106.
23 Letter from Gauguin to William Molard, Atuana, 6 March 1902, in Gauguin 1949, no. 175, p. 229.
24 In a letter to Theo van Gogh from Arles on 3 October 1888, Vincent wrote extensively about this point. For example: "I couldn't ask for more, but when it's a matter of several painters living communally, I stipulate first and foremost that there would have to be a father superior to impose order, and that naturally that would be Gauguin." And further: "But the more Gauguin feels that by joining us he'll have the position of head of a studio, the sooner he'll recover and the keener he'll be to work" (no. 694, http://vangoghletters.org [accessed 12 October 2018]). While this letter is addressed to his brother, Theo, we can assume that Vincent shared similar thoughts with Gauguin himself as was his wont, even if most of his letters to Gauguin are lost.
25 On the relationship and collaboration of the artists, see among others Druick and Zegers 2001; Silverman 2000; and Elizabeth C. Childs, "Seeking the Studio of the South: Van Gogh, Gauguin, and Avant-Garde Identity," in Homburg 2001, pp. 113–152.
26 See Van Gogh's letters from January 1889, in particular his letter to Gauguin from Arles from 21 January: "...if Jeannin has the peony, Quost the hollyhock, I indeed, before others, have taken the sunflower" (no. 739, http://vangoghletters.org [accessed 12 October 2018]).
27 For this portrait, see among others Jirat-Wasiutyński and Newton 2000, pp. 115–136; Druick and Zegers 2001, pp. 236–238; and Gamboni 2014, pp. 165–167.
28 Letter from Vincent van Gogh to Theo van Gogh, Saint-Rémy-de-Provence, 10 September 1889, no. 801, http://vangoghletters.org (accessed 12 October 2018). Gauguin did not give the portrait to Vincent, but sent it to Theo in Paris. He would have known that it would remain in the brothers' personal collection. In *Avant et après* Gauguin wrote: "I decided to do a portrait of him in the act of painting the still life he liked so much, sunflowers. When the portrait was finished, he said to me: 'That is me, all right, but me gone mad'" (Gauguin 1996, p. 254).
29 See Druick and Zegers 2001 and Moyna Stanton, "Gauguin's Yellow Paper," in Lemonedes, Thomson and Juszczak 2009, pp. 115–117. Much research is still needed on the aftermath of the collaboration between the two artists.
30 Gauguin 1894, pp. 273–275, trans. Stein 1986, pp. 121–122.
31 Ibid.
32 "If you have a bit of good luck with the sales, I wish you would send me a few bulbs and seeds of flowers. Simple dahlias, nasturtiums and sunflowers of various sorts, flowers that can stand the hot climate. ... I want to decorate my little plantation, and as you know, I adore flowers" (letter from Gauguin to Daniel de Monfreid, October 1898, in Gauguin 1922, no. 36, p. 107).
33 See Gauguin 1951b, Gauguin 1951c and Gauguin 1923.
34 For discussions of these works, see among others Brettell 1988, pp. 455–458; Druick and Zegers 2001, pp. 350–353; and Gamboni 2014, pp. 349–370.
35 Vincent van Gogh, *Gauguin's Chair* (1888, Van Gogh Museum, Amsterdam), see Brettell 1988, cat. 253, pp. 455–456.

36 Vincent van Gogh, *Two Sunflower Heads* (1887, The Metropolitan Museum of Art, New York, and Kunstmuseum Bern).

37 Druick and Zegers 2001, pp. 350–352.

38 "You mention painted flowers; I don't really know which ones, even though I do so few of them, and that is because (as you have surely noticed) I do not paint by copying nature – nowadays less than previously. Everything I do springs from my wild imagination. And when I am tired of painting human figures (my favorite subject), I begin a still life, which I finish, by the way, without a model" (letter from Gauguin to Ambroise Vollard, Tahiti, January 1900, in Gauguin 1996, p. 204).

39 See, in particular, the essays by Jelka Kröger and Saskia de Bodt in Kröger 2009.

40 Saskia de Bodt, "The Early Years of Meijer de Haan in Amsterdam through 1888," in Kröger 2009, pp. 50–60.

41 In a letter from December 1889, De Haan asked Theo to help Gauguin. He continued: "If I had not jumped in these last three months and taken care on my own account he would have nothing to eat because [s]ince September he hasn't had a penny" (letter from Meijer de Haan to Theo van Gogh, Le Pouldu, 13 December 1889, Van Gogh Museum, Amsterdam, no. b 1319 V/1962, trans. in Kröger 2009, pp. 136–137).

42 For this collaboration, see in particular the various essays in Zafran 2001 and Kröger 2009.

43 Letter from Gauguin to Émile Schuffenecker, Moelan, October 1889, in Gauguin 1949, no. 90, pp. 126–127. See Meijer de Haan's letters to Theo van Gogh, 22 October and 13 December 1889, in Kröger 2009, pp. 135–137.

44 Letter from Gauguin to Vincent van Gogh, Pont-Aven, c. 26 September 1888, no. 688, http://vangoghletters.org (accessed 12 October 2018). For a discussion of these portraits, see Alastair Wright's essay in this catalogue.

45 For the reconstruction, see Robert Welsh, "Gauguin and the Inn of Marie Henry at Le Pouldu," in Zafran 2001, pp. 61–71. For the *Self-portrait with Halo*, see also Alastair Wright's essay in this catalogue.

46 In "Notes Synthétiques," Gauguin wrote: "…you must be a born artist; and though many are called, few are chosen" (Gauguin 1996, p. 9). For Gauguin's portraits of Meijer de Haan, see Eric Zafran's admirable catalogue with a recapitulation of arguments and analysis (Zafran 2001), in particular his essay "Searching for Nirvana" (pp. 103–127). See also June Hargrove's numerous essays on the subject, in particular "Gauguin's Maverick Sage: Meyer de Haan," in Stolwijk 2010, pp. 87–111, and "Les *Contes barbares* de Paul Gauguin," in Hargrove 2010a, pp. 25–37; as well as Barbara Larson, "Gauguin: Vitalist, Hypnotist," in Broude 2018, pp. 179–202.

47 See Françoise Cachin, "Meyer de Haan," in Brettell 1988, cat. 93, pp. 167–169; Eric M. Zafran, "Searching for Nirvana," in Zafran 2001, pp. 103–127; and Hargrove, "Gauguin's Maverick Sage," p. 94.

48 In addition to Hargrove, see also Thomson 2010, pp. 74–75, and Bogomila Welsh-Ovcharov, "Paul Gauguin's Third Visit to Brittany, June 1889 – November 1890," in Zafran 2001, pp. 26–29.

49 Letter from Theo van Gogh to his sister, fall 1888, Van Gogh Museum, Amsterdam, no. b916V/1962, in Kröger 2009, pp. 33–34.

From his stay with Theo we know that De Haan and his pupil J.J. Isaacson enjoyed animated discussions. See also Van Crimpen, Jansen and Robert 1999.

50 See Rathbone and Robinson 2013, pp. 90–99, 154–161, and Homburg 1992, pp. 127–138.

51 Gauguin made a small watercolour of this composition (The Museum of Modern Art, New York), which he took with him to Polynesia.

52 *Life and Death* (1889, Mahmoud Khalil Museum, Cairo, W335), *In the Waves (Ondine)* (1889, The Cleveland Museum of Art, W336) and *At the Black Rocks* (1889, private collection). Zafran argues about the duality of suffering and joy, infertility and fertility, life and death (Zafran 2001, p. 117).

53 See Kröger 2009, p. 17.

54 Gray 1963, for example nos. 58–60, 71, 75. Apparently De Haan also did carvings though no example has come to light so far (see letter from Meijer de Haan to Theo van Gogh, 8 October 1890, in Kröger 2009, pp. 139–140).

55 Welsh, "Gauguin and the Inn of Marie Henry at Le Pouldu," p. 67. For this information and more, Welsh cites details remembered by Marie Henry, written down by Henri Mothéré, a source not always reliable, published in Chassé 1921.

56 The chicken or cock on his head is most certainly a humorous reference to De Haan's name. It would not be surprising if Gauguin was not aware if the exact meaning of the Dutchman's name meant female or male.

57 My sincere thanks go to Doris Couture-Rigert, Chief, Conservation and Technical Research at the National Gallery of Canada, for her detailed research on the sculpture.

58 Gauguin wrote about this work repeatedly, including to Van Gogh in mid-November 1889: "For two months I've been working on a large sculpture (of painted wood), and I dare believe that it's the best thing I've done up to now as regards power and harmony – but the literary side of it is insane to many. A monster who looks like me is taking the hand of a naked woman – that's the main subject. Figures (smaller) in the gaps. The top part a town, some sort of Babylon, the bottom the countryside with a few imagined flowers (an old and desolate woman) and a fox, the fateful animal of perversity for the Indians" (letter from Gauguin to Vincent van Gogh, Le Pouldu, c. 10–13 November 1889, no. 817, http://vangoghletters.org [accessed 12 October 2018]).

59 Compare also Hargrove, "Gauguin's Maverick Sage," in Stolwijk 2010, p. 98.

60 Charles Baudelaire, "Correspondances," poem 103 from *Les Fleurs du mal*.

61 Elizabeth C. Childs, "Catholicism and the Modern Mind": The Painter as Writer in Late Career," in Shackelford and Frèches-Thory 2003, p. 239. See also Teilhet-Fisk 1983, p. 156, and Maurer 1988, p. 174.

62 See Bronwen Nicholson, "Gauguin's Auckland Visit," in Greub 2011, p. 258, and Nicholson 1995, pp. 56–57, 70–71.

63 See also Jean-David Jumeau-Lafond's essay "Head of a Savage, Mask" in this catalogue.

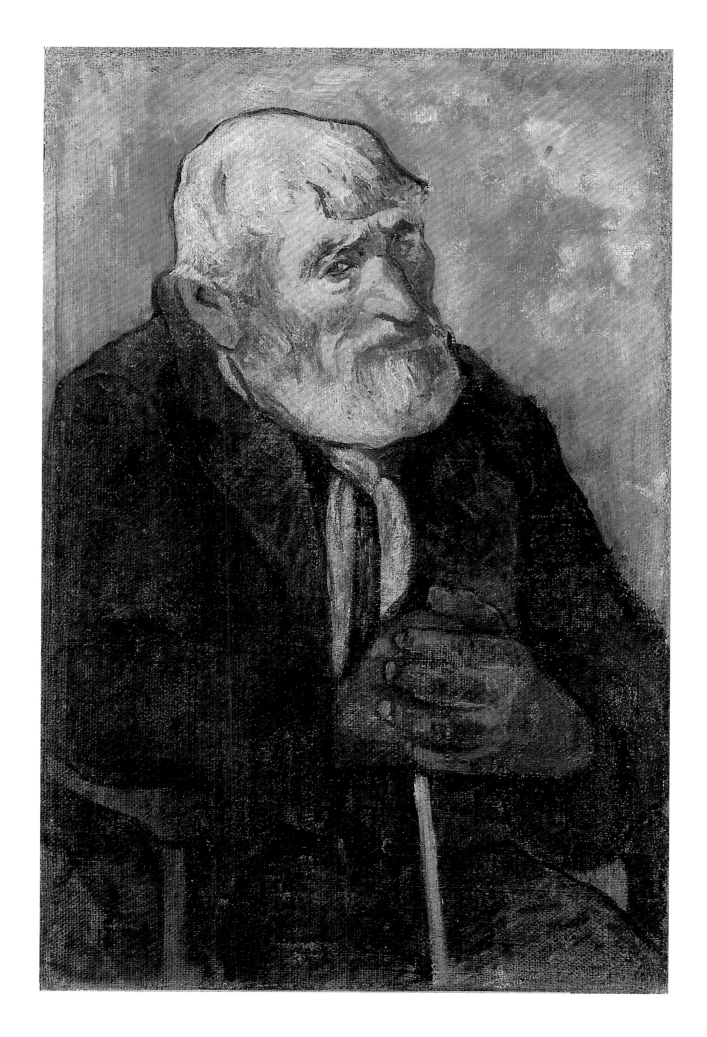

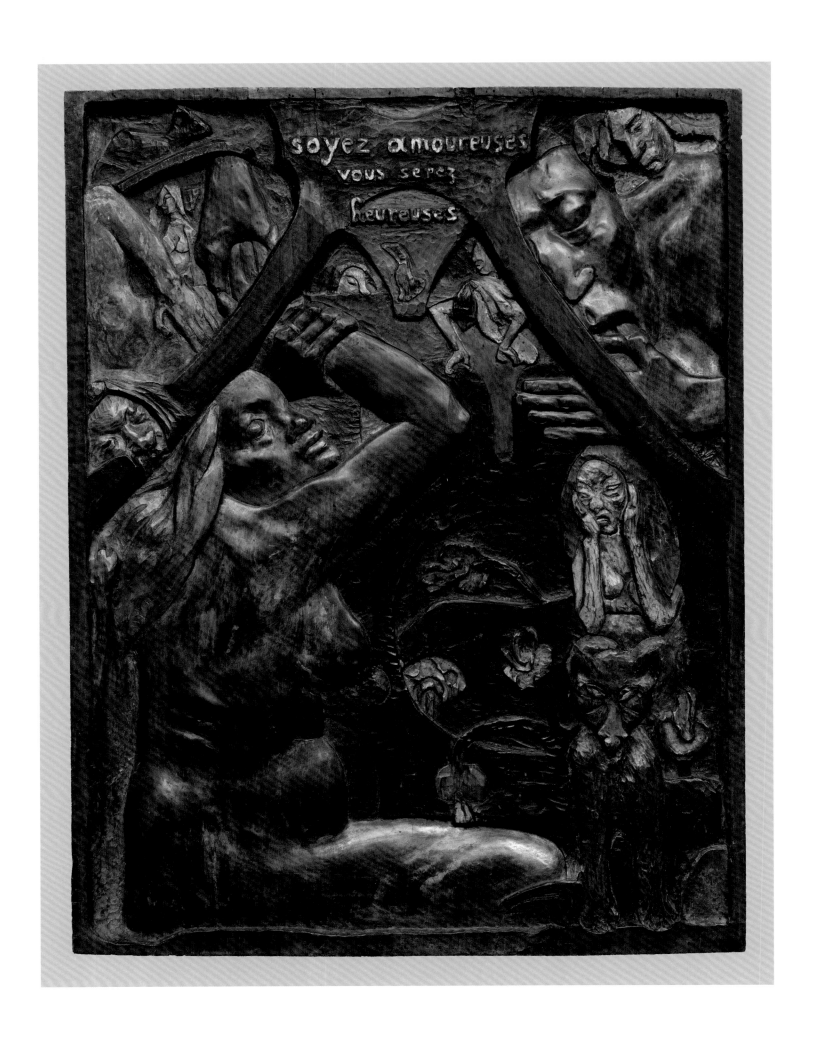

The text carved into the relief reads:

soyez amoureuses
vous serez
heureuses

54 *Be in Love and You Will Be Happy*, 1889 *Portrait of Meijer de Haan* (detail, ill. 50), 1889–90

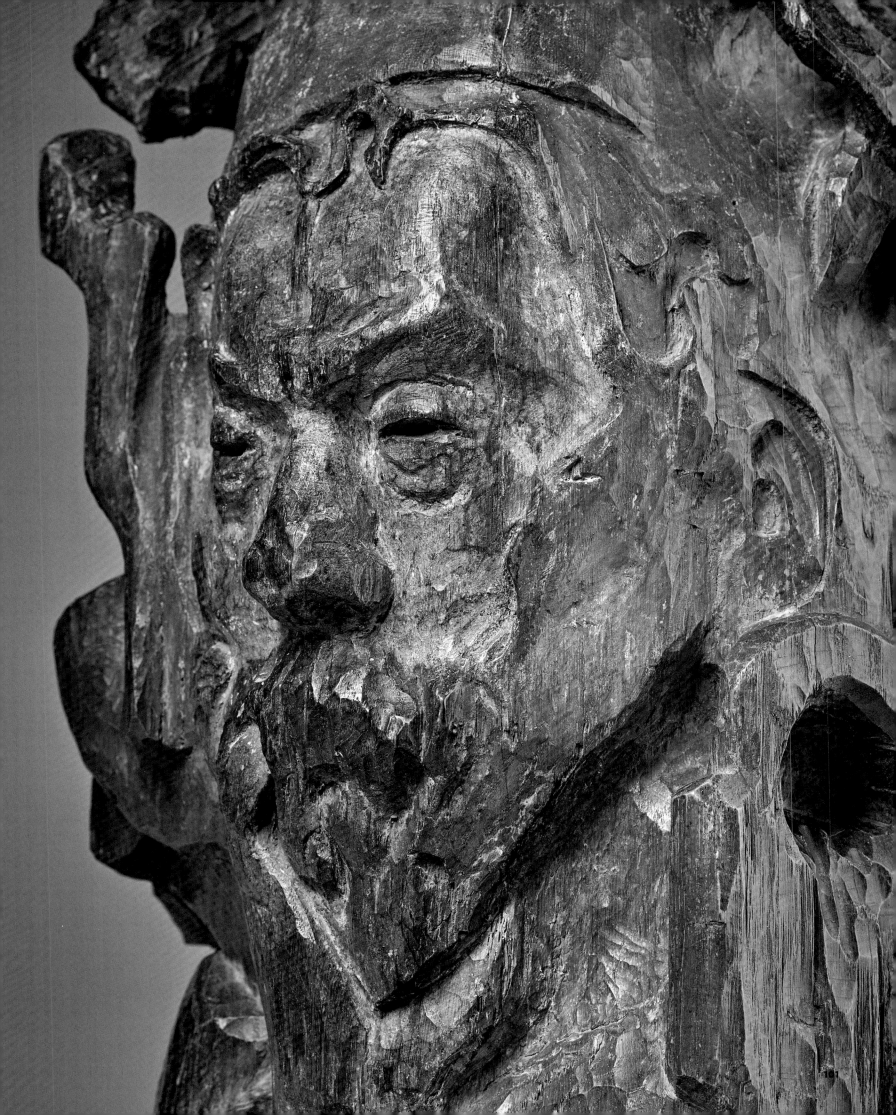

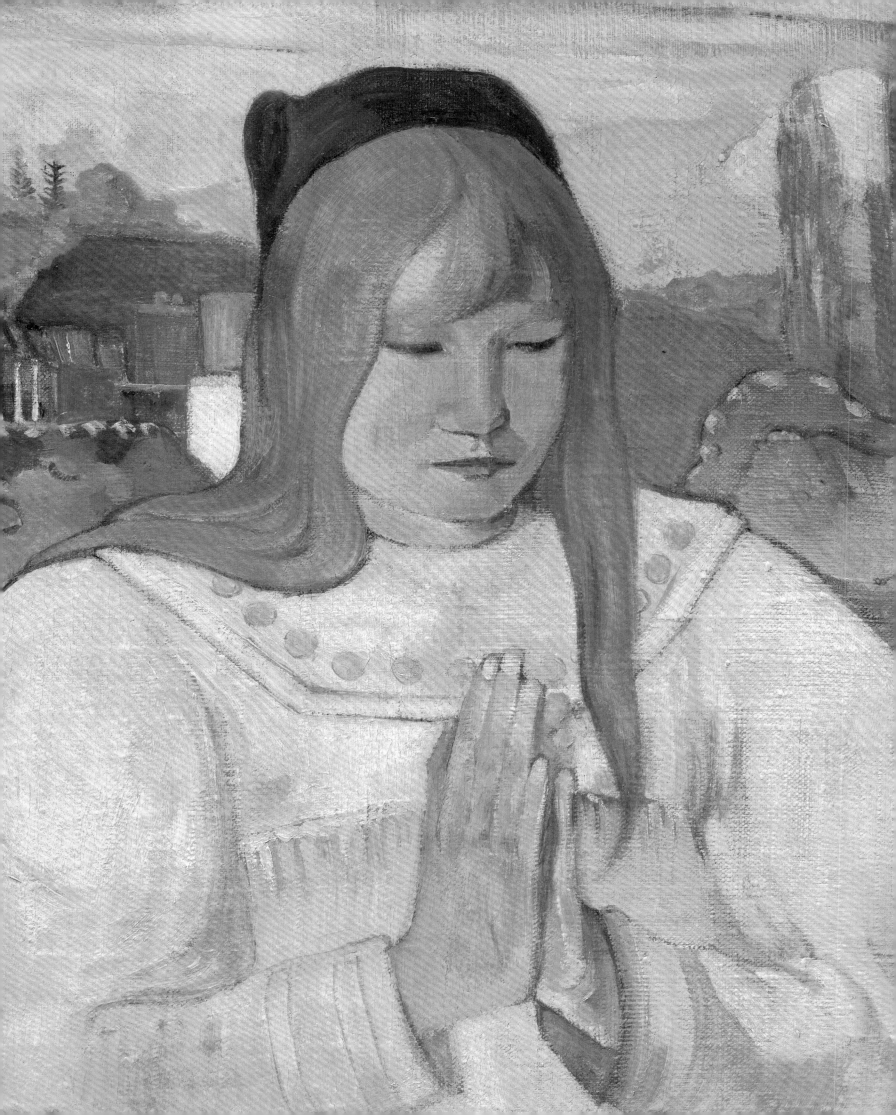

GAUGUIN
IN BRITTANY

CHRISTOPHER RIOPELLE

The proverbial piety and simplicity of Breton peasants and their supposedly timeless way of life were already clichés – of French literature and travel guides if not yet of the visual arts – by the time the French painter Pierre-Charles Poussin exhibited his panoramic *Pardon Day in Brittany* (ill. 55) in 1852 and again, reworked, in 1855.[1] Measuring more than three and a quarter metres across, the canvas includes some thirty-five figures in the foreground and at least a hundred more in the mid- and background. It is a vast ethnographic report on local manners and mores, a visual inventory of rural customs, courting rituals, amusements and foods at a Pardon Day, the religious gathering in late spring or early summer that had long been the highlight of the Breton calendar. An itinerant tradesman in the left foreground, perhaps a wandering Jew selling cloth stuffs to the locals, is the only non-Breton here. All the other figures wear the traditional folk costumes of Brittany; it was a world apart as far as the Parisian public was concerned, as yet unsullied by metropolitan sophistication. Gauguin's Breton models would don the same distinctive and colourful dress when they posed for him around thirty-five years later.

The painting marks an important step in the growing prominence of Breton imagery. In 1852 Poussin sent it to the principal forum for new French art, the annual Paris Salon. A few works on Breton peasant themes by painters such as Adolphe Pierre Leleux had been shown there since the mid-1840s, but nothing on the scale or of the complexity of *Pardon Day* had been seen. Henceforth, hundreds more such images by dozens of artists would follow over the years. Academic masters such as Jules Breton and P.A.J. Dagnan-Bouveret could be counted on to exhibit naturalistic depictions of Breton folkways at the Salon and its successor exhibitions until the end of the nineteenth century and beyond. By the time

Young Christian Girl (detail, ill. 62), 1894

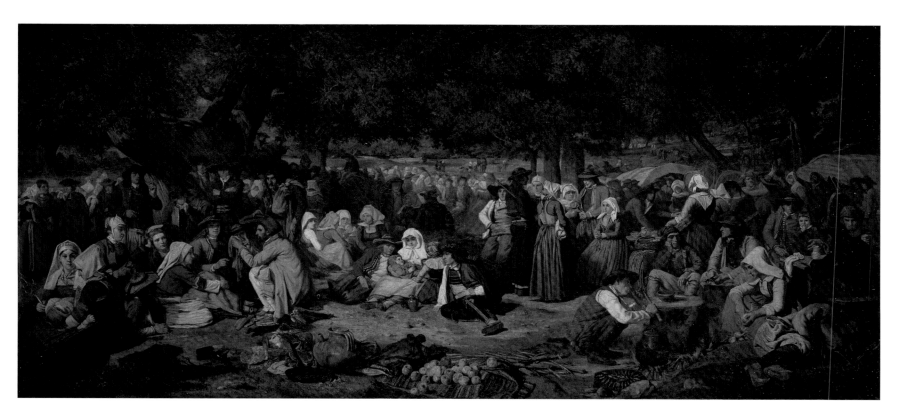

Gauguin began painting in Brittany in July 1886, then, Parisian audiences would have been able to place his images within a well-established fine-arts tradition.

A critic took Poussin to task in 1852 for what he said were the unsuitably strong colour contrasts that marred his composition. Muted tonalities were the index of authenticity in Realist painting of the 1850s, but the pigments Poussin used, perhaps to record striking red-and-white women's costumes and bonnets, were found strident. The artist fell in line. Before showing the painting again at the Exposition Universelle of 1855, also in Paris, Poussin covered the canvas with a heavy varnish impregnated with sombre pigments in order to bring its tones under visual control. Today, we see it as though through amber.[2] Gauguin, on the other hand, would accentuate the jewel-like colours of his Breton paintings; they constituted experiments in increasingly brilliant and startling colour contrasts and radically simplified forms. Their very boldness and break with established traditions of Breton imagery would mark them out within the context of the Paris art world as statements of radical intent.

Gauguin lived in Brittany on three protracted occasions from 1886 to 1891 – interrupted in 1887 by an eight-month voyage to Martinique, and late in 1888 by his two-month stay in Provence with Vincent van Gogh – and once again in 1894

between his two sojourns in Tahiti. During his time in the region, he felt embold-ened to pursue the path of high-keyed decorative painting he had begun to explore as he moved away from his early Impressionist style. Simultaneously, he was teaching the new style to artist friends such as Paul Sérusier, Émile Bernard and Charles Laval, who joined him in Brittany. They would come to call the approach Synthetism, implying not only a melding of colour and form but a broad evocation of symbolic resonances opening up spiritual realms far removed from Realism.

The Breton works Gauguin and a select group of artists showed in a finan-cially disastrous exhibition they themselves mounted at the Café des Arts in Paris in 1889, adjacent to the grounds of another Exposition Universelle, introduced what collectively they had achieved in Brittany over recent years, and announced their stylistic break not only with Salon painting but with Impressionism and Neo-Impressionism as well. Gauguin counted the Impressionists and Neo-Impressionists among his friends and had long made common cause with them against the reigning academic art establishment. But now he drew a line in the sand. If Poussin in the 1850s had assimilated his Breton image to prevailing Parisian pictorial norms, Gauguin in the 1880s employed his Breton works and those of his friends to dia-metrically opposite ends, separating the work of what he called "our group" from the rest of the Parisian art world, academic and avant-garde both.

To be sure, Gauguin discovered a different Brittany when he first arrived at Pont-Aven in July 1886 than the one Poussin had observed thirty-five years earlier. For one, it was now difficult to maintain the myth of primitive authenticity in which outside influences played little role in local lives. "Cultural tourism" was in full swing. Artists in particular, and not only French ones but British and American, filled the hotels of Pont-Aven and other west-coast towns seeking to find and record local folkways. They painted the same rustic motifs over and over again.[3] One American artist there at the time called Pont-Aven "that place of pre-digested food for artists."[4] The peasants for their part were happy to pose for artists in traditional garb in order to earn money. The performance of *folklorique* piety and thrift had become a lucrative spur to the local economy. Such were the dynamics at play, between Paris and Brittany, centre and periphery, sophistication and primitivism, insularity and integration. Gauguin sensed the ambiguity of his situation, moving in 1889 from Pont-Aven to the remoter settlement of Le Pouldu further along the coast where, he told Van Gogh hopefully, "the peasants have a medieval air and do not have the sense that Paris exists or that we are in 1889."[5] Pont-Aven could no longer claim that innocence by the late 1880s, and it was as if Gauguin intuited he was only one step ahead of such encroachments in Le Pouldu as well.

Gauguin's relationship to Brittany was from the beginning one of deep per-sonal identification. Almost from the moment he arrived in Pont-Aven he adopted local costume such as the traditional embroidered man's vest with which he depicted himself in a self-portrait (ill. 6). He carved several pairs of wooden shoes, or *sabots*, the very symbol of rustic Breton life. They appear in paintings including his

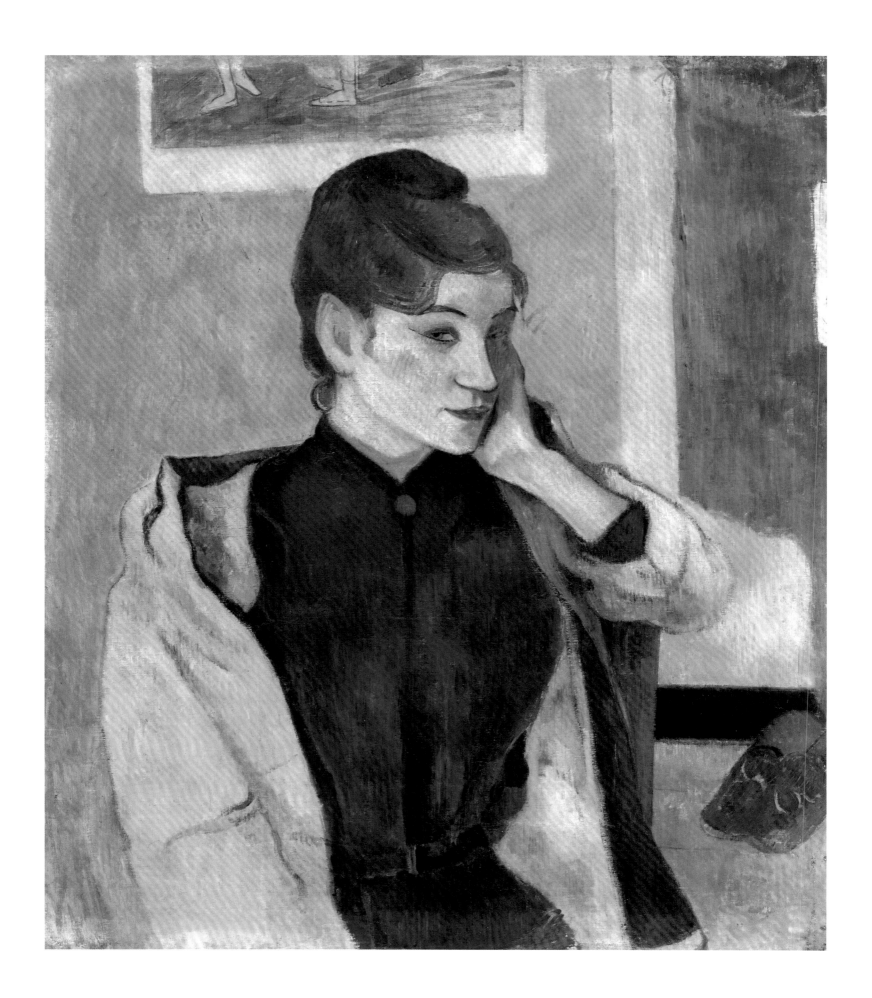

56 *Portrait of Madeleine Bernard*, 1888

Portrait of Madeleine Bernard (ill. 56). Indeed, he declared his allegiance to Breton ways by wearing the wooden shoes on the streets of Paris.[6] He would go so far as to equate the ring of sabots on the cobblestones there with "the muffled, dull, powerful tone I seek in my paintings."[7] Gauguin's deepest psychological immersion in Brittany may have come in 1888 when, as Dario Gamboni has recognized, he inscribed his own profile, seen from a dizzying height, into the very Breton sea-coast in the near-abstract landscape *Seascape with Cow* (*On the Edge of the Abyss*, ill. 57). The title "may refer as much to a moral status," Gamboni notes, "as to a physical position."[8]

Gauguin's self-portraits and portraits of artist friends, both categories including Breton-period works, are addressed elsewhere in this catalogue.[9] His portraits of the Bretons themselves, however, especially his often-poignant depictions of Breton girls and women, stand apart. In Brittany, Claire Frèches-Thory has argued, Gauguin "worked out the main elements of the plastic techniques he would develop later in Tahiti."[10] But the Breton portraits are significant not merely in anticipation of what was to follow. Here, Gauguin began to evolve the lineaments of his psych-ological and moral relationship with people whom he identified as primitive and exotic, pure and carnal by turns. How should he use the vivid personalities and strange customs he met with in Brittany as he evolved a new, fully Synthetist art? What did they tell him about otherness, wildness, the savage state in which he increasingly situated himself? How could his intense personal engagement with such people rise through a process of simplification and intensification to the higher, objective plane of art?

Two simple bust-length portraits show Gauguin directly addressing Breton peasant women with whom, it seems, he began to interact soon after his arrival in Pont-Aven. Marie Lagadu – whose last name may have been a nickname meaning "black eyes" in Breton (her actual sur-name was perhaps Derrien) – likely was employed by the Auberge Gloanec where Gauguin stayed and worked in 1886.[11] Wearing a simple Breton headdress, she is posed before a large window at Lézaven, a dilapidated manor house in the vicin-ity of Pont-Aven that numerous artists, especially Americans, used as a convenient studio (private collection, W290 [2001]).[12] Beyond the window,

golden fields, the tonality of an ancient gold-ground religious painting, roll away. Marie shifts her eyes to her right as if quizzical about the odd bohemian setting in which she finds herself, while a gently enigmatic smile plays across her lips. She is not unobservant, but at the same time appears trusting and placid in demeanour.

Strong-faced Marie Louarn (see ill. 58) likely was portrayed by Gauguin at more or less the same moment as Marie Lagadu, in 1888.[13] She too served the needs of the visiting artists of Pont-Aven. Not least, she would pose nude for them – although fastidiously declining to remove her Breton headdress – and is the model for the nude female figure in Gauguin's erotically charged allegorical wood relief *Be in Love and You Will Be Happy* (ill. 54). Paul Sérusier later confided to Maurice Denis that Louarn "charmed the solitude" of the entire school of artists gathered at Pont-Aven.[14] That the charms were of a sexual nature would not have been lost on Denis – Sérusier may indeed have enjoyed shocking his ultra-Catholic friend with news of goings-on among the supposedly pious rustics – and indeed in 1892 Louarn would officially register as a "*femme publique*."[15] Here, she dominates Gauguin's small painting, staring implacably at her portrayer and silhouetted against a lurid background the colour of absinthe. The charge of her presence is less erotic, however, than it is that of a strong-willed, firm-jawed woman of the people who could be counted on to hold her ground.

One of these two pictures went to Mette Gauguin in Copenhagen. It is not clear which. There, in 1892, the portrait and three other paintings found a Danish buyer for 1,500 francs: Gauguin, reporting the sale, described the portrait as "*une insignifiante (petite tête bretonne)*."[16] Why, beyond the small size of the canvas, would Gauguin have called this little Breton head insignificant? Perhaps it was because both paintings are vividly, unmistakably, studies from life, essentially naturalistic depictions recording a direct confrontation between sitter and artist. Neither image had yet been subjected to that synthesis of form and intensification of colour, that admixture of symbolic content, to which Gauguin would subject his Breton figures as he worked up the complex, increasingly Synthetist images that are the most ambitious of his Breton period. Rather, the two Maries represent a first, unmediated, step in his attempt to comprehend the new and alien people among whom he had chosen to situate himself.

Daniel Wildenstein calls Louarn a key figure for Gauguin, standing somewhere between the life he was leading in Brittany and his evolving imaginative engagement with that life.[17] The synthesis of form and content of which the portrait of Louarn was a preliminary step is achieved with *La Belle Angèle* (ill. 59), the artist's 1889 portrait of Marie-Angélique Satre, the beautiful wife of a Pont-Aven official.[18] She sits in a richly embroidered Breton costume, hands placidly folded on her lap, eyes narrowed as if in prayer or thought. She is imperturbable, surrounded by a circular frame in ochre, like a halo, crisply detaching her from the background of flowered wallpaper. That aspect of the

composition resembles a detail of a Cézanne still-life painting. On a ledge outside the field of the portrait proper stands a ceramic – perhaps one of the artist's own – like a pagan idol to which the sitter in her spiritual self-sufficiency is indifferent.

The source of the motif of an enframing circle has been traced to "a favorite Japanese procedure that occurs frequently in the prints of Hiroshige and Hokusai."[19] It has been compared as well with contemporary magazine illustration.[20] But these sources do not account for the aura of religious intensity that is so striking a characteristic of the painting. Surely, the framing device carries resonances as well of the Early Christian motif of the *imago clipeata*, or portrait on a round shield, in which saints, heroes and deceased ancestors were portrayed, for example on sarcophagi and ivory diptychs.[21] La Belle Angèle is a saintly figure here, and her religiosity as a pious Breton is of an ancient and primitive kind, for which reference to the Early Church is apt. Gauguin's skill in synthesizing motifs both ancient and contemporary and from disparate cultural sources was becoming more confident.

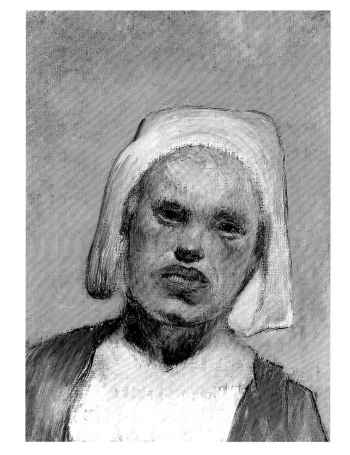

The sitter here thought her representation was a "horror" and told the artist she would not have the painting in her house. Gauguin replied that it was the best portrait he had ever done.[22] Intriguingly, Madame Satre rejected the work not from personal antipathy to it, nor from dislike of Gauguin himself whom she called "a pleasant man," but because she had learned in advance of seeing the completed work that Gauguin's fellow painters in the artists' colony at Pont-Aven had made fun of it, indeed may have come to blows over it.[23] The point is crucial to the evolving relationship of Gauguin and his fellow artists with the Bretons whom they had adopted as their subjects. Breton women like Madame Satre were not indifferent to the alien figures who had come among them. Their lives did not simply carry on as before. Far from quiescent in the face of the newcomers, they assessed and calculated their responses to the novelties they saw, the provocations they experienced. They did not choose to be mocked and stood their ground when they suspected ridicule. It was a lesson Gauguin would learn again in the South Seas.

It was only back in Paris, and among a small coterie, that *La Belle Angèle* was admired. Theo van Gogh, to whom Gauguin sent the painting, thought the woman herself resembled a heifer but the work as a whole was "delightful to look upon."[24]

Another admirer was Edgar Degas, who would acquire the painting in 1891 and retain it the rest of his life. They understood that *La Belle Angèle* represented a significant advance in Gauguin's art, but a generation or more would follow before that opinion came to be widely held.

The identities of the little girls, perhaps sisters, in *Two Breton Girls by the Sea* (ill. 60), painted at Le Pouldu in the autumn of 1889, are not known. Their nervous response to the artist who depicts them against the coastal cliffs is diffident and wary, their large, bare feet rendering them that much more vulnerable. They cling together, strange, anxious, ready to flee, but fully individualized. Gauguin said of such works – and he painted several portraits of children in late 1889 – that he tried to infuse such "desolate" figures with "the wildness I see in them, and which is also in me."[25] He sensed the *sauvage* in himself with special force when he contemplated such skittish, unformed spirits. But class distinctions pertained in Brittany as they did elsewhere in France. At Le Pouldu in 1889 he met the comtesse de Nimal, a local aristocrat of ancient lineage, and her young daughter Thérèse-Josephine Denimal, portraying the latter as an equally pensive and hesitant adolescent glancing nervously away from the artist (ill.61). While she is seen against a Breton landscape, to her right a noble coat of arms is roughly sketched, along with a fleur-de-lys, evidence of high social status.[26] The girl wears prim Parisian dress rather than native costume. But even here something wild and uncontrollable intervenes. At the girl's left is one of Gauguin's ceramics, a figure of a crouching nude woman extruding menstrual blood, perhaps a sign that the girl has reached puberty and waits tentatively on the verge of womanhood.

In the spring of 1894, Gauguin, having arrived back in France from Tahiti in August of the previous year, once again – for a final time as it turned out – made his way from Paris to Brittany. A few weeks later, he and artist friends brawled with sailors at Concarneau, near Le Pouldu. Gauguin, nearing his forty-sixth birthday, unsurprisingly got the worst of it. It took weeks to recover from a broken leg, during which time he was unable to paint. Between his recovery and return to Paris in mid-November, however, he executed one superb portrait of a young Breton girl that resumes those themes of childhood innocence and piety he had explored on earlier visits to Brittany, and in Tahiti as well.

Tahiti was very much on Gauguin's mind as he painted *Young Christian Girl* (ill. 62). He had spent his convalescence writing and illustrating *Noa Noa*, his passionate justification addressed to the Parisian art world for the strange and uncompromising works of art he had executed during his first sojourn in Tahiti from 1891 to 1893. The sitter is unidentified, perhaps a red-headed Breton girl, or perhaps the mistress of his friend Daniel de Monfreid, Annette Belfils.[27] Gauguin had made a drawing of Annette in Paris several years earlier, in the autumn of 1890 (ill. 63). Depicted in strict profile in conté crayon and red chalk in the drawing, Annette glances down, lost in reverie, her high cheekbones and narrow eyes giving her features an Asian cast. If her face and hair are delicately shaded, the background against which she is

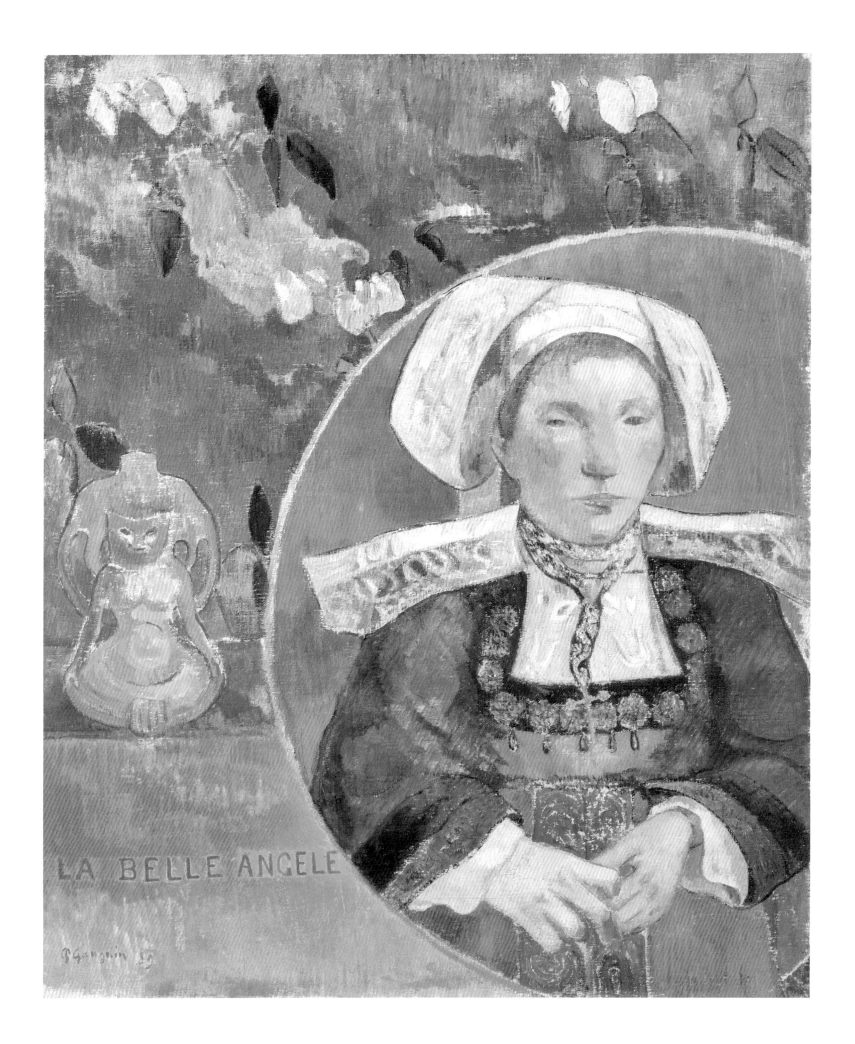

LA BELLE ANGÈLE

P Gauguin 89

59 *La Belle Angèle*, 1889 **111**

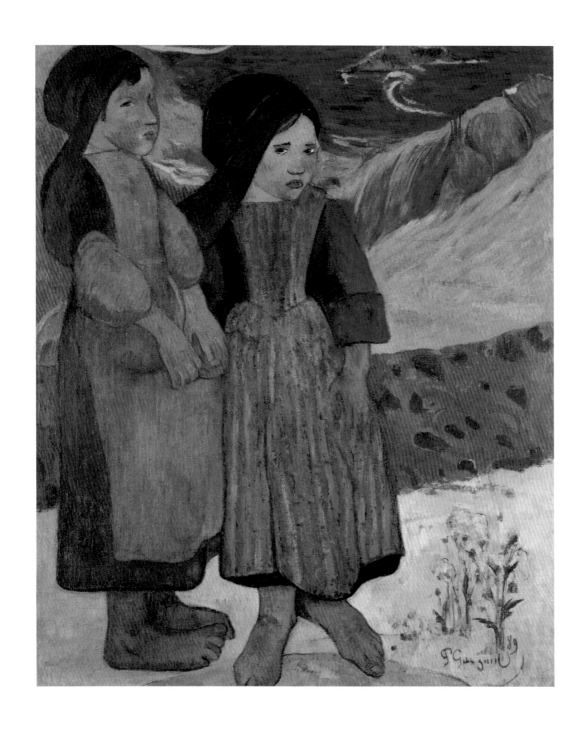

60 *Two Breton Girls by the Sea*, 1889

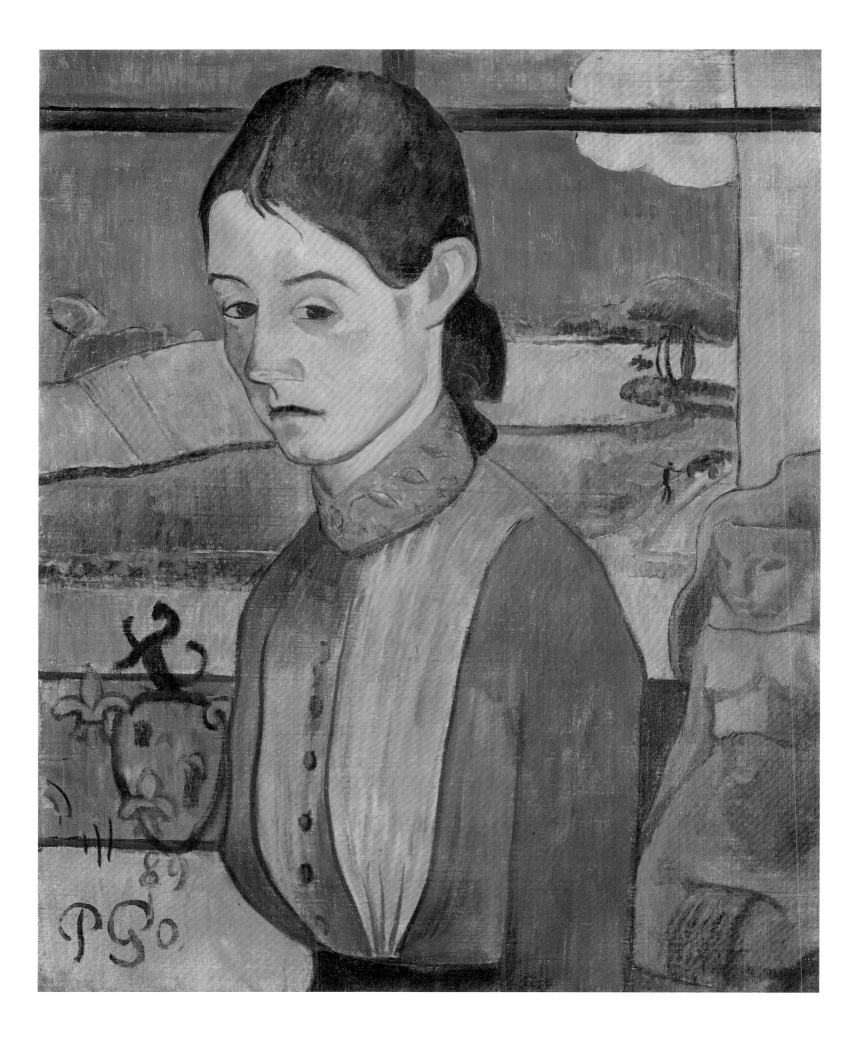

61 *Young Breton Woman*, 1889 **113**

silhouetted comprises violent diagonal strokes of black crayon making her look far older and more inscrutable than her twenty-one years would suggest.

Certainly the figure in *Young Christian Girl* appears much younger. Posed outdoors in an attitude of prayer, hands pressed before her, eyes lowered, she looks like a saint in a medieval altarpiece. Red trees like flames rise up behind her, silhouetted against a blue sky and white clouds. Perhaps she has stopped for a moment of communion with her god before one of those calvaries, or religious sculptures, so common along Breton roadsides and which Gauguin had painted a few years earlier.[28] Most remarkably, Gauguin dressed the girl in a brilliant yellow so-called missionary dress, which he seems to have brought back with him from the South Seas, or borrowed from the wardrobe of his mistress, Annah la Javanaise, who accompanied him. A few years before, Gauguin had told Van Gogh that the faces of Bretons were "almost Asiatic … yellow, triangular and severe."[29] Now, with this yellow dress he effected a daring synthesis of Breton and Tahitian imagery. "Only here," Richard Brettell has argued, "did Gauguin confront Brittany with the force that he had brought to Tahitian subjects."[30]

Young Christian Girl is fully a work of Synthetism. The simplification of form, intensification of colour, and sense the painting conveys of a spiritual realm pervading the material world are convincing and complete. Those first tentative steps of the second half of the 1880s toward a new art here reach resolution. But it is also something more, a work of syncretism as well. The artist, back on the Breton soil where he had first begun to explore a decorative and Symbolist art, dares to meld the two traditions to which he had opened himself, to find a final, rich concordance between East and West, to bring unity in a simple girl's rustic piety to his endlessly eclectic and inventive play of sources.

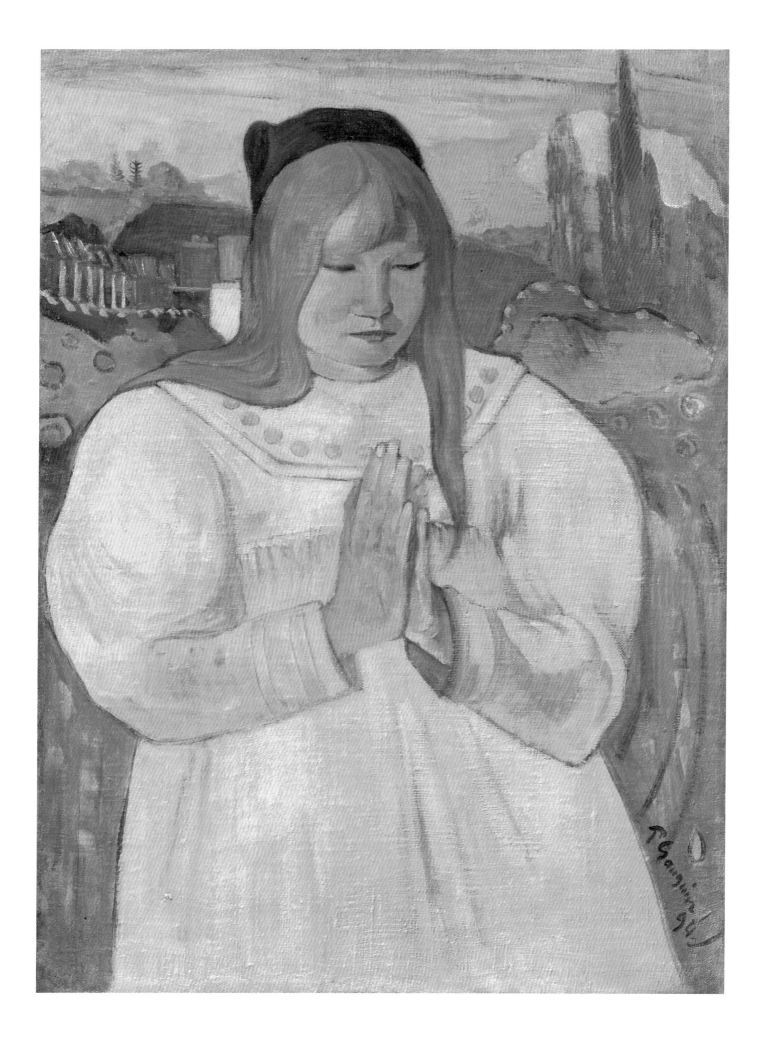

62 *Young Christian Girl*, 1894 **115**

NOTES

1 Martin Davies, with additions and some revisions by Cecil Gould, *National Gallery Catalogues: French School, Early 19th Century, Impressionists, Post-Impressionists, etc.* (London: National Gallery, 1970), p. 115.

2 When, in early 2018, research at the National Gallery, London, revealed that the varnish included pigments and had been applied by Poussin – in short that the artist meant for the painting to be seen in this muted way – plans to remove the varnish were put aside. Comments here are based on the research of Anne Robbins, Associate Curator of Post-1800 Paintings at the National Gallery, carried out in preparation for the abandoned cleaning of Poussin's remarkable and too-little-known painting.

3 On the phenomenon and practices of artists' colonies, see Lübbren 2001.

4 The artist was the American Impressionist Edward Simmons. Cited by Brendan Rooney, "The Lure of Pont-Aven," in Benington 2018, p. 19.

5 Letter from Gauguin to Vincent van Gogh, Le Pouldu, 20 October 1889, in Gauguin 1983, no. 36, cited in Bogomila Welsh-Ovcharov, "Paul Gauguin's Third Visit to Brittany, June 1889 – November 1890," in Zafran 2001, p. 17.

6 Welsh-Ovcharov, "Paul Gauguin's Third Visit to Brittany," p. 15.

7 Cited in ibid.

8 Gamboni 2014, p. 128.

9 See the essays in this catalogue by Cornelia Homburg and Alastair Wright.

10 Claire Frèches-Thory, "Brittany, 1886–1890," in Brettell 1988, p. 54.

11 See Wildenstein 2001/2002, cat. 290, pp. 402–403

12 On Lézaven, see ibid. p. 388.

13 Ibid., cat. 293, pp. 408–410.

14 Letter from Paul Sérusier to Maurice Denis, 10 November 1906, in Denis 1957, vol. II, pp. 48–49, cited in ibid., p. 408.

15 Wildenstein 2001/2002, cat. 293, p. 410.

16 Ibid., cat. 290, p. 403.

17 "All these things combine to make of this Breton woman a key figure for Gauguin, one who inhabited the borderline between his day-to-day experience and the world of his imagination" (ibid., cat. 293, p. 410).

18 Brettell 1988, cat. 89, pp. 158–160.

19 Ibid., p. 159.

20 Ibid.

21 See Kurt Weitzmann, ed., *Age of Spirituality: Late Antique and Early Christian Art, Third to Seventh Century* (exh. cat). The Metropolitan Museum of Art, New York, 1979, p. 676.

22 Brettell 1988, p. 159.

23 Ibid.

24 Cited in ibid.

25 Cited in Brettell 1988, cat. 91, p. 163.

26 See Welsh-Ovcharov, "Paul Gauguin's Third Visit to Brittany," p. 34.

27 Brettell 1988, cat. 190, p. 349.

28 See *Yellow Christ* of late 1889 (Albright-Knox Art Gallery, Buffalo, W327), in which three Breton women, like the girl here, have stopped to pray.

29 Cited in Brettell 1988, cat. 91, p. 164.

30 Ibid., cat. 190, p. 349.

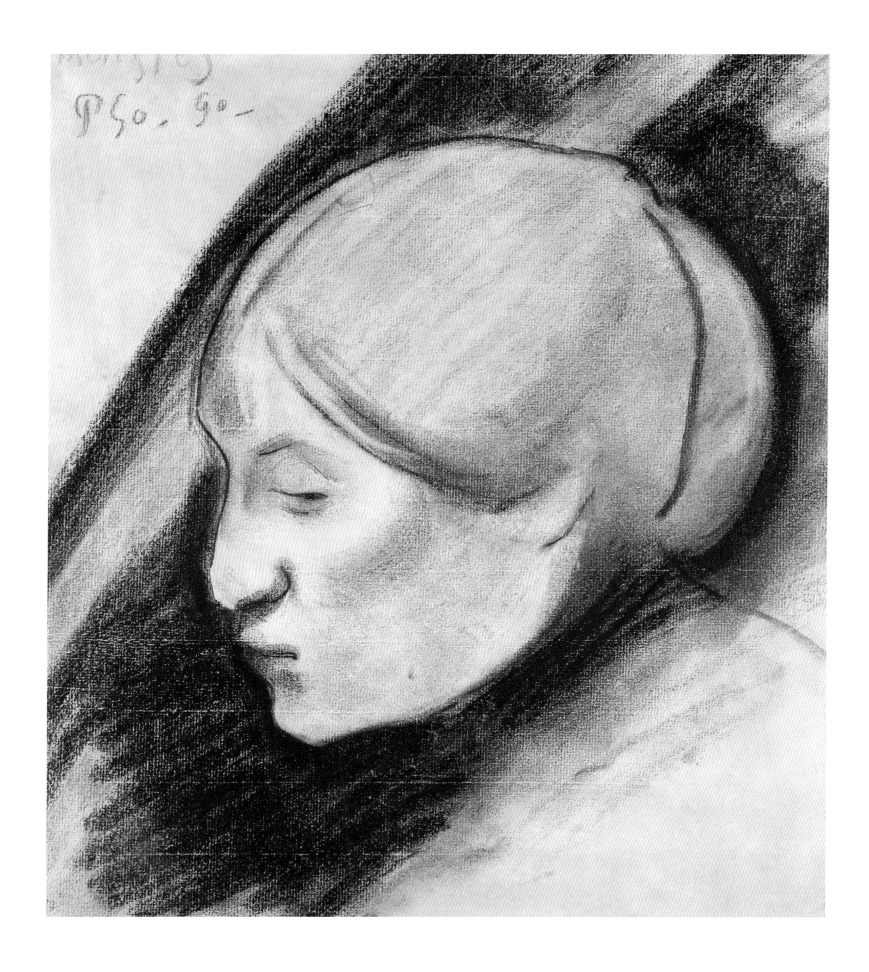

63 *Portrait of Annette Belfils*, 1890 **117**

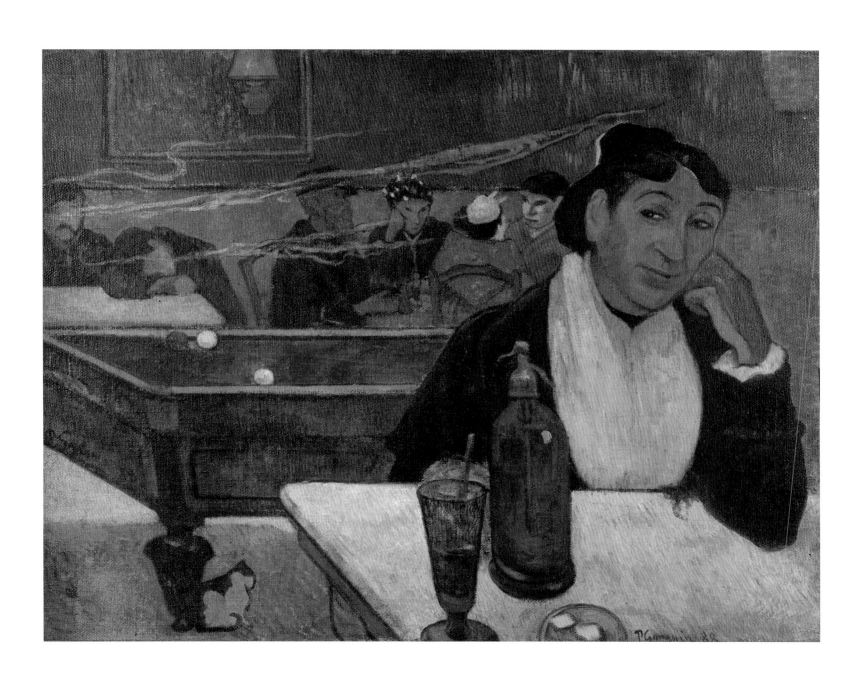

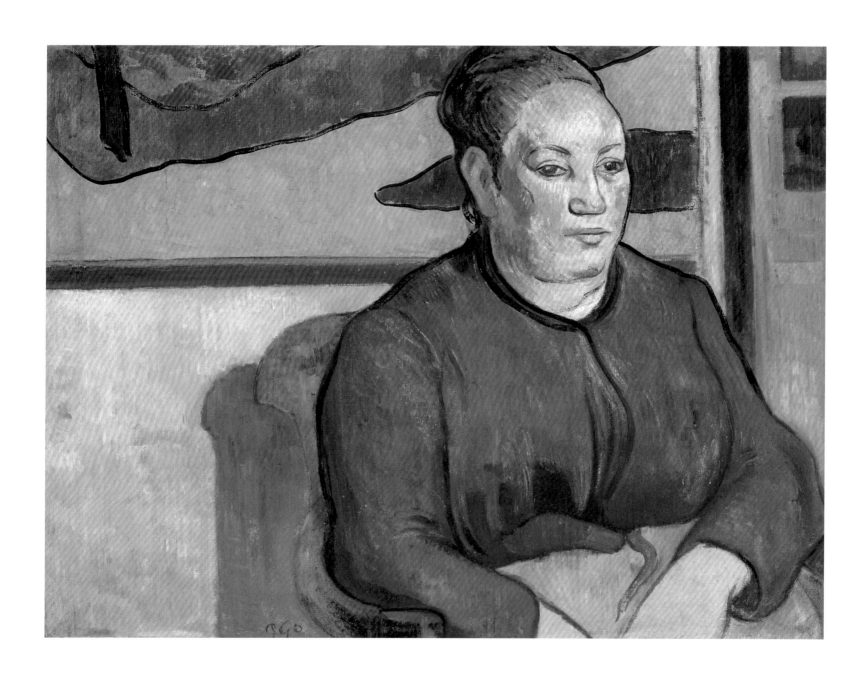

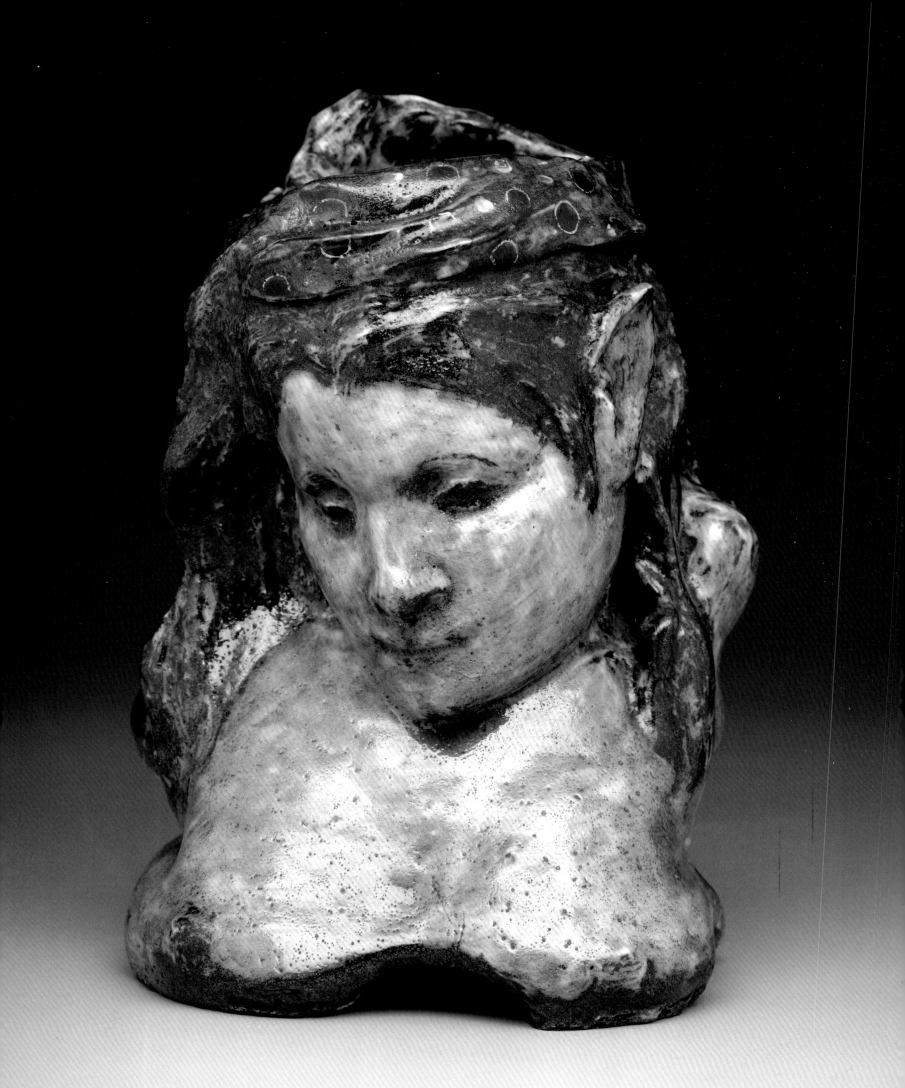

PORTRAIT VASE, MADAME SCHUFFENECKER

JEAN-DAVID JUMEAU-LAFOND

Early in 1889, after stormy months spent living with Vincent van Gogh in Arles, Gauguin stayed in the Paris home of the painter Émile Schuffenecker, a longtime friend. During this period he worked on the zincographs that would form the *Volpini Suite* and a few paintings, among them a portrait of the Schuffenecker family (ill. 67). At the same time, the artist modelled around ten ceramic works, firing them in the studio of Auguste Delaherche on rue Blomet. Delaherche had taken over the studio in October 1887 from Ernest Chaplet, who had introduced Gauguin to the medium. These pieces reflect a clear progression in Gauguin's practice of the art of pottery, with representation and form converging in a compelling synthesis of the plastic and the symbolic.

In the jugs and vases he had been executing since 1886, which were heavily influenced by Andean pottery, the formal and decorative elements were not always successfully integrated. By contrast, in the glazed stoneware pieces created in 1889, with their complex masses and intense reflections, artistic gesture was shaped by imagination, and the objects accede to the realm of statuary. One example is the self-portrait embodied in the *Jug in the Form of a Head* (ill. 111), whose grim association of a decapitated head with Gauguin's own likeness was no doubt prompted by the artist's presence on 28 December 1888 at the beheading of a condemned convict. Another is the *Self-portrait in the Form of a Grotesque Head* (*Anthropomorphic Pot*, ill. 110), in which the artist has shown himself with his thumb in his mouth, illustrating in his inimitable fashion the iconography of silence dear to the Symbolists. The meaning of an additional work from the same period, *Vase in the Form of Two Boys' Heads* (1889, Dina Vierny Collection, Paris, G68), is all the more poetic for remaining mysterious. The work seen here, *Portrait Vase, Madame Schuffenecker* (ill. 66), is part of this corpus, where matter has been etched with the power of an inner vision.

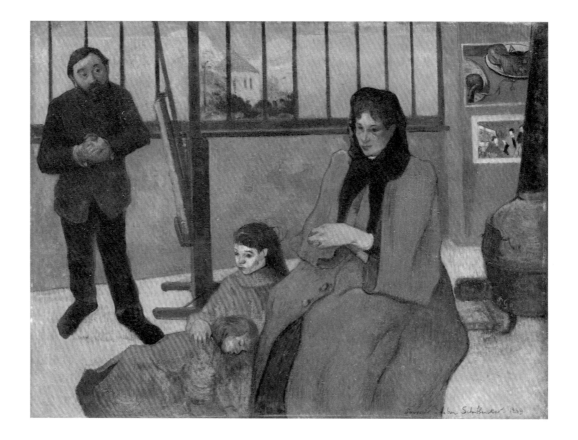

In October 1888, a few months before the vase was conceived, Gauguin had written to Émile Schuffenecker:

> You speak about my *terrible* mysticism. Be Impressionist to the very end and be afraid of nothing. Obviously, this symbolic approach is full of pitfalls, and so far I've only dipped my toe in, but it is fundamental in my nature, and a man must always follow his temperament. ... For the multitude I shall be an enigma, for a few I shall be a poet, and sooner or later, merit will have its way."[1]

There is a hint of irritated disdain in these lines, addressed to someone the painter called "my good Schuff," but for whom he had scant respect, considering him mediocre as an artist and weak as a man. The rather contemptuous allusion to Impressionism as an avenue without risk or mystery, the opposite of a "symbolic approach ... full of pitfalls," reflects Gauguin's development and his desire to break definitively with the legacy of Camille Pissarro, Claude Monet and Alfred Sisley in order to embrace the Symbolism of which he would soon be an acknowledged master.

The vase is, in fact, closely linked to the Schuffenecker family, since it portrays Louise Virginie Lançon, who had been married to Émile Schuffenecker since 1880. Gauguin had previously captured Madame Schuffenecker's features more

realistically in a fairly conventional bust executed in 1879, shortly before her mar-riage (Musée d'Orsay, Paris, G89). In 1887 he had also made a jug in the form of a bust of a little girl that Merete Bodelsen identifies as being a portrait of Jeanne, the Schuffeneckers' daughter, born in 1881, making her six or seven at the time (private collection, G62).[2] This piece was still clearly inspired by the pottery of the Mochica culture of Peru: the face forms the relief on one side of the jug but does not fundamentally affect its form, particularly as the work is not glazed. By 1889, however, Gauguin had taken the vase portraying Louise, with its complex form and rich polychromy, further toward the realm of imagination. From the vase "with portrait" he had moved on to the vase "as portrait" – a plastic rendering of the personality of his model.

Interpretation of the work is complicated by the fact that Gauguin's feelings toward Louise Schuffenecker seem to have been ambivalent. The personality of Schuffenecker's wife was apparently as strong as her spouse's was weak. As witness *Portrait of a Woman in a Pink Dress* (Musée d'Orsay, Paris), a picture of her painted by her husband in 1883, Madame Schuffenecker was extremely beautiful, and Gauguin obviously found her alluring. Despite some speculation, there is no hard evidence concerning the exact nature of their relationship: but whether they conducted an ill-starred affair or whether Louise rebuffed him, the painter was both attracted and repelled. In a July 1886 letter to Mette, he had written of Émile Schuffenecker: "Unfortunately, he is increasingly tormented by his wife, who, far from being a companion to him, is becoming more and more of a harpy."[3]

Gauguin's likening of Louise Schuffenecker to a harpy – a vindictive and rapacious monster of classical mythology with the head of a woman and the body of a bird, but also, in ordinary parlance, a shrewish and evil-minded woman – was scarcely flattering and indicates a hostility that would be echoed in a later letter, from 1889, in which he refers to her as a "millstone."[4] Moreover, the image of Louise presented by Gauguin in his portrait of the Schuffenecker family mentioned pre-viously, also executed early in 1889, is decidedly negative. Although the couple's two little girls have been treated sympathetically, the same cannot be said of the parents: Émile is portrayed as an ineffectual and submissive figure, with a craven expression and a self-conscious stance, while his much larger wife commands the composition, her head swathed in a black cowl, a coarse, almost claw-like hand extended, a bitter and malevolent look on her reddened face. Although her regular features are easily recognizable, the painter has given them a ghastly and overbearing cast.

In view of this strange and far from amicable family portrait, it is no surprise to learn of the rift that would soon come between Gauguin and the couple, nor of the Schuffeneckers' divorce in 1904. According to Merete Bodelsen, Gauguin had taken Louise as the model for an earlier vase, executed around 1887 (Ny Carlsberg Glyptotek, Copenhagen, G49), and the face of the woman on this unglazed piece, shown wearing a snake belt, certainly seems to be hers.[5] The expression, however, is far more pleasing, and the figure is closer to a lovely goddess than a harpy.

In the 1889–90 vase Gauguin seems to have fused the different facets of his feelings toward Louise. The snake, merely decorative in the Copenhagen piece, has been transformed here into an odd strip of fabric entwined in her hair, whose blue spots and gold circles suggest an ocellated skin. This snake-ribbon crowns the vase and encircles the model's head like a symbolic emanation of her mind. There is red marbling among the blue and gold, and similar tints of blue and red ripple across the surface of Louise's face and chest. Through his use of pigments and glazes, but also by exploiting the random effects of firing, Gauguin has captured both a recognizable face and its symbolic context. Reinforcing the theme, the artist has placed another snake on the back of the vase, but accompanied by a dismembered hand that erupts out of the clay, seeming to grasp the reptile or mimic its movements. Gauguin also enhanced the feline quality of Louise's face by elongating the shape of her eyes, as well as exposing and enlarging her left ear so that it resembles the pointed ear of a faun.

By means of the strange and almost monstrously disembodied hand, the two snakes and the pointed ear, the artist combines the suggestion of a kind of female animality – a Baudelairean image encountered frequently in the catalogue of late-nineteenth-century misogyny – with several mythological and biblical references. In sharp contrast to the poeticism of the faun represented in his 1891 portrait of Stéphane Mallarmé (see ills. 31, 32, 105), it is the savagery of the woodland creature Gauguin is evoking here, the physicality of the god Pan, whose mysterious apparitions sowed fear throughout the countryside of the ancient world. As for the snake, it is an obvious reference to the one described in Genesis, forever associated with Eve and her fatal temptation. In 1890 the artist would execute a glazed stoneware figure of Eve (Georges Pecout Collection, Paris, G92), minus the snake, whose elegant lines recall Botticelli's Venus, of which he owned a photograph. But in the Madame Schuffenecker vase Gauguin was evidently sculpting his friend's wife as he perceived her, an evil temptress, blending in a remarkable feat of visual synthesis elements of Western mythology and the emotions inspired in him by his model.

NOTES

1 Letter from Gauguin to Émile Schuffenecker, Quimperle, 16 October 1888, in Gauguin 1949, no. 73, p. 110 (trans. modified).

2 Bodelsen 1964, pp. 58, 59 and 63.

3 Letter from Gauguin to Mette Gauguin, July 1886, in Gauguin 1984, no. 102, pp. 130–131.

4 Letter from Gauguin to Mette Gauguin, Paris, February 1889, in Gauguin 1949, no. 79, p. 117.

5 Bodelsen 1964, pp. 54, 63.

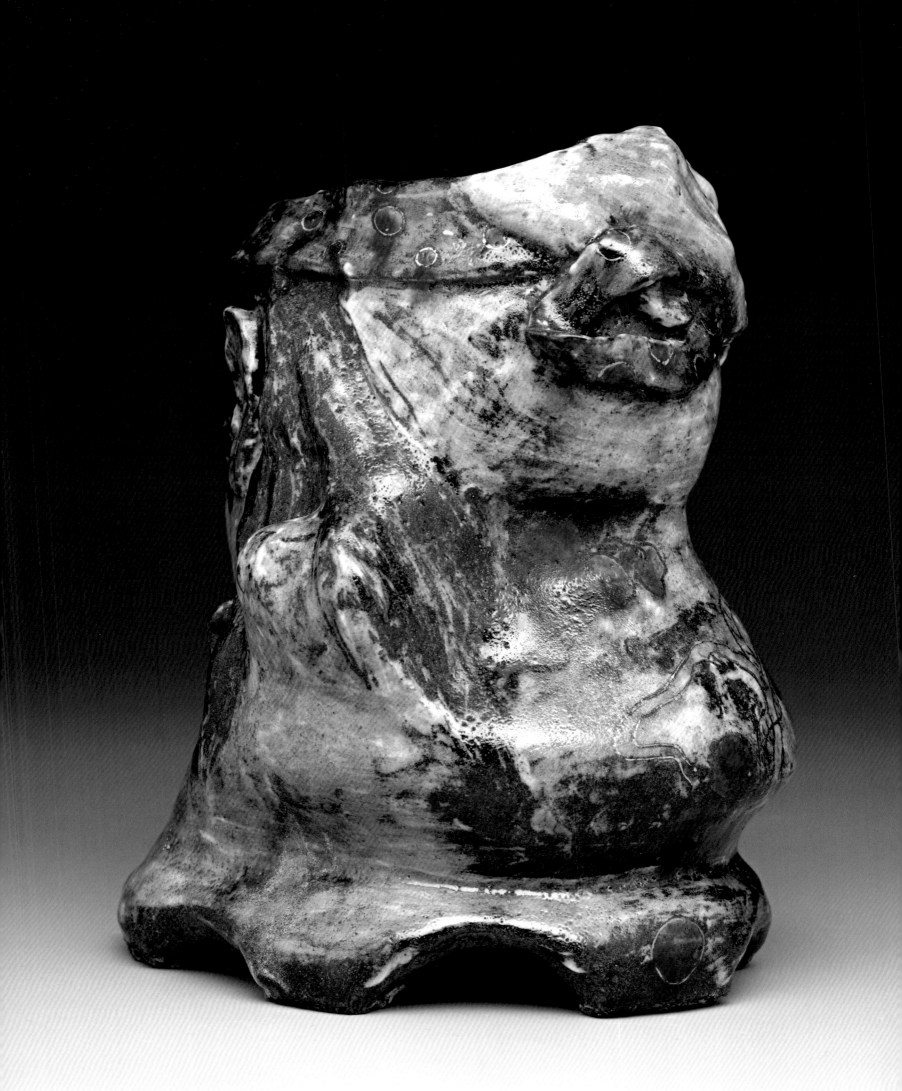

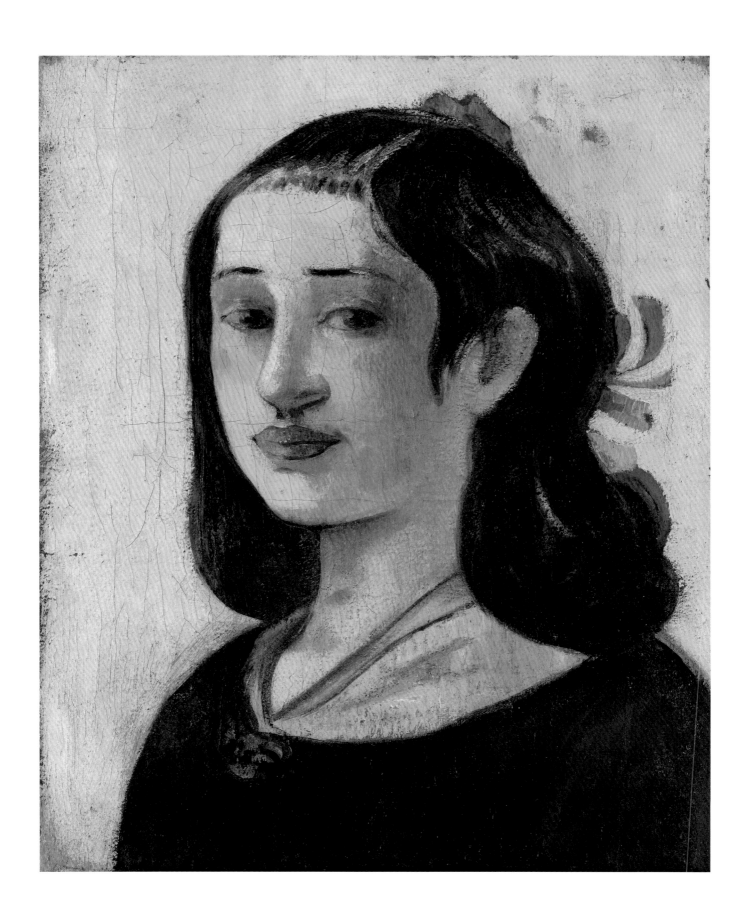

68 *Portrait of the Artist's Mother*, 1889/93

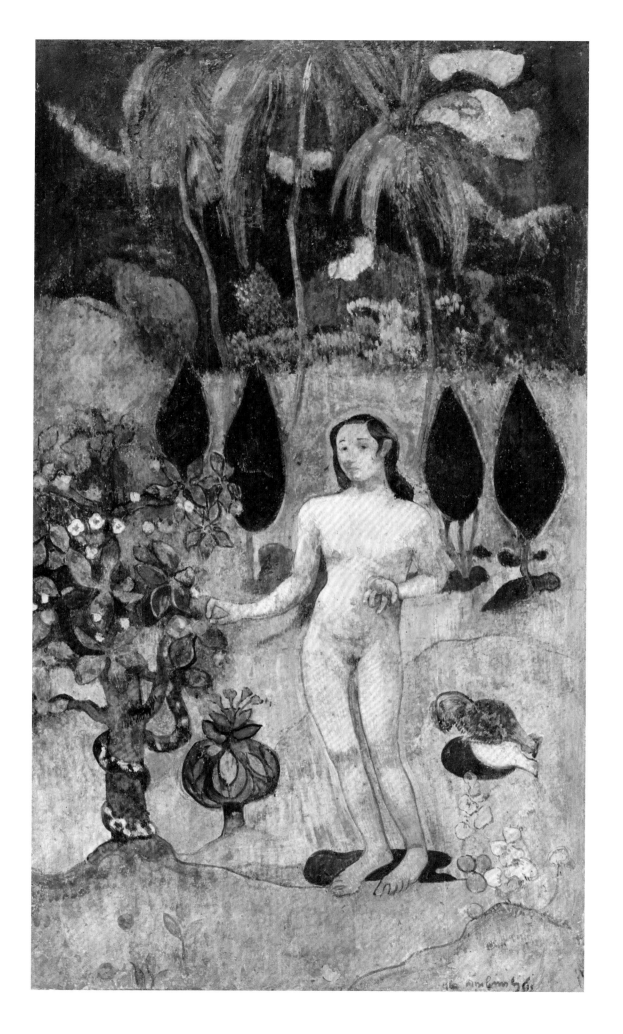

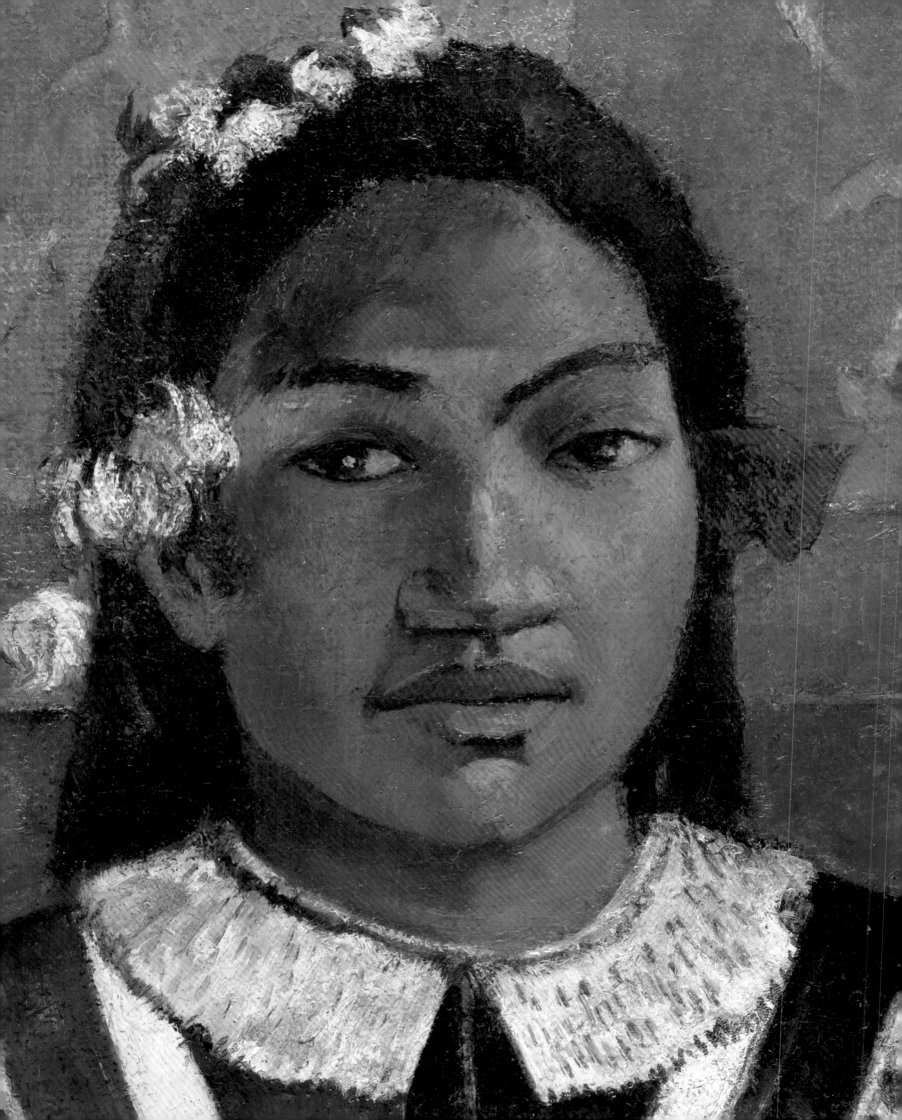

GAUGUIN'S PORTRAITURE IN TAHITI
LIKENESS, MYTH AND CULTURAL IDENTITY

ELIZABETH C. CHILDS

When Paul Gauguin disembarked in Papeete in June 1891, his alluring dream of Tahiti met the real world of colonial life. Following his arrival, a period of adjustment, discovery, disappointment and exploration pushed his art in a variety of new directions. He found a novel island landscape, magnificent tropical vegetation, a diverse Polynesian population, and a thriving French colonial community, but only traces of the cultures of ancient Tahiti that, given his reading and lively exoticist imagination, he had longed to encounter. Yet, as he adjusted to all that was now possible in this new chapter of his career, he began to consider the fresh potential for portraiture.

Rather than seeking solitude in a remote place to make his art in isolation, Gauguin's first order of business in Papeete was to establish a place for himself in the goldfish bowl that was colonial society. One of his earliest friends was Paulin Jénot, a lieutenant in the French marines and an amateur painter who introduced Gauguin around town and to potential clients.[1] The two painted briefly side by side, and Jénot completed a few portraits under Gauguin's instruction using the latter's imported French art materials.[2] The pictures Jénot made confirm that the discussion and practice of portraiture were among Gauguin's first endeavours in Tahiti. Portraiture was a genre that he initially hoped would bring him multiple commissions. In the end, however, the number of portraits that he executed on commission for local residents during his Polynesian career was very limited – probably only about four.[3] But the task of portraiture – to capture a character and a physiognomy that could speak both to an encounter with an individual and a culture – remained a serious challenge in painting that Gauguin believed could advance his art.

Portraiture was one of the most established genres of academic painting in the European tradition, and many of Gauguin's progressive colleagues, including Vincent van Gogh and Paul Cézanne, excelled at works in this genre. Given that Gauguin painted so many canvases that we may consider portraits throughout his Polynesian career, and also given that the work he produced in Polynesia was predominantly intended to be viewed and/or sold in Europe, an essential question arises: was his choice to do significant work in portraiture made to satisfy the interests of the European market? It is tempting but too easy to reduce his interests in developing any part of his oeuvre to purely the result of market-driven ambition and financial strategy; it is clear that artistic choices he made throughout his career were often neither popular nor particularly expedient. He made the development of his art, and an interest in reinvigorating his work through a unique and pro-vocative idiom of modernist primitivism, a top priority. But that said, he was nevertheless extremely concerned with financial success and public impact. His strategy as a portraitist might best be regarded as both market-savvy and idealistic at the same time, and in the 1890s his priorities often aligned in limited instances with the Parisian market.

As Agnès Penot and Léa Saint-Raymond have recently demonstrated, Gauguin was among the higher-valued of those living avant-garde artists whose work came up the most for auction in Paris in the 1890s.[4] Nevertheless, his portraits did not generally sell at his highest price range. The most any of his works achieved at an auction during his lifetime was 500 francs for his canvas *Aha Oe Feii?* (*What? Are You Jealous?*, 1892, The Pushkin State Museum of Fine Arts, Moscow, W461). Sold at the February 1895 Gauguin sale at Hôtel Drouot, the painting is a study of two female nudes on the beach (and by no stretch a portrait). By comparison, Gauguin's *Woman of the Mango* (*Vahine no te vi*, ill. 96) was purchased by Edgar Degas at the same sale for 450 francs, and other portraits by the artist in the auction failed to sell at all.[5] So, in short, while Gauguin's work in portraiture could be profitable in Paris, it was not a genre that brought him much financial success during his Polynesian career. His agenda for making portraits was to paint aesthetically challenging works that registered his cross-cultural encounters with the Polynesians of his acquaintance. He drew upon his curiosity about what was to him a novel culture, and also on his abiding belief in "dreaming before nature," or trusting his imagination to work in concert with the visual facts at hand.[6] His portraiture incorporated these multiple capacities and interests.

In general, Gauguin intervened in the conventions and processes of portraiture to invent modes of representing Polynesian individuals in ways that complemented his larger ambitions for his art. These broadened explorations of portraiture included the production of what I term ethnoportraits; the development of the decorative capacity of a portrait composition; and the creation of deeply imaginative Symbolist portraits using Polynesian idioms. For Gauguin, once portraiture was removed from the mandates of making profit by commission and by working to satisfy a

client, the genre opened up creative possibilities. Throughout his years in Tahiti, he made representations of Tahitian individuals that fit within his larger project of devising a new modern art with an innovative language of form and colour, and with exotic referents that would counter the French subjects of Impressionism and intrigue and mystify his Parisian audience. With the confidence (and colonial privilege) of a visiting French artist, he felt free to observe and appropriate Tahitian people and culture as his subjects, regardless of their opinions of his art.

He painted for himself, and for Paris. He recounts with some arrogance in his journal *Noa Noa* an encounter (perhaps invented for his Parisian readers) with a Tahitian model who inquired if the reproduction of Édouard Manet's *Olympia* on his wall was a painting of his wife. His response was to brush off the inquiry with an expedient lie in the affirmative.[7] The anecdote (regardless of its truth) reinforces that, for Gauguin, Tahitians were the subjects of his art, but not its consumers or interlocutors. For that, he still trusted Paris. And with that art world in mind, Gauguin worked across a continuum of possibilities in representing individual Tahitian subjects. The work he produced was varied, and many figure studies clearly fall outside the genre of portraiture – such exclusions include the clearly invented images of religious subjects (*The Moon and the Earth* [*Hina tefatou*], 1893, The Museum of Modern Art, New York, W499), group scenes that are primarily genre scenes of aspects of daily Tahitian life (*The Siesta*, c. 1892–94, The Metropolitan Museum of Art, New York, W515), or figures posed in the landscape (*By the Sea* [*Fatata te miti*], 1892, National Gallery of Art, Washington, D.C., W463).

Yet across Gauguin's Polynesian oeuvre we find ambitious portraits – considered renderings of individual Tahitians that are the result of observation and cross-cultural encounter. These portraits combine the artist's curiosity and attentive response to his models with some reference (albeit filtered through his expectations and stereotypes) to the Tahitian and Marquesan context in which these people lived. Notable examples such as *Tehamana Has Many Parents* or *The Ancestors of Tehamana* (*Merahi metua no Tehamana*, ill. 85) are discussed subsequently in this essay. These works are also aesthetically considered compositions that place their ostensible subject within Gauguin's signature style of bright flat areas of colour, encasing Synthetist lines, and decorative form. He injects many works with exotic novelty or content, inserting either forms, narratives, histories or contexts to intrigue or mystify the viewer through references to his version or invention of Polynesian culture.

We can divide this group of Polynesian portraits into the three general categories mentioned earlier. First are ethnoportraits, or works that present an individual using fashion, setting and/or accessories to localize their cultural identity as Pacific Islanders. Second are decorative portraits in which the individuality of the subjects, while still palpable, is secondary to an overall harmony and patterning of form and colour imposed on the composition. These elements vie for attention with the discernible image of the sitters, sometimes subordinating their cultural identity to the overall aesthetic concerns of the picture. Third are pictures that are

marked by a highly invented, dreamlike or fantastic scene that is, at base, a Symbolist composition in which the Polynesian referents are developed in order to stimulate but mystify the viewer through an encounter with a selected, mythologized or invented Polynesian world.

None of these proposed categories of Gauguin's portraiture are mutually exclusive, and some paintings can be understood as working with concerns that move across these subgenres. And that is precisely the point. Gauguin used the Polynesian context to inspire a new art that held no specific allegiance to his observations or lived experience in Tahiti, nor to an aesthetic mandate other than to develop an art unlike what was then seen and appreciated in Paris.[8] Rather, as Polynesia became his open studio, this world intensified his curiosity, which was at once visual, social and historical, and the culture stimulated his artistic imagination.

Any discussion of Gauguin's Polynesian art must also address the Pacific Islander women who served Gauguin as models, and in one well-known case – Teha'amana – became his domestic companion and ongoing muse. My discussion of Teha'amana and her image in Gauguin's art will suggest how much his expectations, French sensibilities, artistic imagination and ambitions for the Paris art world shaped his representations of Tahitian individuals.

Numerous pencil sketches testify to Gauguin's fascination with the physiognomy, gestures and gaze of Tahitians he met in daily life on the island. One such example is his drawing of the boy Taoa (ill. 70). An economy of line captures the face, the bearing of the shoulders and the boy's direct gaze. Motion lines to the right of his cheek suggest Gauguin caught him turning to engage the artist. It is a sketch that illustrates his friend Jénot's recollection that, on his arrival, Gauguin "simply made his eye and his hand discover the Tahiti that he wanted to understand and express."[9] In group compositions such as *The Flowers of France* (*Te tiare Farani*, ill. 107), Gauguin included Tahitian figures whose individual presence is palpable, but who are not at the centre of interest or of the composition of the painting. The visual and compositional lessons of Japonisme – absorbed through Gauguin's sustained contact with Impressionists such as the great portraitist Edgar Degas, and also through the collaboration in Arles with Van Gogh – continued to inspire him as he explored modes of representing his new subject of Tahitians. But such works fall along interestingly blurred boundaries of what constitutes portraiture, as they are also generalized observations of daily life.

When Gauguin relocated from Papeete to the southern coast of Mataiea sometime in the early fall of 1891, he began to sketch and paint Tahitians of his acquaintance. One of the first such portraits was probably *The Woman with a Flower* (*Vahine no te tiare*, ill. 71), a bold composition in which a Tahitian woman is seated in a deep-blue dress in front of a decorative background of red and yellow,

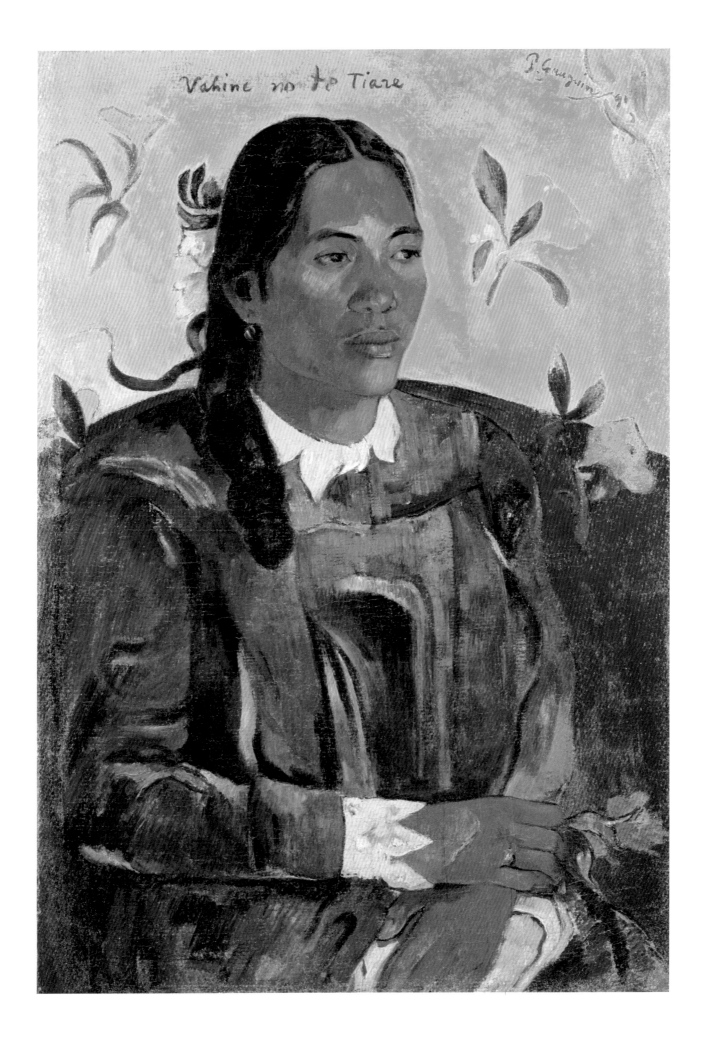

71 *The Woman with a Flower (Vahine no te tiare)*, 1891 **133**

creating a triad of strong primary hues. She holds a flower, and wears another in her hair; these are echoed by blossoms scattered across the surface that fix her within the decorative scheme. But her face, centred in the top third of the canvas, is rendered with great sensitivity, and her figure is firmly and quietly composed. Her pose is somewhat stiff, and the rigid verticality of her sleeve echoes the Egyptian tomb paintings Gauguin kept on his studio wall.[10] Her skin and hair, a missionary-style dress and the tropical blossoms confirm her Polynesian identity, but the Tahitian-language title that floats above her head asks us to think of her not by her name (which has been lost to history), but as "a woman with a flower." We are thus invited not to regard her as a specific woman encountered in Mataiea, nor simply as a typical Tahitienne, but rather as a figure who embodies both. Significantly, this is the first picture from Gauguin's Tahitian sojourn that he sent back to Europe for exhibition; it appeared at Goupil's in Paris in 1892 and in Copenhagen in 1893. Gauguin wrote to his friend, the painter and collector Daniel de Monfreid, that it would probably sell for its novelty value.[11]

In the few portraits Gauguin created in Tahiti that he intended specifically for local society and not for the European market, the markers of Tahitian or partly Tahitian identity of the sitter are more nuanced than in the ethnoportraits already discussed. This could be for two reasons. Firstly, a painting intended for Europe would need to register the distinctive Tahitian cultural character that Gauguin wished to promote as his novel signature subject. Secondly, pictures intended for local viewership were often executed for very specific reasons: either as a commission for a paying client or as a gift that he hoped would deepen a relationship with a new local friend.

Commissions for portraits of local sitters held some promise for Gauguin during his first days in Tahiti. He optimistically wrote to his wife, Mette, upon his arrival in Papeete: "I think I shall soon have some well-paid commissions for portraits: I am bombarded with requests to do them … I think I can earn money here, a thing on which I did not count."[12] A commission for a much-appreciated fee of 200 francs came from an Anglo-Tahitian woman named Suzanne Bambridge, who was both a colonial resident of means and a member of a Polynesian royal family (ill. 72).[13] As such, she offered a fascinating hybrid of the two cultures that Gauguin sought to infiltrate in these early months. Bambridge was a woman of mixed race, the daughter of an English cabinetmaker and a Tahitian (or part-Tahitian) woman, Marae O'Connor.[14] She went by the Polynesian name of Tutana, and held both an established position in colonial society and claims to Polynesian royalty through her husband, a chief named Taroa from the island of Raiatea. She may have helped host events within the Tahitian court in the waning days of the court of Pomare V, and thus was a valuable local insider for Gauguin to know.

Bambridge sat for the portrait in a colonial-style wooden chair. The background is plain, except for a blossom motif at the upper left that references the botanical diversity of Tahiti. She wears an elegant printed gown, a style of fancy dress worn by members of another grand Tahitian family (the royal Teva clan) for

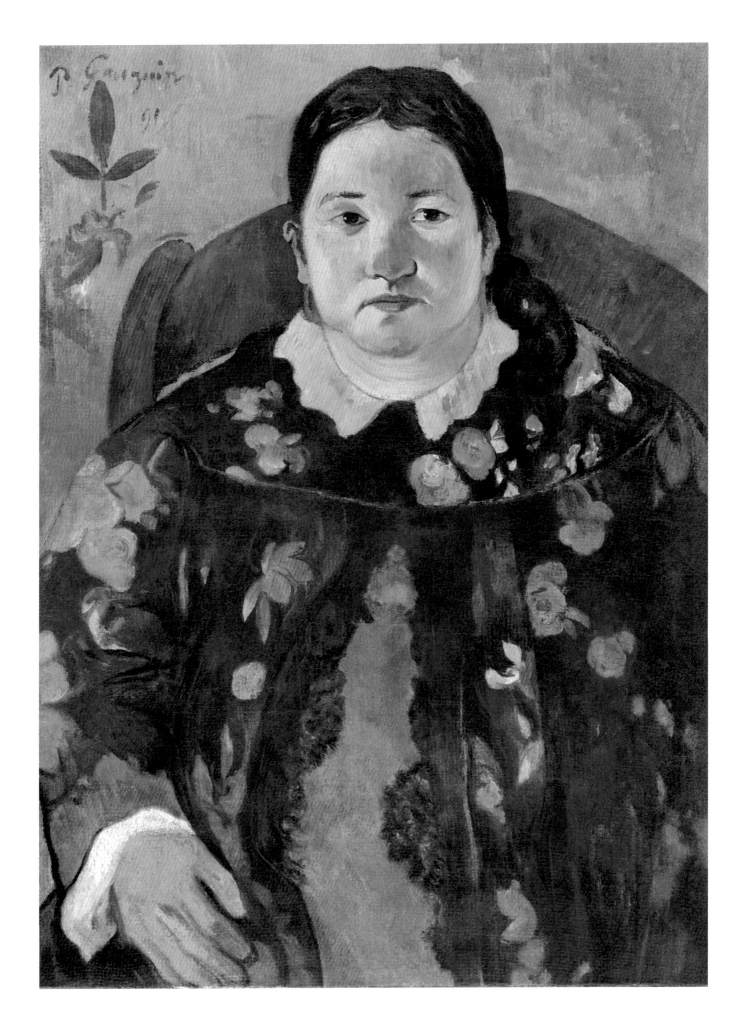

72 *Portrait of Suzanne Bambridge*, 1891 **135**

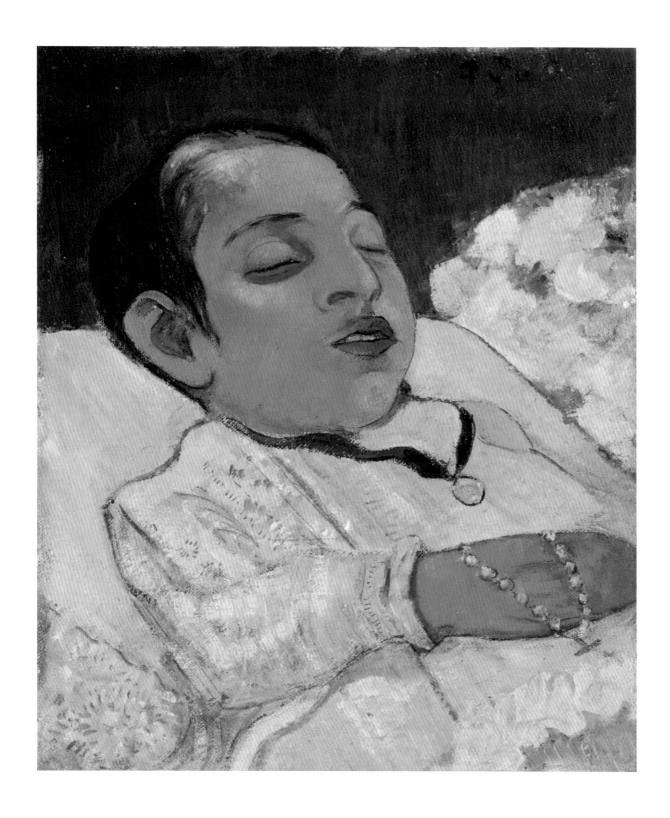

formal photographic portraits in the same era.[15] Gauguin painted much of the gown as a flat plane of undifferentiated pattern, a decorative scheme that nearly overpowers her face. Clues to her mixed-race are given in her thick hair and ivory-coloured skin. Greatly disappointed by the image, she apparently hid the portrait, an indication that Gauguin did not approach the business of paid commissions as a client-pleasing venture.[16]

Another portrait made during the artist's first year, *Atiti* (ill. 73), was intended entirely for the viewership of a local family, and under special circumstances at that. The subject was Aristide Suhas (whose nickname was Atiti), the deceased two-year-old son of Jean-Jacques Suhas, a medical nurse for the French navy and a good friend to Gauguin during his first year in Tahiti. Suhas was married to a woman descended from one of the royal Tahitian lines, and thus their son was of mixed race. Gauguin featured here the Catholic burial practice favoured by the family: the boy is formally dressed, a rosary is draped over his hand, and a bank of flowers rests nearby. In these details, the painting falls within the genre of death portraits, which in the French colonies were most often executed in the affordable medium of photography (see ill. 74). Gauguin gave the portrait to the grieving mother, Helena Burns Suhas, who kept it throughout her life as a treasured memento in a box of tropical wood in their home in Papeete and, later, in France.[17] Moreover, the child was buried in the family tomb with two of Gauguin's canvases that had been hung in his nursery; this interaction between artist and the colonial residents of Papeete was intensely personal and demonstrates that not all of his portraits were intended for the European art market.

75 *Drawing of a Dead Child*, c. 1882

The ethnoportrait remained a viable format for Gauguin throughout his later Polynesian career, a period during which he grew increasingly dependent on the interest and support of the Parisian art dealer Ambroise Vollard, who in 1898 began buying some of the paintings the artist sent to De Monfreid in Paris. Vollard's support became critically important as of 1900, when the dealer started sending Gauguin a monthly stipend in exchange for regular shipments of work.[18] Gauguin surely recalled that portraits had brought him limited market success in the Hôtel Drouot sale of 1895; so when he sent paintings to Vollard he included only a few ethnoportraits, focusing on compositions with still life, landscape and religious themes to attract Vollard's clientele.[19]

One of the canvases Gauguin sent to Vollard was a vibrant portrait of a Tahitian woman and boy from 1899 (ill. 76). The woman sits in a wicker colonial chair, her body and gaze alertly turned to the painter. This, along with her embroidered Mother Hubbard dress and the tiare flower at her ear, denotes the Tahitian context. The boy behind her is dressed very casually in blue work pants and a simple shirt with rolled sleeves. The painting echoes a standard pose of Tahitian

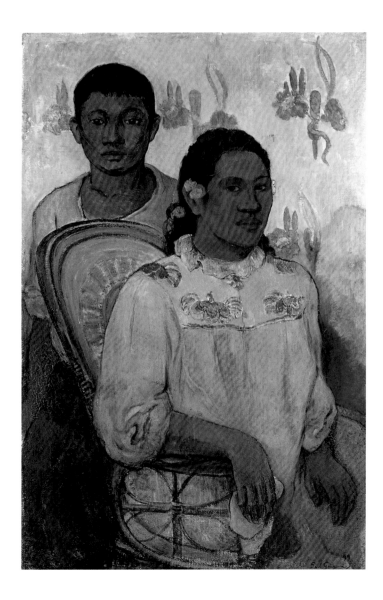

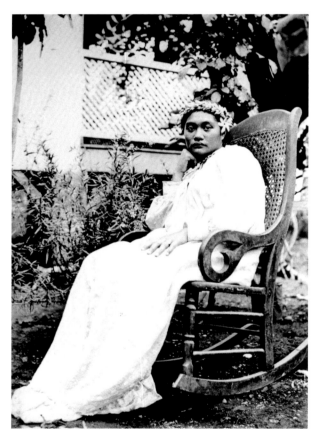

76 *Tahitian Woman and Boy*, 1899
77 Unknown photographer (probably Charles Spitz), *Tahitian Woman*, c. 1890

women sitting in such chairs for photographic portraits of the time (see ill. 77), and in this way, Gauguin has adapted his portrait setting to local visual culture, as well as to conventions of the seated portrait. However, the vividly green background, evoking a floral printed textile, injects intense colour as a parallel subject, and the decorative play of the flowers on her dress and the wall hanging unite the diverse components of this shallow space. Yet for all the attention to decorative pattern here, this unnamed woman and boy confront the viewer and command the scene. Given the date of the portrait, it is possible the sitter was Gauguin's mistress of the time, Pau'ura a Tai (Pahura), who gave birth to their son Émile that same year; she may even be pictured here pregnant.[20] Perhaps Gauguin included the boy at the back so that he might visualize what his Tahitian family might look like over time. But whatever his personal relationship to the model(s), the artist included the work in the final shipment of canvases he sent to Vollard.[21] If the female model was part of Gauguin's private life, he was nonetheless ready to deploy her image more generally as a sample Tahitienne of her time, presented without name or individualizing context to a Parisian clientele.

The line is blurred between what we might regard as a single-figure study and a portrait, and Gauguin excelled in making monumental full-length or three-quarter-length compositions of women from the country and the islands. In such works, the expression and individuality of the sitter are subsumed by both a mood and a decorative order that take priority in the canvas. Examples are the resplendent *Melancholic* (*Faaturuma*, ill. 78) of 1891 and the impressive *Young Christian Girl* (ill. 62), painted in Brittany in 1894 after Gauguin's return to France the previous year. In both, a young woman is cast in a contemplative, meditative mood within a setting that ties her to her native region.

In *Melancholic*, the shocking salmon-pink fabric of the woman's gown, cascading before a deep blue wall, hijacks our attention. We become as engrossed in the display of the dress and its fall to the floor as we are interested in the figure's elongated hands, quiet face and oddly unfinished foot that peeks out from under the hem. Her demeanour and her handkerchief reinforce the melancholia of the title, a mood of nostalgia perhaps for a former Tahiti that Gauguin saw as fading in the wake of colonial contact.[22] The woman's pensive mood matches that of the praying Christian girl in the Breton painting, and was partly inspired by Gauguin's admiration for the quietistic figure studies of Camille Corot, which Gauguin knew well through reproductions he carried with him featuring works from the collection of his godfather, Gustave Arosa. This musing Tahitian model is not in the stock Italian peasant costume of a Corot studio model, however; instead, she is in the popular Mother Hubbard-style smock worn by the Christian girl in the Breton work.[23]

The voluminous gown of the sitter in *Young Christian Girl* both evokes her chastity and innocence and offers a spectacularly radiant swath of yellow that suggests simultaneously the warmth of the countryside and the luminosity of her pure faith. In this figure, Gauguin reprised his favoured notion of a superior feminine spirituality that informed the devout women in his *Vision after the Sermon* (*Jacob Wrestling with*

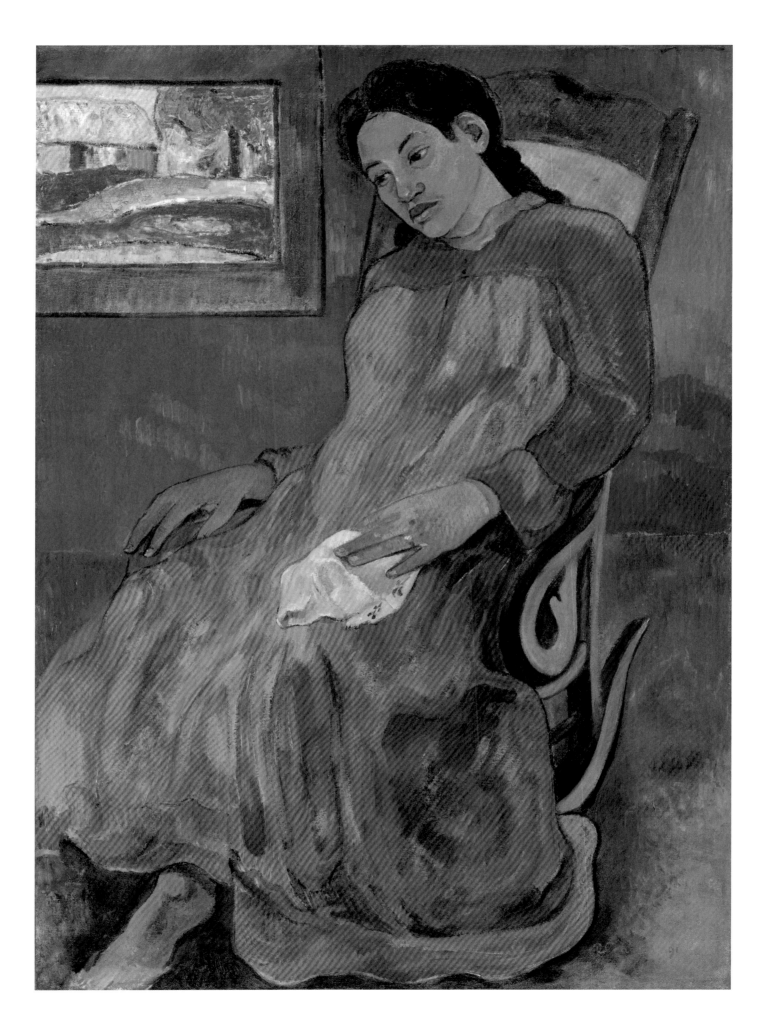

78 *Melancholic (Faaturuma)*, 1891 **141**

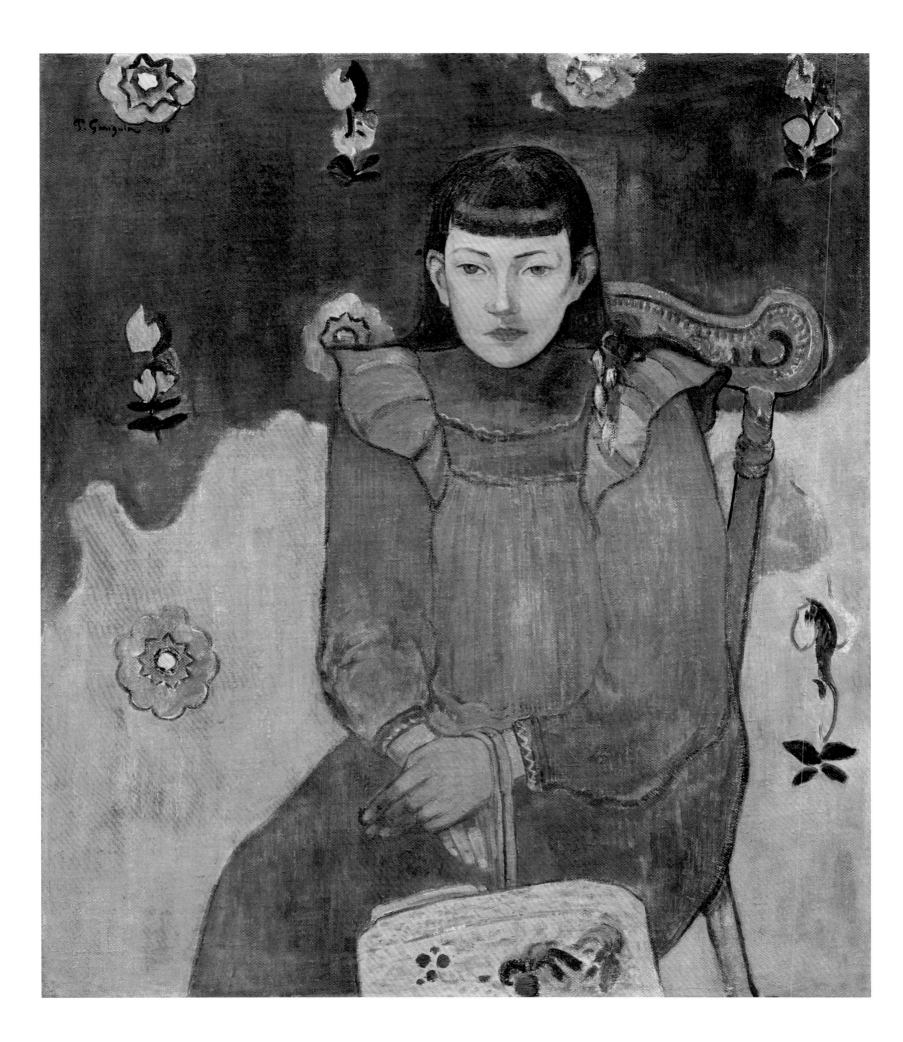

79 *Portrait of a Young Girl. Vaïte (Jeanne) Goupil*, 1896

the Angel, 1888, National Galleries Scotland, Edinburgh W245/W308 [2001]). That meditative mood was probably also inspired in part by the artist's long-standing admiration for European devotional painting, such as the praying virgin in Rogier van der Weyden's *Braque Triptych* (c. 1452, Louvre, Paris) and other Flemish paintings he would have studied in 1894 while on a trip to Brussels and Bruges.[24]

In *Young Christian Girl* Gauguin enhanced the mood of spiritual reflection he sought through the sitter's closed eyes, exaggerating her long, clasped hands at the very centre of the canvas and employing the decorative power of the brilliant yellow cloth that expands exponentially from her body to fill the majority of the foreground. In this way, the artist transformed this decorative composition of a single figure into a compelling icon of youth, belief and the powers of meditation and inner thought. Gauguin's depiction of the girl transcends both her locale (which cannot be confirmed by any detail in the landscape) and her particular identity to affirm a more general affinity between harmonious aesthetic form and expansive inner thought, both of which may serve as agents of individual transformation for the artist and the sensitive viewer alike.

Upon Gauguin's return to Tahiti in 1895 one of his most decorative portraits came in response not to a Tahitian sitter but to a young French girl – Jeanne Goupil, known locally as Vaïte (ill. 79). She was the daughter of the wealthy lawyer Auguste Goupil and thus a member of the local colonial elite (see ill. 80).[25] Gauguin's portrait of Jeanne is at once conventional and radical. She is dressed in a brown school frock and sits in a stiff pose on an ordinary wood chair: so far, this is a safe set of choices for the artist wishing to please a powerful local client. But Vaïte's skin is rendered in an ivory tone that is curiously like a Japanese mask or stage makeup

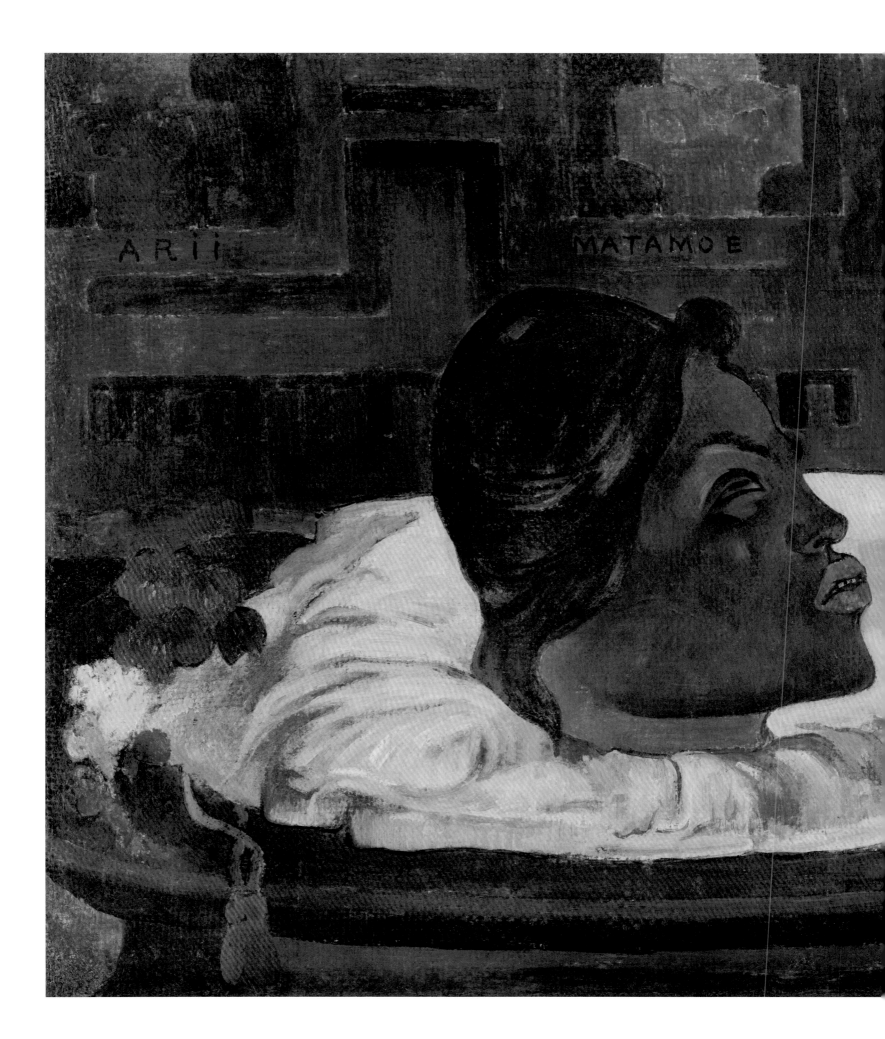

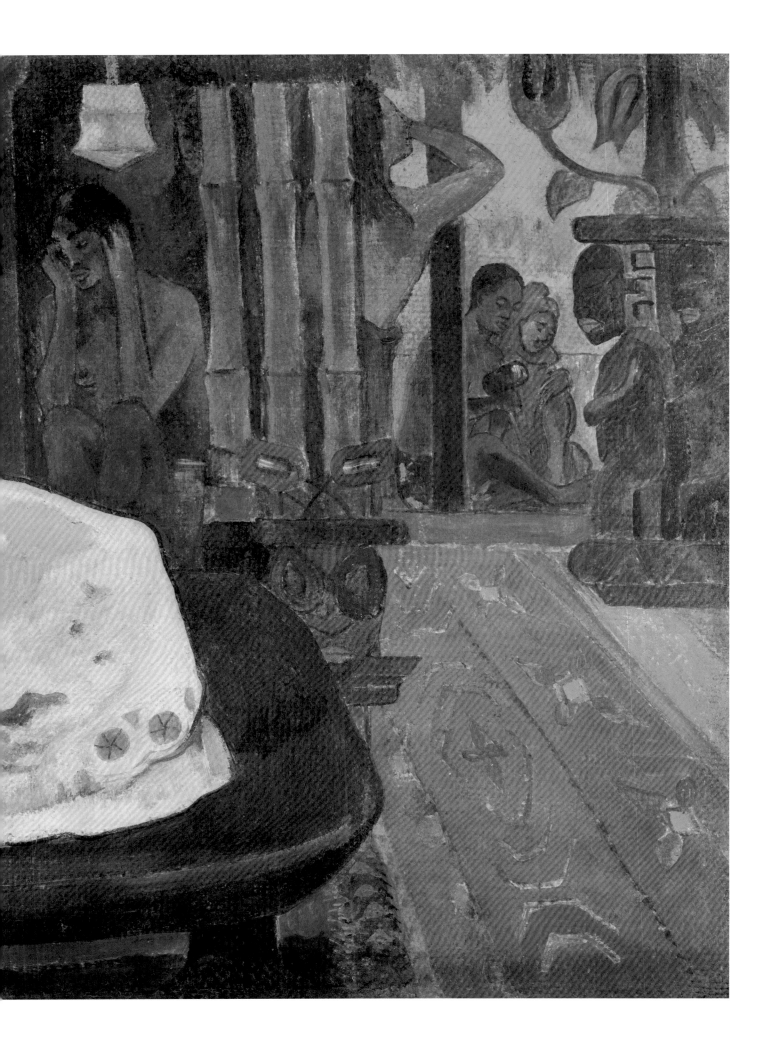

and her full lips are more orange-red than one would expect in a nine-year-old. Other than her woven straw handbag, no fashion details specify the Tahitian setting. It is the background that electrifies the picture: a flat field of bright rose-pink undulates beneath a swath of midnight blue, perhaps a fanciful reinvention of the hues of beach sands and dark night skies of Tahiti. Across both zones float curious floral designs, possibly derived from the types of printed European fabrics imported to the island. The girl's colourful head becomes as decorative an element as the vibrant floral rondels that surround her.[26] For a portrait of a little girl intended for a lavish colonial home, the work is radical.

The enduring lure of the non-visible world of thought and emotion informs the third, Symbolist grouping of portraits from Tahiti. In these works, Gauguin draws inspiration from a face or figure to invent (or dream, to use one of his favourite terms) from nature. The results are scenes that may elude logic, but make reference to the historical or contemporary Polynesian world as Gauguin understood it – from books, oral histories and his lived experience as a visiting French artist, one recently hailed in Paris by Albert Aurier as the first true Symbolist painter.[27] As faces and figures are based in a palpable reality, they invite the viewer into the possibility of the artist's invented scene, paving access to a world – a Tahiti, a paradise, a vanishing utopia – of possibility. But this requires the viewer to open eyes and mind to sheer potentiality, and to what cannot be fully grasped, categorized, confirmed or explained by reason, detail, logic, fact or the mandates of quotidian experience and the immediate physical world.

An excellent example of such invention is *The Royal End* (*Arii matamoe*, ill. 81). The main subject of this work is the head of a deceased chief, shown in profile with eyes partly open and bright pink lips slightly parted. The visage is as horrific as it is legible, for it is a severed head placed on a white pillow that sets it off with shuddering clarity. The pillow rests on a chief's seat, decorated with red flowers that are a visual displacement of the hue of the blood one associates with the violent act required for decapitation.[28] Women in the canvas lament the death, as if the head has been displayed for mourning. The decorative details of the setting are lush: a pink Persian-style rug, two tiki and large bamboo rods supporting the roof – all part of the artist's scheme to intermingle horror with beauty. In a nod to Leonardo da Vinci's inventiveness, Gauguin took pride in his inspiration for the painting – a head that he saw in wood grain:

> …a Kanaka's head … in a palace I invented, and surrounded by women, also of my imagination. I think it is a pretty bit of painting. Yet it's not altogether mine, for I stole the idea from a pine plank– … when marble or wood insist on tracing a head for you, it is very tempting to steal.[29]

This fantastic scene also echoes a contemporary event that greatly impressed Gauguin: the death of King Pomare V on 12 June 1891. Royal funeral events took over the island in the artist's first days; he even followed the cortège to the royal

mausoleum. Colonial photographers sold images of the observances, such as the display of the draped casket decked with flowers and topped with an empty crown – a scene evoking the missing monarch (see ill. 82). Gauguin's *Royal End* is a sublime reworking of this contemporary event, suggesting the artist's perception of the comingling of beauty and barbarism in a non-Europeanized Tahitian world. This displacement was particularly apt, as the Pomare funeral had much of the pomp, display and speech-giving of a modern, French-style burial for a dignitary. The idea of trophy heads is not taken from old Tahitian practice, however, but was rather one Gauguin could have picked up from the New Zealand Maori. A photograph sold in Tahiti by Charles Spitz (a colonial French photographer whose work directly inspired some paintings by Gauguin) features two trophy heads and a framed photograph of a tattooed chief, among other Maori objects (ill. 83). For Gauguin, all of Polynesia was a territory to be mined for novel customs and compelling objects, and photographs often provided useful visual resources for his art.[30]

To consider the full range of portraits Gauguin completed in Polynesia it is useful to focus here on a specific cluster of works, to ask how his encounter with one person – or his elaborations of an idea of one person – informed his art. The Tahitian most associated with Gauguin's own accounts is certainly the young woman with whom he lived in Mataiea during his first Tahitian trip – Teha'amana. In *Noa Noa* he celebrates her extreme youth (she was purportedly about thirteen when he met her), her Tahitian beauty and, in his primitivizing and patronizing view, her simplicity. She is named in the title of one painting (ill. 85), and she appears only in oblique references in some letters. Her full name was perhaps Teha'amana a Tahura (although she was known in Gauguin's second draft of *Noa Noa* as Tehura).[31] But a fair question is, did she really exist as a historical person? Or was she an amalgam of the young Tahitian women he encountered, a fantasy of his desires? Was she simply an elaborate fiction, produced in his art and texts for a Parisian audience as part of his project of Tahitian primitivism?

Gauguin was heir to the myriad stereotypes of Polynesia generated by Europeans since the time of Louis Antoine de Bougainville and James Cook, and he clearly expected adventures with Tahitian women, in spite of remaining legally married to Mette throughout his life. It is tempting to imagine that Teha'amana was entirely Gauguin's fantasy, and that he painted images based on a dream and a few random encounters with various willing women, but there is some historical evidence that such a young woman existed, and was his partner. The British novelist W. Somerset Maugham informally inquired about Teha'amana in the early twentieth century, and then, decades later, Bengt Danielsson did more serious historical and interview work to glean facts about her life.[32] She lived from around 1878 to 1918. Her parents were from Rarotonga in the Cook Islands, but she was born in Huahine and raised in Tahiti. At the time she met Gauguin, she lived with her family in Fa'aone, on the remote eastern coast. Although she was pregnant by Gauguin in the winter of 1892–93, no child was born.[33] What she truly thought of him and of their relationship is lost to history, although her Tahitian friends in Mataiea later told Danielsson that she had other lovers during the time she lived with the artist (as per his account in *Noa Noa*, Gauguin also certainly had other lovers early in his stay in Tahiti).[34] After Gauguin returned to France in 1893, Teha'amana married Ma'ari a Teheiura, had a son, and continued to live in the Mataiea district until her death during the Spanish flu epidemic after the First World War. Given the importance of her presence in Gauguin's self-narrative *Noa Noa*, it is not surprising that scholars have tried to pin down her historical identity. Art historians have proposed many images of her, but none can be incontrovertibly confirmed. Period photographs of women with this name continue to emerge in the archives of colonial photography, but definitive images of Gauguin's partner will probably remain elusive.[35]

Beyond this, what we think we may know about Teha'amana today is still largely framed by what Gauguin, his critics and even European novelists and film-makers have told us about her.[36] Pacific Islander interventions in art and writing have been few, but significant.[37] In feminist and postcolonial critique of the past three decades, she has been understood as a target of sexual and colonialist exploitation by a much older European man, one who might have been expected to abide by the cultural norms regarding the age of sexual consent in France.[38] But as Jehanne Teilhet-Fisk has emphasized, their relationship was not so unusual in Tahiti, where young people frequently lived with partners – often a series of them – for a period of time before marriage. What made this relationship inappropriate by Tahitian norms was not so much the age difference, nor her partnering with a European, but that a young Tahitian woman would not have *knowingly* lived with a married man.[39] In this key fact, Gauguin probably deceived her. Her family may well have suggested or at least approved of the relationship, as Gauguin claims in *Noa Noa*, following a long-standing practice of young Pacific Islander women seeking relations with visiting Europeans in the hopes of securing useful resources.[40]

But such agency, even if consciously practised by this young woman and/or her family, does not neutralize the clear power dynamic and subordination of Teha'amana to a situation of unequal resources and cultural power in a colonial setting. Gauguin clearly sought and used the privileges of his race, his gender and even, deeply impoverished as he felt, his class, as the artist still had access to some financial support from France and, as this essay has demonstrated, from a few supporters among the white colonial population. No evidence remains in his letters that he felt loyalty to, or financial responsibility for, this young woman, nor for the child he might have had by her, as he made plans in 1892 and 1893 to either move to the Marquesas Islands or to return to France.[41] Clearly, the representations he made of Teha'amana in his writings, and in works intended for the Paris art market, were the benefits and outcomes he most valued from this relationship. It was, in the end, all about serving his art. And it is through this filter that we apprehend the identity of this woman; in the absence of any firm historical record, a more complete understanding of her life must remain speculative.

Scholars and biographers have characterized many of Gauguin's paintings of young Tahitian women as being portraits, or at least representations, of Teha'amana.[42] A premise of this essay is that these images of women could well be understood by his Parisian audience, particularly the relatively small group who read *Noa Noa* before 1900, as being portraits of his young domestic partner; that is not the same as confirming that she actually served as his live model for all (or even any) of the images. To return to the categories of portraiture of Tahitians established earlier, I examine here three paintings and a sculpture that fit within the descriptions, generally, of an ethnoportrait, a decorative portrait and a Symbolist fantasy (or a combination of these). Gauguin's portraits of Tahitian women may have been inspired by his personal encounters, his expectations of local society, and his projections of cultural stereotypes, but these paintings owe no specific or inherent allegiance as works of art to his lived experience in Tahiti. His creativity lay therefore in the open possibilities of constantly remixing his perceptions with invention in what was to him an exotic and stimulating environment.

The only painting to bear the name Teha'amana in its title is the iconic *Tehamana Has Many Parents* or *The Ancestors of Tehamana* (*Merahi metua no Tehamana*, ill. 85), and as such, scholars often assume that this canvas records her visage.

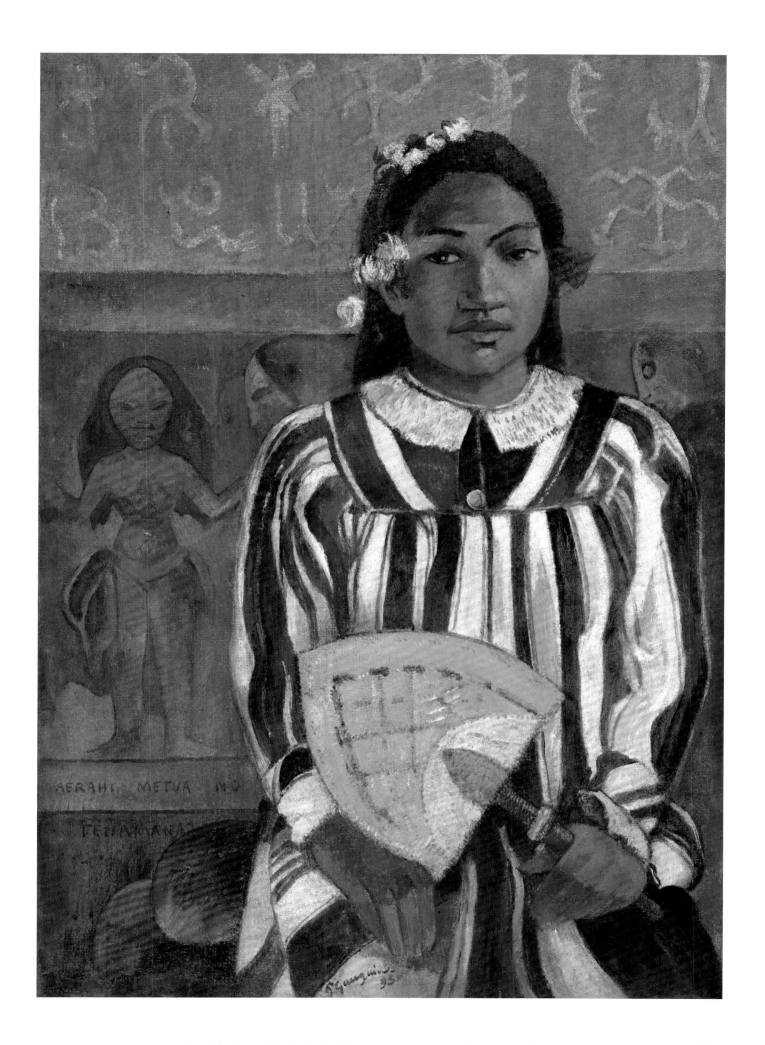

85 *Tehamana Has Many Parents* or *The Ancestors of Tehamana (Merahi metua no Tehamana)*, 1893 **151**

A preparatory drawing shows a young woman with a similar collar and hairstyle, a flower on the left ear, and eyes cast to the side (ill. 84). But in the painting Gauguin makes her lips fuller and face rounder, flattening it in accord with the effect of the striped fabric of her clothes and the woven fan that are pressed up in a shallow foreground. In this ethnoportrait, she is dressed for the occasion in a gown appropriate for visits to town and church. With island flowers scattered in her hair, hands in her lap, and a fan, she is poised. Such a presentation is akin to those in the popular photographs of individual sitters made in the commercial studios of Papeete at the time (see ill. 86). A comparison to a group photograph by Charles Spitz, taken of himself with ten island *vahines*, achieves a similar effect with a crowd: the women are calm and poised, bedecked with flowers, hands folded sedately in their laps, looking their very best (ill. 87). They are remarkably still and self-engaged, arranged like notes on a scale behind the Frenchman who commands the front spot, pleased to have composed the scene and to have included himself in what will become his souvenir photograph. Both images are in a sense visual trophies of the women's self-display, made for the French producer of the image. Gauguin did not literally include himself in the painting, as Spitz did in the photograph, but he did boldly inscribe his name and the date across the white fabric falling over Teha'amana's knee. It is like a tattoo of both authorship and ownership (or at least intimate familiarity with the model) that he foregrounds in a central location on her dress, where the viewer could not possibly miss it.

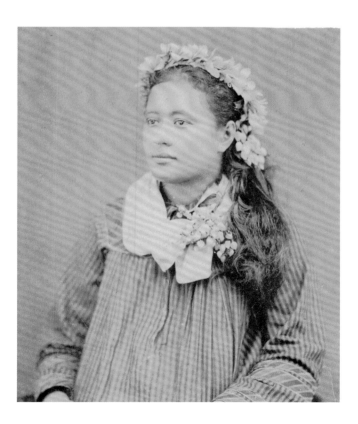

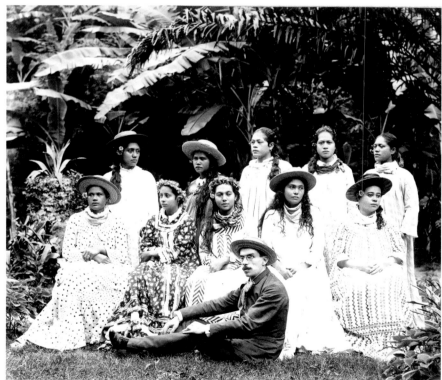

86 Germain Coulon, *Tahitian Woman*, 1890 87 Charles Spitz, *Group of Vahines*, c. 1885–89

There is, of course, more. What sets Gauguin's portrait well apart from its more quotidian photographic counterpart is the wildly inventive background that ultimately gives the picture its mysterious reference to Teha'amana's ancestors, and its title. Inscriptions lifted from Rapa Nui (Easter Island) rongorongo boards float above her head, and a goddess-like form, perhaps the ancestor-goddess of creation Hina, and mysterious shapes of *tupapau* – spirits believed to roam the night – hover behind her and over her shoulders. These forms appear to extend beyond the canvas at each side, like registers of an ancient time, flowing past. Mangoes on display at her side may suggest her fertility.[43] Gauguin positioned her to the right of centre, pointing her fan toward the upper left to direct our attention to these alluring yet enigmatic forms. She is both derived from and implicitly embedded in this remote cultural matrix, yet also palpably present in the world inhabited by the painter and viewer. So, as we contemplate her as the specific contemporary Tahitian woman named in the title (regardless of her actual physiognomic resemblance to that person) we are also asked to regard her in relation to a mysterious past that both invites the viewer through the intricate references to Polynesian culture and resists us, since these elements were unfamiliar and inscrutable to the European viewer of the day. Named as the specific individual Teha'amana and seated so that she faces us directly, she becomes the point of encounter for the viewer.

Some of Gauguin's portraits of Teha'amana are conceptually simpler. For instance, *Woman of the Mango* (*Vahine no te vi*, ill. 96) is a work often assumed to be of her.[44] But unlike the previous picture, she is not named in the title, except as a *vahine* (a term that could mean woman or mistress). Her twisting body and her averted gaze present her less directly to us than her stance does in the previous picture. The active pose and gesture have been interpreted as deriving from Pierre-Paul Prud'hon's drawing of *Joseph and Potiphar's Wife*, which Gauguin had with him in a reproduction (date unknown, Bibliothèque nationale de France, Paris).[45] The hand of the Tahitian woman raising the mango aloft evokes not just youth and the plenitude of Tahiti, but perhaps again the fertility of Teha'amana. Yet, in this case, the purple-blue dress, the decorative background and the *pareu* fabric behind her all demand our attention as much as her face and form. This picture is as much about colour relations as identity: for example, the yellow strip of background beside her black hair at right intensifies to a sun yellow, whereas the same field of warm hue turns orange at left, where it is opposed more with the complementary tones of the dress.

Teha'amana is perhaps more the excuse than the subject in Gauguin's most highly inventive Symbolist scenes. In *Spirit of the Dead Watching* (*Manao tupapau*, ill. 88), the Parisian viewer might well have assumed the woman depicted was Gauguin's partner, both because of the intimate context of the scene and because of the narrative he subsequently supplied in *Noa Noa*.[46] The composition is equal parts Tahitian nude and French Olympia. Here, a Tahitian woman lies prone on a white cloth spread over a deep blue and gold *pareu* cloth on her bed. She glances back toward the viewer, her brow somewhat furrowed; it is an expression Gauguin

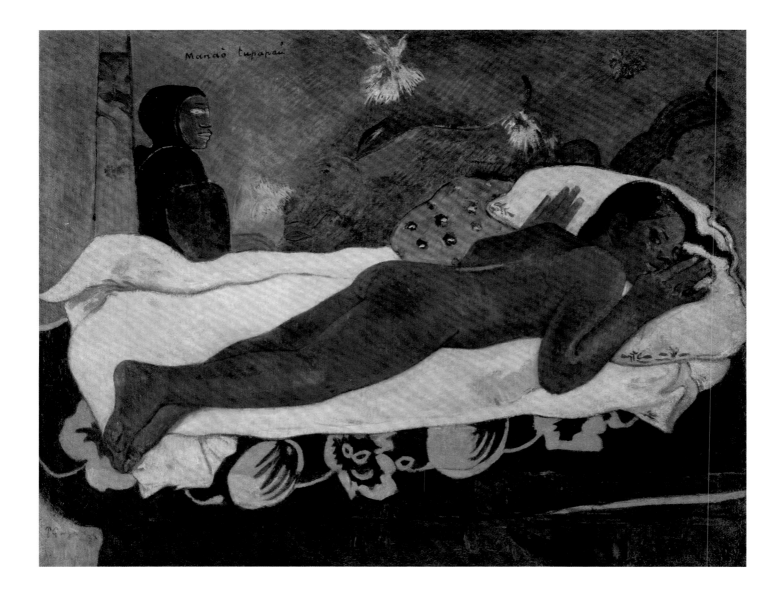

identifies in *Noa Noa* as both dread of him as he enters the room and fear of the *tupapau* spirits. Her figure is displayed provocatively, and a stroke of brighter skin tone on the curve of her buttocks, located at the very centre of the canvas, underscores the undeniably sexual presentation of her body. Gauguin combines this vulnerability with the disturbing presence of the spirits that materialize around her, as if both her body and soul are at risk of assault: one glowing-eyed hooded spirit at her bedside, others emerging as phosphorescent flashes and profiles on the back wall, and yet others appearing more subtly in profile. The scene is untethered from the world of logic in a phantasm of desire, threatening presences and visions of a realm that is not knowable or safe. She becomes our gateway to a knowledge that is attractive yet dangerous – a world of the senses liberated from the rational thought and the visible sphere that Gauguin, as a Symbolist, disdained.

In a later lithographic version of this painting (ill. 89) key changes in the composition emphasize Gauguin's intent. Teha'amana's face engages the viewer more directly, asking us to see what she sees, and more importantly, to feel what she feels. The creatures of the night in her room have multiplied: a new eerily-lit horned figure hovers at back, alongside the hooded one, while the profile of the spirit emerging from the wall is more explicit. The image and idea of Teha'amana do not just invite us: we are pulled into a spinning world of mental projection and fantasy. If this is a portrait, it is not of her as an individual, but rather of her body advanced by the artist as an agent of his own imagination.

Indeed, there is explicitly Tahitian content here. Gauguin's Tahitian acquaintances, including Teha'amana, probably shared their beliefs in *tupapau*, appreciated by French visitors of the era as one of the last surviving vestiges of the indigenous

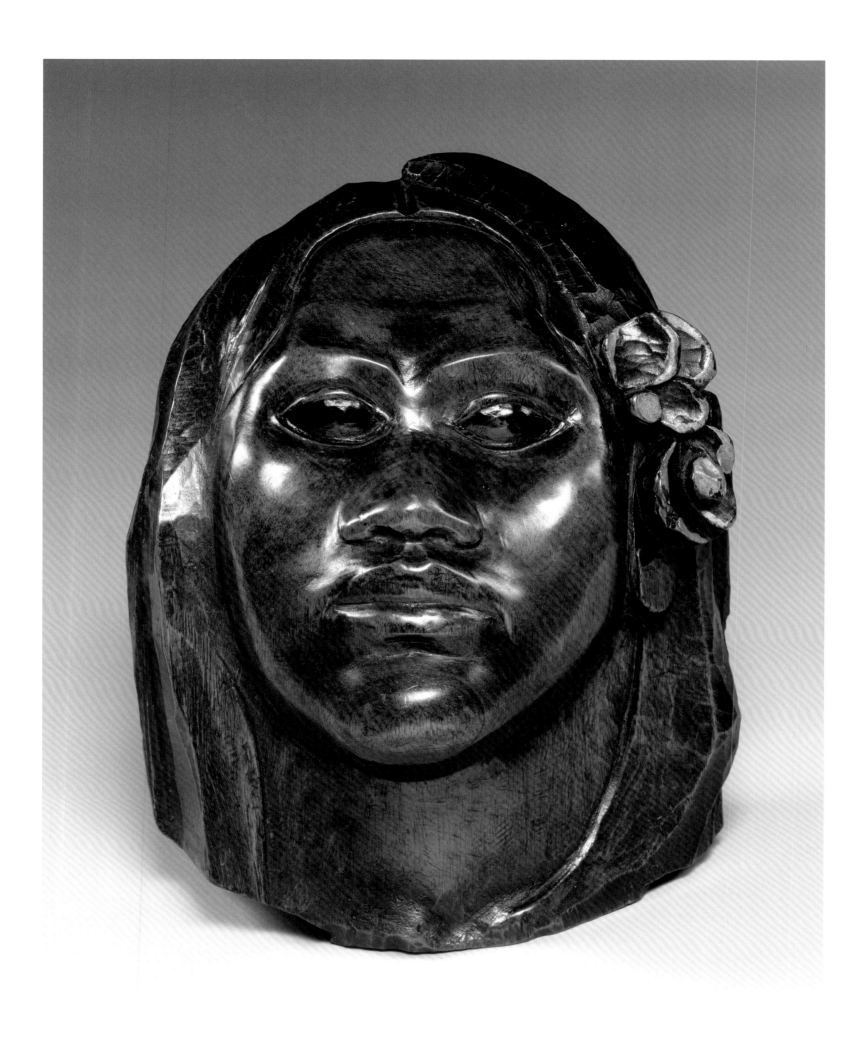

90 *Tehura*, 1891–93 (front and back)

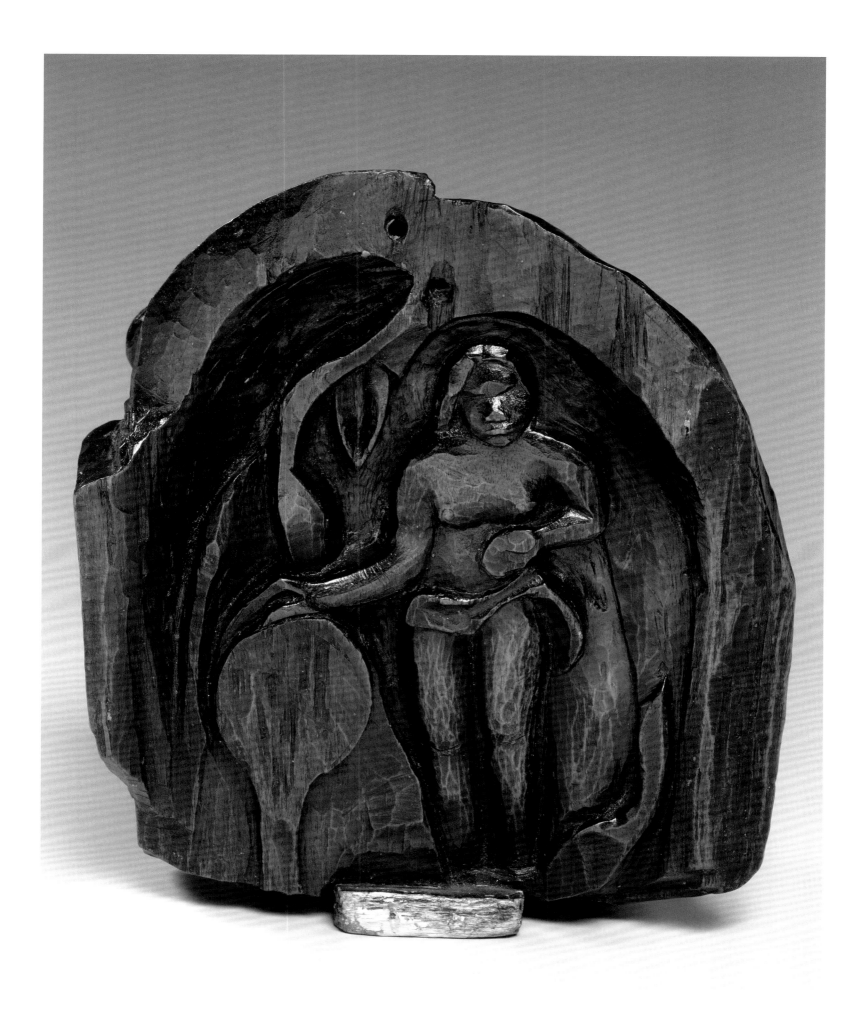

religion.[47] But Gauguin takes over these vestigial beliefs in the night spirits as a means to visualize the powers of the creative imagination. He uses both Teha'amana's body and mind as actors in his primitivist critique of what he saw as the modern over-valuation of rationality and empiricism.

Working in three dimensions on his first Tahitian trip, Gauguin carved a sculpture of a young woman's head (ill. 90) to combine these worlds of the observed Tahitian sphere and the power of the imagination inspired by this context. This carved head has often been assumed to be of Teha'amana, but there is no evidence that Gauguin himself identified the sculpture using that name.[48] The pua wood itself announces the exotic nature of the subject. Her full lips, broad nose and cascading hair in part identify her as Tahitian. But it is the blossoming flowers at her ear, highlighted with gilt to draw the eye and stimulate ideas of a floral fragrance, that confirm her island identity. Yet this sculpture is more than an ethnoportrait; it also is a worthy Symbolist invention. On the back of her head, Gauguin carved a scene as if inscribed in the girl's mind. Here, he inserted an Eve-like figure reaching toward tropical bushes and fruits. Teha'amana becomes the pure embodiment of the ideal Tahitian woman in paradise, a dream shown to literally take shape in the mind. The two-sided sculpture fully embodies Jean Moréas' definition of a Symbolist work of art: the artistic idea clothed in a sensitive form.[49]

The significance of Teha'amana for Gauguin's art is nowhere more evident than in the artist's self-portrait painted in Paris in 1893–94 (ill. 2). He is dressed as a bohemian, sporting a Breton shirt and the boater straw hat so popular in Tahiti. On a chair is draped a bright *pareu*, a visibly Tahitian souvenir of his two-year artistic sojourn. Above it is *Spirit of the Dead Watching*. In his placement of that picture in this studio scene, Teha'amana's body hovers just to the right of the artist's alert eyes (and his mind), emphasizing here that *she* is the subject who has deeply inspired him and allowed him to clarify his artistic project. This insight suggests that Gauguin's many depictions of Teha'amana can best be understood more as reflections of his self-exploration and his artistic process in the face of engaging – but to him exotic – subjects than as direct records of personal encounters with a particular woman. In the end, these portraits of Teha'amana are extended self-portraits of Gauguin himself, at different stages of his perception and creative reinvention of his Tahitian experience. By keeping Teha'amana's name out of his letters, and all of his painting titles (except for the one that he used to invoke her entire ancestral history), he has admitted as much. In the end, after they parted company in 1893, Gauguin no doubt missed her presence as his artistic muse far more than she missed him.

NOTES

1 On Jénot, see O'Reilly and Teissier 1975, p. 281. See also Charlotte Hale, "Gauguin's Paintings in the Metropolitan Museum of Art: Recent Revelations through Technical Examination," in Ives and Stein 2002, pp. 187–189, and Jénot 1956, reprinted as "Gauguin's First Stay in Tahiti," in Prather and Stuckey 1987, pp. 173–178.

2 For instance, *Captain Swaton* (1891, The Metropolitan Museum of Art, New York, W419). For the attribution of this work to Jénot, see Hale, "Gauguin's Paintings," pp. 187–189, 232. Other portraits that Hale attributes to Jénot are W416, W417 and W418.

3 These include a portrait of Suzanne Bambridge (ill. 72), who paid Gauguin 200 francs; two portraits for a schooner captain named Charles Arnaud, who at first promised a staggering fee of 2,500 francs for a portrait of his wife (which Gauguin did not produce); and then, on Gauguin's return trip to Tahiti in 1895, a portrait of Jeanne Goupil, daughter of a wealthy French lawyer (ill. 79; see subsequent discussion of this picture in the section on decorative portraits). On Arnaud, see O'Reilly and Teissier 1975, p. 20; on Gauguin's hopes for the commission, see letter from Gauguin to Paul Sérusier, March 1892, in Danielsson 1966, pp. 106–107. When Gauguin could not complete the commission for the portrait of Arnaud's wife, the captain paid Gauguin 400 francs for an alternate painting. Danielsson discovered that Gauguin also made a portrait of Arnaud himself that has since disappeared (Danielsson 1966, pp. 112; 299, no. 82).

4 Of these, several of the Impressionists (including Monet, Sisley, Degas, Pissarro and Renoir) exceeded 2,000 francs for a single work. Given Gauguin's highest single hammer price was 500 francs, he sold less well than these artists, but better than all the other painters of the Pont-Aven school, all the Neo-Impressionists, and all the Nabis painters but Pierre Bonnard. Gauguin did not, however, sell large quantities of works at prices near his record of 500 francs for one painting. See Agnès Penot and Léa Saint-Raymond, "Paul Gauguin: Businessman or Starving Artist?," in Hellmich and Pedersen 2018.

5 Only twenty-eight of seventy-six lots sold. Many significant works of interest to this study, such as *Spirit of the Dead Watching* (*Manao tupapau*, ill. 88) and *Tehamana Has Many Parents* or *The Ancestors of Tehamana* (*Merahi metua no Tehamana*, ill. 85) were bought in by the artist. *Two Sisters* (*Piti teina*, 1892, The State Hermitage Museum, Saint Petersburg, W479) sold to Władysław Ślewiński for 430 francs. See the entries in Wildenstein 1964 (W449, W457, W479, W461 and W497).

6 Gauguin wrote: "Art is an abstraction. Derive the abstraction from nature while dreaming before it" (letter from Gauguin to Émile Schuffenecker, 14 August 1888, in Gauguin 1984, no. 159, p. 210).

7 Gauguin 1919, p. 13.

8 He wrote to his wife Mette in June 1892: "I can assert that what I am doing here has not been done by anyone else and nothing like it is known in France. I hope that this novelty will turn the scale in my favor" (Gauguin 1949, no. 129, p. 170).

9 Jénot, "Gauguin's First Stay in Tahiti," p. 176.

10 Isabelle Cahn, "The First Stay on Tahiti," in Greub 2011, p. 163.

11 Munck and Olesen 1993, p. 46.

12 Letter from Gauguin to Mette Gauguin, Tahiti, 4 June 1891, in Gauguin 1949, no. 125, p. 162.

13 I am grateful to Richard Brettell for sharing his fascinating draft entry on this painting. He has clarified that it was Suzanne herself, not her father, who commissioned the portrait.

14 O'Reilly and Teissier 1975, pp. 33–34.

15 A similar dress of black fabric printed with an overall bright floral pattern is worn both by Queen Marau and her mother Chief Ariitaimai of the Salmon family of the Teva clan, Papara, in a formal photographic family portrait of 1885 (Bishop Museum Archives, Honolulu, CP 128923).

16 Bengt Danielsson interviewed Bambridge's family and learned of the picture's fate (Danielsson 1966, p. 82).

17 See article in curatorial files of the Kröller-Müller Museum, Otterlo, by Louis Ginies, "Histoire d'un portrait inconnu de Gauguin de deux toiles qui ont suivi son modèle dans un tombeau," unknown publication (21 December 1937).

18 Suzanne Diffre and Marie-Josèphe Lesieur, "Gauguin in the Vollard Archives," in Shackelford and Frèches-Thory 2003, pp. 307, 339, notes 9 and 10.

19 While scholars keenly await the updated catalogue raisonné of Gauguin's paintings from 1889 to 1903, some general observations may be drawn from consulting the original Wildenstein catalogue (Wildenstein 1964). Only three works recorded there as appearing in Vollard's stock may be regarded as ethnoportraits: the work discussed in this paragraph, *Polynesian Woman with Children* (1901, Art Institute of Chicago, W595) and *Two Women* (1901–02, The Metropolitan Museum of Art, W610). Other canvases sent to Vollard included still lifes (W553, W591, W592 and W593); Polynesian landscapes (W563, W589, W637 and W638); figure studies in a landscape (W575, W584, W597 and W612); scenes with either Christian, Polynesian or religious hybrid references (W540, W559, W579, W617, W621 and W622); bathers (W564 and W572); scenes of rural life (W588); and themes of maternity (W581).

20 Richard R. Brettell and Stephen F. Eisenman, *Nineteenth-Century Art in the Norton Simon Museum*, vol. 1 (New Haven: Yale University Press, 2006), p. 383. For the spelling of Pau'ura a Tai, see Danielsson 1975, p. 190.

21 De Rotonchamp 1925, p. 221.

22 See the entry on this painting by Elizabeth C. Childs in online collection catalogue, The Nelson-Atkins Museum of Art, Kansas City (forthcoming, 2019).

23 This similarity does not necessarily indicate that Gauguin brought the billowing yellow garment of the Brittany work back with him from Polynesia; the loose wrap was extremely popular with young women in Europe and America in the 1890s. An excellent study of the style is Sally Helvenston Gray, "Searching for Mother Hubbard: Function and Fashion in Nineteenth-Century Dress," *Winterthur Portfolio* 48, no. 1 (spring 2014), pp. 29–73.

24 Brettell 1988, cat. 190, p. 350.

25 O'Reilly and Tessier 1975, pp. 223–224.

26 George T.M. Shackelford has observed that this background recalls the portraits of Madame Roulin by Van Gogh (Shackelford and Frèches-Thory 2003, pp. 150–152).

27 Aurier 1891, reprinted as "Symbolism in Painting: Paul Gauguin," in Prather and Stuckey 1987, pp. 150–156.

28 For an example of such a seat, see Bishop Museum, Honolulu, photograph archive, N16193.

29 Letter from Gauguin to Daniel de Monfreid, June 1892, in Gauguin 1922, no. 4, pp. 30–31.

30 On Gauguin's relationship to colonial photography see Childs 2013, chapter 4.

31 W. Somerset Maugham recalled being told this possible full name by Louvaina Chapman, a manager of the Tiare Tahiti hotel in Papeete (Menard 1981, p. 117). Gauguin may have thought the name Teha'amana was too long or complicated for Parisian readers. The name Tehura that he uses in his draft manuscript of *Noa Noa* probably derives from that of a young woman he knew in Papeete in his early days on the island. He writes of her in a letter as Tehora, which was his abbreviated version of the Tahitian name Te'ahura (Sweetman 1995, p. 283).

32 My biographical sketch, unless otherwise noted, is based on Danielsson 1966, especially pp. 116–130. The Danielsson archives are now at the Kon-Tiki Museum in Oslo, where they are as yet unavailable for consultation. Danielsson's notes on his interviews with Teha'amana's husband and son and his notes on legal documents (which are all only briefly referenced in his endnotes) would be particularly useful to consult in full. The recollections of Maugham are only partially useful to the historian. In 1981 Wilmon Menard recalled conversations of the 1950s with the British author, in which Maugham recounted his experiences in Tahiti in 1917. The time lag between these events and their publication by Menard in 1981 may explain the inconsistencies. Maugham recalled a meeting in the town of Puna'auia with the Tahitian woman Pau'ura a Tai, who was Gauguin's mistress during his second Tahitian sojourn (1895–1902), and with whom he had a son, Émile Marae a Tai. Maugham confused Pau'ura with Teha'amana (as he thought the woman he interviewed was the subject of *Noa Noa* and the model for *Spirit of the Dead Watching*). Menard did not recognize the error, and the entire interview may have been highly romanticized (or even fabricated) in either Maugham's retelling of it or in Menard's account of Maugham's memories. See Menard 1981, pp. 116–117.

33 On 3 March 1893 Gauguin wrote to De Monfreid that he would "soon be a father again in Oceania" (Gauguin 1922, p. 46).

34 Danielsson 1966, p. 300, note 92.

35 Modern efforts by Charles Stuckey, Philippe Peltier and others to propose photographs of Teha'amana reveal a persistent desire to confirm her physiognomy, a common effort in portraiture studies. Richard Brettell has recently noticed that such identifications are usually based on how much the Tahitian woman in a photograph resembles the model in the painting that bears her name in the title. Ultimately, there can be no guarantee that Gauguin aspired to paint that closely to nature. See Richard Brettell and Genevieve Westerby, "Gauguin, cat. 50," in Groom, Westerby and Solomon 2016. However, there is yet one more possibility to add to this list of photographs: an albumen print of 1897, hand-labelled "Tehamana." The seated woman on the right could be the requisite twenty years old that Gauguin's partner would have been by 1897; but there were surely many women named Tehamana in that era (see Musée de Tahiti et des îles, Puna'auia, Tahiti, D2004.32.411).

36 Key here are the accounts in *Noa Noa*; W. Somerset Maugham's *The Moon and Sixpence* (1919); and more recent representations such as the 2017 film *Gauguin – Voyage de Tahiti*, starring Vincent Cassel as Gauguin and Tuheï Adams as Teha'amana. For a critical analysis of *Noa Noa*, see the essay in this catalogue by Linda Goddard.

37 See Elizabeth C. Childs, "Taking back Teha'amana: Feminist Interventions in Gauguin's Legacy," in Broude 2018, pp. 229–249, especially pp. 243–247.

38 Central to this line of feminist critique is Pollock 1992.

39 Teilhet-Fisk 1983, p. 70.

40 Tahitian elders frequently offered teenage girls to arriving Europeans in the first encounters of the eighteenth century. See Tcherkézoff 2013. The modern Pacific Islander practice known as "picking up Captain" is referenced in Caroline Vercoe, "Not So Nice Coloured Girls: A View of Tracey Moffatt's 'Nice Coloured Girls,'" *Pacific Studies* 20, no. 4 (December 1997), pp. 151–159.

41 In a letter of 31 March 1893 from Gauguin to De Monfreid he mentioned Teha'amana's pregnancy only by referring to his own fertility. He also dismissed his own responsibility based on what he regarded as Tahitians' characteristic generosity: "I shall soon be a father again in Oceania. Good heavens, I seem to sow everywhere. But here it does no harm, for children are welcome and are spoken for in advance by all the relatives … So I do not worry as to its fate" (Gauguin 1922, no. 9, p. 46).

42 See Brettell and Westerby, "Gauguin, cat. 50."

43 Whether or not the model was Teha'amana, fertility and fecundity may well have been on Gauguin's mind, as she was pregnant by him in the winter of 1892–93 (see Gauguin 1922, no. 9, p. 46).

44 Charles F. Stuckey, in Brettell 1988, cat. 143, pp. 259–261.

45 Ibid., p. 260.

46 Gauguin 1919, pp. 33–34.

47 A travel account of 1888 by Gaston Liebert, a member of the French navy based in Papeete, observed how widely the belief in these spirits remained (see his unpublished, unpaginated memoir, University of Hawai'i Mānoa Special Collections, PAC Rare, mss P00029).

48 Gray 1963, p. 225.

49 Jean Moréas, "Un manifeste littéraire. Le Symbolisme," *Le Figaro* (18 September 1886), p. 150.

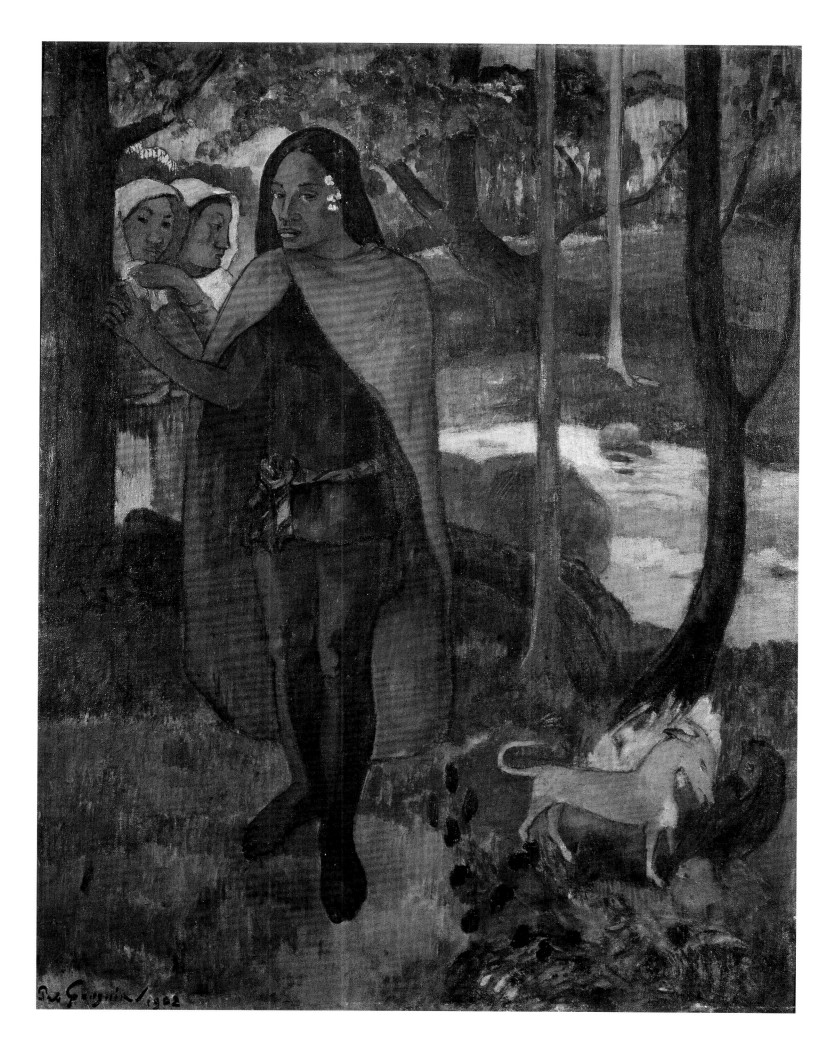

91 *The Sorcerer of Hiva Oa (Marquesan Man in a Red Cape)*, 1902 **161**

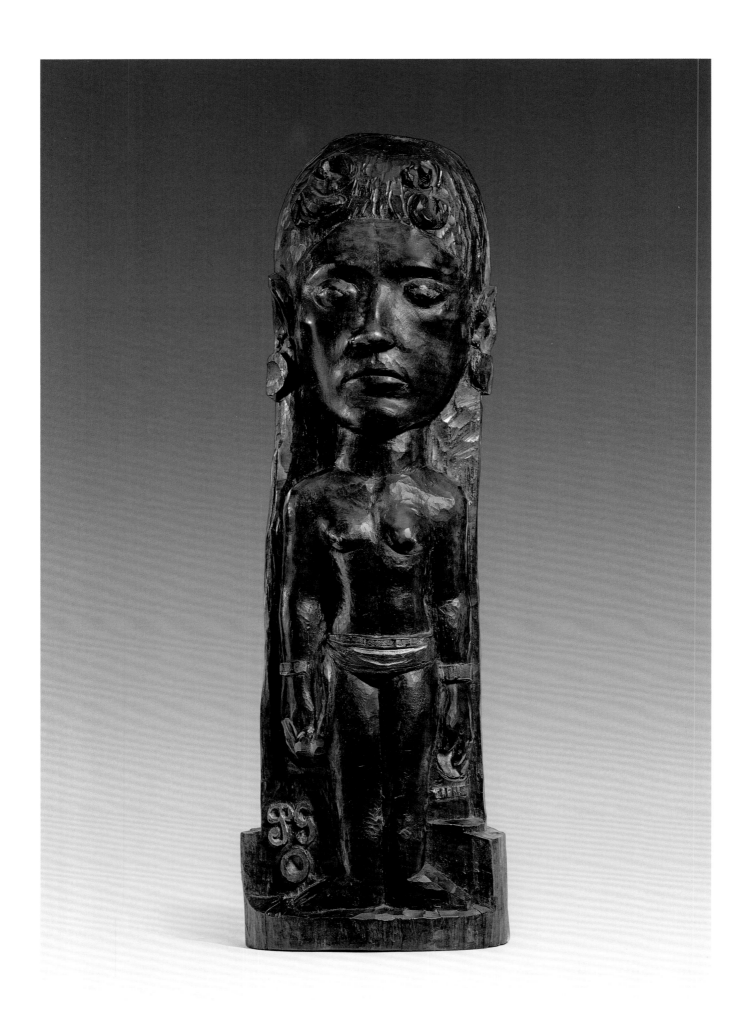

92 *Thérèse*, c. 1902–03

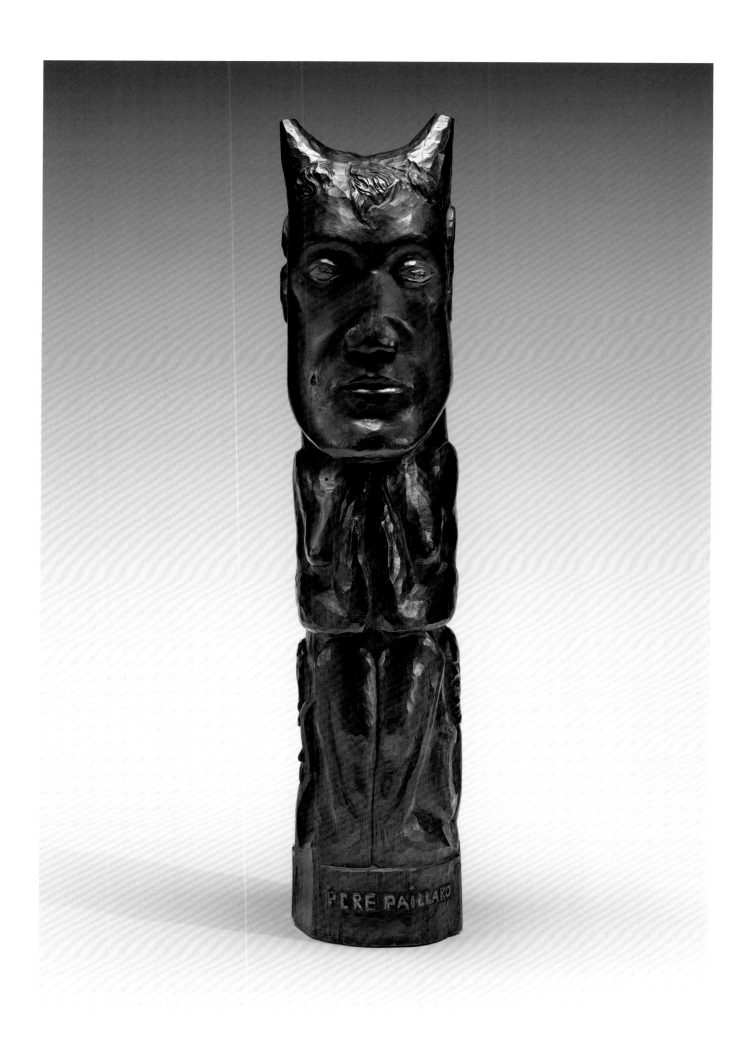

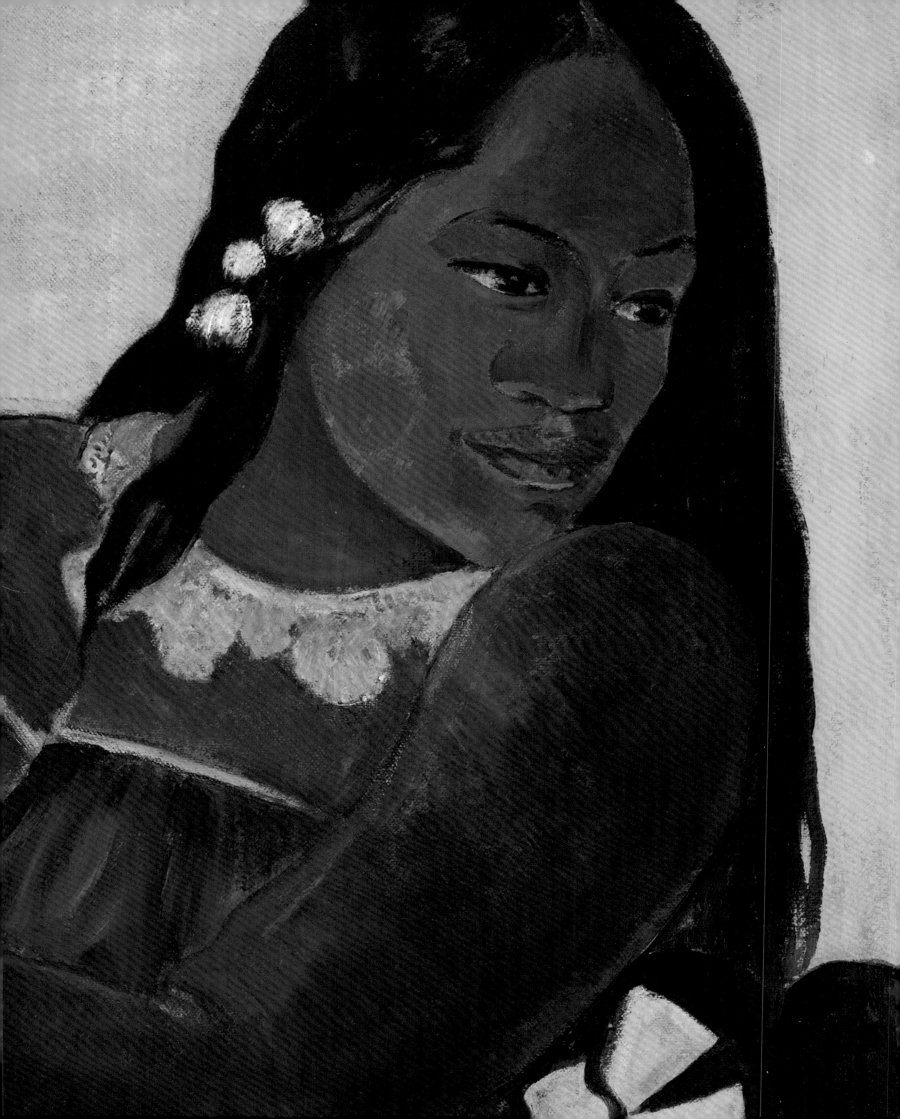

NOA NOA AS SELF-PORTRAIT

Although few would categorize Gauguin as a writer, many people who are familiar with his art also have at least a passing acquaintance with *Noa Noa*, the apparently autobiographical tale of his first two years in Tahiti (see ill. 94). An episodic, first-person narrative, initially drafted in 1893, it relates a series of intercultural encounters, framed by the protagonist's arrival and departure. It is here that the narrator (not explicitly named as Gauguin, but identified as a male artist) tells how he met his thirteen-year-old Tahitian wife, Tehamana, and recounts an expedition with a local guide to find wood for carving that assumes a pivotal role in his supposed conversion to a "primitive" state. Both incidents are episodes that hold a privileged place in studies on the artist.[1] The text opens with the funeral of the last King of Tahiti, Pomare V, which did indeed take place a few days after Gauguin landed, a symbolic marker of the demise of "authentic" Polynesian culture.[2] However, apart from this occurrence, few events or characters are corroborated by sources outside the text. Individuals are often unnamed, and most of the events are generic in nature – a wedding, a fishing expedition, a portrait sitting.[3] Nevertheless, whether celebrating or condemning his "primitive" adventure, historians repeatedly turn to *Noa Noa* as a source of information about the artist's life in Tahiti. Although it has had an enduring impact on the myth of Gauguin's attempts at "going native," it is rarely analyzed as a work of literature in its own right.[4]

In his essay "Autobiography as De-Facement," Paul de Man defines autobiography as "not a genre or a mode, but a figure of reading or of understanding that occurs, to some degree, in all texts."[5] Texts by artists, in particular, are often

LINDA GODDARD

Woman of the Mango (Vahine no te vi) (detail, ill. 96), 1892

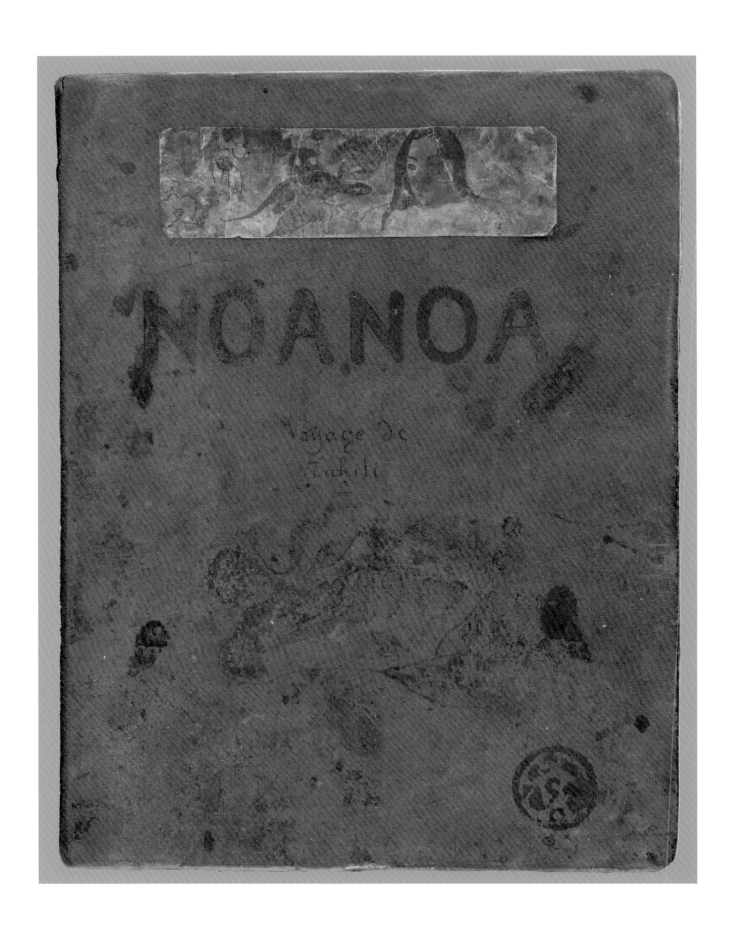

94 Cover of *Noa Noa* (Louvre manuscript), 1894–1901

interpreted autobiographically, and tend to advertise their own apparent absence of artifice. De Man's observation that "the autobiographical project may itself produce and determine the life," in a reversal of the commonly held assumption that "life *produces* the autobiography as an act produces its consequences," is particularly apt in the case of *Noa Noa*.[6] As in his visual self-portraits, Gauguin used his text strategically to fashion an artistic identity that would help to contextualize his "savage" Polynesian art, and its readers, in turn, have used it to construct a narrative of the artist's life. Instead, I will relate *Noa Noa* to Gauguin's literary strategies more broadly, as well as to travel writing by fellow nineteenth-century French artists, and argue that it is best considered not as a biographical record but as a carefully crafted literary self-portrait.

Gauguin himself was highly equivocal about the idea of verbal self-revelation. His texts often extend the promise of disclosure only, ultimately, to withhold it. For example, he described his last volume, *Avant et après*, which is a collection of reminiscences, anecdotes and quotations, to his friend Daniel de Monfreid as "a means to make myself known and understood."[7] But in its opening pages, he displayed a marked scepticism for biographical facts: "Memoirs! That means history, dates. Everything in them is interesting except the author. And one has to say who one is and where one comes from."[8] In line with his frequently expressed view that his work should speak for itself, and did not require critical commentary, he mocked the reader's inquisitiveness: "You wish to know who I am; my works are not enough for you. Even at this moment, as I write, I am revealing only what I want to reveal."[9]

Such statements cast doubt on his descriptions of *Noa Noa* as a tool for understanding his art and life. In October 1893, in the run-up to an exhibition of his work that opened at the Durand-Ruel gallery in Paris the following month, he wrote to his wife that he was preparing a "book on Tahiti, which will facilitate the understanding of my painting."[10] Announcing it publicly nearly two years later on the eve of his return to Polynesia in 1895, with the book still incomplete, he told his interviewer: "I describe my life in Tahiti and my thoughts on art … That will explain to you why and how I went there."[11] References in *Noa Noa* to the titles of paintings that were included in the exhibition suggest that Gauguin may initially have intended the text to act as a guide of sorts, although it was not finished in time. Many commentators have taken this as a cue to turn to *Noa Noa* for the stories behind the pictures. Although most acknowledge that he must have embellished his tale, the lure of *Noa Noa* as biography proves too difficult to resist, and the case of Tehamana is symptomatic.[12] Little is known about her outside of Gauguin's text, and in later versions of *Noa Noa* the name of the narrator's lover is changed to Tehura.[13] While he surely had equivalent relationships with Tahitian girls, to seek to identify them on the basis of his account in *Noa Noa* is to mistake Gauguin's fantasy for reality.

In fact Tehamana's name is mentioned only once by Gauguin outside of the first draft of *Noa Noa*: in the title of the painting *Tehamana Has Many Parents* or *The Ancestors of Tehamana* (*Merahi metua no Tehamana*, ill. 85), which depicts, in

portrait format, a young woman in a "missionary" dress. However, such is the power of Gauguin's narrative that any Tahitian female figure from the artist's first Polynesian period (1891–93) who is not explicitly associated with an alternative identity is deemed to be her.[14] It is commonplace to personify the female figures in these works by calling them by Gauguin's fictional lover's name, even where the resemblance to the one named portrait is superficial, and even though the artist's typically straight-haired models do not match the description of her in *Noa Noa* as having "bushy" and "crinkled" hair.[15] Such is the desire to ground the character of Tehamana in biographical reality that Charles Stuckey insists on identifying the woman with a billowing gown in *Woman of the Mango* (*Vahine no te vi*, ill. 96) as the artist's pregnant mistress, in the absence of any information about the identity of this sitter, or any certainty that she is depicted as pregnant. He takes Gauguin's announcement in a letter to De Monfreid that he is about to become a father again as proof that Tehamana was expecting a child, even though no pregnancy occurs in *Noa Noa*, no name is mentioned in the letter, and the artist's impending paternity could have been the result of one liaison among many.[16]

Rather than explaining the scenes depicted in Gauguin's paintings, the episodes in *Noa Noa* serve, if anything, to mystify them further. The phrase "Description of the picture *Pape moe*," for instance, interrupts the story of a journey to the Tamanou plateau, where the narrator startles a woman drinking from a waterfall. However, the text, in which she is compared to an "uneasy antelope" who "violently dived" as he approached, relates awkwardly to the corresponding painting, in which the figure appears static and undisturbed (ill. 95).[17] The episode's biographical authenticity is undermined by the painting's actual source in a colonial photograph of a person drinking from a waterfall, while the theme of the female bather surprised, as evoked in Gauguin's vignette, is a common subject in travel writing on Polynesia.[18] In short, *Noa Noa* does not faithfully record events, but reworks existing literary tropes in order to frame the reception of his art.

Ultimately, it makes less sense as autobiography than as part of Gauguin's wider effort to establish an artistic identity that would help to promote his art. Through self-portraits in various media and written statements he sought to align self and work: to present his creations as the natural product of his "savage" personality. The pioneering studies of Abigail Solomon-Godeau and Griselda Pollock first exposed Gauguin's investment in promoting his own "primitive" persona as a means of advertising his art; for Solomon-Godeau, *Noa Noa* was a vital tool in the process by which the artist cynically charted his "assumption of the role of savage."[19] Recent accounts have shown that Gauguin's self-mythologizing involved an element of self-awareness, irony and even melancholy, as the variety of personae and alter egos that he adopted allowed him to explore the mutability and constructedness of identity.[20]

If Gauguin used writing to forge his identity as an artist-savage, it was as much through the *style* that he adopted as the content of his statements. Like the seemingly unrefined forms of his visual art, his fragmentary, sometimes crude

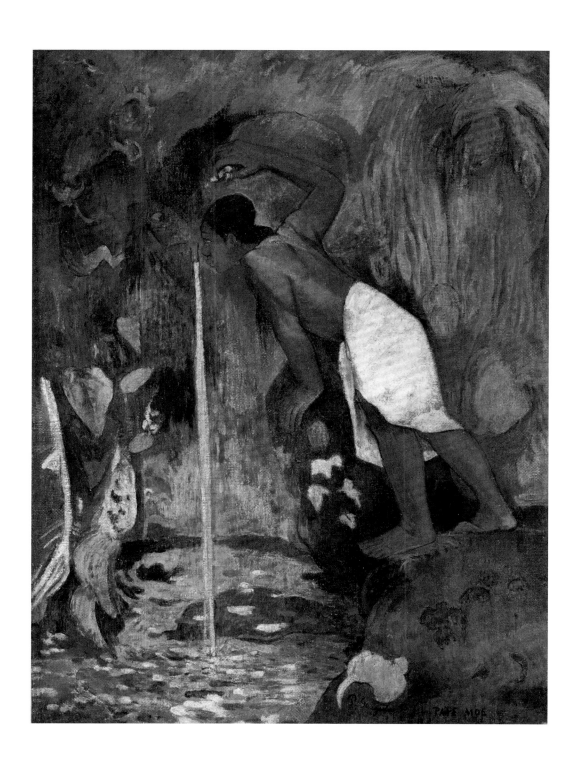

95 *Mysterious Water (Pape moe)*, 1893 **169**

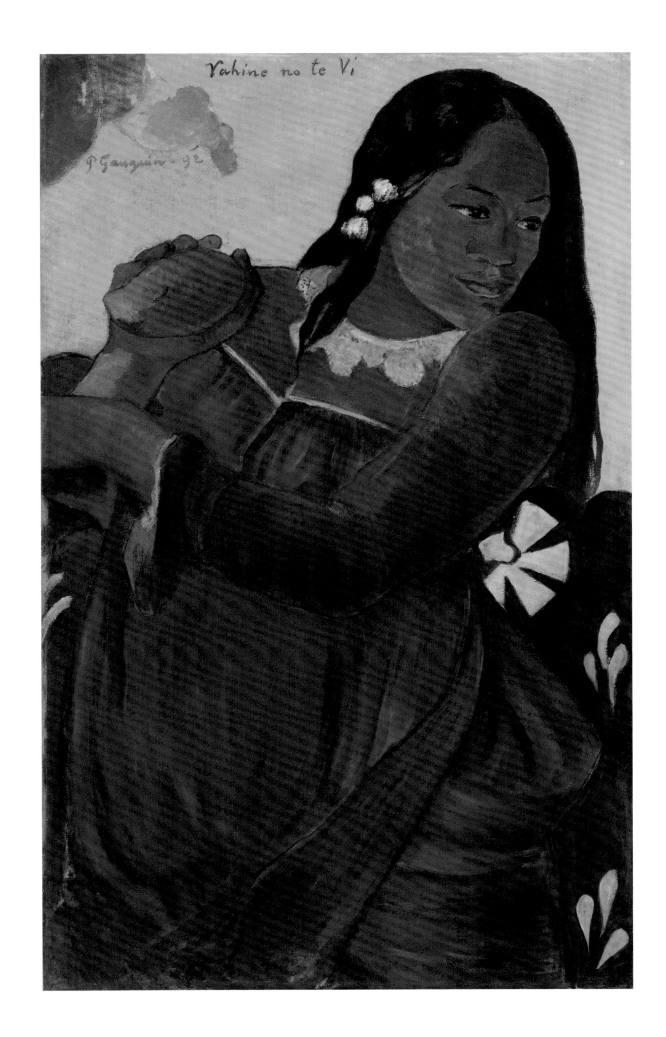

Vahine no te Vi

P Gauguin 92

literary technique allowed him to align himself with the "primitive." In his statements, Gauguin claimed that his artistic creations were connected to his personality through their very forms and the material from which they were made. For instance, he described an "unpolished" and "savage" pot that he bequeathed to Madeleine Bernard, sister of the artist Émile Bernard, as an "expression of myself," equating its rough surface texture with his own rebarbative nature.[21] In a parallel manner, he connected the tone that he sought in his writing with the image that he projected of himself as a "savage," as when he wrote to the critic André Fontainas, regarding *Avant et après*, that "the style must be in harmony with the subject, undressed like the whole man, and frequently shocking."[22]

Gauguin's collaboration with the Symbolist poet Charles Morice on a later version of *Noa Noa* was instrumental in his cultivation of a "primitive" writing style. At some point following his exhibition at the Durand-Ruel gallery, he engaged Morice as a partner. They worked on the text together until Gauguin's departure for Tahiti in 1895, but were unable to complete it to their mutual satisfaction, apparently due to Morice's prevarications.[23] During their phase of co-operation in 1894–95, the idea emerged to intersperse Gauguin's original tale with prose poems and verse by Morice, in roughly alternating chapters. Those consisting of Gauguin's ostensibly personal story were given the title "Le conteur parle" (the storyteller speaks), thereby seeming to affirm both their unrehearsed quality and the artist's association with the oral traditions of Polynesia. A preface, entitled "Memory and Imagination," defined the terms of the partnership, with the painter offering "the simplest tale" based on his memories, and the poet creating a work of art in his own turn, inspired by the artist's pictures.[24] The enterprise was thus construed as a contrast between nature (the artist) and culture (the poet).

Morice is often vilified for corrupting Gauguin's spontaneous chronicle with his tediously overwrought Symbolist poems. However, as Gauguin saw it, this conflict of styles worked in his favour and was always part of the intended effect. As he later explained to De Monfreid:

> I wanted, when I wrote of the non-civilized people, to contrast their character with our own. And I thought it would be interesting to write (me quite simply as a savage) alongside the *style* of a civilized human being, as is that of Morice. So it was in this way that I *thought of and directed* the collaboration. And then, too, not being a professional writer, I wanted to see *which of us* was the more valuable – the naive and brutal savage, or the rotten civilized man.[25]

The opposition between Morice's "professional" style and his own "naive" one could be construed, then, as intended to reflect the confrontation between Europe and Polynesia that is explored in *Noa Noa* through the narrator's various encounters with Tahiti and its inhabitants.[26] However, this self-conscious strategy in itself contradicts Gauguin's protestations of naïveté. It points to his literary ambitions and calls into question the idea that *Noa Noa* was simply an artless travel diary or memoir.

Indeed, the opposition between "savage" and "civilized" was a device that Gauguin used on other occasions as a means of throwing his own "primitive" style into relief. In 1895 he orchestrated an exchange of letters with the playwright August Strindberg, which he printed in the catalogue for an auction of his works designed to fund his return to Tahiti.[27] Strindberg had ostensibly refused Gauguin's request that he write the catalogue preface, on the grounds that he could not understand the painter's art. By printing this refusal alongside his own reply, Gauguin was able to stage a "clash," as he put it, with Strindberg, "between your civilization and my barbarousness."[28] Gauguin was also fond of referencing Jean de La Fontaine's seventeenth-century fable "The Dog and the Wolf" (in which the famished wolf forgoes the comforts enjoyed by the domesticated dog in exchange for its freedom). Writing to Morice in 1901, he contrasted his own radical symbolism with the more orthodox allegorical mode of Pierre Puvis de Chavannes by claiming that "He is Greek, whereas I am a savage, a wolf in the woods without a collar."[29] In a 1902 letter to De Monfreid, Gauguin recalled that Edgar Degas had defended him to some uncomprehending visitors at the Durand-Ruel exhibition by

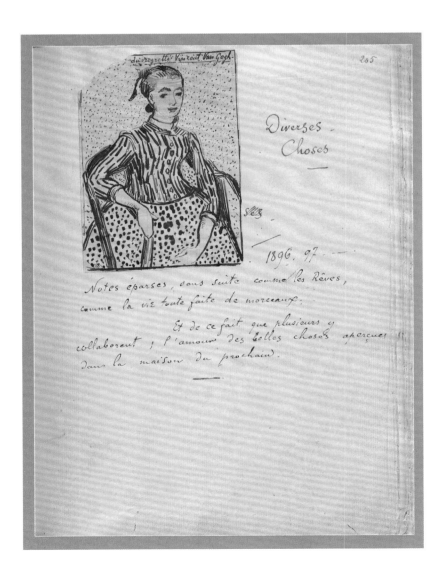

97 Title page of *Diverses choses* (from *Noa Noa*, Louvre manuscript), 1894–1901

recounting La Fontaine's fable, explaining "Gauguin is the wolf."[30] Asking if De Monfreid would write a catalogue essay for an exhibition of his work slated to take place in Paris the following year, he suggested that his friend could use the analogy again, since "the quotation ... would serve as a good theme."[31]

At other times, Gauguin located this tension between "savage" and "civilized" within his own character, citing the division between two aspects of his nature, "the Indian and the sensitive," or anointing himself a "civilized savage."[32] This duality was, of course, another aspect of his self-mythologization, evoking the inner struggle intrinsic to genius. However, there is also a sense in which it more aptly conveys his conflicted status as an outsider to both the colonial and indigenous communities in Tahiti. Gauguin's self-declared dualism also better reflects the fact that his role as the originator of the *Noa Noa* project was not actually limited to that of the "naive" narrator, but required a "sophisticated" literary self-consciousness too. Moreover, as the venture evolved, the original distinction between the artist's "simple tale" and the poet's more literary response became blurred as both parties introduced further changes.

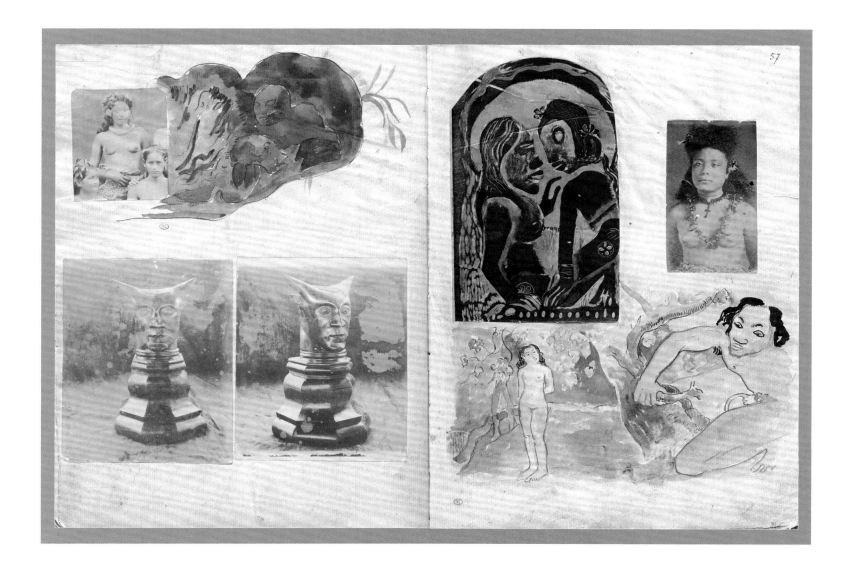

98 Pages from *Diverses choses* (from *Noa Noa*, Louvre manuscript), 1894–1901 **173**

When Gauguin returned to Tahiti in 1895, each author kept a copy of the revised narrative and continued to work on it separately. Morice published the first full edition in 1901, including substantial further changes not approved by the artist, and Gauguin never saw it.[33] Meanwhile, Gauguin augmented and illustrated his copy of the joint text back in Tahiti over a number of years. This version, known as the Louvre manuscript (see ill. 94), is followed by the essay *Diverses choses*, completed in 1898. Bound in the same volume, but with a separate title page (ill. 97), it has not been published in full and has never been included in printed or facsimile editions of the Louvre manuscript of *Noa Noa*. Distributed among the pages of both texts are sequences of commercial photographs, reproductions of artworks, pasted-in fragments of Gauguin's woodcuts, sketches and original watercolours (see ills. 98, 99).[34]

Because it contains Morice's poems and editorial revisions, the Louvre manuscript is typically dismissed as merely a rough draft of the poet's final version.[35] But this is to ignore those elements, absent from both the first draft and Morice's final 1901 edition, which are very much Gauguin's own, including *Diverses choses* and the manuscript's striking collage aesthetic.[36] While admired in their own right, the illustrations are usually thought to be an arbitrary, detachable feature of the manuscript, serving only as place-fillers on pages that were left blank while Gauguin awaited further poems from Morice.[37] However, Gauguin always intended *Noa Noa* to have a visual dimension. In 1894 he urged Morice to complete his portion of the work, since he wanted the book to be available alongside the suite of ten woodcuts that he had created to accompany it, and which he exhibited in his Paris studio in 1894.[38] In the course of his attempts to find a publisher for *Noa Noa*, Morice also referred on a number of occasions to "drawings" by Gauguin that were difficult to reproduce.[39] Although ultimately the visual component of the Louvre manuscript took a different form, the collaged images are far from arbitrary. In their diversity of sources and media they replicate the eclectic display of reproductions on the walls of Gauguin's Paris studio. There, he read extracts from the text during gatherings, introducing a three-dimensional and performative element to its mediation of his artistic identity.[40]

Gauguin also used the collaged sequences of the Louvre manuscript to construct a visual and verbal self-portrait, showing himself through the eyes of others, or in the guise of various alter egos. For example, in one sequence of pages in *Diverses choses*, he transcribed a favourable review, which he introduced with the words "Mon portrait par Jean Dolent" (My portrait by Jean Dolent). The article compares Gauguin to his own depictions of Christ, and describes him as a "martyr."[41] It is followed by several pages of pasted-in reproductions, including Lucas van Leyden's *Jesus Meeting Saint Veronica* (1521), which visually affirms the association with divine suffering. Midway through his transcription of Dolent's piece, Gauguin introduced a double-page spread (ill. 100), inaugurated at top left by a caricatural sketch of his own "savage" visage. Masquerading as "mon portrait par ma Vahine Pahura" (my portrait by my vahine Pahura), it is a visual equivalent of Dolent's

verbal "portrait."[42] On the right-hand page, clippings from a review by Roger Marx of Gauguin's 1893 Paris exhibition include a portrait photograph that positions the artist in front of one of his paintings, as well as reproductions of his other works – cementing the association between Gauguin and his creations – and a fragment of the text, in which Marx compares him to Charles Baudelaire. Consolidating this affiliation with his literary counterparts, Gauguin implicitly aligns himself with another of his heroes, Paul Verlaine, by placing his self-portrait sketch directly above his transcription of one of the poet's sonnets.

Thus the Louvre manuscript of *Noa Noa*, as developed by Gauguin in Tahiti, evolved into a multi-faceted, multimedia dramatization of his artistic identity. In other writings, too, he explored the shifting nature of identity, much as he did in his self-portraiture, through the adoption of different authorial voices.[43] In *Le Sourire* (1899–1900), the newspaper that he wrote, printed and distributed in

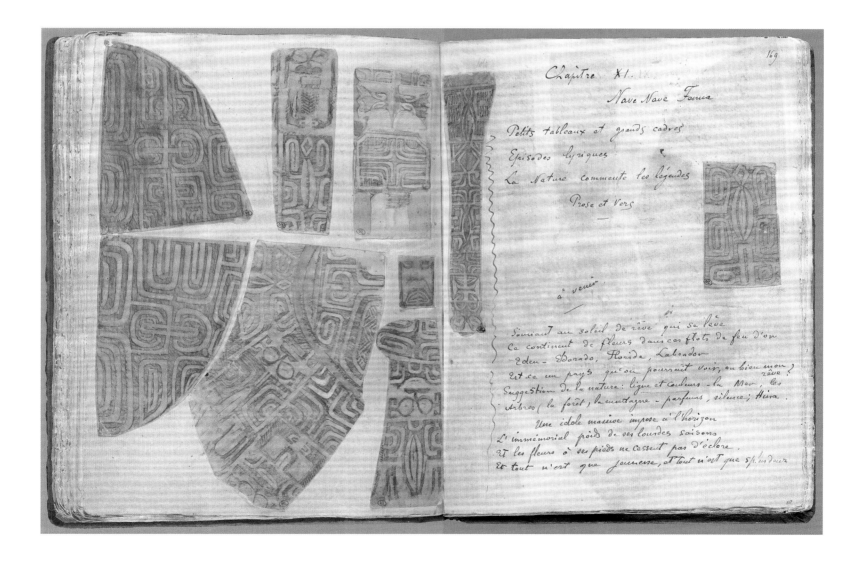

Mon portrait par ma Vahiné Pahura.

Vers DE Verlaine.

Le ciel est par dessus le toit
Si Bleu , si calme !
Un Arbre, par-dessus le toit
Berce sa palme.

La cloche dans le ciel qu'on voit
Doucement tinte.
Un Oiseau sur l'arbre qu'on voit
Chante sa plainte.

– Qu'as-tu fait, ô toi que voilà
Pleurant sans cesse,
Dis, qu'as tu fait, toi que voilà
De ta jeunesse ?
Mon Dieu, mon Dieu, la vie est là
Simple et tranquille
Cette paisible rumeur là
Vient de la ville.

———

– Teo Teo –
Accompagnement de la mer se brisant sur les rochers
de corail ,

St Bernard – O beata solitudo !
O Sola beatitudo !

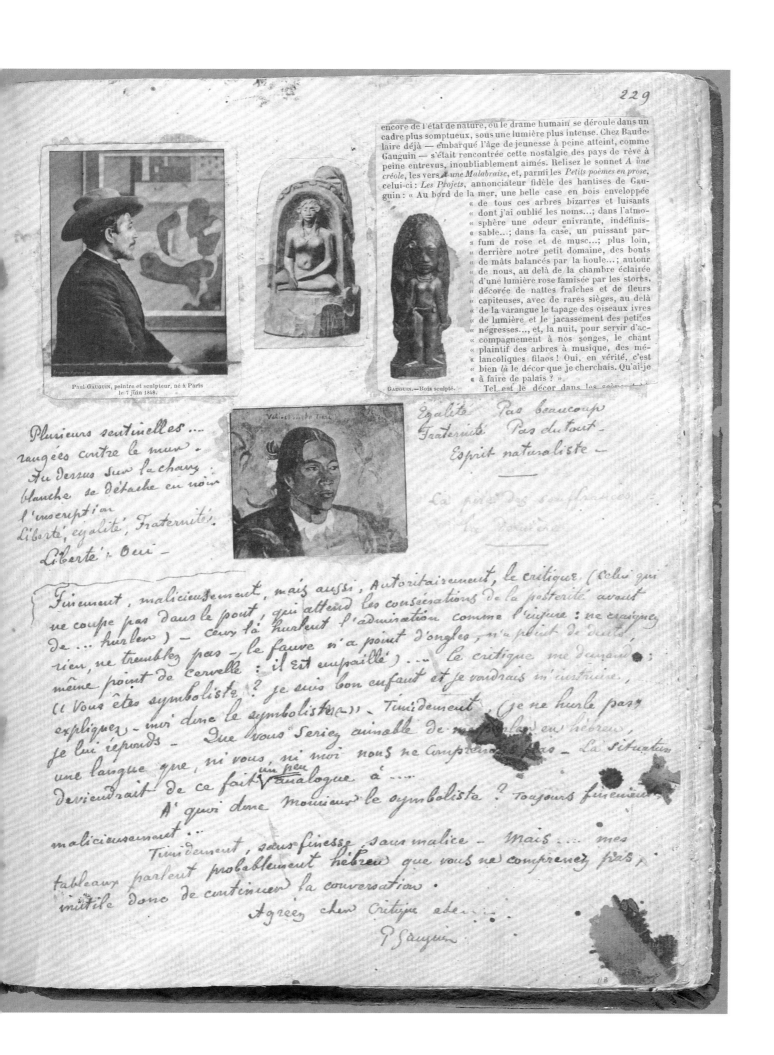

encore de l'état de nature, où le drame humain se déroule dans un cadre plus somptueux, sous une lumière plus intense. Chez Baudelaire déjà — embarqué l'âge de jeunesse à peine atteint, comme Gauguin — s'était rencontrée cette nostalgie des pays de rêve à peine entrevus, inoubliablement aimés. Relisez le sonnet *A une créole*, les vers *A une Malabraise*, et, parmi les *Petits poèmes en prose*, celui-ci : *Les Projets*, annonciateur fidèle des hantises de Gauguin : « Au bord de la mer, une belle case en bois enveloppée « de tous ces arbres bizarres et luisants « dont j'ai oublié les noms...; dans l'atmo- « sphère une odeur enivrante, indéfinis- « sable...; dans la case, un puissant par- « fum de rose et de musc...; plus loin, « derrière notre petit domaine, des bouts « de mâts balancés par la houle...; autour « de nous, au delà de la chambre éclairée « d'une lumière rose tamisée par les stores, « décorée de nattes fraîches et de fleurs « capiteuses, avec de rares sièges, au delà « de la varangue le tapage des oiseaux ivres « de lumière et le jacassement des petites « négresses..., et, la nuit, pour servir d'ac- « compagnement à nos songes, le chant « plaintif des arbres à musique, des mé- « lancoliques filaos ! Oui, en vérité, c'est « bien là le décor que je cherchais. Qu'ai-je « à faire de palais ? » Tel est le décor dans les co...

Paul GAUGUIN, peintre et sculpteur, né à Paris le 7 juin 1848.

GAUGUIN.—Bois sculpté.

Plusieurs sentinelles ...
rangées contre le mur .
Au dessus sur la chaux
blanche se détache en noir
l'inscription
Liberté, égalité, Fraternité.
Liberté : Oui —

Egalité Pas beaucoup
Fraternité Pas du tout —
 Esprit naturaliste —

La ... des souffrances ...
 de Daumier

Finement, malicieusement, mais aussi, Autoritairement, le critique (celui qui ne coupe pas dans le pont, qui attend les consécrations de la postérité avant de ... hurler) — ceux là hurlent l'admiration comme l'injure : ne craignez rien, ne tremblez pas — le fauve n'a point d'ongles, n'a point de dents, même point de cervelle : il Est empaillé) ... Le critique me demande : (« Vous êtes symboliste ? je suis bon enfant et je voudrais m'instruire, expliquez-moi donc le symbolisme. » Timidement, (je ne hurle pas) je lui réponds — Que vous seriez aimable de me ... en hébreu, une langue que, ni vous, ni moi nous ne comprenons pas — La situation deviendrait de ce fait un peu analogue à ...
 À quoi donc Monsieur le symboliste ? Toujours finement malicieusement ...
 Timidement, sans finesse, sans malice — Mais ... mes tableaux parlent probablement hébreu que vous ne comprenez pas, inutile donc de continuer la conversation.
 Agréez cher Critique etc...
 P Gauguin

Tahiti, and as a correspondent for the Tahitian Catholic party newspaper *Les Guêpes*, he sometimes used the pseudonym Tit-Oïl, whose obscenity (it is close to the Tahitian words for shit and masturbation) conveys the aggression and ambivalence of his status as rebel within the colonial system.[44] On one occasion in *Le Sourire* he penned a theatre review in the voice of a female critic, signing it Paretenia (Tahitian for virgin) – a move not unlike the attribution of his self-portrait sketch to Pahura, or his decision to sign his painting *Still Life – Fête Gloanec* (Musée

101 Page from *Cahier pour Aline*, 1893 (pre-restoration)

des beaux-arts d'Orléans, 1888, W290/W301 [2001]) as "Madeleine B" in reference to the younger sister of his colleague Émile Bernard.[45] In a further instance of this tendency to switch genders, an untitled notebook compiled around 1893 – known as *Cahier pour Aline* after the dedication to his daughter – bears the now hardly visible inscription "Journal de jeune fille" (a young girl's diary) on the front cover, suggesting that he wrote it *as*, as much as *for*, his young daughter.[46]

Resembling a commonplace book or scrapbook, *Cahier pour Aline* consists of personal reminiscences and anecdotes, mingled with the transcribed words of other authors. In the case of the newspaper articles reviewing Gauguin's work that open and close the manuscript, these have been literally cut and pasted, producing a jostling of names and perspectives (ills. 101, 102).[47] Following the dedication to Aline, it opens with the phrase "Scattered Notes, without sequence like dreams, like life all made of fragments," which is also found in two later manuscripts, *Diverses choses* and the unconventional memoir *Avant et après* (1903), which are also composed in a non-linear manner; in these two later texts, the sentence continues: "And because others have collaborated in it, the love of beautiful things seen in your neighbour's house."[48] Among the citations in the *Cahier*, alongside the "Notes by Edgar [Allan] Poe" and other quotations and pro-verbial sayings, are the "words of Zunbul-Zadi."[49] This is an allusion to an aesthetic credo that Gauguin circulated in 1886 and attributed to an invented Oriental painter, whom he also called "the great professor Mani Vehbi-Zunbul-Zadi."[50] He reprised and adapted this fake treatise on several occasions, echoing the way in which he recycled motifs across different media and assumed various identities – from Buffalo Bill to Christ – in his letters and self-portraits. Gauguin's ostensibly autobiographical writings do not offer transparent access to his inner self, but engage in an equivalent process of impersonation and role play to that found in his visual art.

Expectations of biographical truth weigh more heavily on texts by artists because they are assumed to lack the literary skills to manipulate their stories. "As soon as he picks up a pen," Jean Loize argues, "Gauguin is entirely spontaneous, with no literary tricks: he knows that he is barbarous and shocking."[51] Gauguin himself encouraged this perception of his authorial limitations, claiming that he spoke about painting "not as a literary man, but as a painter" and that his books were written with "no literary pretension."[52] As we have seen, his role play as a "naive" writer was designed to differentiate his own "primitive" text from Morice's conventional prose. But this anti-literary attitude was also widely shared by nineteenth-century artist-writers, who were wary of being perceived as overstepping the boundaries of their own areas of expertise. *Noa Noa* fits into a tradition of travel writings by artists who promoted themselves as unpretentious and were valued for their authenticity. As Elizabeth Childs has observed, Eugène Delacroix's notes on his 1832 journey to North Africa, recorded in his annotated sketchbooks and ambitious journal, an edition of which was published in 1893, were a notable precedent.[53]

In a passage from a planned book on his travels to Morocco, Delacroix expressed his distaste for lengthy description, calling it "the plague of literature."[54] This sentiment was shared by Gauguin, who declined the artist Émile Schuffenecker's request for a description of Tahiti by saying that "One day a painting will come and you will read my 'description' in a couple of seconds."[55] Gauguin would not have seen Delacroix's account of his journey, provisionally titled "Souvenirs d'un voyage dans le Maroc," as the manuscript has only recently been unearthed.[56] But he could have known of Delacroix's intention to write it, as the project was mentioned by the artist's executor, Eugène Piron, in his anthology of Delacroix's writings printed in 1865.[57] In any case, the publication of Delacroix's diaries clearly showed the public appeal of an intimate form of writing. As Richard Hobbs has revealed, there was an increasing appetite for artists' writings in late-nineteenth-century France, and the voyage memoir was one of the genres in which they excelled.[58]

Gauguin knew Delacroix's writings, as he copied a section from Piron's anthology, in which his predecessor praised the superiority of visual art over literature, into *Diverses choses*.[59] In a passage from this same volume discussing his unrealized project for a Dictionary of Fine Arts, Delacroix insisted that the structural difficulties of writing a book, with its divisions of material and thematic developments, are all the more acute "when one is not a professional author, when one writes only in order to give in to the need to express ideas as and when they come."[60] This point of view was often expressed in the travel writings of nineteenth-century artists. For instance, Jan Baptist Huysmans, a Belgian Orientalist painter who published two accounts of his journeys to Italy, Spain and Algeria in the 1850s and 1860s, introduced the first volume by insisting that "I have no intention of posing as a writer. Wielding the brush is enough to satisfy my ambition: the pen is not my thing."[61] However, he is clearly conscious that what he calls a "naive and crude draft" from the "innocent pen of a painter tourist" has the virtue of greater local colour.[62] A simple account of chance events and things observed in passing, he suggests, may shed more light on the customs and character of a place than would a learned description.[63]

In the 1874 preface to the collective edition of his two travel accounts of the Sahara and the Sahel, Eugène Fromentin (who had already published a novel, *Dominique*, in 1862) emphasized that he was not a writer by trade, and that the public had been kind enough to accept his foray into a sphere that "did not and should not belong to him."[64] His decision to structure his account in the form of (fictional) letters was a device, he explained, that enabled him to do without any formal method.[65] In one of the letters, he informs his correspondent that he will not attempt to introduce any sort of order into what he calls his "notes," but will simply write things down as they happen, without worrying about the overall structure.[66] This seemingly casual approach was typical. Narcisse Berchère, whose account – published in 1863 – of his journeys to Egypt to document work on the Suez Canal was also in an epistolary format, claimed that his letters were "written somewhat aimlessly."[67] He had, he insisted, "no ambition to write a book," but simply to offer a "sincere reflection" of the land and the effect that it had upon him. He warned his addressee – Fromentin again – to expect shifts in tone, since "I let my pen run on, following the whim of the often varied scenes that pass before my eyes."[68] Berchère argued that his haphazard structure reflected the peripatetic nature of travel itself, in which "impressions come one after the other, present themselves and muddle themselves up without much respect for carefully managed transitions."[69]

In other words, although he apologizes for it, Berchère's seemingly disorganized style is consciously designed to suit its theme. A lack of literary skill, it seems, was the very quality required to be a good travel writer. By presenting themselves as inadequate writers, these artists were simultaneously announcing their qualifications as ideal chroniclers of the "exotic." Similarly, emulating this modest

approach allowed Gauguin to distinguish his candid narrative from the polished clichés, not only of his literary partner Morice, but of Orientalist novelists such as Pierre Loti (Julien Viaud), author of the hugely popular Tahitian romance *Le Marriage de Loti*, whose "innumerable adjectives" Gauguin identified disparagingly as the mark of a "talent for description."[70] Despite his disdain, however, Gauguin could not have failed to recognize the publicity potential in imitating Loti's Tahitian fable. With its emphasis on dramatic episodes and romance, rather than descriptive detail, *Noa Noa* is in some respects closer in tone to Loti's fiction than to the diaristic or epistolary mode of his fellow artists' travel writings.

Indeed, on a basic structural level, the similarities between Loti's tale and Gauguin's are unavoidable. In both cases, the confrontation between Europe and Polynesia is symbolized by the protagonist's love affair with an adolescent Tahitian female, and Loti's fictional fourteen-year-old Rarahu is as much the model for Tehamana as any real-life Tahitian wife or model. The relationship between France and its exotic "Other" is therefore cast as a (gendered) contrast between mature and cultured wisdom versus youthful and intuitive innocence. In both cases the protagonist's marriage to his young companion symbolizes communion with the indigenous population. Following the standard structure of the voyage memoir, both accounts are arranged as a series of journeys, progressing from initial disappointment on arrival in the capital to insights gained during excursions to less populated areas, and ending in the bittersweet sorrow of departure.

However, the ease with which Loti slips into his new habitat is in marked contrast to the sense of displacement that Gauguin's narrator experiences. In charting the protagonist's transformation from "civilized" to "savage," *Noa Noa* tracks an ambivalent set of false starts and ironic encounters between self and other, rather than any straightforward evolution. In the often-cited "woodcutter" episode, the narrator tells how a young Tahitian man, to whose androgynous form he is physically attracted, guided him on an expedition to find wood for carving. When the artist and his guide reach the chosen tree and begin to attack it with an axe, he experiences a transfiguration: "I struck furiously," he cries, "and, my hands covered with blood, hacked away with the pleasure of sating one's brutality ... Well and truly destroyed indeed, all the old remnant of civilized man in me. I returned at peace, feeling myself thenceforward a different man, a Maori."[71]

For most commentators, this episode marks what is assumed to be Gauguin's own, staged conversion from European to "primitive." However, even after this event, the narrator ironically highlights the fragility of his conversion. He frequently undermines his "savage" identity, or adopts it as a sign, not of assimilation, but of his own difference: "For them too, I was the savage."[72] Depending on his point of comparison, he represents himself either as a primitive artist-prophet or as a European, alternately inept – as when he lacks the physical skills required to provide food for himself – or (temporarily) superior.[73] After a successful catch on a fishing expedition, for example, no sooner has he acquired "native" skills than

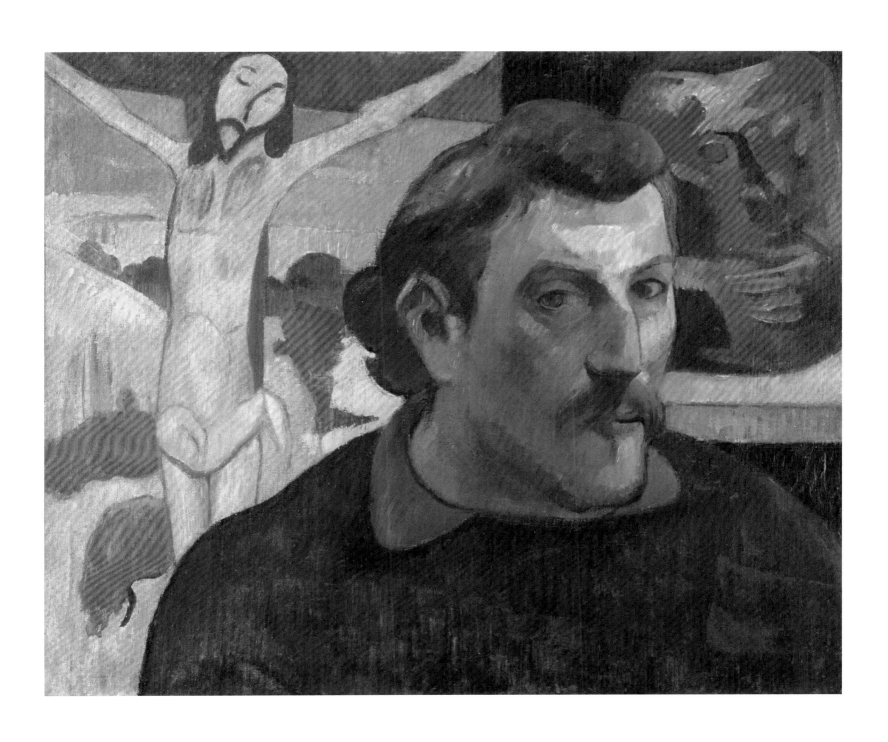

103 *Self-portrait with Yellow Christ*, 1890–91 **183**

he signals his difference by heralding his European nationality: "clearly the Frenchman brought luck."[74] He immediately regrets his outsider status, however, when his companions reveal that his particular fishing technique is an omen of his wife's infidelity.

No straightforward autobiography, *Noa Noa* was a key part of a carefully orchestrated campaign on Gauguin's part to construct an image of himself as a "savage." His seemingly artless mode of narration in the first draft, which has contributed to its reputation as a guileless record of his Tahitian experience, was deliberate and strategic. It was intended to counterbalance Morice's elaborate prose, and it fitted with expectations of artists' writings as simple and authentic. However, just as Gauguin's narrator remains at least partially aware that he cannot fully shed his "civilized" self, so too could Gauguin at times admit an association with a more self-consciously literary style. In a passage of *Avant et après*, he wrote that "The subterfuges of language, the artifices of style, brilliant turns of phrase that sometimes please me as an artist are not suited to my barbaric heart," but acknowledged that "One understands them and tries one's hand at them; it is a luxury which harmonizes with civilization and which for its beauties I do not disdain."[75]

In his *Self-Portrait with Yellow Christ* (ill. 103) Gauguin portrays himself flanked by two of his own works that also bear his features: the Breton *Yellow Christ* (1889, Albright-Knox Art Gallery, Buffalo, W327) and his ceramic pot in the form of a grotesque head (ill. 110). Positioned on either side of his imposing form, they stand for the two sides of his character – divine and savage – and consolidate the theme of the artwork as an expression of its maker. In the shifting identity of its narrator, and the unstable partnership between "civilized" poet and "primitive" painter, *Noa Noa* provided another means for Gauguin to stage his "dual" identity. A portrait of the artist as "savage" creator, it is as deliberately constructed as his myriad visual self-representations.

NOTES

1 I use Gauguin's spelling instead of the Tahitian "Teha'amana" to indicate that I am referring to Gauguin's fictional character rather than a potential historical referent.

2 As is often noted, Pomare's demise was but a figurative end to Tahitian self-governance as control had long since passed to the colonial authorities, but it allowed Gauguin to set the tone of disappointment at the fading of the "true" Tahiti that he had hoped to find – a disillusionment that is in itself a literary trope.

3 An appendix, not preserved in later editions of the text, contrasts sharply with the main body of the narrative both in its drier tone and its greater level of precision. In it, Gauguin detailed the bureaucracy surrounding his journey. He listed the names of colonial officials involved and of fellow travellers on his return voyage. His own name is also mentioned once here, in reported dialogue. Tellingly, this section begins "After the work of art the truth, the dirty truth," thus hinting at the fictional nature of what had gone before (Gauguin 1985, p. 43).

4 For an exception that places it within the context of nineteenth-century artists' writings, see Richard Hobbs, "Reading Artists' Words," in Smith and Wilde 2002, pp. 173–182, and for a rare analysis of Gauguin's use of language, see Alastair Wright, "On Not Seeing Tahiti: Gauguin's *Noa Noa* and the Rhetoric of Blindness," in Broude 2018, pp. 129–156.

5 De Man 1984, p. 70.

6 Ibid., p. 69.

7 Gauguin 1922, p. 165.

8 Gauguin 1923, pp. 1–2.

9 Ibid., pp. 157–158.

10 Letter from Gauguin to Mette Gauguin, Paris, October 1893, in Gauguin 1949, no. 145, p. 187.

11 Cited in Eugène Tardieu, "Interview with Paul Gauguin," *L'Écho de Paris* (13 May 1895), reprinted in English in Gauguin 1996, p. 110 (trans. modified).

12 For instance, Nancy Mowll Mathews observes that "it is difficult to rely on *Noa Noa* for factual information," but also that "the writing seems rooted in his actual experience" (Mathews 2001, p. 178).

13 Conducting fieldwork in Polynesia in the 1950s and 1960s, Bengt Danielsson met a man who claimed to have married Tehamana after Gauguin left, and other local residents who testified to aspects of her behaviour and appearance, but such details provide tantalizing hints rather than conclusive evidence about her identity. He notes that her death certificate, which records her date of death as 9 December 1918, is preserved in the Registry Office in Papeete, but he provides no further information (such as a full name) to securely connect the Tehamana of the certificate to the one recalled by his informants. See Danielsson 1975, pp. 343–344, n. 57; p. 344, n. 60; pp. 344–345, n. 66.

14 Stephen F. Eisenman, for example, declares that the figure in *Delightful Land* (*Te nave nave fenua*, 1892, W455) is "probably modeled from the artist's lover Teha'amana," then elides the two, referring to "Teha'amana's nude body" and (in reference to the figure's extra toes) to "Teha'amana's curious disfigurement" (Eisenman 1997, p. 66).

15 Gauguin 1985, p. 33.

16 "I will soon be a father again in Oceania" (letter from Gauguin to Daniel de Monfreid, September 1892, in Gauguin 1950, p. 68, cited in Charles F. Stuckey, "The First Tahitian Years," in Brettell 1988, p. 213). The fact that the child is not mentioned again has led to diverging speculations as to its fate: abortion (Danielsson 1975, p. 136); adoption (Mathews 2001, p. 59); the child's death (Sweetman 1995, p. 339); and Tehamana's death (Stuckey, "The First Tahitian Years," p. 213).

17 Gauguin 1985, p. 32.

18 On the photographic source, see Childs 2001a, p. 70, n. 55. Gauguin's narrative resembles a similarly voyeuristic waterfall scene in the popular romance by Pierre Loti (Julien Viaud), *Le Mariage de Loti* (*The Marriage of Loti*, 1880, see Loti 1925, pp. 21–22): when Loti first spies his young Tahitian mistress, Rarahu, she is lying naked in the Apiré Falls, unaware of his presence. For another example of this theme, see Monchoisy 1888, pp. 56–57.

19 Solomon-Godeau 1992, p. 314; see also Pollock 1992.

20 Notable examples are: Thomson 2010, especially Belinda Thomson's essay, "Paul Gauguin: Navigating the Myth," pp. 10–23, and the section introduction "Identity and Self-Mythology," pp. 71–75; Alastair Wright, "Paradise Lost: Gauguin and the Melancholy Logic of Reproduction," in Wright and Brown 2010, pp. 49–99; and Moran 2017.

21 Letter from Gauguin to Émile Bernard, Arles, December 1888, in Gauguin 1949, no. 78, p. 116 (trans. modified).

22 Letter from Gauguin to André Fontainas, Atuana, February 1903, in ibid., no. 177, p. 232.

23 On the history of the different versions of *Noa Noa*, see Gauguin 1985 (intro); Isabelle Cahn, "Noa Noa: The Voyage to Tahiti," in Shackelford and Frèches-Thory 2003, pp. 91–113; and Goddard 2008, pp. 277–293.

24 Gauguin and Morice 2017, p. 22.

25 Letter from Gauguin to Daniel de Monfreid, May 1902, in Gauguin 1922, pp. 155–156 (trans. modified).

26 See Gauguin 1985. In this edition, Nicholas Wadley convincingly challenges the prevailing view that the first draft manuscript was the only authentic version, and shows how this assumption had been exacerbated by the reverse order of publication, with the first draft only coming to light in 1954. Nonetheless, he still proposes that Gauguin asked Morice to help him because he "was not a writer himself" and was "consistently attracted to young men intellectually more articulate than himself" (p. 101), and therefore takes at face value Gauguin's own contrast between his "primitive" style and Morice's cultured one.

27 *Vente de tableaux et dessins par Paul Gauguin, artiste peintre, Hôtel des ventes, salle 7, le lundi 18 février 1895*, Paris, 1895.

28 Gauguin 1896–98, p. 244. Strindberg's and Gauguin's letters were published in *L'Éclair* on 15 and 16 February 1895 respectively, and Gauguin transcribed both letters into *Diverses choses* (Gauguin 1896–98, pp. 243–246) and Strindberg's into *Avant et après* (Gauguin 1923, pp. 18–21). On their exchange, see Morehead 2014.

29 Letter from Gauguin to Charles Morice, Tahiti, July 1901, in Gauguin 1949, no. 174, pp. 226–227.

30 Letter from Gauguin to Daniel de Monfreid, 25 August 1902, in Gauguin 1922, p. 158.

31 Ibid.

32 Letter from Gauguin to Mette Gauguin, c. 22 January 1888, in Gauguin 1984, no. 139, p. 170; and letter from Gauguin to an unknown correspondent [probably Morice's wife], Tahiti, February 1899, in Gauguin 1949, no. 169, p. 214.

33 Gauguin and Morice 1901. A manuscript of *Noa Noa* in Morice's hand, dated 1897, in Paley Library, Temple University, Philadelphia, contains minor variations to this published edition. The whereabouts of his copy of the joint manuscript of 1894–95 is unknown. In 1897 Morice published extracts in *La Revue Blanche* 14, no. 105, pp. 81–103 and no. 106, pp. 166–190.

34 Louvre Museum, Département des arts graphiques, Fonds du Musée d'Orsay, Paris, RF7259. First facsimile (minus *Diverses choses*), Berlin/Munich, 1926. *Diverses choses* (1896–98) can be consulted in facsimile on the CD-ROM *Gauguin écrivain* (2003). Extracts are included in Gauguin 1974.

35 Nicholas Wadley calls it an "intermediate state" (Gauguin 1985, p. 8); Jean Loize describes it as "merely a first state, obviously incomplete, of the version sketched out by Gauguin's collaborator, Charles Morice" (Jean Loize, "The Real *Noa Noa* and the Illustrated Copy," in Gauguin 1961, p. 69).

36 For a fuller discussion of Gauguin's writing as a material practice closely related to his visual art, see Goddard 2019. On the foregrounding of reproduction in Gauguin's art and writing, and the significance of this to his colonial identity, see Wright, "Paradise Lost," pp. 49–99. Gauguin's habit of borrowing, adapting and reiterating motifs across media is a strong theme in the current literature on the artist, and the focus of two recent exhibitions: *Gauguin: Metamorphoses* at the Museum of Modern Art (see Figura 2014) and *Gauguin: Artist as Alchemist* at the Art Institute of Chicago and Grand Palais, Paris (see Groom 2017).

37 Among the few accounts that address the physical form of the Louvre manuscript, see in particular Moran 2017, pp. 147–151, and Wright, "Paradise Lost," pp. 81–85, 88–90. Moran's recent edition (Gauguin and Morice 2017) is the first full transcript (minus the illustrations and *Diverses choses*) to include all of Morice's contributions since that published under the auspices of Daniel de Monfreid by Crès in Paris in 1924.

38 Gauguin wrote to Morice that he had just "finished my work (engraving) for *Noa Noa*. I believe that will contribute much to the success of the book. It is therefore necessary that the book be finished, and as soon as possible" (unpublished letter from Gauguin to Charles Morice, cited in Jean Loize, "Gauguin sous le masque ou cinquante ans d'erreur autour de *Noa Noa*," in Gauguin 1966, p. 76). For recent contributions to the literature on the *Noa Noa* suite, see Wright and Brown 2010 and Dario Gamboni, "Gauguin, Cats. 51–60, The Noa Noa Suite: 'Veiled in a Cloud of Fragrance,'" in Groom, Westerby and Solomon 2016, paras 10 to 45.

39 Gauguin 1966, pp. 83, 88–89.

40 See Allison Perelman, "The Burning Yellow Atelier," in Groom 2017, pp. 64–71.

41 Gauguin 1896–98, p. 230.

42 Ibid., p. 227.

43 On Gauguin's literary alter egos, see Wright, "Paradise Lost," especially pp. 66–67 and 71–75; Moran 2017, pp. 100–107, and Linda Goddard, "Gauguin's Alter Egos: Writing the Other and the Self," in Broude 2018, pp. 15–40.

44 For Gauguin's articles in these two publications, see, respectively, Gauguin 1899 and Danielsson and O'Reilly 1965, pp. 1–63.

45 *Le Sourire* 1 (August [1899]), unpaginated, in Gauguin 1899.

46 The phrase was identified by Suzanne Damiron in her 1963 facsimile edition of Gauguin's *Cahier pour Aline*: Gauguin 1963, vol. 1, unpaginated. See also Wright, "Paradise Lost," p. 75.

47 The manuscript is held in the Bibliothèque de l'Institut nationale d'histoire de l'art (INHA), MS 227, and is accessible online at www.purl.org/yoolib/inha/5749 (accessed 28 June 2018). There are two facsimile editions (1963 and 1989; reprint 2014).

48 Gauguin 2009, p. 9, and Gauguin 1896–98, p. 205; and Gauguin 1951b, p. 16.

49 Gauguin 2009, p. 25.

50 Gauguin 1896–98, p. 209; Gauguin 1951b, p. 35. It was published (attributed to "the Hindu [l'hindou] Wehli-Zunbul-Zadé") by Félix Fénéon in *L'Art Moderne de Bruxelles* (10 July 1887), reprinted in Fénéon 1970, vol. 1, p. 81.

51 Gauguin 1961, p. 69.

52 Gauguin 1951b, p. 192; letter from Gauguin to André Fontainas, September 1902, in Gauguin 1949, no. 176, p. 230.

53 Delacroix 1893, vol. 1. See Childs 2003b, p. 75, and Brettell 1988, p. 212.

54 Delacroix 2009, p. 267.

55 Letter from Gauguin to Émile Schuffenecker, 6 December 1895, in Gauguin 1995, p. 88.

56 It was located by Michèle Hannoosh, who published it in her edition of Delacroix's diaries (Delacroix 2009, pp. 264–324).

57 Piron 1865, p. 90, as noted by Hannoosh in Delacroix 2009, p. 181, n. 31.

58 See Richard Hobbs' essays "Reading Artists' Words," in Smith and Wilde 2002, and "L'apparition du peintre-écrivain," in Keith Cameron and James Kearns, eds., *Le Champ littéraire 1860–1900: études offertes à Michael Pakenham* (Amsterdam: Rodopi, 1996), pp. 127–137.

59 Gauguin 1896–98, p. 221. The copied passage is from Piron 1865, pp. 409–410.

60 Piron 1865, pp. 430, 437.

61 Huysmans 1857, cited in Christine A. Dupont, "Comment on devient peintre orientaliste: Les voyages de Jean-Baptiste Huysmans (1856 et 1862)," in Brogniez 2012, p. 68.

62 Huysmans 1865, cited in Bibiane Fréché, "Les peintres belges en voyage: Un continent à explorer," in Brogniez 2012, p. 143.

63 Huysmans 1857, cited in Dupont, "Comment on devient peintre orientaliste," p. 71.

64 Fromentin 1981, p. 57.

65 Ibid., p. 60.

66 Eugène Fromentin, "Alger: fragments d'un journal de voyage," *L'Artiste* (26 July and 2 and 9 August 1857), revised and reprinted in Fromentin 1984, p. 960.

67 Berchère 2010, p. 7.

68 Ibid., p. 38.

69 Ibid.

70 Gauguin 1923, p. 105, and Gauguin 1951b, p. 117.

71 Gauguin 1985, p. 28.

72 Ibid., p. 20.

73 Ibid., pp. 19–20.

74 Ibid., p. 40.

75 Gauguin 1923, p. 132. He concluded this passage with another dualistic metaphor: "There are savages who clothe themselves now and then."

Published in the form of a lithograph in January 1891, as a supplement to the issue of *La Plume* devoted to "The Symbolism of Jean Moréas," this extraordinary drawing with its prestigious provenance has a special place in Gauguin's work.[1] A portrait or "satirical portrait" of the poet Jean Moréas, a complete mockery of him, or a manifesto of the Symbolist movement: the multiple readings of it, some fanciful, show the singularity of this long-celebrated image. In 1973 Philippe Jullian interpreted the drawing as a self-portrait of Gauguin

JEAN-DAVID JUMEAU-LAFOND

with Moréas. Anna-Maria Damigella for her part in 1989 imagined Moréas as a saint haloed by a profane religion, accompanied by an esoteric and erotic symbolism, while in 2004 Hélène Millot very seriously went as far as to see in the drawing a poet flanked by baby Jesus in his manger, and even wondered what character from the Nativity Moréas was supposed to incarnate (Mary, Joseph, the bull or the donkey). More recently, Patrick McGuinness described the *putto* as a "new-born baby," asking himself, "Is this the 'roman' baby born of Symbolism?"[2] This was a much subtler and more justifiable question, as we will see below.

We can smile at some of these suggestions, but the difficulty in interpreting the drawing itself reveals its complexity and its reflection of a very specific context. It is true that Gauguin carefully chose the imperative phrase *"Soyez symboliste"* (Be Symbolist). But here again, this can be read in different ways (as a parody or more seriously), and we cannot help but think of the drawing by Émile Bernard entitled *A Nightmare* (Musée d'Orsay, Paris) that shows Émile Schuffenecker, Gauguin and Bernard in front of a painting on which is written the word *synthétisme*. The temptation to consider Gauguin's drawing simply as a "caricature" or "satirical portrait" is therefore legitimate, but does not resist analysis for very long. We should note that the lithograph was indexed in *La Plume* with this reference: "Symbolist Poetry, composition with portrait of Jean Moréas."

Be Symbolist: Portrait of Jean Moréas (detail, ill. 104), 1890–91

Other portraits published in *La Plume* in 1891 are clearly presented as satirical portraits, which is not the case for Gauguin's drawing. Certainly, it is hard to see why Gauguin would have published a "satirical" portrait of Moréas, even in a friendly way, in a publication that was conceived as a tribute, and that was to be issued shortly before the banquet given in the poet's honour on 2 February. Moreover, this beautiful drawing is intriguing: in it we can certainly recognize the emblematic face of the poet, this Yánnis Papadiamantópoulos known as Jean Moréas, a Greek man who had settled in France in 1880, the author of collections such as *Les Syrtes* (1884) and *Les Cantilènes* (1886) and of the famous manifesto on Symbolism in literature that appeared in *Le Figaro* in September 1886. But the allegorical organization of the drawing appears complex (we also find some elements comparable to the mysterious *Nabic Landscape* painted by Paul Ranson in 1890 [private collection]). The peacock, whose feathers symbolize glory, but perhaps also pride, the cherub brandishing a laurel branch, who expresses astonishment as much as admiration, the phylactery whose inscriptions "*Soyez symboliste*" and "*Les Cantilènes*" spark a somewhat circumspect vision of the bird: everything expresses a form of ambiguity.

Undoubtedly, Gauguin's genius lies in having synthesized, perhaps even without thinking, a very precise moment in literary and artistic history. So, what is the context? Gauguin had recently returned to Paris after his fifth stay in Pont-Aven, and his work was beginning to resonate with the advent of Symbolism in the visual arts, the theoreticians of which (especially Albert Aurier) were busily defining the contours. The painter was then consecrated as one of the heroes of this new movement. Indeed, for the few months he stayed in Paris, Gauguin spent most of his time with writers, noting how popular he was with the Symbolists.

For his part, Moréas, whose Symbolist Manifesto from September 1886 was already five years old, was, at the banquet given in his honour on 2 February 1891, consecrated as the leader of a literary and poetic school that, for him, already belonged to the past as he was in the process of founding the "*école romane*" (Roman school). This new school claimed a return to a Mediterranean and Neoclassical aesthetic, far from the mists of Symbolism.

The dinner was organized to celebrate the publication of *Le Pèlerin passionné*, a collection of poems that marked Moréas' new direction. The "homage" issue of *La Plume* and the celebration given to Moréas were a form of apotheosis, but proved in the end to be a sort of farewell to Symbolism, while the banquet that was given in Gauguin's honour on 23 March of the same year, a send-off dinner before the painter's departure for Tahiti, was instead a kind of anointment ceremony. Among those in attendance at Gauguin's banquet were Stéphane Mallarmé, Charles Morice, Eugène Carrière, Odilon Redon, Albert Aurier (who published his article "Le Symbolisme en peinture: Paul Gauguin" at the same time in the *Mercure de France*) and Moréas himself, who appointed Gauguin the head of the Symbolist movement in painting.

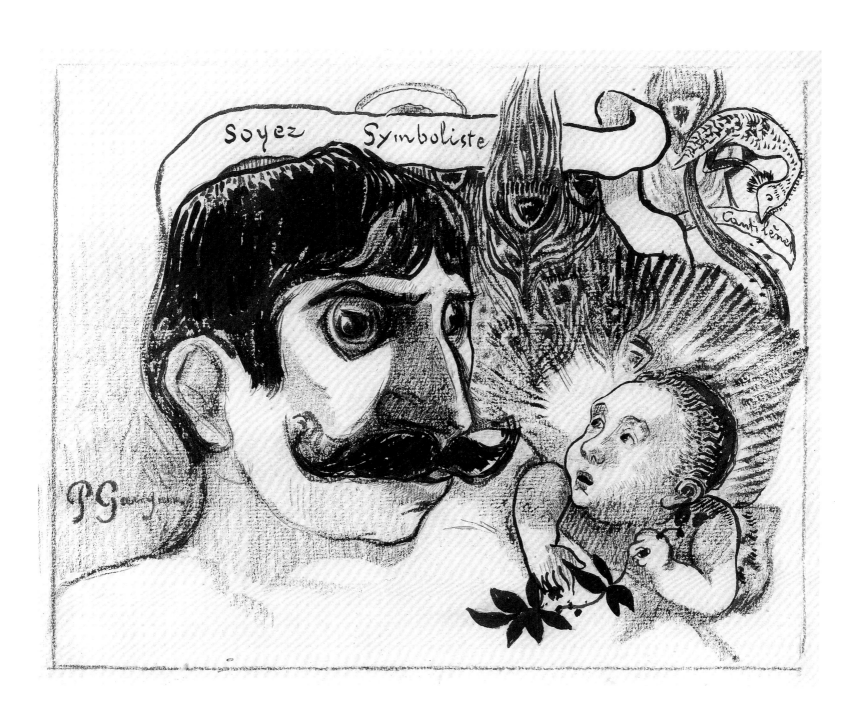

Soyez Symboliste

P Gauguin

Cantilène

104 *Be Symbolist: Portrait of Jean Moréas*, 1890–91 **191**

This rather paradoxical crossover finds a sort of mirror in our drawing. It is Gauguin, a new recruit to the Symbolist milieu, who in an image has sanctified the author of the 1886 manifesto now ready to leave the Symbolist ship for a Neoclassical world. McGuiness' interpretation with respect to this is therefore correct: perhaps the cherub with the laurel branch incarnates this classical "renaissance" sought by Moréas, a "Romanesque" newborn (like the *école romane*), while the peacock looks backward, toward *Les Cantilènes* of the Symbolist past. Because how not to wonder, indeed, about the fact that Gauguin chose to show in his drawing the title of this collection, which was dated 1886 – in other words during Moréas' fully Symbolist period – rather than *Le Pèlerin passionné*, which had just been published?

These divergent aesthetic destinies appear to be confirmed in Charles Morice's 1919 report of an encounter between Moréas and Gauguin, in the company of about a dozen painters and poets, at La Côte d'Or café one evening at the end of 1890. Morice reflected that while Gauguin was praising primitive art and "the most scholarly of all, Egypt" – in contrast to naturalism, "which begins with the Greeks of Pericles" – Moréas' voice rang out, "Mr. Gauguin, Have you read Ronsard?" Morice's account continues:

> It was against Moréas that Gauguin was arguing. ... Moréas, who already carried the *école romane* in his soul and was beginning to work on recruiting for it, was absolutely the most essentially antipathetic mind that could be seen to this doctrine of a reasoned primitivism. Later, however, his thinking broadened, going back far beyond Renaissance horizons to the simplicity of the true Hellenistic spirit, in other words, to the poems of Homer. ... Moréas took note of what was just and fruitful in Gauguin's theories. Without fully subscribing to them himself, he spoke of them only with respect.[3]

In fact, at the end of 1890, Moréas wrote to Léon Deschamps about the issue of *La Plume* that was being prepared: "I have Gauguin's compositions. They are very beautiful;" his portrait therefore did not seem "caricatural."[4] Moreover, in a letter to the journalist Georges Collet, Moréas wrote: "If you can, say also that *La Plume*, whose editor Léon Deschamps is devoted to my theories, will publish on 15 December a special issue under the title 'Le Symbolisme de Jean Moréas' illustrated by the allegorist Paul Gauguin."[5] To this can be added the ambiguous relationship of painters, and Gauguin in particular, to literary theories. The application of the concept of Symbolism to the visual arts in 1891, summarized by Moréas for poetry five years earlier, could only make painters wary.

 In his recent book on Gauguin and Pont-Aven, André Cariou describes Gauguin's joy, after so many difficulties, at being greeted as a hero in Paris at the end of 1890, and his skilful manner of using this Symbolist label, even if he was hardly interested in questions of movements and groups.[6] In this context, Charles Chassé related an anecdote heard directly from Paul Sérusier: "When Gauguin and Sérusier

returned to Paris from Le Pouldu, the Symbolists, whom they had almost ignored until then, let them know that ... they were themselves Symbolists without knowing it."[7] Gauguin thus exclaimed: "Good, we are now Symbolists! Did you understand a single word of these doctrines? – Nothing at all, Sérusier evidently answered. – Me neither, Gauguin apparently said, but let's go for Symbolism."[8] The painter's attachment to this "doctrine" was therefore somewhat opportunistic – not that he was opposed to it, but rather because he was hardly interested in theories. For instance, as Chassé also related, Gauguin wrote the word *sintaise* (as one would write *foutaise* [rubbish]) instead of *synthèse* on a vase, in the same way that Paul Verlaine wrote ironically about the "cymbalists."

As early as 1978 Vojtěch Jirat-Wasiutyński commented on the Symbolist dimension of Moréas' face as drawn by Gauguin, with its big eyes that describe an internal intensity, but also the curious expression of the peacock that scratches its own head while considering *Les Cantilènes*, adding according to him, "a note of ironic detachment, as if to suggest that Gauguin's attitude with respect to some of the most 'literary' aspects of the Symbolists and their work was not always full of respect."[9] In this regard it is not impossible that the imprecation "Be Symbolist" also has a slightly humorous character, and it is evident that Gauguin drew inspiration from his own contemporaneous wooden sculptures: *"Soyez amoureuses vous serez heureuses"* (*Be in Love and You Will Be Happpy*, ill. 54) and *"Soyez mystérieuses"* (*Be Mysterious*, Musée d'Orsay, Paris, 1890). This did not escape Paul Signac, who wrote to Félix Fénéon from the 1891 XX exhibition in Brussels, where Gauguin was showing some work: "Be in Love; Be Mysterious; Be Symbolist; Be Boulangist; Be always well dressed; Be Grenadine; Trust old Gauguin!"[10]

One of Gauguin's most beautiful drawings, *Be Symbolist* is also one of his only portraits of a writer, and so it must be compared to his portrait of Mallarmé (ills. 31, 32, 105), designed at the beginning of 1891. The first drawing for this drypoint similarly presents a face in three-quarter view, while the definitive print includes the mysterious and symbolic presence of a raven, a reference to Mallarmé's translations of the poems of Edgar Allan Poe. From the enigmatic peacock that accompanies Moréas to Mallarmé's raven, Gauguin has practised the same type of association: a pre-eminent figure in the presence of symbolic elements that give it meaning. It is very likely that Moréas' portrait served as a starting point for the painter to create his *Mallarmé* shortly afterward.

An exceptional record of artistic and literary life at the end of the nineteenth century, the portrait of Jean Moréas, published in *La Plume* in 1891, one of the major years of the Symbolist movement, is a sort of icon, not without mysteries, of this plentiful period. It is thus not surprising that at the time of the commemorations of the Fiftieth Anniversary of Symbolism in 1936 at the Bibliothèque Nationale it was this image that was chosen by the press to embody the event.

NOTES

1 We know today that this drawing first belonged to Léon Deschamps (1864–1899), founder and editor of *La Plume*. The second owner, the bibliophile L. Allix, who sold it in February 1928 by auction at the Hôtel Drouot (no. 878), also owned Gauguin's drawing for Rachilde's "Madame la mort," which was reproduced in the same issue of *La Plume* as the Moréas portrait, along with various other autographs and works dedicated to Deschamps or from *La Plume* that had remained with Deschamps' family after his death in 1899. When the drawing was lent in 1934 to the Gauguin exhibition organized by the *Gazette des Beaux-Arts*, then in 1936 to the National Library for commemorations of the Fiftieth Anniversary of Symbolism, it was declared to be part of the collection of Karl Boès (1864–1940), Deschamps' successor as editor of *La Plume*, who had probably bought it at the Allix sale. Georges Renand (1879–1968), director of La Samaritaine, and close to the Cognacq family, acquired it in 1949, probably from the heirs of Karl Boès. The drawing then fell to the Japanese art historian Soichiro Tominaga (1902–1980), first director of the National Museum of Western Art in Tokyo and author of many books on European art.

2 Patrick McGuiness, *Poetry and Radical Politics in fin de siècle France: From Anarchism to Action Française* (Oxford: Oxford University Press, 2015), p. 187.

3 Morice 1919, p. 23.

4 Letter from Jean Moréas to Léon Deschamps, end of 1890, in Moréas 1968, no. 111, p. 98. If Moréas refers to compositions by Gauguin, in the plural, this is probably because the artist also gave him the drawing *Madame la mort* (1890–91, Musée d'Orsay, Paris), which was also reproduced in the same issue of the journal.

5 Unpublished letter from Jean Moréas to Georges Collet, 6 December 1890, private collection, Paris.

6 Cariou 2015, pp. 125–128.

7 Chassé 1955, p. 125.

8 Ibid.

9 Jirat-Wasiutyński 1978, p. 352.

10 Letter from Paul Signac to Félix Fénéon, 10 February 1892, Cachin-Signac Archives, trans. Halperin 1988, p. 222.

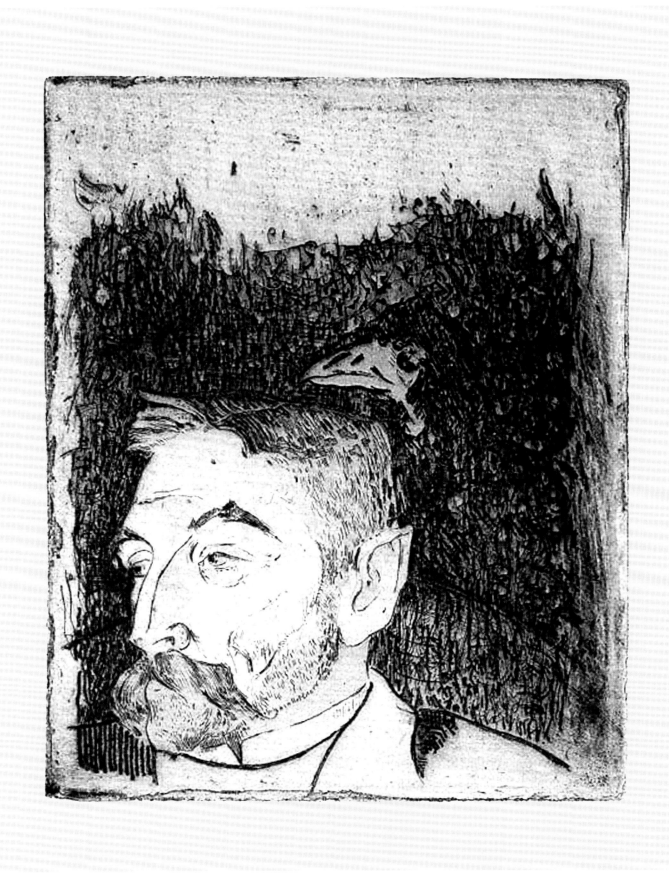

ANIMATION AND PERSONHOOD
GAUGUIN'S STILL LIFES AS PORTRAITS

DARIO GAMBONI

The word "portrait" originally meant the depiction of an object or a scene, and its scope was only later restricted to representations of a person, with an emphasis on the personality of the sitter and his or her characterization as an individual.[1] In the nineteenth century this psychological requirement led to disputes about certain works being portraits or not, as when style drew more attention to the painting than its subject matter, to the artist's personality rather than that of the sitter. In his review of the 1868 Salon, Odilon Redon thus warned against imitating Édouard Manet's *Portrait of Émile Zola* (1868, Musée d'Orsay, Paris): "It is rather a still life, so to speak, than the expression of a human character."[2] Similar remarks were often made about portraits by Paul Cézanne: Charles Morice wrote in 1905 that the artist took "no more interest in a human face than in an apple."[3] Ambroise Vollard later claimed, however, that while Cézanne treated his sitter like a still life, he liked painting portraits and considered that "the culmination of art is the figure."[4]

Complexities of this kind abound in Gauguin's oeuvre. The depiction of an unnamed couple in a quotidian environment qualifies *Interior of the Painter's House, rue Carcel* (ill. 106) as a genre scene, yet Gauguin exhibited this work in 1882 under the title *Flowers, Still Life*.[5] All the objects in it, not only the bouquet in the foreground, compete successfully for our attention with the two human figures, which are visible only in fragments; a porcelain figurine, sitting on top of the armoire, seems to provide a more complete and self-assured version of the woman at the piano. In *Still Life, Interior, Copenhagen* (1885, private collection, W176/W164

[2001]) the foreground is occupied by a still life including dead birds, while the background, seen through an opening or in a mirror, shows three women and two boys who seem trapped and unable to move.[6] In *The Flowers of France* (*Te tiare Farani*, ill. 107) two unconnected human figures – a Tahitian boy and a woman in a high-necked black dress – appear relegated to the left of the canvas by the bouquet of oleander sitting on the table, which expands freely into space.[7]

The still-life elements in such paintings seem to compete with the human beings for the qualities of animation, individuality, perhaps even interiority and personhood. Should we then take inspiration from Gauguin's primitivism and extend the meaning of "portrait" back to include the artist's depictions of non-human subjects?

Objects as Attributes and Substitutes

A traditional way of associating an object with a person, which sometimes leads to the depiction of the former replacing that of the latter, is its use as an attribute, that is as "a material object recognized as appropriate to, and thus symbolic of, any office or actor," which in art becomes "a conventional symbol added, as an accessory, to denote the character or show the identity of the personage represented."[8] Despite Gauguin's critical attitude toward the allegorical tradition, such attributes can be found in his portraits and self-portraits. This is the case in his *Self-portrait with Palette*

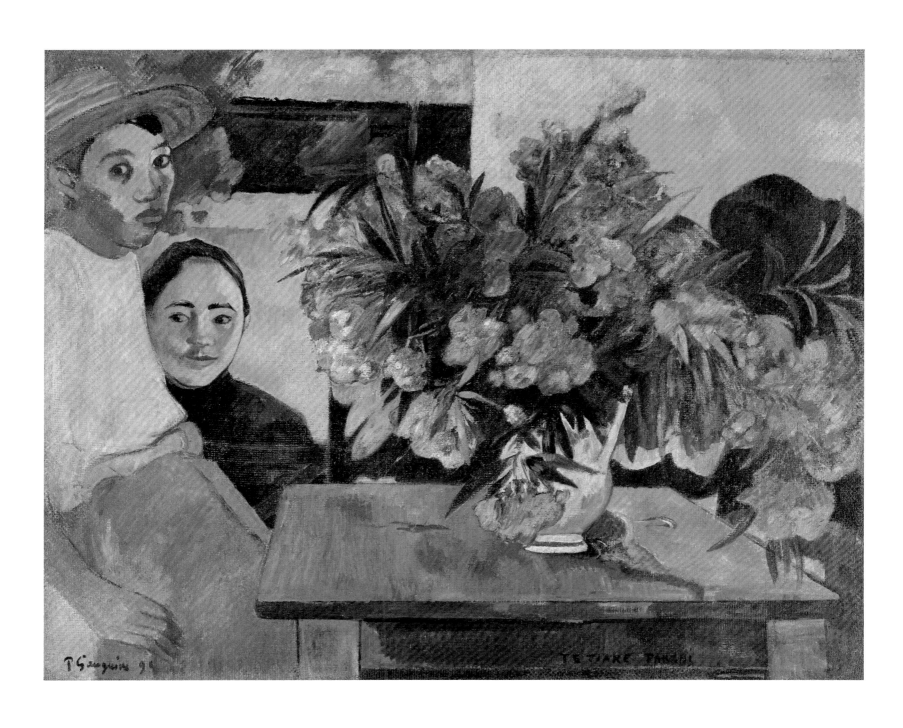

of c. 1894 (ill. 17), in which the paintbrush, held almost horizontally, points at the palette with its inchoate areas of yellow, pink and red, a source of future forms as well as a professional emblem.[9] Polynesian women hold fans in a comparable way in *Tehamana Has Many Parents* or *The Ancestors of Tehamana* (*Merahi metua no Tehamana*, ill. 85), in *Young Girl with a Fan* (ill. 109) and in mythological paintings such as *The Noble Woman* (*Te arii vahine*, 1896, Pushkin Museum, Moscow, W542). This prominence corresponds to the value of the fan as a symbol of rank in pre-colonial – and to some extent in colonial – Polynesia. In *Tehamana Has Many Parents*, the plaited palm fan is combined with the missionary dress, the flower hair ornament, the Easter Island glyphs, the mythological frieze in the background and the mangoes to compose an image of the complex identity of the sitter, whose "many parents" include not only her biological and foster parents, but also her ancestors and the historical layers, antagonistic influences and cultural hybridization to which she is heir.[10]

A more ambiguous connection between objects and figures is established in *The Meal* (*The Bananas*, ill. 108). Since the three children, while possessing individual features, are unnamed, the picture has been defined by Charles Stuckey as "half still life and half genre" rather than half portrait.[11] The two elements are indeed juxtaposed, giving rise to the notion that the upper part with the children may have been added at a later stage. But the abrupt confrontation of people with fruit and utensils may also be understood as suggesting a parallel between the two planes rather than an interaction. Naomi Maurer saw evidence of the awakening of sexual awareness among the young Tahitians in the "gazes of the two boys directed to the girl between them, taken together with the phallic and uterine shapes of the bananas and bowl."[12] Such an interpretation is further supported by

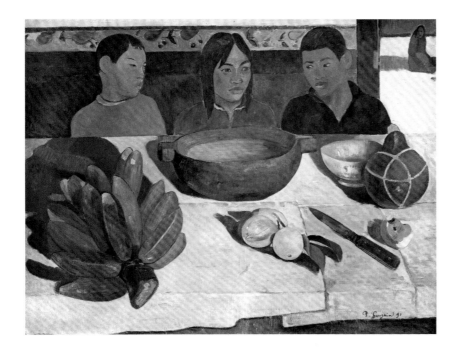

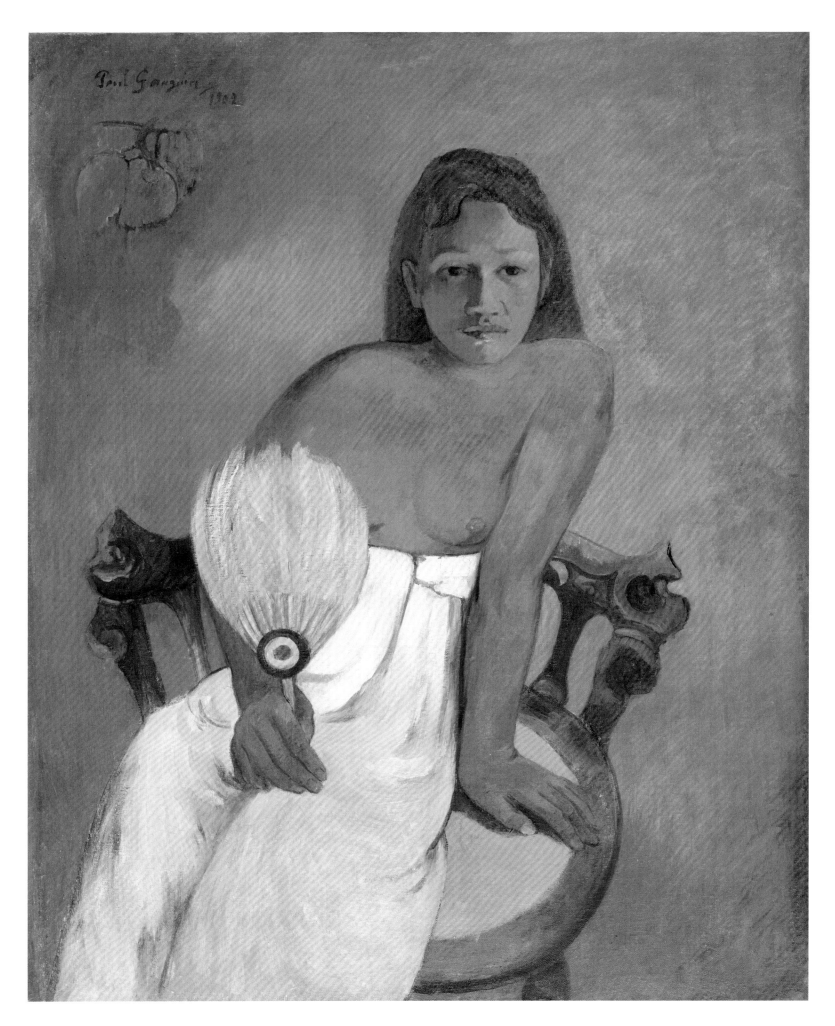

the position of the knife, which underlines the centrality of the girl and points menacingly toward her.

A famous example of objects taking the place of people is provided by the paintings *Gauguin's Chair* (1888, Van Gogh Museum, Amsterdam) and *Van Gogh's Chair* (1888, National Gallery, London) that Vincent van Gogh made in Arles when the two artists lived there together. The two different seats, together with the objects placed on them – modern novels and a burning candle on Gauguin's chair; a pipe and a pouch of tobacco on Van Gogh's – are intended to convey something of the artists' respective personalities and of the contrast between them.[13] Gauguin returned the compliment when he included sunflowers, which he associated with Van Gogh (as did Van Gogh himself), in four still lifes painted in 1901, at a time when he was preoccupied with his late friend and their fraught relationship (ills. 37–40).[14] Three of these paintings also include homages to Redon and Pierre Puvis de Chavannes: Redon is present by way of a sunflower head painted in grisaille with an eye at its centre, which recalls his 1883 lithograph *There Was Perhaps a First Vision Attempted in the Flower* (ill. 41), and Puvis by way of a representation of his painting *Hope* (1871–72, Musée d'Orsay, Paris).[15]

The Uncanny Life of Ceramics

The depiction of an artist's work is a common attribute in many portraits and self-portraits, as in Gauguin's *Self-portrait with Manao tupapau* (ill. 2), in which an abstracted image of *Spirit of the Dead Watching* (*Manao tupapau*, ill. 88) in the background summarizes the body of work that he had brought back from Tahiti and, together with the blue-and-yellow *pareu* fabric, his Tahitian experience.[16] In *Self-portrait with Yellow Christ* (ill. 103), Gauguin's bust is framed by two of his recent works: the eponymous painting (1889, Albright-Knox Art Gallery, Buffalo, W327) is on the left, placed in such a way that one of the crucified's arms seems to protect and sanctify the artist, and on the right, his *Self-portrait in the Form of a Grotesque Head* (*Anthropomorphic Pot*, ill. 110) appears at a scale almost equal to the artist's face and as if coming out of his forehead.[17] The combination of a physical effigy, the image of a three-dimensional self-representation as a "poor devil all doubled up to endure his pain" in "the ovens of hell," and that of a religious painting with auto-biographical overtones results in a complex image of the self in psychological and artistic terms.[18] In *Still Life with a Japanese Print* (ill. 113), another ceramic self-representation – *Jug in the Form of a Head, Self-portrait* (ill. 111) – faces a vase containing a lush bouquet, with an *ukiyo-e* image of an actor on the wall between them. Individualized flowers come out of Gauguin's effigy, suggesting life and mental activity, and the expansive shape of the other vessel reminds June Hargrove of *Portrait Vase, Madame Schuffenecker* (ill. 66), so that their juxtaposition may refer to the relationship between the artist and the wife of his friend Émile Schuffenecker.[19]

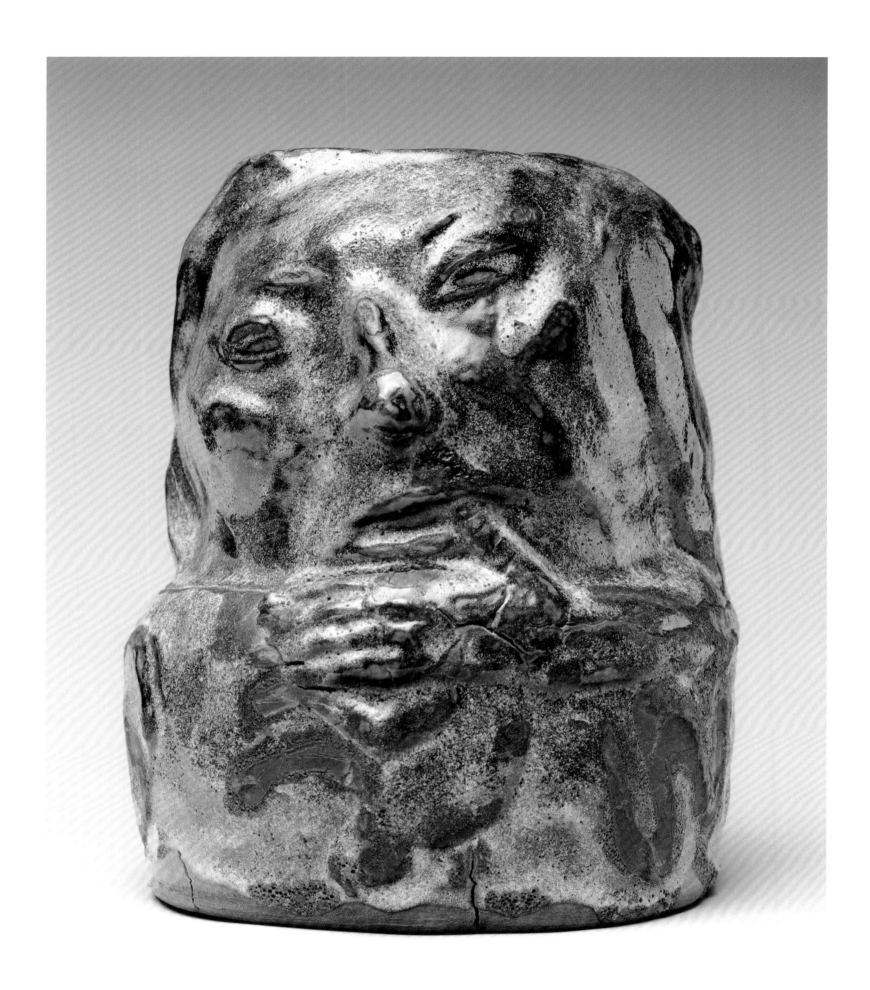

110 *Self-portrait in the Form of a Grotesque Head (Anthropomorphic Pot)*, 1889

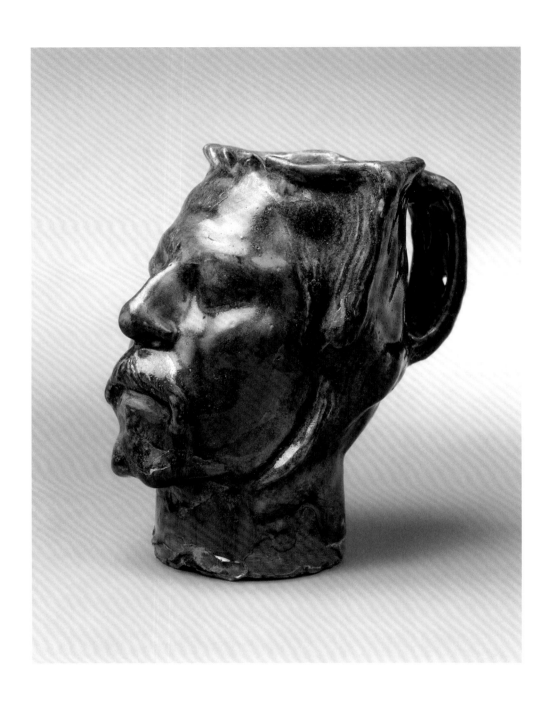

111 *Jug in the Form of a Head, Self-portrait*, 1889

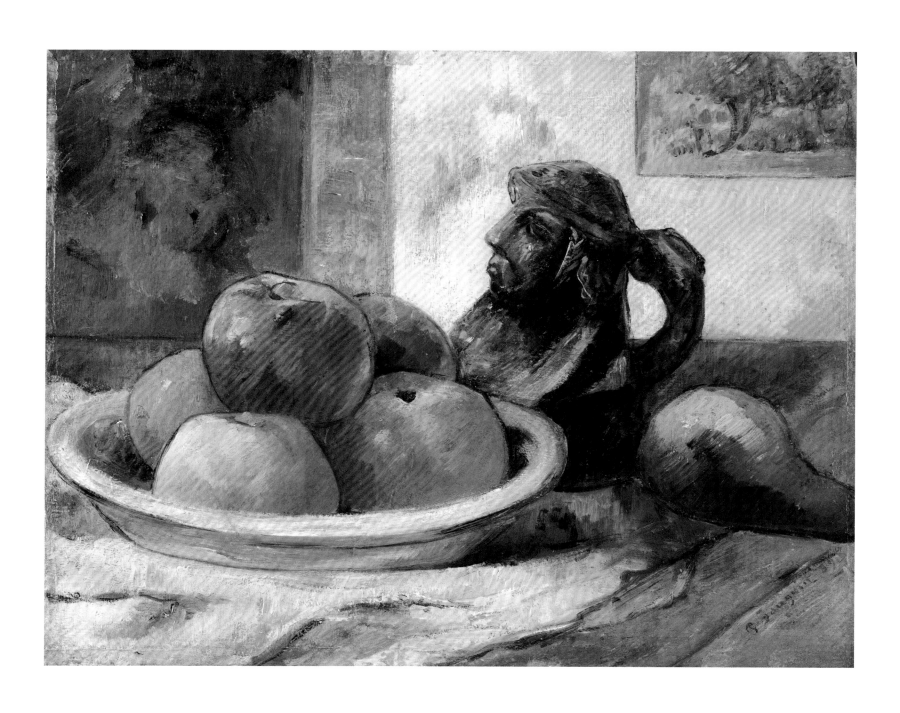

Ceramics by Gauguin – or that he may have made – also appear in his portraits of other people, such as Madame Alexandre Kohler (ill. 115) and Louis Roy (ill. 30). In the latter case, the vase, which cannot be identified with certainty, rhymes with the sitter's hair and moustache, while a painted figure appears next to his forehead. The combination of two- and three-dimensional works may allude to Roy's involvement in the printing of Gauguin's *Noa Noa* suite of woodblock prints, which the critic Julien Leclerq hailed as constituting "between sculpture and painting ... an intermediary medium which takes as much from one as the other."[20] The ceramic depicted in *Madame Alexandre Kohler* has been recognized – although its present whereabouts are unknown – as the *Horned Rats* vase (G57) that Gauguin made after his return from Martinique. The vase is also depicted in *Still Life with Fan*

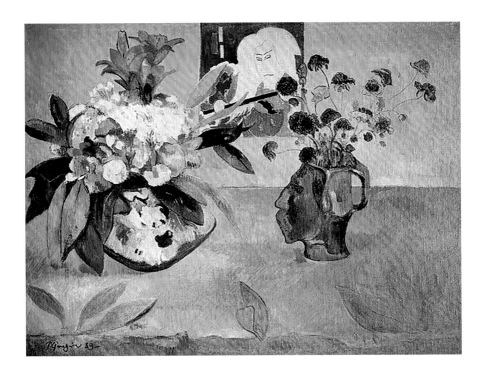

(c. 1889, Musée d'Orsay, Paris, W377), in the same position and combined with the same fan by the artist.[21] Hovering beside the face of Madame Kohler, the wife of a cashier at the Bon Marché department store in Paris, its grotesque presence adds a disquieting note to her portrait.[22]

Another ceramic by Gauguin known only from indirect evidence takes pride of place in *Still Life with Profile of Laval* (ill. 114). To some extent, one may say that the painting inverts the positions of human sitter and accessory object found in *Self-portrait with Yellow Christ* or *Madame Alexandre Kohler*.[23] Calling this picture a portrait of a vase seems all the more justified as the strange object not only has biomorphic features reminiscent of plants and animals, but also shares the paradoxical openings of the *Bust-Vase with Exploded Head* (1887–88, private collection) and – at the back – of the *Double-Headed Vase* (1889, private collection, G68).[24] An enigmatic exchange takes place between the two main protagonists and the spectator: Laval looks at the vase, but with a closed eye, and the vase "looks" at the spectator, but with an empty eye. Of the two depicted, the more animated is clearly the one made of clay, a fact further emphasized in their echoes unfolding on a dark surface in the background.

Ceramics that do not appear to have been made by Gauguin – and may be entirely fictional – also feature in some of his portraits. The piece presented in *La Belle Angèle* (ill. 59) and *Young Breton Woman* (ill. 61), frontally and in

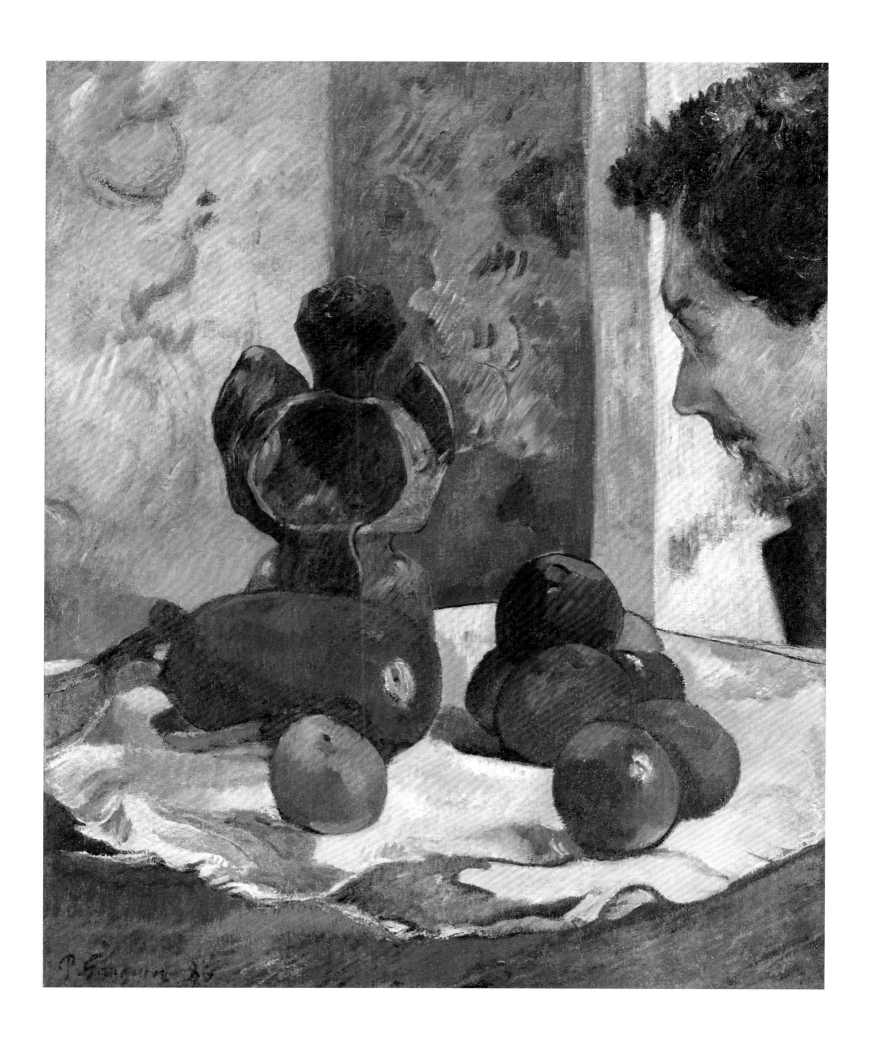

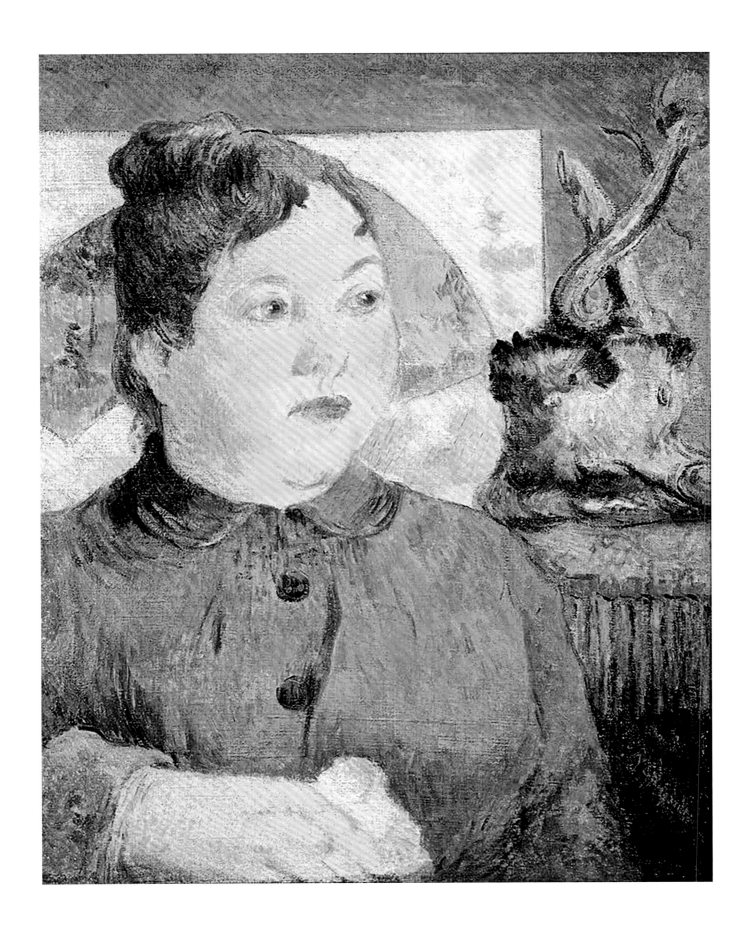

three-quarter view like the respective sitters, resembles the figurine from *Interior of the Painter's House, rue Carcel* (ill. 106), with the added element of hair or a headdress connecting the head with the back.[25] The vase mingles Oriental elements with echoes of Pre-Columbian – especially Peruvian – pottery and connects the two women with a prototype of spirituality, femininity and fecundity. Anthropomorphic vases also introduce an element of human interiority in works such as *Still Life with Apples, a Pear and a Ceramic Portrait Jug* (ill. 112), in which the resplendent rotundity of the fruit is compared with the equally portly, but hollow shape of the Andean-inspired ceramic, its dark colour and its pensive expression. A similar effect is produced in a more implicit manner in *Vase with Nasturtiums and Quimper Faience* (1886, National Gallery of Canada, Ottawa, W218 [2001]) thanks to the symmetrically presented flower motifs that endow the Breton feeding bottle with a sort of gaze.[26]

The special proximity of ceramics to humans in Gauguin's works derives from the analogy he perceived between vessel and body, thanks perhaps to his early exposure to Pre-Columbian pottery; in 1889 he argued for the importance of ceramics because of its antiquity "among the American Indians" and of its role in myths of anthropogeny: "God made man out of a little clay."[27] The same analogy, however, can be extended to vessels in other materials, a major example being the eighteenth-century *tine* – a Norwegian wooden beer mug – that Gauguin included in *Still Life, Interior, Copenhagen* and in three other pictures.[28] In one of these paintings, *Still Life: Wood Tankard and Metal Pitcher* (1880, Art Institute of Chicago, W47/W60 [2001]), it stands on a white tablecloth beside a pewter pitcher, which it dominates thanks to its superior height and bulk; the work was nicknamed *The Iron Pot and Clay Pot* in reference to a seventeenth-century tale by Jean de La Fontaine, in which two vessels are anthropomorphized and their material opposition moralized. The fact that Gauguin's wife, Mette, had brought the *tine* to Paris must have associated it with her, but in *At the Window (Still Life with Tine and Carafon*, ill. 116) it appears relatively masculine in comparison to the Danish glass decanter standing next to it. The couple is surrounded by a lemon on a plate, two lumps of sugar and a spoon in a glass, and it is tempting to draw a parallel between this group portrait of objects and the growing Gauguin family, which welcomed its fourth child, Jean, on 12 April 1882.[29]

Cézanne's Example

Gauguin was, of course, not the first artist to endow the depiction of objects with human connotations and to blur the line between still life and other genres, and he may have been inspired by some of his antecedents and contemporaries. Manet's still lifes and the still-life elements included in many of his portraits are a case in point, and we saw that they prompted Redon – whose flower-eyes have been mentioned in connection with Gauguin's late sunflower pieces – to define his *Portrait of Émile Zola* as a still life. Gauguin's *The Flowers of France* (*Te tiare Farani*, ill. 107) can be compared to Edgar Degas' 1865 *Woman Seated beside a Vase of Flowers* (ill. 117), in which the portrait of an unnamed sitter – possibly the wife of the artist's schoolboy friend Paul Valpinçon – is relegated to one side of the picture by a sumptuous bouquet.[30] The most important model from whom Gauguin learned in this regard, however, was Cézanne, who had the reputation of treating sitters like apples but may also have done the reverse. Gauguin admired Cézanne immensely and regarded his *Still Life with Fruit Dish* (ill. 118), which he owned, as "an exceptional

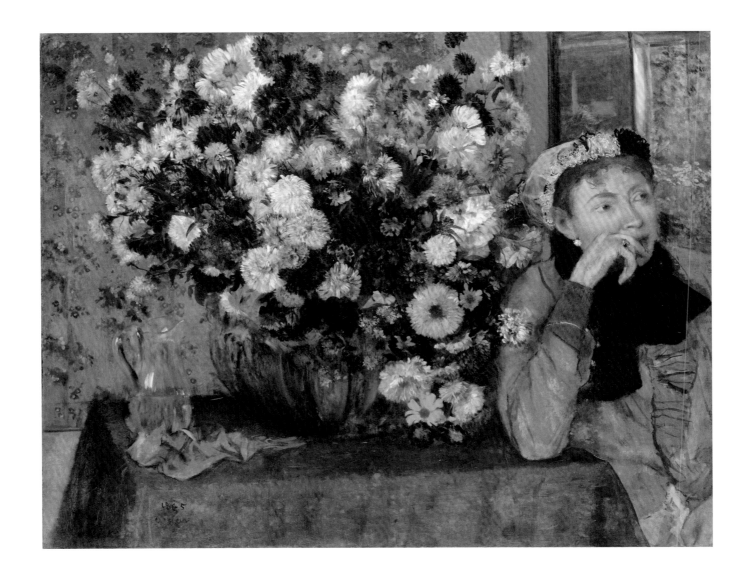

pearl ... the apple of [his] eye."[31] He included a translation of the painting as a background in his *Woman in Front of a Still Life by Cézanne* (ill. 119) and positioned it in such a way that the knife it features points at the unnamed sitter – a first try at the device he used in *The Meal* (*The Bananas*, ill. 108).

This suggestive use of the background is already present in Cézanne's *Still Life with Fruit Dish*, in which the objects are placed in front of a fictional wallpaper that seems to absorb the glass of the same colour. Gauguin was very aware of its importance for the art of Cézanne, and for his own, writing about the other artist in 1885: "Like Virgil who has several meanings and whom one can interpret as one wishes, the literature of his pictures has a dual-purpose parabolic meaning; his backgrounds are as imaginative as they are real."[32] Backgrounds are only mentioned here as an example, and it is clear that Gauguin perceived a co-presence of the real and the imaginary and a "dual-purpose parabolic meaning" – by which he meant the literal and figurative meanings of a parable – in Cézanne's work as a whole, including in the objects depicted in his still lifes.[33]

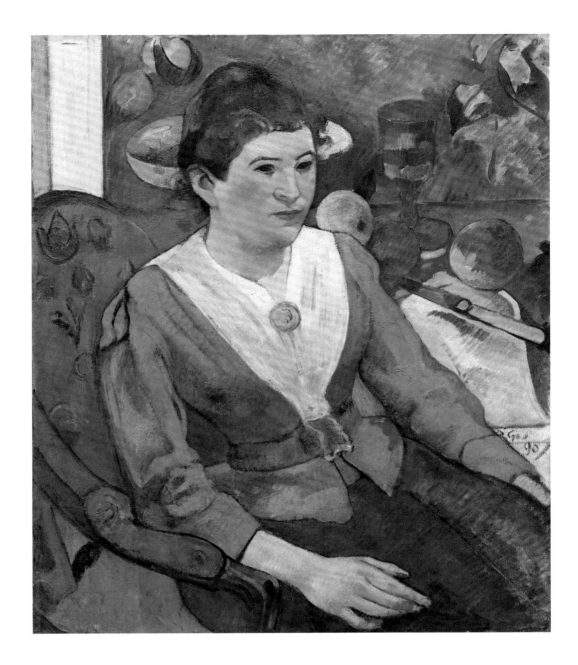

In his 1968 "The Apples of Cézanne: An Essay on the Meaning of Still Life," Meyer Schapiro interpreted Cézanne's evolution from the overtly sexual themes of his youth to the still lifes of his mature style as a psychological process of displacement and sublimation, in which the importance of fruit and especially apples could be explained by their association with female nudity.[34] He found "a striking example of the defusing of a sexual theme through replacement of a figure by still-life objects" in Cézanne's *Reclining Nude* (1886/90, Von der Heydt-Museum, Wuppertal), in which the predatory bird of *Leda and the Swan* (c. 1880 or later,

Barnes Foundation, Philadelphia) has been replaced with two large pears on a white cloth.[35] A similar substitution can be observed in Gauguin's *Still Life with Ceramic Cup* (ill. 120), in which a vegetal motif takes the place of the nude descending into the concavity of the artist's *Cup Decorated with the Figure of a Bathing Girl* (1887–88, private collection, G50); one can assume that the erotic appeal of this human figure is confided to the rotund fruit enclosed within the serpentine ceramic, and the conflation of real and imaginary is given free rein in the tablecloth with its motifs of bird and flower.[36]

Morice asserted in 1907 that Gauguin had "accomplished" what Cézanne had only "indicated."[37] This claim, approved since by Richard Shiff, is especially valid in the genre of still life, which the younger artist clearly identified with his elder.[38] Gauguin's "accomplishment" reconciles Cézanne's equanimous treatment of face and fruit with his notion that "the culmination of art is the figure."[39] And it agrees with a lesson that Wassily Kandinsky later drew from Cézanne in *On the Spiritual in Art* (1913). Having attributed a "spiritual turn" to the art of Dante Gabriel Rossetti, Arnold Böcklin and Giovanni Segantini, who "were looking

for the interior content in exterior forms," Kandinsky saw this spiritualization take a decisive step with Cézanne:

> Using other means, which are closer to the purely pictorial, Cézanne, the seeker after new laws of form, sets himself a similar task. He knows how to create a living being out of a teacup – or rather, how to recognize such a being within this cup. He can raise "still life" to a level where external "dead" objects come internally alive. He treats these objects just as he does people, for he had the gift of seeing inner life everywhere.[40]

To Kandinsky, this step was of crucial importance for the art of the twentieth century, and we may add that Gauguin shared responsibility for it.

Imaginative Perception, Empathy and Animism

The example of Cézanne, however, is insufficient to explain Gauguin's treatment of objects, and itself requires an explanation going beyond individual psychology – the conceptual tools of psychoanalysis, to which Schapiro resorted, were forged after all during the period in question. One reason for Gauguin's tendency to endow objects with human-like qualities was his profound interest in analogies, which sprang from a cultivation of the interpretive, mnemonic and imaginative dimensions of perception, and his delight in producing "potential images," that is images that would become actual through the active participation of the beholders.[41] An instance of this can be found in his *Still Life with Fruits* (ill. 121), in which a formal and positional parallelism is established between the human head at the upper-left corner of the picture contemplating the cornucopia spread on the table and the teapot around which some of the fruit are gathered at the top. The two large oval shapes seem to attract the other elements scattered on the surface in an inversion of gravity underlined by the empty space at the bottom, and the slanted eyes of the face are mimicked by tonal variations in the vessel. On an affective level, the darkness and closeness of the teapot aggravates the air of despondency of the female figure, who finds a narrative context in the painting *Human Misery* (1888, Ordrupgaard, Copenhagen, W304/W317 [2001]). Since the first appearance of this figure, in *Still Life with Fruits*, gives the impression that she was added to the assembly of objects, it is tempting to take a cue from Kandinsky's remark about Cézanne and imagine that Gauguin "recognized a living being within" this teapot before giving it an autonomous, human existence.

Another factor is Gauguin's creative interest in objects, some of which he started incorporating in his sculptures from the early 1880s onwards, prompting Anne-Birgitte Fonsmark to speak of "found objects" and compare his appropriating practices to those of Dada and the Surrealists.[42] Such an attitude implied seeing beyond the functions and "affordances" of objects, even beyond their aesthetic

qualities, to perceive the potential for fiction, reuse and assemblage that was inherent in them. Before and beside psychoanalysis, the unconscious animation of objects was seen as a normal trait of perception by the theory of "empathy" (*einfühlung* in German), which exerted a strong influence on Kandinsky and his generation of artists. Similar insights found expression in France within the context of Symbolism and the new science of psychology. Victor Basch, who occupied the first chair of aesthetics, wrote in 1896 about a "symbolic sympathy," allowing humans to plunge into objects, breathe their vitality into them, and let their feelings make them alive.[43] If this was the case for everyday objects, it had to be even truer of artworks and *objets d'art,* which were regarded as an extension of their creator's personality – a notion at the root of their legal status as *œuvres de l'esprit.*[44] These conceptions were therefore especially important for Gauguin's ceramics, their depiction in his two-dimensional works – the animation of an animation – and the revaluation of the so-called decorative arts in general.

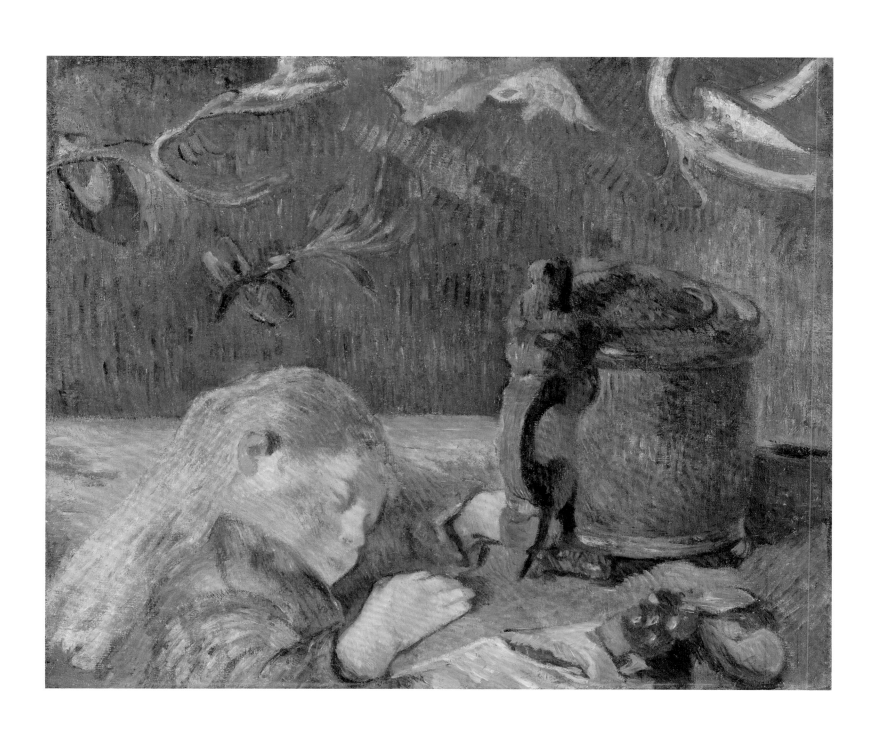

The critic Albert Aurier wrote in 1891 that Gauguin had kneaded "more soul than clay" into his ceramics, and his colleague André Fontainas observed four years later that "the decorative work of art is a perpetual provocation to unexpected meditation, to a continuous enhancement, indeed a maturation of the thinking being in us."[45] This silent influence of the material world – especially when shaped by art – on the human psyche could be mediated, expressed and reflected upon in the genre of still life, which had once been called in French *vie coye*, "silent life."[46]

Indeed, Gauguin seems to depict such an influence in *Still Life with Profile of Laval* (ill. 114). It is also the case in *Clovis Asleep* (ill. 122), which shows his son – then four or five years old and still wearing long hair – sleeping beside the *tine*. The wooden mug dominates the child and mediates visually between the surface on which he is lying or leaning and the wall covered with animal and vegetal imagery – a background "as imaginative as [it is] real," evoking the interior world of Clovis' dreams.[47] Gauguin had already used this device to visualize mental activity in a painting of his daughter Aline asleep, which he presented as a genre scene rather than a portrait by turning the sitter away from the spectator and entitling the result *The Little One is Dreaming, Étude* (ill. 123).[48] No object similar

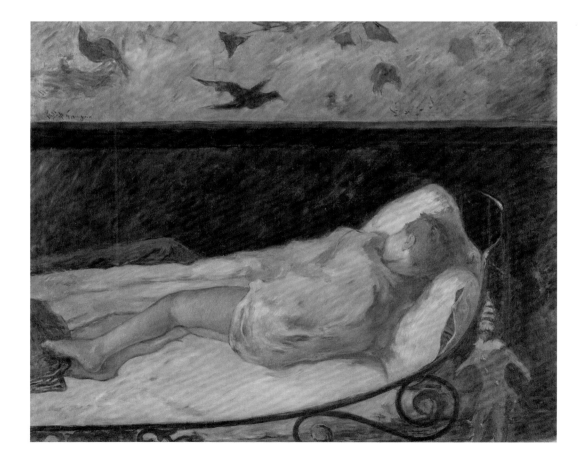

to the *tine* is shown influencing Aline's dreams, but a bearded puppet with a pointed bonnet and a jester's costume is dangling from the head of her iron bed. Its striking dress and colours relate it to the fictional world of tales and storytelling, which indirectly feeds the child's oneiric one. Close to Clovis' right hand lies another object that is difficult to identify but probably represents a swaddled doll, possibly one made for the child by his parents from materials that he liked – what Donald Winnicott has since called a "transitional object."[49] If this is the case, the very fact that it does not look like a human or animal body means that the child compensates imaginatively for its lack of resemblance, rendering superfluous and even counter-productive the kind of realism that Gauguin criticized in art as "servile imitation of nature."[50]

The child's imagination was proposed as a model for the artist's creation and the reception of the work of art by psychologists and aestheticians; in 1883, Gabriel Séailles compared it to a wand and wrote that "from an inanimate toy, [the child] makes a living being who resembles and loves him."[51] A major apologist of the "spirit of childhood" was the famous Danish children's writer Hans Christian Andersen, whom Gauguin had every reason to be interested in, at the latest when he stayed unhappily in Copenhagen with his family in 1884–85. Andersen's tales, in which objects similar to the figurine of *Interior of the Painter's House, rue Carcel* (ill. 106) come to life, may have played a role in Gauguin's animated still lifes.[52] In the author's 1844 tale "The Elder Tree Mother," a girl and a boy turn their father's walking stick into a hobbyhorse:

> For the little children, there was life in that stick. When they seated themselves upon it, the polished head turned into the head of a noble neighing horse with a long, black flowing mane. Four slender, strong legs shot out; the animal was strong and spirited; and they galloped around the grass plot.[53]

This example of what Séailles called the children's "power of metamorphosis" became Gauguin's paradigm of artistic primitivism when he wrote in 1896–98: "As for myself, my art goes way back, further back than the horses on the Parthenon – all the way to the dear old wooden hobby horse of my childhood."[54]

The Sculptor Aubé and His Son Émile (ill. 124), a double portrait presented as a diptych by its passe-partout mount, seems to allude to the kinship of the child's imagination and the artist's creativity, and to the mediation that a product of the latter can effect between the two: the pot on which sits a nude figure modelled by Aubé is placed in the middle and the card mullion separating the child's space from the adult's one passes exactly over the head of the figurine, so that her mind seems to belong to neither or to both. The dedication poem written down by Mette on the mount praises the elder Aubé's hand for "animating at his will women and flowers," announcing Gauguin's later call for "intelligent hands which could impart the life of a figure to a vase and yet remain true to the character of the material."[55]

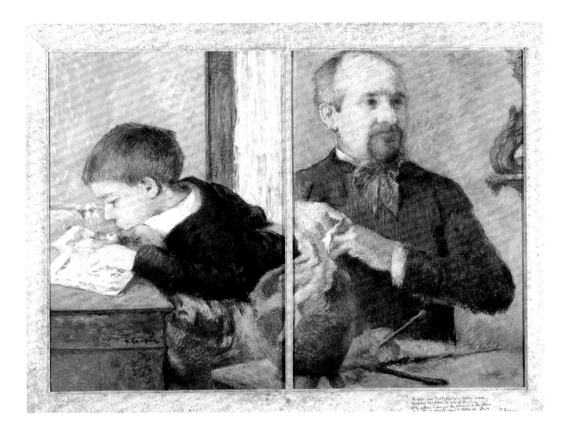

Gauguin's primitivism has already been alluded to above in the discussion of the analogy between the vessel and body that informs his ceramics. He seems to have been fascinated by the ways in which, in ancient cultures, the human body or part of it – generally the head – could be preserved and thus turned into an image of itself, an "auto-icon" to use the expression coined by Jeremy Bentham.[56] The best-known example is the Peruvian mummy that Gauguin saw in the Ethnographical Museum of the Trocadéro in 1878 and that he used as a model in many works, including *Life and Death* (1889, Mahmoud Khalil Museum, Cairo, W335), where it sits on the beach and is contrasted with a red-haired bather.[57] Other objects preserving the memory of their animated state are the mummified heads of the Maori (*toi moko*), which had been popular with Westerners since the early nineteenth century and to which Gauguin's painting *The Royal End* (*Arii matamoe*, ill. 81) makes reference. He may also have thought of such antecedents when, in 1881, he decided to model in wax – a material associated with anatomical models – a life-sized three-dimensional portrait of his newborn son, Jean (ill. 125).

Finally, Gauguin's Peruvian childhood and extensive travels, his plans for leaving Europe, and his two stays in Polynesia must have contributed to the onto-logical ambiguity pervading his works. He developed an interest in pre-modern

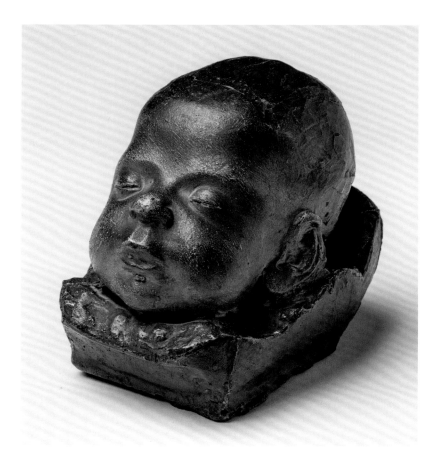

and non-Western modes of thought at a time when the burgeoning discipline of anthropology, in works such as Edward Tylor's *Primitive Culture* (1871) and James George Frazer's *The Golden Bough* (1890), saw in animism and magic the first phases of development of all religions and cultures. Such ideas were widespread and certainly appealed to Gauguin. They may also have confirmed the results of observations he made on himself, his children and his contemporaries. Whatever the causes, Gauguin not only blurred the distinctions between genres in works such as *The Flowers of France*, but gave to his depictions of objects, and to the objects he made, a quality that calls to mind the notion of "persons other than human," proposed by the anthropologist Irving Hallowell in an essay on the ontology of the Ojibwa people of North America, possessing "potentialities for animation … under certain circumstances."[58]

The *tine* brought by Mette from Denmark was recognized by Gauguin as a "person" in a similar sense, capable of influencing Clovis' dreams (see ill. 122) and of spreading personhood around itself in *At the Window* (ill. 116). The "monstrosities" that Gauguin created out of clay, his "ceramic sculptures," also possessed this

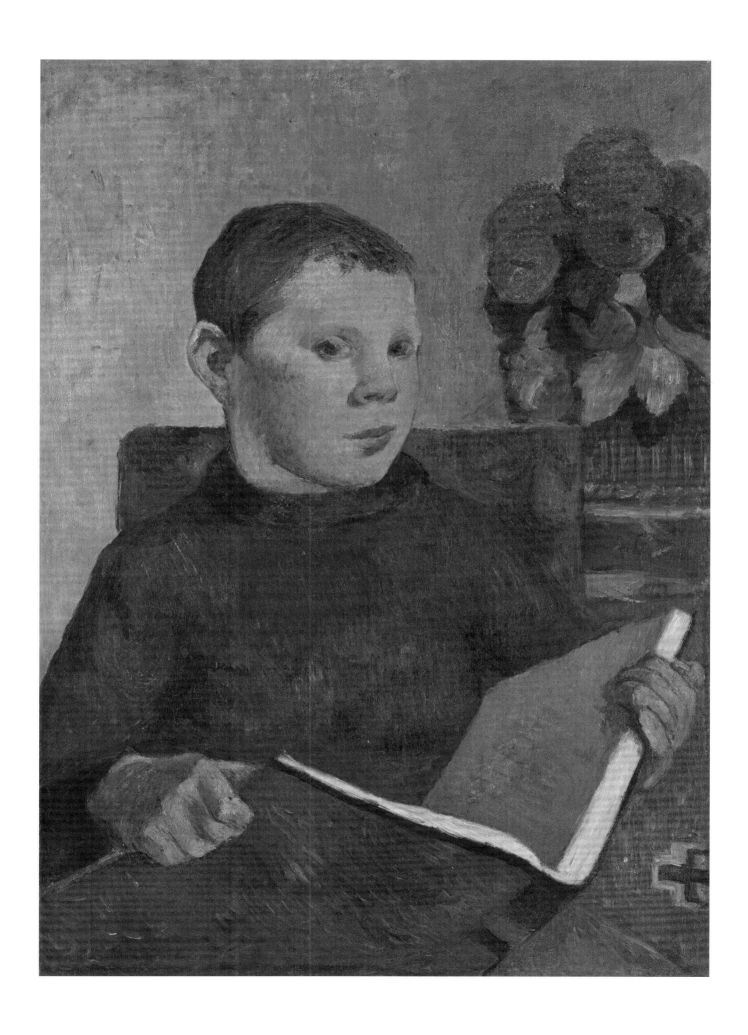

126 *Clovis*, c. 1886 **221**

quality for him.[59] At the end of 1888 he asked Émile Schuffenecker to send his pot *Horned Rats*, which he had depicted in *Madame Alexandre Kohler*, from Paris to Arles because he needed it (one is tempted to say that he needed its company), and we have seen that if the *Still Life with Portrait of Laval* can be regarded as a portrait, it is not as one of Charles Laval.[60] These insights shed light on Gauguin's relation to objects and especially to the ones coming out of the "intelligent hands" he found must replace the potter's wheel.[61] More broadly, they illuminate the relationships that Western artists and art lovers cultivated with artworks and *objets d'art* at the turn of the century, in parallel to the exploration of the unconscious and the development of anthropology and theories of empathy. And they may contribute to explaining the fascination that Gauguin's works in all media exert on us, at a time when the ecological price of the opposition between humans and non-humans has become impossible to ignore and the anthropologist Philippe Descola calls for a "restoration of animism."[62]

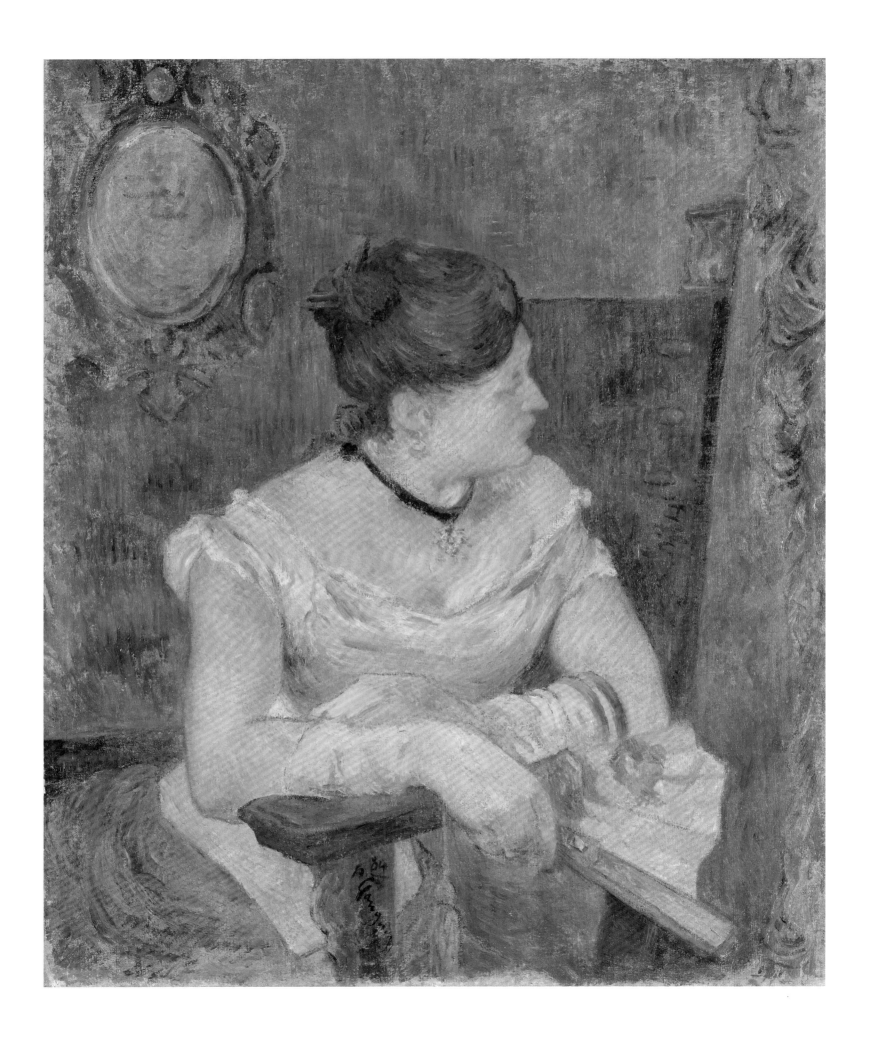

127 *Mette in Evening Dress*, 1884 **223**

NOTES

1 See "portrait, n., adv., and adj.," Oxford English Dictionary online, www.oed.com/view/Entry/148230?rskey=trQLP6&result=1&isAdvanced=false (accessed 27 April 2018), and Lorne Campbell, "Portraiture," Grove Art Online, http://www.oxfordartonline.com/groveart/view/10.1093/gao/9781884446054.001.0001/oao-9781884446054 -e-7000068853 (accessed 20 August 2018).

2 Redon 1987, p. 56.

3 Morice 1905, p. 522, cited in Elderfield 2017, p. 31.

4 Vollard 1914, p. 101; see also Elderfield 2017, p. 31.

5 See Brettell 1988, cat. 7, pp. 27–28, and Wildenstein 2001/2002, cat. 76, pp. 87–89.

6 See further Wildenstein 2001/2002, cat. 164, pp. 195–196, and Gamboni 2014, pp. 270–272.

7 See Brettell 1988, cat. 120, pp. 220–221.

8 "attribute, n.," Oxford English Dictionary online, www.oed.com/view/Entry/12931?rskey=pT9U2T&result=1&isAdvanced=false (accessed 30 April 2018).

9 See Brettell 1988, cat. 159, pp. 304–305.

10 See ibid., cat. 158, pp. 288–289.

11 Ibid., cat. 129, p. 233.

12 Charles F. Stuckey, in Brettell 1988, cat. 129, p. 234. Stuckey paraphrases Naomi Maurer's argument from "The Pursuit of Spiritual Knowledge: The Philosophical Meaning and Origins of Symbolist Theory and its Expression in the Thought and Art of Odilon Redon, Vincent van Gogh, and Paul Gauguin," PhD diss., University of Chicago, 1985, pp. 960–962.

13 Druick and Zegers 2001, pp. 209–210.

14 W602, W603, W604 and W606.

15 See Gamboni 2014, pp. 355–358.

16 See Brettell 1988, cat. 164, pp. 311–313.

17 See ibid., cat. 99, pp. 177–178.

18 See ibid., cat. 65, pp. 128–129, and cat. 88, pp. 156–157; letter from Gauguin to Émile Bernard, Le Pouldu, end of 1889, cited in ibid., p. 128.

19 Hargrove 2017, pp. 148–149.

20 Leclerq 1895, pp. 121–122. See Lemonedes, Thomson and Juszczak 2009, cat. 31, p. 46, and Ives and Stein 2002, cat. 9.

21 See Brettell 1988, cat. 41, pp. 90–91.

22 See Gamboni 2014, p. 273.

23 See Brettell 1988, cat. 30, pp. 76–77, and Wildenstein 2001/2002, cat. 238, pp. 304–308.

24 See Gamboni 2014, pp. 148–150, and Groom 2017, p. 170.

25 See Brettell 1988, cat. 89, pp. 158–160.

26 See Wildenstein 2001/2002, cats. 217–218, pp. 270–272.

27 Gauguin 1889a, p. 86. See Gamboni 2014, pp. 181–182.

28 See Wildenstein 2001/2002, cat. 60, pp. 67–68; cat. 92, pp. 103–104; cat. 151, pp. 171–172; and cat. 164, pp. 195–196.

29 See Gamboni 2014, pp. 269–270.

30 See www.metmuseum.org/art/collection/search/436121 (accessed 3 May 2018); Françoise Cachin, "Degas and Gauguin," in

Dumas 1997, pp. 231–233; and George T.M. Shackelford, in Rathbone and Shackelford 2001, pp. 23, 50.

31 Letter from Gauguin to Émile Schuffenecker, early June 1888, in Gauguin 1984, no. 147, p. 182. See Brettell 1988, cat. 111, pp. 192–193. Richard Shiff has recently proposed to consider that "Gauguin's persistent efforts at explanation" and his praise of Cézanne's genius "caused apples, Cézanne, and the technical abstractions of painting to become linked in the collective imagination, not only at the close of the nineteenth century but throughout the twentieth" (Richard Shiff, "Apples and Abstraction," in Rathbone and Shackelford 2001, p. 42).

32 Letter from Gauguin to Émile Schuffenecker, 14 January 1885, in Gauguin 1984, no. 65, p. 88.

33 On Gauguin's understanding of what he called a "dual-purpose parabolic meaning," see Gamboni 2014, especially pp. 22–26, and Dario Gamboni, "Gauguin and the Challenge of Ambiguity," in Broude 2018, pp. 109–114.

34 Schapiro 1968, reprinted in Schapiro 1978, pp. 1–38.

35 Ibid., p. 12 and figs. 14, 15.

36 See Groom 2017, pp. 166, 174–175.

37 Morice 1907, p. 547.

38 Richard Shiff, "The Primitive of Everyone Else's Way," in Solana 2004, p. 77. On Gauguin's association of still life with Cézanne, see Hargrove 2017, p. 150.

39 Morice 1905, p. 522, cited in Elderfield 2017, p. 31.

40 Wassily Kandinsky, *Kandinsky: Complete Writings on Art*, edited by Kenneth C. Lindsay and Peter Vergo (New York: Da Capo Press, 2004), p. 151.

41 See ibid., notably pp. 18–20, 148, and Gamboni 2014.

42 See Anne-Birgitte Fonsmark, "Gauguin Creates His World. The Object in a World of Myth and Dream," in Eisenman 2007, pp. 35–47, and Gamboni 2014, pp. 49–50.

43 Victor Basch, *Essai critique sur l'esthétique de Kant* (Paris: Alcan, 1896), cited in Andrea Pinotti, *L'empathie: histoire d'une idée de Platon au posthumain,* trans. Sophie Burdet (Paris: J. Vrin, 2016), pp. 183–184.

44 See Edelman 1989.

45 Aurier 1891, pp. 155–165, cited in Aurier 1995, p. 38; André Fontainas, *Notes et scolies*, unpublished notes, 24 February 1895, pp. 124–125, cited in Laurent Houssais, "André Fontainas (1865–1948), critique et historien de l'art," PhD diss., Université Blaise-Pascal, Clermont-Ferrand II, 2003, p. 422.

46 See Hans J. Van Miegroet, "Still life," in *Grove Art Online*, 2003, https://doi.org/10.1093/gao/9781884446054.article.T081448 (accessed 22 August 2018).

47 See Gamboni 2014, pp. 86–91.

48 See Brettell 1988, cat. 8, pp. 28–29, and Wildenstein 2001/2002, cat. 75, pp. 86–87.

49 See Winnicott 1953, pp. 89–97, and Gamboni 2014, pp. 90–91, 363.

50 Gauguin 1889a, p. 86.

51 Séailles 1902, p. 79.

52 See Gamboni 2014, pp. 264–268.

53 Hans Christian Andersen, "The Elder Tree Mother" (1844),

The Hans Christian Andersen Center, www.andersen.sdu.dk (accessed 22 August 2018).

54 *Diverses choses*, f. 107 r; repeated in Gauguin 1989, p. 27.

55 Gauguin 1895b, p. 1, cited in Gauguin 1996, p. 106 (trans. modified).

56 See Campbell, "Portraiture," www.ucl.ac.uk/bentham-project/who-was-jeremy-bentham/auto-icon (accessed 4 May 2018).

57 See Andersen 1967, pp. 615–619, and Brettell 1988, cat. 79, pp. 145–147.

58 Alfred Irving Hallowell, "Ojibwa Ontology, Behavior, and World View" (1960), in *Contributions to Anthropology: Selected Papers of A. Irving Hallowell*. Edited by Raymond D. Fogelson (Chicago: University of Chicago Press, 1976), pp. 357–390, citation p. 363.

59 Letter from Gauguin to Félix Bracquemond, end of 1886 – beginning of 1887, in Gauguin 1984, no. 116, p. 143.

60 Letter from Gauguin to Émile Schuffenecker, 25 October 1888, in ibid., no. 174, p. 264.

61 Gauguin 1895b.

62 Descola 2014, pp. 129–142. See also Latour 2002.

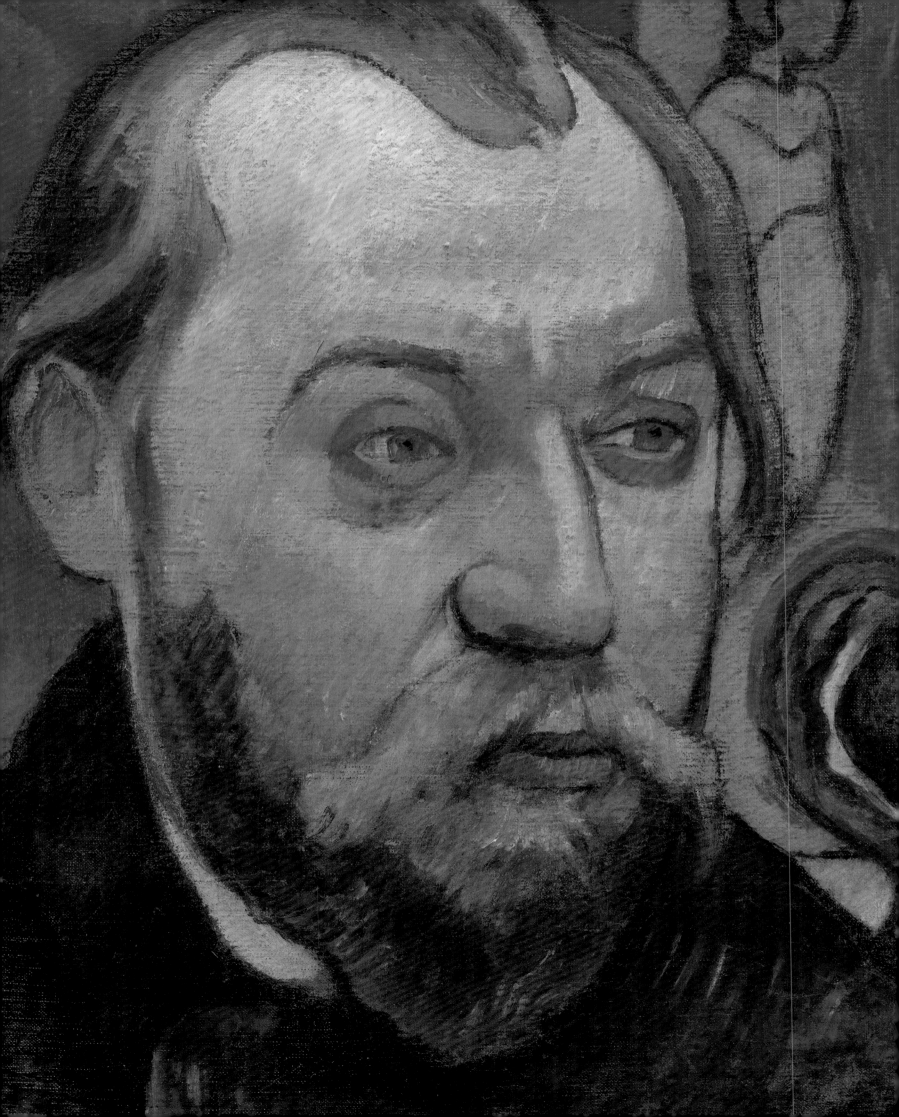

GAUGUIN AND PORTRAITURE IN THE LATE NINETEENTH CENTURY

For anyone who knows how to look, a work of art is a mirror that reflects the artist's mood. When I see a portrait by Velázquez or Rembrandt, I scarcely see the features of the face he painted, whereas I have an intimate impression of the moral portrait of the painter himself.

Diverses choses, **1896–97**[1]

CLAIRE GUITTON

The second half of the nineteenth century witnessed an unprecedented flourishing of the genre of portraiture. Much favoured by the newly prosperous bourgeoisie, it was also increasingly popular among the less affluent classes, owing in part to advances in photography. This democratization of the portrait led to a significant increase in demand and the development of a highly lucrative market. While portrait painting provided artists with a welcome source of revenue, there were those – including the author and art critic Émile Zola – who felt that production in the genre had become excessive, turning it into a veritable "industry."[2] Nevertheless, portraiture reigned at the annual Salon, and there were many exhibitions in Paris devoted exclusively to the form. Both mainstream artists and members of the various avant-garde movements were happy to take up the challenge of portraiture, and, for potential clients, choosing among a host of artists of varying repute was no simple matter. Nor was the final result always what the model had anticipated, and the ensuing discomfiture became a favourite theme among caricaturists (see ill. 128).

The passion for portraiture, which spread to the literary realm, reflected society's growing fascination with its own image and its predilection for celebrating figures of the time. Though much admired, the genre was also fiercely criticized by defenders of modernity, who judged the work of the most fashionable portraitists to be artificial and insipid. Nevertheless, many artists and critics saw the portrait as a demanding art form and a crucible for radical aesthetic experimentation.

On several occasions in his letters and writings, Paul Gauguin expressed his particular ideas about portraiture – a genre he would practise throughout his career. Although for a time he was tempted by the lucrative opportunities offered by portrait painting, commissions were few, and the artist proved incapable of modifying his approach to meet client expectations.

Portrait of Louis Roy (detail, ill. 30), 1890–91

Laval is differently placed; he can earn fair money for some time painting portraits, which is quite well paid here, 500 francs, as much as one wants (there is no competition), but they must be done in a special way and very badly, a thing I could not do.

Gauguin to his wife, Mette, c. 12 May 1887[3]

I want to have as many acquaintances as possible. I think I shall soon have some well-paid commissions for portraits: I am bombarded with requests to do them. I am making the utmost difficulties about it at present (the surest way of getting good prices). In any event, I think I can earn money here, a thing on which I did not count. Tomorrow I am going to see all the Royal Family. All of which is advertisement, however tiresome.

Gauguin to his wife, Mette, 4 June 1891[4]

I have a promise for a portrait of a woman to be done in May: 2,500 francs, but it's just a promise and I'm not sure what to think ... If this portrait gets done – I'll have to do something that pleases, Bonnat-style – and it's paid for, then I think I could get one or two others, and I will have regained my independence.

Gauguin to Paul Sérusier, 25 March 1892[5]

CRITICS' VIEWPOINTS

A Demanding Art Form

Although the large number of artists producing portraits and the unevenness of the results did something to discredit the genre, many critics continued to be interested in portraiture and to defend it vigorously. In his *Grammaire des arts*, a book much appreciated by artists, the theorist Charles Blanc described portraiture as "one of the highest categories of art."[6] The artist and critic Zacharie Astruc went so far as to claim that "you are not a great painter, in the fullest sense of the word, if it is established that your work does not include a single fine portrait."[7] According to the art critic Jules-Antoine Castagnary, a champion of naturalism in painting, "the portrait, which invokes the painter's highest faculties, represents the zenith of the art of painting."[8] It was recognized as a particularly demanding genre, moreover, that required specific qualities of the artist. These, analyzed minutely by critics, varied according to artistic sensibility.

Portraying an Era

Many critics believed it was the portraitist's task to depict the model within the context of the time. Some, like Paul Mantz, editor of the highly respected *Gazette des Beaux-Arts*, stressed the portrait's documentary function. He likened portrait painters to "historians" and characterized portraits as "speaking effigies, which, just like the book of a chronicler, will recount the past, or at least help in understanding it."[9] This view was shared by the author and art critic Théophile Gautier, for whom "the portraitist, more than anyone, should give meaning to his era."[10] Zola, true to the naturalist approach he advocated, urged portraitists to exercise acuity and sensitivity in observing not only the model but also their surroundings. Describing portraits as "pictures of ordinary life," he believed it was the very nature of the genre, grounded in reality, to permit the illustration of a theme he held dear: modernity.[11]

Zola ushered in trivial naturalism and pornography, the pornography of things read between the lines. So many portraits of distinguished women looking like infamous whores. Semi-nudity.

Racontars de rapin, 1898–1902[12]

Painting the Soul

While critics saw the descriptive role of portraiture as crucial, visual accuracy was not necessarily enough. According to Zola, portraitists should "capture above all an individual resemblance – to the whole man, his state of mind, his character, his essential self, in the flesh."[13] The critic Octave Mirbeau also stressed the need to go beyond appearances, explaining that "it is not sufficient to depict the external features, but on these features must be recorded the model's character and intimate nature."[14] For this supporter of the avant-garde, who believed that "there is no art more difficult or more profound than the art of the portrait," it was necessary to be "not only a painter, to reproduce an individual's facial features, but also a psychologist and a poet, to represent his soul."[15] In the view of the critic Edmond About, this obligation to capture the essential nature of the model could justify some divergence from reality. Portraitists, he maintained, should take a synthetic approach to their subject: "By limiting yourself to a particular disposition, an event in the individual's life, a thought in his mind, you deprive yourself of the finest purpose of your art, which is to paint the entire man."[16]

I recently made a portrait of your brother for the picture "the sunflower painter," no. 30 canvas [ill. 35]. From the geographic point of view it is perhaps not a very good likeness, but I believe it has something of his inner self, and if you have no objection keep it, unless you don't like it.

Gauguin to Theo van Gogh, December 1888[17]

In order to familiarize myself with the character of a Tahitian face, all the charm of a Maori smile, I had wanted for some time to make a portrait of a neighbour, a young woman of pure Tahitian extraction ... I asked if I could make her portrait. *Aita* (no), she said, in an almost angry tone, and fled. This refusal made me very sad. An hour later she returned wearing a beautiful dress. Caprice, the lure of forbidden fruit. She smelled good, she was primped ...

I realized that in my painter's scrutiny there was a kind of tacit request for surrender, permanent surrender with no possibility of reversal, a penetrating excavation of what was beneath the surface. Not really pretty, by European standards: yet beautiful. All her features had a Raphaelesque harmony in the meeting of the curves, the mouth modelled by a sculptor who spoke all the tongues of language and kisses, of joy and suffering; the melancholy of bitterness mixed with pleasure, the passivity inherent to domination. A huge fear of the unknown.

I worked quickly and with passion. It was a portrait that resembled what my eyes, veiled by my heart, had perceived. I think above all that it resembled the interior. The vigorous fire of a contained force. She had a flower behind her ear that heeded her perfume. And her brow, in its majesty, by its raised lines, recalled these words by Poe: "There is no beauty without some [strangeness]," and I worked hastily, for I suspected the intention might waver. Portrait of a woman Vahine no te tiare [ill. 71].

Noa Noa, first manuscript, fall 1893[18]

Which do you prefer? A beautiful painting of an ugly person or a bad painting of a beautiful person?

Cahier pour Aline, 1892[19]

In an exhibition on the Boulevard des Italiens I saw a strange head. I do not know why something happened inside of me, why, standing in front of a painting, I heard strange melodies. A doctor's head, very pale, with eyes that do not look at you, that do not see but listen. In the catalogue I read, *Wagner* by Renoir [ill. 129]. This speaks for itself.

Avant et après, 1903[20]

In Praise of the Imagination

Although portraiture at the time seemed especially focused on reality, the part played by the artist's inventiveness was also significant. Some commentators, notably Charles Baudelaire, stressed the vital role of reverie and imagination in the execution of a portrait. This poet and critic, who had a profound influence on late-nineteenth-century avant-garde movements, devoted an entire chapter of his *Salon de 1846* to the portrait genre, asserting that there are two ways of understanding portraiture – "either as history or as fiction."[21] He associated "history" with the faithful representation of the model, although not necessarily without a degree of idealization, and identified Jacques-Louis David and Jean-Auguste-Dominique Ingres as the masters of what he described as the "historical" school. The second approach, more ambitious and difficult, he saw as the special province of the colourists. It involved transforming "the portrait into a picture – a poem with all its accessories, a poem full of space and reverie."[22] He named Rembrandt, Joshua Reynolds and Thomas Lawrence as leaders of this Romantic school.

In the chapter on portraiture in his *Salon de 1859*, Baudelaire emphasized the importance of the imagination.[23] He saw what he called this "queen of the faculties" as playing a vital role in portraiture, since "the more positive and solid the thing appears to be, the more subtle and laborious is the work of the imagination."[24] The artist's "submissiveness must be great, but his power of divination must be equally so."[25] This invocation by Baudelaire of imagination and intuition encouraged portraitists to distance themselves from reality – a move that many *fin-de-siècle* artists were only too happy to make.

Your idea for an exchange, to which I haven't yet replied, appeals to me, and I'll do the portrait you want, but not *yet*.[26] I'm not in a fit state to do it, seeing that it's not a copy of a face that you want, but a portrait as I understand it. I'm studying young Bernard, and I don't have him yet. I shall perhaps do it from memory, but in any case it will be an abstraction. Perhaps tomorrow, I don't know, it will come to me all at once [see ill. 7].

Gauguin to Vincent van Gogh, c. 26 September 1888[27]

It's good to copy the model meticulously from life, but be careful we don't breathe its odour.

Gauguin to Theo van Gogh, 20 or 21 November 1888[28]

One painter who has never known how to draw but who draws well is Renoir ... In Renoir's work, nothing is in its rightful place; don't look for line, there is none; as if by magic, a pretty spot of colour, a caressing light are eloquent enough. A light down ripples on the cheeks as it does on a peach, stirred by the breeze of love that whispers its music to the ears. You'd like to bite into the cherry that expresses the mouth, the laughing mouth that reveals one sharp little white pearl of a tooth. Be careful, it bites cruelly; it is a woman's tooth. Divine Renoir, who does not know how to draw.

I borrow again from Jean Dolent (may he forgive me!) when he says: "Transposing everything in order to be able to say everything, and borrowing from all models without treason or insult: the gesture of a friend, the face of a friend." And the artist can be recognized by the quality of his transpositions. Transposing reality doesn't mean changing the colour of the garters ... I make a portrait of a woman. I like the dress. I don't like the face. I use another one instead. The first model is furious and accuses me of giving another woman a dress that belonged to her.

The point is that there are several ways of understanding theft.

Racontars de rapin, 1898–1902[29]

Artists and Men of Letters

Art and literature were closely linked throughout the century, and it is therefore not surprising that the taste for portraiture in art was echoed by a powerful interest in its literary equivalent. Publications celebrating contemporary figures – writers, historians, politicians and artists – were extremely popular in the decades leading up to 1900, reflecting a growing preoccupation with both the individual and celebrity.[30] Among the many books published in France that were devoted partly or entirely to portraits of artists were *Les Hommes du jour* by Eugène Vermersch, *Portraits contemporains* by Théophile Gautier, *Vus de profil* by Henry Jouin and *Nos Peintres et Sculpteurs, Graveurs, Dessinateurs – Portraits et Biographies* by Jules Martin.[31] The second volume of the ambitious series *Portraits du prochain siècle*, which was never actually published, would have focused on painters, sculptors, musicians, actors, architects and printmakers. Newspapers and magazines also often featured biographical portraits, some even making it their speciality. A notable example was a periodical much appreciated by members of the avant-garde, *Les hommes d'aujourd'hui*, published between 1878 and 1899. Each issue was dedicated to a personality of the day and consisted of a caricature and a biography. The issue on Gauguin, published in 1896, featured a drawing by Émile Schuffenecker (ill. 130), which was severely criticized by Gauguin, and a text by Charles Morice.

I have received from [Schuff] his absurd portrait of me in *Les Hommes du jour* [sic].
That fellow exhausts me; gets on my nerves; what an idiot! And what pretention!
A cross, flames. Bah! There you have symbolism.

Gauguin to Daniel de Monfreid, April 1897[32]

EXHIBITING THE PORTRAIT

A number of initiatives organized in France during the last three decades of the nineteenth century testified to the portrait's growing appeal. While its defenders were arguing for the creation of a permanent institution to be devoted exclusively to the genre, many individual events were held that focused on the portrait and its developments. Aside from the annual Salon, which was thronged with portrait painters, portraiture was the object of numerous high-profile exhibitions that drew large and enthusiastic crowds. This intense activity had a stimulating effect on artists who, like Gauguin, were keen visitors to museums and exhibitions.

Galeries des Portraits nationaux, Exposition Universelle
September to October 1878, Palais du Trocadéro, Paris[33]

For a few weeks in 1878 the exhibition of "National Portraits," which was part of the official program of the Exposition Universelle, offered an institutional view of the genre. Devoted to "historical French portraiture from its origins to around 1830," the display was composed of more than nine hundred items, including paintings, sculptures, tapestries, enamel works and drawings. The organizers summarized their objective clearly in the catalogue: "To represent at once the history of our country and the history of our School."[34] Despite a number of logistical difficulties (a delayed opening, poor exhibition conditions), Paul Mantz described the event in the *Gazette des Beaux-Arts* as "truly admirable" and "worth repeating," while also stressing the pedagogical and even political value of the genre.[35] "An image," he reminded readers, "is a lesson. Let us teach history through portraiture."[36]

Gauguin and Museums

Although Mantz deplored the fact that France, unlike England, did not yet boast an institution devoted permanently to portraiture, there were nonetheless innumerable portraits on view in the country's museums. The Musée du Louvre, for example, much visited by artists, possessed a rich collection. Gauguin, an assiduous student of the works of earlier masters, referred on several occasions in his writings to visits to the Louvre and the portraits that had the greatest impact on him, singling out works by Rembrandt, Velázquez and Ingres (see ills. 131–133). Gauguin's familiarity with these masterpieces undoubtedly helped shape his own artistic vision and reinforced his quest for innovation.

I advise you, when at the Louvre, to look closely at the portraits by the venerable Ingres. You will find an inner life in the work of this French master; the apparent coldness he is accused of conceals an intense heat, a violent passion. There is also in his painting an impressive love for the lines of the whole, and a quest for beauty in its true essence – form.

Gauguin to Jens Ferdinand Willumsen, fall 1890[37]

131 Jean-Auguste-Dominique Ingres, *Mademoiselle Caroline Rivière*, 1806
132 Rembrandt van Rijn, *Young Man with a Stick*, 1651

Drawing, what is it? Do not expect me to give a lecture on the subject.
The critic probably thinks of it as a number of things done on paper in pencil, no doubt imagining that this is where one can tell if a man can draw. Knowing how to draw is not the same as drawing well. Does he realize, the critic, this authority, that tracing the outline of a painted figure results in an entirely different kind of drawing? In the portrait of a traveller by Rembrandt (Lacazes Gallery) the head appears square [ill. 132]. Trace the outline and you'll see that the head is twice as high as it is wide.

***Avant et après*, 1903**[38]

We wonder why Velázquez's *Infanta* (Lacazes Gallery) has artificial shoulders and why the head does not fit onto them [ill. 133]. And the result is good. While in a Bonnat the head fits onto real shoulders. And the result is bad.

***Racontars de rapin*, 1898–1902**[39]

Gauguin also made a point of visiting museums outside the capital. He made a special trip to the Musée Antoine Lécuyer in Saint-Quentin to see the works of Maurice-Quentin de La Tour (see ill. 134), and he travelled twice to the Musée Fabre in Montpellier, accompanied on the second occasion by fellow painter Vincent van Gogh. Many years later, Gauguin still recalled the portraits he had seen on these visits.

133 Diego Velázquez, *Portrait of the Infanta Maria-Theresa, Future Queen of France*, 17th century **237**

Did you know that about a dozen years ago I went to Saint-Quentin purposely to get a comprehensive view of La Tour's work: I had seen it badly in the Louvre and I had a feeling I would see it quite differently in Saint-Quentin. At the Louvre, I don't know why, I always lumped him together with Gainsborough. But at Saint-Quentin, nothing of the sort. La Tour is definitely French and a gentleman, for if there is one quality I value in painting, it's that one … This is not the heavy sword of a Bayard but rather the dress sword of a marquis, not the bludgeon of a Michelangelo but the stiletto of La Tour. The lines are as pure as a Raphael; the curves are always composed in a harmonious and significant way. I had almost forgotten him, but fortunately the *Mercure* came at just the right time to revive in me a pleasure I used to feel, and also to let me share the pleasure you feel when you look at the portrait of *La Chanteuse* [*The Singer*].

Gauguin to André Fontainas, August 1899[40]

Cabanel! That's another story.
I hated him when he was alive, I hated him after he was dead, and I'll hate him till I die myself.
And this is why.
As a young man, I made a trip to the Midi, and in Montpellier I visited the famous museum built and donated, with his entire collection, by Monsieur Brias. … One entered a very large gallery … here was Brias' personal collection, a selection, that is, of what were once the revolutionary painters. O Roujon!
There were portraits of Brias by himself, by Courbet, by Delacroix and others …
A magnificent canvas by Chardin. A large portrait of a noble lady seated before a table, working at a tapestry. All of this, revolutionary as it was, was for me a source of joy, when suddenly my eye lit on a spot that was entirely out of harmony.
A little picture depicting the head of a young man, a pretty youth resembling a hairdresser. Stupidity and fatuity. Cabanel, painted by himself [ill. 135].

***Avant et après*, 1903**[41]

134 Maurice-Quentin de La Tour, *Portrait of Marie Fel*, 1757
135 Alexandre Cabanel, *Self-portrait (at the Age of Twenty-Nine)*, 1849–52

Opening of the Gallery of Portraits of Artists
14 February 1888, Denon Gallery, Musée du Louvre, Paris

During the second half of the nineteenth century a number of defenders of portraiture, convinced of its importance, urged that the genre be given greater visibility. One such person was the archivist Henry Jouin, who called for the creation of a national museum devoted to portraits of artists, and to this end published a list of three thousand potentially suitable works.[42] The only concrete effect of these efforts at the institutional level, however, was seen at the Musée du Louvre. Although the idea of dedicating a gallery at the Louvre exclusively to portraits was not new, it was not realized until 1888, under the impetus of the Director of Fine Arts, Jules-Antoine Castagnary.[43] Despite numerous restrictions, notably of space and money, he succeeded in assembling a corpus of 104 portraits drawn from the collections of the Louvre, Versailles, the École des Beaux-Arts and the Musée du Luxembourg, which were all itemized in a catalogue published for the occasion.[44]

Although the gallery was decried as "too large and poorly lit," critics nonetheless welcomed the new installation, noting that the crowds who had flocked to see it since its inauguration were proof of the soundness of the enterprise.[45] The significance of this tribute to France's painters was multi-faceted – historical, patriotic, aesthetic and didactic. Philippe de Chennevières was of the opinion that "these portraits, assembled at the Louvre, [would] themselves serve to instruct the portraitists of today."[46] But the young art critic Félix Fénéon, a voice of the *fin-de-siècle* avant-garde, did not share De Chennevières' enthusiasm: "Four superimposed rows of miserable dummies, wearing wigs and grasping palettes – a chilling spectacle."[47]

The Salon

While the Louvre focused on masters of the past, those eager to keep up with the latest trends counted on the Salon. Portraiture was especially well represented at this major annual highlight of the Paris art scene, which showed works by such fashionable portraitists as Léon Bonnat, Alexandre Cabanel, Carolus-Duran and Charles Chaplin. The concentration of mainstream artists did not please everyone, however. "The flood of portraits increases from year to year and threatens to take over the entire Salon," complained Zola, going on to rail against the "trashy portraits" on display."[48] Artists who took a facile approach to the genre were severely criticized by the partisans of modernity. Zola denounced portraitists whose sole concern was "to please the model," and caricaturists like Honoré Daumier wittily captured the self-satisfaction of members of the bourgeoisie come to admire their portraits

at the Salon (see ills. 136, 137).[49] Jules Castagnary, for his part, deplored the frivolous attention devoted to costume at the expense of the face: "The heads are nothing, the fabrics take over," he remarked, writing of the portraits of Carolus-Duran.[50] Many critics also denounced the unnaturalness of the poses. Octave Mirbeau, a fierce opponent of academic convention, likened the models to "faces made of wax stuck onto mannequins" and the Salon itself to "a kind of Musée Grévin."[51] Gauguin's views of the popular Salon portraitists weren't very kind either, and he did not hide his aesthetic judgments.

There are people who say: "Rembrandt and Michelangelo are vulgar; I prefer Chaplin." One very homely woman tells me: "I don't like Degas because he paints ugly women." Then she adds: "Have you seen my portrait by Gervex at the Salon?"

Avant et après, 1903[52]

136 Honoré Daumier, "Quand on a son portrait au salon" [When you have your portrait at the Salon], 1845
137 Honoré Daumier, "C'est tout d'même flatteur d'avoir son portrait à l'exposition" [It's flattering, after all, to have one's portrait in the exhibition], 1857

Portraits du siècle
April to June 1883 and April to June 1885, École des Beaux-Arts, Paris[53]

Several other events celebrated nineteenth-century portraiture during this period. Of these were two exhibitions held at the École des Beaux-Arts in 1883 and 1885. Both were organized by the Société philanthropique with the goal of raising funds for various charities. In the hope of attracting both lenders and visitors, the organizers chose the alluring theme of "portraits of the century," and they obtained numerous loans, with 356 items listed in the first catalogue and 424 in the second.[54] These thematic shows owed their success in part to the fact that they presented little-known works, drawn largely from private collections, but also to the theme itself: people were fascinated, and flocked to see pictures of the century's most famous figures.

Both a financial and a critical success, the first exhibition was attended by "Paris' artistic and social elite."[55] It included works by the great portrait painters from early in the century, such as Jacques-Louis David, François Gérard and Jean-Auguste-Dominique Ingres, but contemporary artists were also well represented.

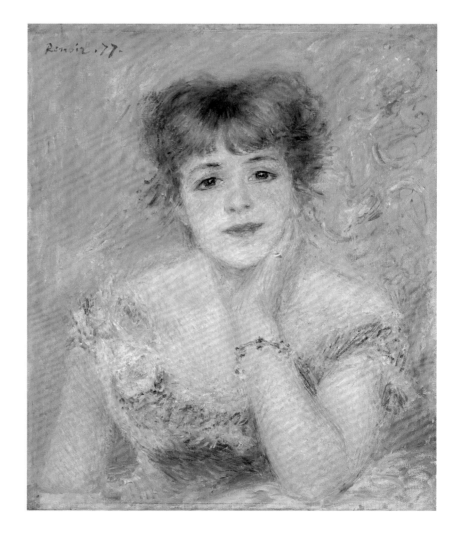

Writing in the *Gazette des Beaux-Arts*, Alfred de Lostalot seemed delighted with the new wave: "As long as there exist masters like Baudry, Meissonier, Dubois, Carolus-Duran, Delaunay, Chaplin, Henner, Bonnat, Gaillard, Fantin-Latour and their young emulators there need be no fear that the essentially French art of the portrait will perish."[56] The composition of the patron's committee (a group of academic artists that included Paul-Jacques-Aimé Baudry, Léon Bonnat, Alexandre Cabanel, Carolus-Duran and Jules-Élie Delaunay) explains the poor representation of more radical painters. Auguste Renoir and Édouard Manet were among the exceptions, however, and Gauguin, who visited the exhibition, would long remember the portraits by them he saw on this occasion (see ills. 138, 139).

138 Pierre-Auguste Renoir, *Portrait of Jeanne Samary (La Rêverie)*, 1877 **241**

And once again I see the beautiful portrait of Samary that I once saw at the "Portraits of the Century" exhibit at the Beaux-Arts.

Let me tell you a little story about that. I went to the exhibit with a man who was an enemy of Manet, Renoir, the Impressionists. When he saw that portrait he declared it was loathsome. To divert his attention from it I showed him a large portrait, *Père et mère dans une salle à manger [Monsieur and Madame August Manet]*. The signature was so tiny it was invisible. "Ah, at last!" he exclaimed. "That's what I call painting." "But it's by Manet," I told him. He was furious. We have been at swords' point ever since.

Gauguin to André Fontainas, August 1899[57]

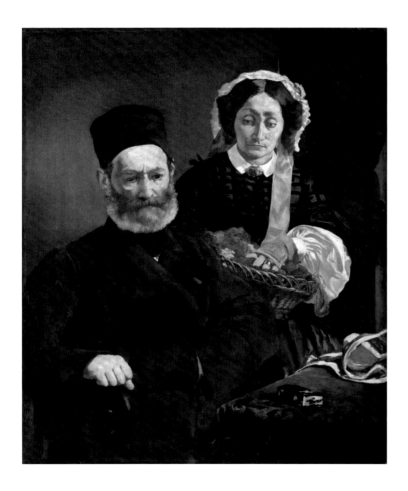

Encouraged by the success of 1883, the organizers of the 1885 exhibition adopted the same formula, although they gave a larger place to foreign portrait painters such as Thomas Gainsborough, Thomas Lawrence and Francisco de Goya. While the *Courrier de l'art* critic Paul Aula praised "the extraordinary fecundity of the modern French school," Edmond Bazire, writing in *L'Intransigeant* under the pen name of Edmond Jacques, was violently critical of the contemporary portraitists who numerically dominated the exhibition: "There is a profusion of Bonnats, all sadly drowning in molten pitch. The Cabanels are upsetting in their anaemic stiffness. The Carolus-Durans are pretentiously and rashly explosive, but despite the chromatic fanfares fail to engage the eye. I might also mention the Chaplins and their penchant for cold cream."[58] So while these two exhibitions paid tribute to the nineteenth century's pioneers – such universally admired artists as David and Ingres – they gave considerable space to the "official" painters Gauguin scorned and hardly any to the avant-garde of which he was himself a member.

I also own a travel book, full of illustrations. India and China, the Philippines, Tahiti, etc. All the figures, carefully copied to make a portrait, resemble Minerva or Pallas. How marvellous it is, the École des Beaux-Arts.

Avant et après, **1903**[59]

Exposition des portraits des écrivains et journalistes du siècle (1793–1893)
10 June to 15 August 1893, Galerie Georges Petit, Paris[60]

This non-profit exhibition was composed of a selection of works that showed a little more evidence of the experimentations being conducted outside the academic system. Owing to a lack of space at the École des Beaux-Arts it was held in the gallery of Georges Petit, a long-time defender of the most recent art trends, and it focused on the notably more liberal *fin-de-siècle* literary milieu. The success of the exhibitions of 1883 and 1885 no doubt influenced the choice of theme, which was once more the portrait: "Not again!" exclaimed the critic Henri Bouchot in the *Gazette des Beaux-Arts*.[61] Organized by the Association des journalistes parisiens in aid of its charity fund, this loan exhibition was composed of portraits of nineteenth-century authors and journalists. Although the ambitious project – the catalogue lists 993 items – was reported to be "a resounding success among artists

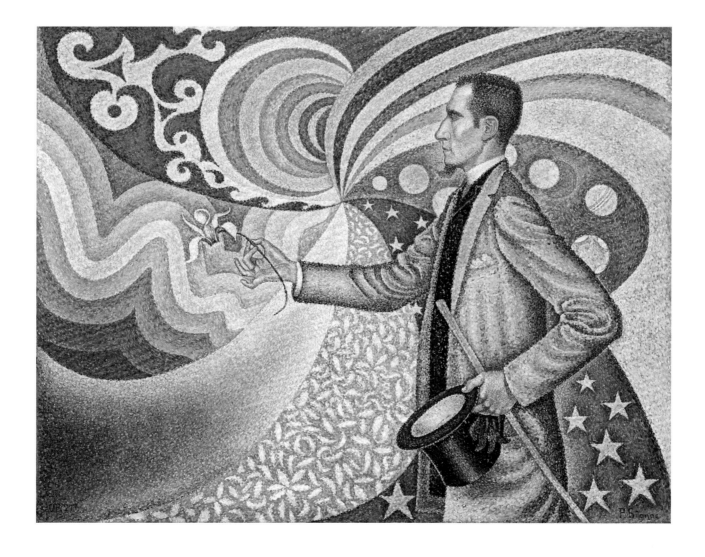

140 Paul Signac, *Opus 217. Against the Enamel of a Background Rhythmic with Beats and Angles, Tones, and Tints, Portrait of M. Félix Fénéon in 1890*, 1890

and members of society," there were those who questioned the quality of some of the works, and others who criticized the ostentatious and corporatist celebration of personalities whose importance was not necessarily a matter of consensus.[62] Considerable space was given to historical artists, but living artists were also well represented. The presence of works by Bonnat and Carolus-Duran was hardly surprising, while the inclusion of numerous portraits by Jacques-Émile Blanche and Eugène Carrière can likely be explained by the artistic open-mindedness of the gallerist, for both these artists offered a personal take on the traditional academic portrait. The more liberal atmosphere, reinforced by the event's literary dimension, opened the way to artists from more radical circles. Some of the more daring submissions, like the picture of Félix Fénéon by the Neo-Impressionist painter Paul Signac (lent by the model himself, ill. 140), testified to the close ties that existed between the literary and artistic avant-gardes near the end of the century. Examples of innovation were rare, however – a fact deplored by the progressive press, which condemned what the Symbolist critic Camille Mauclair described as the overly bourgeois aesthetic dominating the "pretty walls" of the "fashionable Galerie Petit."[63]

Exposition des portraits du prochain siècle
7 September to October 1893, Galerie Le Barc de Boutteville, Paris[64]

This event was intended as a radical riposte to the exhibition held at the Georges Petit gallery. According to its organizer, the libertarian poet Paul-Napoléon Roinard, the idea grew out of his joking remark that an exhibition devoted to "Portraits of the Next Century" would be "at least as interesting."[65] Although there was some opposition, this daring and provocative project was enthusiastically backed by defenders of the avant-garde, including the gallerist Louis-Léon Le Barc de Boutteville, who offered to host it, and the publisher Edmond Girard, who pledged to provide media coverage in his magazine *Essais d'art libre*. A call for contributions was placed in the April/May issue, inviting "men of letters, journalists, painters, sculptors, architects, musicians and theatrical artists to send their painted or drawn portraits to Monsieur Le Barc de Boutteville's gallery before 28 June."[66]

The event, which seems not to have opened until September, reportedly consisted of around fifty works representing "the very best of the decadent and Symbolist schools."[67] In *La Plume*, Jules Christophe wrote of the "exquisite atmosphere of liberty" and "fine odour of anarchy" that permeated the exhibition.[68] It included pictures of such political thinkers as Karl Marx, Mikhail Bakunin, Pierre-Joseph Proudhon and Elisée Reclus, alongside portraits of modern literary figures such as Paul Verlaine, Jules Barbey d'Aurevilly, Albert Aurier and Joséphin Péladan. Also on view were self-portraits by some of the most innovative artists of the period:

Paul Cézanne, Vincent van Gogh, Émile Bernard, Louis Anquetin and Gauguin. The latter was actually represented by two paintings – a self-portrait and a picture of his friend Louis Roy, also a painter (ill. 30).[69]

Some critics were harsh – "Monsieur Gauguin … well! Yes, good Lord, Monsieur Gauguin! Nothing will ever make me like his self-portrait, which is frightful and ridiculous," Mauclair exclaimed.[70] However, the artist also received praise: Paul-Armand Hirsch wrote in *L'art social* of "the admirable Gauguin," and in *Le Cœur* Tiphereth described him as a "giant of painting."[71] Although the exhibition amused or irritated numerous critics, *L'Art moderne* described as a "great success" this bold attempt to identify among representatives of the avant-garde the names that would endure in the century to come.[72] A number of commentators remained sceptical, but there was also optimism, notably from Tiphereth, who wrote: "Many, we feel assured, will have the influence on the next century that their incontestable talent warrants."[73]

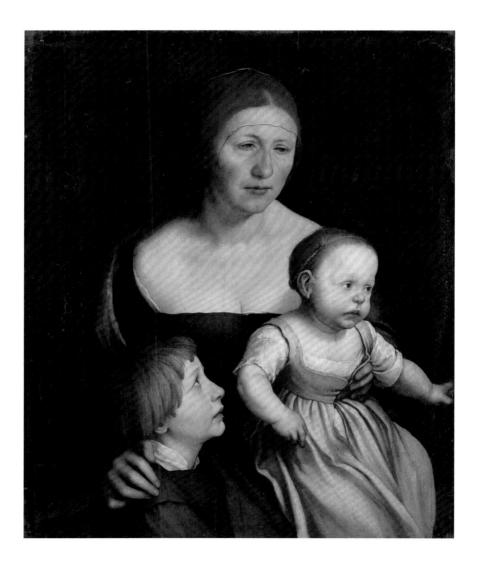

Although there seems to have been no catalogue, after the exhibition Girard and Roinard decided to publish a major book that would embody "in a comprehensive and lasting form the idea behind the exhibition."[74] Entitled *Portraits du prochain siècle*, the publication was initially intended to consist of three volumes – the first devoted to poets and prose writers, the second to painters, sculptors, musicians, actors, architects and printmakers, and the third to sociologists, philosophers and scientists. A call for contributions appeared in the magazine *Essais d'art libre* asking for "summarized portraits of fifteen to twenty lines."[75] Although it was not part of the original plan, Girard later suggested that the "painters, draftsmen and printmakers execute a self-portrait using burin, pen or pencil."[76]

Only the first volume was actually published, but some of the proposed content of the second appeared in the magazine, which regularly published lists of the portraits to be included.[77] The names that appear there confirm the avant-garde nature of the venture, which brought together both the pioneers and the younger proponents of *fin-de-siècle* modernity. Among the planned portraits were texts on Louis Anquetin by Roinard, on Émile Bernard by Hirsch, on Maximilien Luce, Félix Vallotton and Henri Toulouse-Lautrec by Francis Jourdain, and on Édouard Manet and James McNeill Whistler by Stéphane Mallarmé. Gauguin was to have appeared as both subject and author: subject of a portrait written by the art critic Jean Dolent and author of a portrait of his friend Van Gogh, who had died in 1890.

CONCLUSION

One way of perceiving Gauguin's unique oeuvre is within the context of the remarkable flourishing of portraiture that occurred in the final decades of the nineteenth century. Interest in the genre, shared by artists, critics and public alike, reflected the preferences and anxieties of a society fascinated by its own image and haunted by the spectre of oblivion. As the century drew to a close, the writer Jules Barbey d'Aurevilly described the proliferation of portraits as "drops in the sea of individuality that is rising and will soon cover everything!"[78] Gauguin, isolated in Polynesia, would continue to take on the challenge of the portrait until his death, surrounded by reproductions of his favourite examples, including, pinned to the wall, a triple portrait by the German Renaissance painter Hans Holbein the Younger (see ills. 141, 142).

In my hut there are things which are bizarre, because not usually seen: Japanese prints, photographs of paintings, Manet, Puvis de Chavannes, Degas, Rembrandt, Raphael, Michelangelo, Holbein.

Avant et après, **1903**[79]

NOTES

1 Gauguin 1996, p. 127.

2 Zola 1991, p. 303.

3 Letter from Gauguin to Mette Gauguin, Colón, Panama, c. 12 May 1887, in Gauguin 1949, no. 52, p. 80.

4 Letter from Gauguin to Mette Gauguin, Tahiti, 4 June 1891, in ibid., no. 125, p. 162.

5 Letter from Gauguin to Paul Sérusier, Papeete, 25 March 1892, in Sérusier 1950, p. 59. This portrait was never executed.

6 Blanc 1879, p. 230.

7 Astruc 1868, pp. 1–2.

8 Castagnary 1892, p. 245.

9 Mantz 1863, p. 32.

10 Gautier 1852, p. 2.

11 Zola 1991, pp. 302–303.

12 Gauguin 1996, p. 224.

13 Zola 1991, p. 303.

14 Octave Mirbeau, "Notes sur l'art, Renoir," *La France* (8 December 1884), in Mirbeau 1993, p. 89.

15 Octave Mirbeau, "Les portraits du siècle," *La France* (23 April 1885), in ibid., p. 154.

16 About 1858, p. 50.

17 Letter from Gauguin to Theo van Gogh, Arles, 3rd week of December 1888 (c. 19 or 20?), in Gauguin 1984, no. 192, p. 302.

18 Gauguin 1893, pp. 8–9.

19 Gauguin 2009, p. 31.

20 Gauguin 1996, p. 261.

21 Baudelaire 1956, p. 92.

22 Ibid., p. 93.

23 Ibid., pp. 233–234, 273–274.

24 Ibid., pp. 233, 273.

25 Ibid., p. 274.

26 Van Gogh had asked Gauguin to make a portrait of Émile Bernard and Bernard to make one of Gauguin, but each executed a self-portrait with a portrait of their fellow artist in the background.

27 Letter from Gauguin to Vincent van Gogh, Pont-Aven, c. 26 September 1888, no. 688, http://vangoghletters.org (accessed 14 September 2018).

28 Letter from Gauguin to Theo van Gogh, Le Pouldu, 20 or 21 November 1888, in Gauguin 1983, p. 167.

29 Gauguin 2003, pp. 23, 31–32, trans. Gauguin 1996, pp. 217–218, and Groom 2017, p. 58.

30 For more on this subject, see Dufour 1997.

31 Vermersch 1866–67; Gautier 1874; Jouin 1897; and Martin 1897.

32 Letter from Gauguin to Daniel de Monfreid, Tahiti, April 1897, in Gauguin 1922, no. 24, April 1897, p. 81 (trans. modified).

33 The opening of this event, initially scheduled for May, was delayed until September. For more on this, see Philibert Bréban, "L'exposition universelle," *Le XIXᵉ siècle* (10 October 1878), pp. 2–3, and Mantz 1878, pp. 857–858.

34 Jouin 1879.

35 Mantz 1863, p. 858.

36 Ibid., p. 882.

37 Letter from Gauguin to Jens Ferdinand Willumsen, Pont-Aven, fall 1890, published in *Les Marges* (15 March 1918) and in the *Bulletin de la société d'études océaniennes*, no. 5 (March 1919), p. 44.

38 Gauguin 1923, p. 183.

39 Gauguin 2003, pp. 15–16.

40 Letter from Gauguin to André Fontainas, Tahiti, August 1899, in Gauguin 1996, p. 188.

41 Gauguin 1923, pp. 220–221.

42 Jouin 1888.

43 For an account of the project's development, see De Chennevières 1888, pp. 321–340.

44 The author of the catalogue, Georges Lafenestre, stressed the temporary nature of the chosen space, explaining that the portraits had been "placed in the Denon Gallery until the enlargement of these galleries permits a more thoroughgoing display of this collection." In fact, the hoped-for change of venue never took place. See Lafenestre 1888, p. 3.

45 *L'Art pour tous*, 27th year, nos. 666–667 (March 1888), unpaginated.

46 De Chennevières 1888, p. 335.

47 Fénéon 1888, p. 478.

48 Zola 1991, pp. 192, 303.

49 Ibid, p. 303.

50 Castagnary 1892, p. 25.

51 Octave Mirbeau, "Le Salon (I)," *La France* (3 May 1886), in Mirbeau 1993, p. 252. The Musée Grévin is a wax museum in Paris.

52 Gauguin 1996, p. 260.

53 *Exposition de portraits du siècle (1783–1883)*, 25 April to 5 June 1883 (officially open until 30 May, the exhibition was extended until 5 June. See *L'Intransigeant* [4 June 1883], p. 3); *Deuxième exposition de portraits du siècle*, 20 April to 7 June 1885 (officially open until 31 May, the exhibition was extended until 7 June. See *Le Figaro* [6 May 1885], p. 1).

54 Exposition de portraits du siècle 1883; Exposition de portraits du siècle 1885.

55 *Le Gaulois* (20 May 1883), p. 1.

56 De Lostalot 1883, p. 91.

57 Letter from Gauguin to André Fontainas, Tahiti, August 1899, in Gauguin 1996, pp. 188–189.

58 Aula 1885, p. 238; Bazire 1885, p. 2.

59 Gauguin 1923, p. 205.

60 Although the catalogue gives the exhibition opening date as 12 June, it actually opened on 10 June, as announced in the *Journal des débats politiques et littéraires* (10 June 1893, p. 2). According to *La Chronique des arts et de la curiosité*, the exhibition was extended until 15 August (20 May 1893, p. 156). See also, Exposition des portraits des écrivains et journalistes du siècle 1893.

61 Bouchot 1893, p. 202.

62 Exposition des portraits des écrivains et journalistes du siècle 1893; Bouchot 1893, p. 203.

63 Mauclair 1893, p. 118.

64 A call for loans was published in the April/May 1893 issue of the magazine *Essais d'art libre* (p. 200), inviting potential lenders to submit works by 28 June. Although Paul-Napoléon Roinard states in the *Revue encyclopédique* ("Les Portraits du prochain siècle," 15 November 1893, p. [641]) that the exhibition ran from July to September, daily newspapers of the time seem to indicate that it opened later: *Gil Blas* announced an opening on 28 June (27 June 1893, p. 3), later delayed to 5 July (30 June 1893, p. 3). *Le Petit Parisien* subsequently stated that the delayed opening would take place on 20 August (24 July 1893, p. 2), while the 8 September 1893 edition of the *Petit Journal* (p. 1) reported that "the *Portraits du prochain siècle* exhibition opened yesterday." The exhibition must have closed at the latest a few days before the opening on 25 October at the Galerie Le Barc de Boutteville of the 5th exhibition of Impressionist and Symbolist painters. The August/September/October issue of the magazine *Essais d'art libre* includes the following announcement: "The exhibition *Les portraits du prochain siècle* has recently closed, and we ask those of our colleagues who have sent their portrait to Monsieur Le Barc de Boutteville's gallery to kindly have it picked up as soon as possible" ("notes et communications," unpaginated).

65 Roinard 1893, p. 641.

66 *Essais d'art libre* (April/May 1893), p. 200.

67 *Le Temps* (13 September 1893), p. 3; *Le Petit Journal* (8 September 1893), p. 1. For a review of newspaper articles related to the event, see Lobstein 2012, pp. 28–40.

68 Christophe 1893, p. 415.

69 There is unfortunately no concrete information about who lent these two paintings: perhaps Gauguin himself, just back from his first trip to Tahiti; or Louis Roy, as the owner of his own portrait.

70 Mauclair elaborated: "I know some very powerful works by this artist, and if I did not admire him, I would not bother to reproach him with one bad painting, more or less; we could have done without this one. I've heard that Gauguin is back from Oceania: he should waste no time in showing us his negresses and virgin vegetation! I'll soon forget his face." See Mauclair 1893, p. 119.

71 Hirsch 1893, p. 287; Tiphereth 1893, p. 8.

72 "Petite chronique," *L'Art moderne*, no. 1 (8 October 1893), p. 327.

73 The review in the newspaper *Le Temps* concluded with the observation that, aside from a few interesting experiments, "the twentieth century will certainly think, if it judges by the exhibition on rue Le Peletier, that the legacy left it by our poor nineteenth century is thoroughly mediocre" (13 September 1893, p. 3). See also Tiphereth 1893, p. 8.

74 Girard and Roinard 1893, pp. 124–126.

75 *Essais d'art libre* (August/September/October 1893), pp. 124–126.

76 Girard 1894, pp. 217–218.

77 Roinard 1894. For more on this publication, see Dufour 2003, pp. 191–204. For the content of the second publication, see *Essais d'art libre*, for example the 1894 issues for February/March/April (pp. 70–72) and June–July (pp. 139–140).

78 Jules Barbey d'Aurevilly. "Le Cardinal Maury," in Barbey d'Aurevilly 1898, p. 35.

79 Gauguin 1996, p. 27.

LIST OF ILLUSTRATIONS

Dimensions are height × width × depth
All works are by Paul Gauguin, unless otherwise stated

* refers to works in the exhibition

1
Interior with Aline 1881 *
oil on canvas
75.7 × 86.9 cm
Private collection
On loan to Museums Sheffield
W51 / W77 (2001)

2
Self-portrait with Manao tupapau
1893–94 *
oil on canvas, double-sided
(verso: *Portrait of William Molard*)
46 × 38 cm
Musée d'Orsay, Paris
Acquired with the assistance of an
anonymous Canadian donation, 1966
(RF1966-7)
W506

3
Self-portrait n.d.*
charcoal on vellum paper
31 × 19.9 cm
Musée d'Art moderne et contemporain
de Strasbourg
Purchased from M. Comte, 1921
(XXI 159)
London only

4
Louis-Maurice Boutet de Monvel
Paul Gauguin 1891
aristotype
11.1 × 9.2 cm
Private collection

5
Self-portrait 1885 *
oil on canvas
65.2 × 54.3 cm
Kimbell Art Museum, Fort Worth
(AP 1997.03)
W138 / W165 (2001)

6
Self-portrait Dedicated to Carrière
1888/89 *
oil on coarse fabric
46.5 × 38.6 cm
National Gallery of Art, Washington, D.C.
Collection of Mr. and Mrs. Paul Mellon
(1985.64.20)
W384

7
*Self-portrait with Portrait of Bernard
(Les Misérables)* 1888
oil on canvas
44.5 × 50.3 cm
Van Gogh Museum, Amsterdam
Vincent van Gogh Foundation
(s0224V1962)
W239 / W309 (2001)

8
Émile Bernard
Self-portrait with Portrait of Gauguin
1888
oil on canvas
46 × 56 cm
Van Gogh Museum, Amsterdam
Vincent van Gogh Foundation
(s0206V1962)

9
Vincent van Gogh
Self-portrait Dedicated to Gauguin
1888
oil on canvas
61.5 × 50.3 cm
Harvard Art Museums / Fogg Museum,
Cambridge, Massachusetts
Bequest from the Collection of Maurice
Wertheim, Class of 1906 (1951.65)

10
Claude Monet
Self-portrait with a Beret 1886
oil on canvas
56 × 46 cm
Private collection

11
Bonjour, Monsieur Gauguin 1889 *
oil on canvas and panel
74.9 × 54.8 cm
Hammer Museum, Los Angeles
The Armand Hammer Collection.
Gift of the Armand Hammer
Foundation (AH.90.31)
W321

12
Gustave Courbet
*The Meeting (Bonjour, Monsieur
Courbet)* 1854
oil on canvas
129 × 149 cm
Musée Fabre, Montpellier
Bruyas donation, 1868 (868.1.23)

13
Self-portrait with Halo 1889
oil on wood
79.2 × 51.3 cm
National Gallery of Art, Washington, D.C.
Chester Dale Collection (1963.10.150)

14
Christ in the Garden of Olives 1889 *
oil on canvas
72.4 × 91.4 cm
Norton Museum of Art, West Palm
Beach, Florida
Gift of Elizabeth C. Norton (46.5)
W326

15
Unknown photographer
Paul Gauguin 1893
photograph

16
Georges Pissarro
Caricature of Gauguin 1893
gouache enhanced with golden bronze
on paper
45.5 × 32 cm
Private collection

17
Self-portrait with Palette c. 1894
oil on canvas
92 × 73 cm
Private collection
W410

18
Self-portrait "à l'ami Daniel" 1896 *
oil on canvas
40.5 cm × 32 cm
Musée d'Orsay, Paris
Gift of Madame Huc de Monfreid, 1951
(RF1951-7)
W556

19
Head of a Savage 1889
charcoal on paper
19 × 30 cm
Current location unknown

20
*Self-portrait Caricature with De Haan
and O'Connor* 1889–90
crayon on paper
28.5 × 45 cm
J.F. Willumsen Museum, Frederikssund

21
Self-portrait with Idol c. 1893 *
oil on canvas
43.8 × 32.7 cm
McNay Art Museum, San Antonio
Bequest of Marion Koogler McNay
(1950.46)
W415

22
Self-portrait 1889–90 *
oil on canvas
46 × 38 cm
The Pushkin State Museum of Fine Arts,
Moscow
W297
London only

23
Self-portrait (Near Golgotha) 1896 *
oil on canvas
75.5 × 63 cm
Museu de Arte de São Paulo Assis
Chateaubriand
Gift of Guilherme Guinle, Álvaro Soares
Sampaio, Francisco Pignatari and
Fúlvio Morganti, 1952 (MASP.00108)
W534

24
Self-portrait 1903 *
oil on canvas
41.4 × 23.5 cm
Kunstmuseum Basel
Legacy of Dr. Karl Hoffmann, 1945 (1943)
W634

25
Head of a Savage, Mask 1894–95 *
terracotta wood, stained
25 × 19 × 5 cm
Musée Léon Dierx, Saint-Denis
Conseil départemental de La Réunion
(1947.01.52)

26
Head of a Savage, Mask c. 1895 *
bronze
25 × 12 × 18 cm
Musée d'Orsay, Paris
Gift of Lucien Vollard, 1944 (AF14392)
G110

27
Self-portrait "Oviri" 1894–95 *
bronze, posthumous cast
35.5 × 34 cm
Kelton Foundation, Santa Monica
G109

28
Portrait of Claude Antoine Charles Favre
1877
oil on canvas
45.5 × 38 cm
Collection Lancaster, Paris
W43

29
Portrait of William Molard 1893–94 *
oil on canvas, double-sided
(recto: *Self-portrait with Manao tupapau*)
46 × 38 cm
Musée d'Orsay, Paris
Acquired with the assistance of an
anonymous Canadian donation, 1966
(RF1966-7)
W507

30
Portrait of Louis Roy 1890–91 *
oil on canvas
40.7 × 33 cm
Private collection
W317

31
Portrait of Stéphane Mallarmé,
Dedicated to Charles Morice 1891 *
etching on copper, with drypoint
and engraving
18.3 × 14.3 cm
Institut national d'histoire de l'art, Paris
Ottawa only

32
Portrait of Stéphane Mallarmé,
Dedicated to Daniel de Monfreid 1891 *
etching on copper, with drypoint
and engraving
18.3 × 14.3 cm
Chancellerie des Universités de Paris –
Bibliothèque littéraire Jacques Doucet,
Paris

33
The Afternoon of a Faun c. 1892 *
tamanu wood, stained
35.6 × 14.7 × 12.5 cm
Musée départemental Stéphane Mallarmé,
Vulaines-sur-Seine (995.5.1)
Département de Seine-et-Marne
G100

34
Portrait of the Painter Ślewiński 1891 *
oil on canvas
53.5 × 81.5 cm
National Museum of Western Art, Tokyo
Matsukata Collection (P1959-0107)
W386

35
Vincent van Gogh Painting Sunflowers
1888
oil on canvas
73 × 91 cm
Van Gogh Museum, Amsterdam
Vincent van Gogh Foundation
(s0225V1962)
W296 / W326 (2001)

36
Vincent van Gogh
Sunflowers 1888
oil on canvas
92 × 73 cm
Neue Pinakothek Munich
Acquired in 1912 as an anonymous gift
as part of the Tschudi donation (8672)

37
Sunflowers on an Armchair (I) 1901
oil on canvas
68 × 75.5 cm
Foundation E.G. Bührle Collection, Zurich
W602

38
Sunflowers on an Armchair (II) 1901 *
oil on canvas
73 × 92 cm
The State Hermitage Museum,
Saint Petersburg (6516)
W603
London only

39
Still Life with "Hope" 1901 *
oil on canvas
65 × 77 cm
Private collection, Milan
W604

40
Sunflowers with Mangoes 1901
oil on canvas
93 × 73 cm
Private collection
W606

41
Odilon Redon
There Was Perhaps a First Vision
Attempted in the Flower 1883
from *Les Origines*
lithograph
48.8 × 35.2 cm
Bibliothèque nationale de France, Paris
Département des estampes et de la
photographie

42
Meijer de Haan
Self-portrait in Breton Dress 1889
oil on canvas
74 × 54 cm
Private collection

43
Portrait of Meijer de Haan 1889 *
oil on wood
79.6 × 51.7 cm
The Museum of Modern Art, New York
Gift of Mr. and Mrs. David Rockefeller,
1958 (2.1958)
W317
Ottawa only

44
Portrait of Meijer de Haan 1889 *
black crayon and brush on paper
16.2 × 19.1 cm
Kelton Foundation, Santa Monica

45
Portrait of Meijer de Haan 1889–90 *
charcoal on paper
31 × 19.4 cm
Dr. Richard and Astrid Wolman

46
Portrait of Meijer de Haan Reading
1889 *
pen and ink on paper
29.2 × 19.4 cm
Kelton Foundation, Santa Monica

47
Vincent van Gogh
L'Arlésienne, Madame Ginoux 1888–89
oil on canvas
91.4 × 73.7 cm
The Metropolitan Museum of Art,
New York
Bequest of Sam A. Lewisohn, 1951
(51.112.3)

48
L'Arlésienne, Madame Ginoux 1888 *
beige chalk under charcoal with
stumping, with salmon-coloured
pastel, heightened with white chalk
on beige wove paper
56.1 × 49.2 cm
Fine Arts Museums of San Francisco
Memorial gift from Dr. T. Edward and
Tullah Hanley, Bradford, Pennsylvania
(69.30.78)

49
Nirvana: Portrait of Meijer de Haan
1889–90
gouache and bronze paint on cotton
20 × 29 cm
Wadsworth Atheneum Museum of Art,
Hartford, Connecticut
The Ella Gallup Sumner and Mary Catlin
Sumner Collection Fund (1943.445)
W320

50
Portrait of Meijer de Haan 1889–90 *
waxed distemper paint and metallic
oil paint on oak
58.4 × 29.8 × 22.8 cm
National Gallery of Canada, Ottawa
Purchased 1968 (15310)
G86

51
Barbarian Tales 1902 *
oil on canvas
131.5 × 90.5 cm
Museum Folkwang, Essen
(G 54)
W625

52
Bouquet of Flowers 1901/02*
oil on canvas
96 × 62.2 cm
Private collection
W594
London only

53
Old Man with a Stick 1888 *
oil on coarse fabric
70 × 45 cm
Petit Palais, Musée des Beaux-Arts
de la Ville de Paris
(PPP623)
W318

54
Be in Love and You Will Be Happy 1889
carved and painted linden wood
95 × 72 × 6.4 cm
Museum of Fine Arts, Boston
Arthur Tracy Cabot Fund (57.582)
G76

55
Pierre-Charles Poussin
Pardon Day in Brittany 1851
oil on canvas
146 × 327 cm
The National Gallery, London
Presented by R.E. Lofft, 1870 (NG 810)

56
Portrait of Madeleine Bernard 1888
oil on canvas
72 × 58 cm
Musée de Grenoble
Purchased by the Galerie Bernheim-
Jeune in 1923 (MG 2190)
W240 / W305 (2001)

57
*Seascape with Cow (On the Edge
of the Abyss)* 1888
oil on canvas
72.5 × 61 cm
Musée d'Orsay, Paris
(RF1938-48)
W282 / W310 (2001)

58
*Portrait of a Pont-Avennoise
(Perhaps Marie Louarn)* 1888 *
oil on canvas
33 × 23 cm
Private collection
W244 / W293 (2001)

59
La Belle Angèle 1889
oil on canvas
92 × 73 cm
Musée d'Orsay, Paris (RF2617)
W315

60
Two Breton Girls by the Sea 1889
oil on canvas
92.5 × 73.6 cm
National Museum of Western Art, Tokyo
Matsukata Collection (P.1959-0106)
W340

61
Young Breton Woman 1889 *
oil on canvas
46 × 38 cm
Private collection
W316

62
Young Christian Girl 1894 *
oil on canvas
65.3 × 46.7 cm
Sterling and Francine Clark Art
Institute, Williamstown, Massachusetts
Acquired in honour of Harding F.
Bancroft, Institute Trustee 1970–87;
President 1977–87 (1986.22)
W518

63
Portrait of Annette Belfils 1890 *
conté crayon and red chalk on paper
38.1 × 35 cm
Private collection

64
The Night Café, Arles 1888
oil on canvas
72 × 92 cm
The Pushkin State Museum of Fine
Arts, Moscow
(3367)
W305 / W318 (2001)

65
Portrait of Madame Roulin 1888 *
oil on canvas
50.5 × 63.5 cm
Saint Louis Art Museum
Funds given by Mrs. Mark C. Steinberg
(5:1959)
W298 / W327 (2001)

66
Portrait Vase, Madame Schuffenecker
c. 1889–90 *
glazed stoneware
23.7 × 17.2 × 17.8 cm
Dallas Museum of Art
The Wendy and Emery Reves
Collection (1985.R.28)
G67

67
The Schuffenecker Family 1889
oil on canvas
73 × 92 cm
Musée d'Orsay, Paris
(RF1959-8)

68
Portrait of the Artist's Mother 1889/93
oil on canvas
41 × 33 cm
Staatsgalerie Stuttgart
Acquired in 1959 with lottery funds
(2554)
W385

69
Exotic Eve 1890/94 *
watercolour on paper
42.8 × 25.1 cm
Pola Museum of Art, Hakone
W389

70
Taoa c. 1891
pencil on paper
17 × 11 cm
Private collection

71
*The Woman with a Flower (Vahine
no te tiare)* 1891
oil on canvas
70.5 × 46.5 cm
Ny Carlsberg Glyptotek, Copenhagen
(MIN 1828)
W420

72
Portrait of Suzanne Bambridge 1891 *
oil on canvas
70 × 50 cm
Royal Museums of Fine Arts of Belgium,
Brussels
Acquired from M. Barbazanges, Paris,
1923 (4491)
W423

73
Atiti 1892 *
oil on canvas
29.7 × 24.7 cm
Kröller-Müller Museum, Otterlo
(KM 104.366)
W452

74
E. Jaulmes
Tahitian Child on Its Death Bed
before 1892
albumen silver print, from the Jaulmes
album
11.2 × 17.2 cm
Musée de Tahiti et des îles – Te Fare
Manaha, Puna'auia, Tahiti
(D2004.32.454)

75
Drawing of a Dead Child c. 1882 *
charcoal on paper
20 × 27 cm
Kelton Foundation, Santa Monica

76
Tahitian Woman and Boy 1899
oil on canvas
94.6 × 61.9 cm
Norton Simon Museum, Pasadena
Norton Simon Art Foundation. Gift
of Mr. Norton Simon (M.1976.08.P)
W578

77
Unknown photographer (probably
Charles Spitz)
Tahitian Woman c. 1890
albumen silver print
Private collection, Tahiti
(D2004.32.152)

78
Melancholic (Faaturuma) 1891 *
oil on canvas
94 × 68.3 cm
The Nelson-Atkins Museum of Art,
Kansas City, Missouri
Purchase: William Rockhill Nelson Trust
(38-5)
W424

79
*Portrait of a Young Girl. Vaïte (Jeanne)
Goupil* 1896
oil on canvas
75 × 65 cm
Ordrupgaard, Copenhagen
(224 WH)
W535

80
Unknown photographer
*The Goupil Family with Daughter
Jeanne* c. 1895
albumen silver print
13 × 18 cm
University of Hawai'i Mānoa, Honolulu
Special Collections, Hamilton Library.
PAC Rare Photographs (P00 036)

81
The Royal End (Arii matamoe) 1892 *
oil on coarse fabric
45.1 × 74.3 cm
The J. Paul Getty Museum, Los Angeles
W453
London only

82
Unknown photographer
Death of King Pomare V 1891
albumen silver print
10.2 × 16 cm
Musée de Tahiti et des îles – Te Fare
Manaha, Puna'auia, Tahiti
(D2004.32.474)

83
Charles Spitz
*All the Cannibals up to Pomare V
Were Entitled to the Title of Mata ioré*
1885–89
albumen silver print, from the Raoul
album
10.4 × 15.5 cm
Musée de Tahiti et des îles – Te Fare
Manaha, Puna'auia, Tahiti
(D2004.32.413.56)

84
Portrait of Tehamana 1891–93
charcoal on paper
41.3 × 32.5 cm
Art Institute of Chicago
Gift of David Adler and his friends
(1956.1215)

85
Tehamana Has Many Parents or
*The Ancestors of Tehamana
(Merahi metua no Tehamana)* 1893 *
oil on coarse fabric
75 × 53 cm
Art Institute of Chicago
Gift of Mr. and Mrs. Charles Deering
McCormick (1980.613)
W497

86
Germain Coulon
Tahitian Woman 1890
photograph
11.1 × 9.6 cm
Bishop Museum Library and Archives,
Honolulu
(CP 53732)

87
Charles Spitz
Group of Vahines c. 1885–89
albumen silver print, from the Raoul
album
18.5 × 22.2 cm
Musée de Tahiti et des îles – Te Fare
Manaha, Puna'auia, Tahiti
(D2004.32.413.43)

88
*Spirit of the Dead Watching
(Manao tupapau)* 1892
oil on coarse fabric, mounted on canvas
73 × 92.4 cm
Albright-Knox Art Gallery, Buffalo
A. Conger Goodyear Collection, 1965
(1965:1)
W457

89
*Spirit of the Dead Watching
(Manao tupapau)* 1894 *
lithograph on wove paper
42 × 57.4 cm
National Gallery of Canada, Ottawa
Purchased 1960 (9065)

90
Tehura 1891–93 *
polychromed pua wood
22.2 × 12.6 × 7.8 cm
Musée d'Orsay, Paris
Gift of Mme Huc de Monfried, 1951
(OA9528)
G98

91
The Sorcerer of Hiva Oa (Marquesan Man in a Red Cape) 1902 *
oil on canvas
92 × 73 cm
La Boverie, Liège
W616
London only

92
Thérèse c. 1902–03
carved portia wood, gilding and
copper nails
66 × 21.2 × 17.2 cm
Private collection
G135

93
Père Paillard 1902 *
painted miro wood
67.9 × 18 × 20.7 cm
National Gallery of Art, Washington, D.C.
Chester Dale Collection (1963.10.238)
G136

94
Cover of *Noa Noa* (Louvre manuscript)
1894–1901
watercolour and brown ink
31.5 × 23.2 cm
Musée d'Orsay, Paris
(RF7259-1)

95
Mysterious Water (Pape moe) 1893
oil on canvas
99 × 75 cm
Private collection
W498

96
Woman of the Mango (Vahine no te vi)
1892 *
oil on canvas
73 × 45.1 cm
Baltimore Museum of Art
The Cone Collection, formed by
Dr. Claribel Cone and Miss Etta Cone
of Baltimore, Maryland (BMA 1950.213)
W449

97
Title page of *Diverses choses* (from
Noa Noa, Louvre manuscript) 1894–1901
drawing by Vincent van Gogh,
pen and ink
31.5 × 23.2 cm
Musée d'Orsay, Paris
(RF7259, Folio 106 recto)

98
Pages from *Diverses choses* (from
Noa Noa, Louvre manuscript) 1894–1901
watercolour and brown ink,
photographs of Tahitians and two idols,
Hina Tefaton and Hiro
31.5 × 23.2 cm (each)
Musée d'Orsay, Paris
(RF7259 folio 30 verso; 31 recto)

99
Pages from *Noa Noa* (Louvre
manuscript) 1894–1901
pasted rubbings of Marquesan reliefs,
black lead and watercolour; Polynesian
decorative motifs and text, pen and ink
and graphite
31.5 × 23.2 cm (each)
Musée d'Orsay, Paris
(RF7259-27-recto-folio88)

100
Pages from *Diverses choses* (from
Noa Noa, Louvre manuscript) 1894–1901
manuscript notes and sketch (pen and
ink) and press cuttings
31.5 × 23.2 cm (each)
Musée d'Orsay, Paris
(RF7259, ff. 117v and 118r [pp. 228–229])

101
Page from *Cahier pour Aline* 1893
manuscript
21.5 × 17 cm
Bibliothèque de l'Institut national
d'histoire de l'art, Paris
(MS 227)

102
Pages from *Cahier pour Aline* 1893
manuscript
21.5 × 17 cm (each)
Bibliothèque de l'Institut national
d'histoire de l'art, Paris
(MS 227)

103
Self-portrait with Yellow Christ 1890–91 *
oil on canvas
38 × 46 cm
Musée d'Orsay, Paris
Acquired by the Musées nationaux with
the participation of Philippe Meyer and
a Japanese patron, coordinated by the
newspaper Nikkei, 1994 (RF1994-2)
W324

104
Be Symbolist: Portrait of Jean Moréas
1890–91 *
brush and pen and ink on paper
25.4 × 28.2 cm
Galerie Talabardon & Gautier, Paris

105
Portrait of Stéphane Mallarmé 1891 *
etching on copper, with drypoint and
engraving
18.3 × 14.3 cm
Kelton Foundation, Santa Monica

106
*Interior of the Painter's House,
rue Carcel* 1881
oil on canvas
130.5 × 162.5 cm
National Museum of Art, Architecture
and Design, Oslo
(NG.M.01153)
W50 / W76 (2001)

107
The Flowers of France (Te tiare Farani)
1891 *
oil on canvas
72 × 92 cm
The Pushkin State Museum of Fine
Arts, Moscow
W426
London only

108
The Meal (The Bananas) 1891
oil on paper, mounted on canvas
73 × 92 cm
Musée d'Orsay, Paris
(RF1954-27)
W427

109
Young Girl with a Fan 1902
oil on canvas
91.9 × 72.9 cm
Museum Folkwang, Essen
Acquired in 1904 for the Museum
Folkwang, Hagen, since 1922 Essen
(G53)
W609

110
*Self-portrait in the Form of a Grotesque
Head (Anthropomorphic Pot)* 1889 *
glazed stoneware
height 28.4 cm; diameter 21.5 cm
Musée d'Orsay, Paris
Gift of Jean Schmit, 1938 (OA9050)
G66

111
Jug in the Form of a Head, Self-portrait
1889
stoneware, glazed in olive green,
grey and red
height 19.3 cm; diameter 12 cm
Designmuseum Danmark, Copenhagen
G65

112
*Still Life with Apples, a Pear and a
Ceramic Portrait Jug* 1889 *
oil on paper, mounted on panel
28.6 × 36.2 cm
Harvard Art Museums / Fogg Museum,
Cambridge, Massachusetts
Gift of Walter E. Sachs (1958.292)
W405

113
Still Life with a Japanese Print 1889
oil on canvas
73 × 92 cm
Tehran Museum of Contemporary Art
W375

114
Still Life with Profile of Laval 1886 *
oil on canvas
46 × 38 cm
Indianapolis Museum of Art at
Newfields
Gift of Mrs. Julian Bobbs in memory
of William Ray Adams, 46.22,
DiscoverNewfields.org (1998.167)
W207 / W238 (2001)

115
Madame Alexandre Kohler 1887–88
oil on linen
46.3 × 38 cm
National Gallery of Art, Washington, D.C.
Chester Dale Collection (1963.10.27)
W314 / W258 (2001)

116
*At the Window (Still Life with Tine and
Carafon)* 1882
oil on canvas
54 × 65.3 cm
The State Hermitage Museum,
Saint Petersburg
W92 (2001)

117
Edgar Degas
*Woman Seated beside a Vase of
Flowers* 1865
oil on canvas
73.7 × 92.7 cm
The Metropolitan Museum of Art,
New York
H.O. Havemeyer Collection, Bequest of
Mrs. H.O. Havemeyer, 1929 (29.100.128)

118
Paul Cézanne
Still Life with Fruit Dish 1879–80
oil on canvas
46.4 × 54.6 cm
The Museum of Modern Art, New York
Gift of Mr. and Mrs. David Rockefeller
(69.1991)

119
*Woman in Front of a Still Life by
Cézanne* 1890
oil on canvas
65.3 × 54.9 cm
Art Institute of Chicago
Joseph Winterbotham Collection
(1925.753)
W387

120
Still Life with Ceramic Cup 1888
oil on canvas
55 × 65 cm
Private collection
W289 / W263 (2001)

121
Still Life with Fruits 1888
oil on canvas
43 × 58 cm
The Pushkin State Museum of Fine
Arts, Moscow
(3271)
W288

122
Clovis Asleep 1884 *
oil on canvas
46 × 55.5 cm
Private collection
W81 / W151 (2001)

123
The Little One is Dreaming, Étude 1881
oil on canvas
59.5 × 73.5 cm
Ordrupgaard, Copenhagen
W52 / W75 (2001)

124
The Sculptor Aubé and His Son Émile
1882
pastel on paper
53.8 × 72.8 cm
Petit Palais, Musée des Beaux-Arts
de la Ville de Paris
(PPD1348)

125
Head of Jean Gauguin 1881
wax and pigment
15 × 12 × 17 cm
Ordrupgaard, Copenhagen

126
Clovis c. 1886 *
oil on canvas
56.6 × 40.8 cm
Private collection
On loan to Portland Museum of Art
W187 / W208 (2001)

127
Mette in Evening Dress 1884 *
oil on canvas
65 × 54 cm
The Fine Art Collections, National
Museum of Art, Architecture and
Design, Oslo (NG.M.00771)
W95 / W154 (2001)

128
Henri Avelot
"À travers les Quat'z'arts" [Across the
Arts], in *La Caricature*, 6 June 1896,
p. 180
Private collection

129
Auguste Renoir
Richard Wagner 1882
oil on canvas
53 × 46 cm
Musée d'Orsay, Paris
(RF1947-11)

130
Émile Schuffenecker
Portrait of Gauguin on the cover of
Les hommes d'aujourd'hui 1896
journal
29 × 20 cm
National Gallery of Canada Library and
Archives, Ottawa

131
Jean-Auguste-Dominique Ingres
Mademoiselle Caroline Rivière 1806
oil on canvas
100 × 70 cm
Musée du Louvre, Paris
Bequest, 1870 (MI1447)

132
Rembrandt van Rijn
Young Man with a Stick 1651
oil on canvas
83 × 66 cm
Musée du Louvre, Paris
Bequest of Louis La Caze, 1869 (M959)

133
Diego Velázquez
*Portrait of the Infanta Maria-Theresa,
Future Queen of France* 17th century
oil on canvas
71.5 × 60.5 cm
Musée du Louvre, Paris
Bequest of Louis La Caze, 1869
(MI898)

134
Maurice-Quentin de La Tour
Portrait of Marie Fel 1757
pastel on paper
32 × 24 cm
Musée Antoine Lécuyer, Saint-Quentin

135
Alexandre Cabanel
Self-portrait (at the Age of Twenty-Nine)
1849–52
oil on canvas
62.4 × 47 cm
Musée Fabre, Montpellier
Alfred Bruyas donation, 1868 (868.1.9)

136
Honoré Daumier
"Quand on a son portrait au salon"
[When you have your portrait at
the Salon] 1845
lithograph on newsprint
Brooklyn Museum
Gift of Sydel Solomon (65.265.16)

137
Honoré Daumier
"C'est tout d'même flatteur d'avoir son portrait à l'exposition" [It's flattering, after all, to have one's portrait in the exhibition] 1857
lithograph
38.5 × 27.5 cm
Musée Carnavalet, Paris

138
Pierre-Auguste Renoir
Portrait of Jeanne Samary (La Rêverie)
1877
oil on canvas
56 × 47 cm
The Pushkin State Museum of Fine Arts, Moscow (3405)

139
Édouard Manet
Monsieur and Madame Auguste Manet
1860
oil on canvas
110 × 90 cm
Musée d'Orsay, Paris
(RF1977-12)

140
Paul Signac
Opus 217. Against the Enamel of a Background Rhythmic with Beats and Angles, Tones, and Tints, Portrait of M. Félix Fénéon in 1890 1890
oil on canvas
73.5 × 92.5 cm
The Museum of Modern Art, New York
Gift of Mr. and Mrs. David Rockefeller
(85.1991)

141
Hans Holbein
The Artist's Family c. 1528–29
mixed media on paper, mounted on wood
79.4 × 64.7 cm
Kunstmuseum Basel

142
Louis Grelet
Tohotaua in Gauguin's Studio, with a reproduction of Hans Holbein's "The Artist's Family" 1902
photograph
Private collection

143
Two Children c. 1889
oil on canvas
46 × 60 cm
Ny Carlsberg Glyptotek, Copenhagen
(MIN 1833)
W530

SELECTED BIBLIOGRAPHY

Numbers beginning with a "W" or "G" throughout this book refer to catalogue numbers from Wildenstein 1964, Wildenstein 2001/2002 and Gray 1963.

GAUGUIN'S WRITINGS

Gauguin 1889a
"Notes sur l'Art à l'Exposition Universelle I." *Le Moderniste illustré*, no. 11 (4 July 1889), pp. 84–86.

Gauguin 1889b
"Notes sur l'Art à l'Exposition Universelle II." *Le Moderniste illustré*, no. 12 (13 July 1889), pp. 90–91.

Gauguin 1893
Noa Noa. Draft manuscript. 1893. Getty Research Institute, http://hdl.handle.net/10020/850041.

Gauguin and Morice 1893–99
Paul Gauguin and Charles Morice. *Noa Noa*. Illustrated manuscript, 1893–99. Département des arts graphiques, Musée d'Orsay, Paris, RF 7259. Facsimile reproduced on CD-ROM *Gauguin écrivain*. Edited by Isabelle Cahn. Paris: Réunion des musées nationaux, 2003.

Gauguin 1894
"Natures mortes." *Essais d'art libre* 4 (January 1894), pp. 273–275.

Gauguin 1895a
"Armand Séguin." *Mercure de France* (February 1895), pp. 222–224.

Gauguin 1895b
"Une lettre de Paul Gauguin: à propos de Sèvres et du dernier four." *Le Soir* (23 April 1895), p. 1.

Gauguin 1896–98
Diverses choses. Illustrated manuscript. Département des arts graphiques, Musée d'Orsay, Paris, RF 7259,201. Facsimile reproduced on CD-ROM *Gauguin écrivain*. Edited by Isabelle Cahn. Paris: Réunion des musées nationaux, 2003. Translated in Prather and Stuckey 1987, pp. 256, 273–274.

Gauguin 1899
Le Sourire. 1899–1900. Published as *Le Sourire de Paul Gauguin: collection complète en facsimile*. Edited by L.J. Bouge. Paris: Maisonneuve, 1952.

Gauguin and Morice 1901
Paul Gauguin and Charles Morice. *Noa Noa*. Paris: Éditions de La Plume, 1901.

Gauguin 1902
L'Esprit moderne et le catholicisme. 1902. Manuscript. Saint Louis Art Museum. Translated excerpts and illustrations from original manuscript in H.S. Leonard. "An Unpublished Manuscript by Paul Gauguin." *Bulletin of the Saint Louis Art Museum* 34, no. 3 (summer 1949), pp. 41–48.

Gauguin 1919
Noa Noa: The Tahitian Journal. Translated by O.F. Theis. New York: Nicholas L. Brown, 1919.

Gauguin 1922
Lettres de Gauguin à Daniel de Monfreid. 1918. Translated as *The Letters of Paul Gauguin to Georges Daniel de Monfreid*. Translated by Ruth Peilkovo. New York: Dodd, Mead and Company, 1922.

Gauguin 1923
Avant et après. Translated as *The Intimate Journals of Paul Gauguin*. Translated by Van Wyck Brooks. London: William Heinemann Ltd, 1923.

Gauguin 1949
Lettres de Gauguin à sa femme et à ses amis. 1946. Translated as *Paul Gauguin: Letters to His Wife and Friends*. Edited by Maurice Malingue. Translated by Henry Stenning. Cleveland and New York: The World Publishing Company, 1949.

Gauguin 1950
Lettres de Gauguin à Georges-Daniel de Monfreid. 1920. Edited by Annie Joly-Segalen. Revised edition. Paris: Georges Falaize, 1950.

Gauguin 1951a
Ancien culte mahorie. Edited by René Huyghe. Paris: La Palme, 1951.

Gauguin 1951b
Avant et après. Copenhagen: Scripta, 1951.

Gauguin 1951c
Racontars de rapin. 1951. Translated as *Ramblings of a Wannabe Painter*. Edited and translated by Donatien Grau. New York: D. Zwirner Books, 2016.

Gauguin 1961
Noa Noa: Voyage to Tahiti. Translated by Jonathan Griffin. Postscript by Jean Loize. Oxford: Cassirer, 1961.

Gauguin 1963
Cahier pour Aline. 2 vols. Edited by Suzanne Damiron. Paris: Société des amis de la Bibliothèque d'art et d'archéologie de l'Université de Paris, 1963.

Gauguin 1966
Noa Noa. Edited by Jean Loize. Paris: André Balland, 1966.

Gauguin 1974
Oviri: écrits d'un sauvage. Edited by Daniel Guérin. Paris: Gallimard, 1974.

Gauguin 1983
Paul Gauguin: 45 lettres à Vincent, Theo et Jo van Gogh. Edited by Douglas Cooper. s'Gravenhage: Staatsuitgeverij, 1983.

Gauguin 1984
Correspondance de Paul Gauguin: Documents, témoignages. Edited by Victor Merlhès. Paris: Fondation Singer-Polignac, 1984.

Gauguin 1985
Noa Noa: Gauguin's Tahiti. Edited by Nicholas Wadley. Translated by Jonathan Griffin. Oxford: Phaidon, 1985.

Gauguin 1989
Avant et après. Taravao: Avant et après, 1989.

Gauguin 1995
De Bretagne en Polynésie: Paul Gauguin, pages inédites. Edited by Victor Merlhès. Taravao: Avant et après, 1995.

Gauguin 1996
The Writings of a Savage. Edited by Daniel Guérin. Translated by Eleanor Levieux. New York: Da Capo Press, 1996.

Gauguin 2003
Racontars de rapin. Edited by Bertrand Leclair. Paris: Mercure de France, 2003.

Gauguin 2009
Cahier pour Aline. Edited by Philippe Dagen. Paris: Éditions du Sonneur, 2009.

Gauguin and Morice 2017
Paul Gauguin and Charles Morice. *Noa Noa.* Edited by Claire Moran. Cambridge: The Modern Humanities Research Association, 2017.

OTHER REFERENCES

About 1858
Edmond About. *Nos artistes au Salon de 1857.* Paris: L. Hachette, 1858.

Andersen 1967
Wayne V. Andersen. "Gauguin and a Peruvian Mummy." *The Burlington Magazine* 109, no. 769 (April 1967), pp. 615–619.

Astruc 1868
Zacharie Astruc. "Salon de 1868." *L'Étendard* (29 July 1868), unpaginated.

Aula 1885
Paul Aula. "L'Exposition des Portraits du siècle à l'Ecole des Beaux-Arts." *Courier de l'art* (15 May 1885), p. 238.

Aurier 1891
G.-Albert Aurier. "Le symbolisme en peinture. Paul Gauguin." *Mercure de France* (March 1891), pp. 155–165. Translated as "Symbolism in Painting: Paul Gauguin," in Prather and Stuckey 1987, pp. 150–156.

Aurier 1995
Albert Aurier. *Textes critiques, 1889–1892. De l'impressionnisme au symbolisme.* Paris: ENSBA, 1995.

Barbey d'Aurevilly 1898
Jules Barbey d'Aurevilly. "Le Cardinal Maury." In *Les œuvres et les hommes. Portraits politiques et littéraires.* Paris: A. Lemerre, 1898, pp. 35–46.

Baudelaire 1956
Charles Baudelaire. "The Salon of 1846." In *The Mirror of Art: Critical Studies by Charles Baudelaire.* Translated and edited by Jonathan Mayne. Garden City, NY: Doubleday Anchor Books, 1956, pp. 38–130.

Bazire 1885
Edmond Bazire. "Exposition des portraits du siècle." *L'Intransigeant* (30 April 1885), p. 2.

Benington 2018
Jonathan Benington. *Roderic O'Conor and the Moderns.* Exhibition catalogue. National Gallery of Ireland, Dublin, 2018.

Berchère 2010
Narcisse Berchère. *Le Désert de Suez: cinq mois dans l'Isthme.* 1863. Edited by Barbara Wright. London: MHRA, 2010.

Blanc 1879
Charles Blanc. *Grammaire des arts du dessin, architecture, sculpture, peinture.* 1876. Translated as *The Grammar of Painting and Engraving.* Translated by Kate Newell Doggett. Chicago: S.C. Griggs and Company, 1879.

Bodelsen 1964
Merete Bodelsen. *Gauguin's Ceramics: A Study in the Development of His Art.* London: Faber & Faber, 1964.

Bond and Woodall 2005
Anthony Bond and Joanna Woodall. *Self Portrait: Renaissance to Contemporary.* Exhibition catalogue. National Portrait Gallery, London, 2005.

Bonnet 1998
Alain Bonnet. "Le Musée des portraits au musée du Louvre." In Musée de l'Hôtel-Dieu, Mantes-la-Jolie 1998, pp. 56–69.

Bouchot 1893
Henri Bouchot. "Exposition des portraits des écrivains et journalistes du siècle." *Gazette des Beaux-Arts* (1 September 1893), pp. 202–203.

Bouvier and Schwander 2015
Raphaël Bouvier and Martin Schwander, eds. *Paul Gauguin.* Exhibition catalogue. Fondation Beyeler, Riehen/Basel, 2015.

Brettell 1988
Richard Brettell et al. *The Art of Paul Gauguin.* Exhibition catalogue. National Gallery of Art, Washington, D.C.; Art Institute of Chicago; and Grand Palais, Paris, 1988–89.

Brettell and Fonsmark 2005
Richard R. Brettell and Anne-Birgitte Fonsmark. *Gauguin and Impressionism.* Exhibition catalogue. Ordrupgaard, Copenhagen, and Kimbell Art Museum, Fort Worth, 2005–06.

Brogniez 2012
Laurence Brogniez, ed. *Écrits Voyageurs: les artistes et ailleurs.* Brussels: Peter Lang, 2012.

Broude 2018
Norma Broude, ed. *Gauguin's Challenge: New Perspectives after Postmodernism.* New York and London: Bloomsbury Visual Arts, 2018.

Cachin 1997
Françoise Cachin. "Degas and Gauguin." In Dumas 1997, pp. 221–233.

Cachin 1988
Françoise Cachin. "Gauguin Portrayed by Himself and Others." In Brettell 1988, pp. xv–xxvi.

Cahn 2003
Isabelle Cahn. "Noa Noa: The Voyage to Tahiti." In Shackelford and Frèches-Thory 2003, pp. 91–113.

Cahn 2011
Isabelle Cahn. "The First Stay on Tahiti." In Greub 2011, pp. 162–171.

Cariou 1978
André Cariou. "Louis Roy." In Musée des beaux-arts, Quimper 1978, unpaginated.

Cariou 2015
André Cariou. *Gauguin et l'École de Pont-Aven.* Paris: Hazan, 2015.

Castagnary 1892
Jules-Antoine Castagnary. *Salons (1857–1870).* Paris: Bibliothèque Charpentier, G. Charpentier et E. Fasquelle, 1892.

Chassé 1921
Charles Chassé. *Gauguin et le groupe de Pont-Aven*. Paris:
H. Floury, 1921.

Chassé 1955
Charles Chassé. *Gauguin et son temps*. Paris: Bibliothèque des
arts, 1955.

Childs 2001a
Elizabeth C. Childs. "The Colonial Lens: Gauguin, Primitivism,
and Photography in the *Fin-de-Siècle*." In Lynda Jessup, ed.
*Antimodernism and Artistic Experience: Policing the Boundaries of
Modernity*. Toronto: University of Toronto Press, 2001, pp. 50–70.

Childs 2001b
Elizabeth C. Childs. "Seeking the Studio of the South: Van Gogh,
Gauguin, and Avant-Garde Identity." In Homburg 2001, pp. 113–152.

Childs 2003a
Elizabeth C. Childs. "Catholicism and the Modern Mind": The
Painter as Writer in Late Career. In Shackelford and Frèches-
Thory 2003, pp. 223–242.

Childs 2003b
Elizabeth C. Childs. "Gauguin as Author: Writing the Studio of
the Tropics." *The Van Gogh Museum Journal* (winter 2003–04),
pp. 70–87.

Childs 2013
Elizabeth C. Childs. *Vanishing Paradise: Art and Exoticism in
Colonial Tahiti*. Berkeley: University of California Press, 2013.

Childs 2018
Elizabeth C. Childs. "Taking back Teha'amana: Feminist
Interventions in Gauguin's Legacy." In Broude 2018, pp. 229–249.

Christophe 1893
Jules Christophe. "Les Portraits du prochain Siècle." *La Plume*,
no. 107 (1 October 1893), pp. 415–416.

Van Crimpen, Jansen and Robert 1999
Han van Crimpen, Leo Jansen and Jan Robert. *Kort Geluk:
de briefwisseling tussen Theo van Gogh en Jo Bonger*. Cahier
Vincent 7. Amsterdam/Zwolle: Van Gogh Museum/Waanders, 1999.

Danielsson 1966
Bengt Danielsson. *Gauguin in the South Seas*. Translated by
Reginald Spink. Garden City, NY: Doubleday, 1966.

Danielsson 1975
Bengt Danielsson. *Gauguin à Tahiti et aux îles Marquises*. Papeete:
Éditions du Pacifique, 1975.

Danielsson and O'Reilly 1965
Bengt Danielsson and Pierre O'Reilly. "Gauguin journaliste à
Tahiti et ses articles des *Guêpes*." *Journal de la Société des
Océanistes* 21 (1965), pp. 1–63.

De Bodt 2009
Saskia de Bodt. "The Early Years of Meijer de Haan in Amsterdam
through 1888." In Kröger 2009, pp. 50–60.

De Chennevières 1888
Philippe de Chennevières. "Portraits d'artistes." *L'Artiste* (1888),
pp. 321–340.

Delacroix 1893
Eugène Delacroix. *Journal de Eugène Delacroix*. 3 vols. Paris: Plon,
1893.

Delacroix 2009
Eugène Delacroix. "Souvenirs d'un voyage dans le Maroc."
In Eugène Delacroix. *Journal (1822–1857)*. Vol. 1. Edited by
Michèle Hannoosh. Paris: José Corti, 2009, pp. 264–298.

De Lostalot 1883
Alfred de Lostalot. "Exposition de portraits du siècle." *Gazette
des Beaux-Arts* (1 July 1883), pp. 77–92.

De Man 1984
Paul de Man. "Autobiography as De-Facement." In Paul de Man.
The Rhetoric of Romanticism. New York: Columbia University
Press, 1984, pp. 67–81.

Denis 1957
Maurice Denis. *Journal*. 3 vols. Paris: La Colombe, 1957.

De Rotonchamp 1925
Jean de Rotonchamp. *Paul Gauguin: 1848–1903*. Paris: G. Crès, 1925.

Derrida 1993
Jacques Derrida. *Memoirs of the Blind: The Self-portrait and Other
Ruins*. Chicago: University of Chicago Press, 1993.

Descola 2014
Philippe Descola. *Par-délà nature et culture*. 2005. Translated as
Beyond Nature and Culture. Translated by Janel Lloyd. Chicago:
University of Chicago Press, 2014.

Diffre and Lesieur 2003
Suzanne Diffre and Marie-Josèphe Lesieur. "Gauguin in the
Vollard Archives." In Shackelford and Frèches-Thory 2003,
pp. 305–311.

Van Dijk and Van der Hoeven 2018
Maite van Dijk and Joost van der Hoeven. *Gauguin and Laval
in Martinique*. Exhibition catalogue. Van Gogh Museum,
Amsterdam, 2018.

Druick and Zegers 2001
Douglas W. Druick, Peter Kort Zegers, et al. *Van Gogh and
Gauguin: The Studio of the South*. Exhibition catalogue. Art
Institute of Chicago and Van Gogh Museum, Amsterdam, 2001–02.

Dufour 1997
Hélène Dufour. *Portraits en phrases: les recueils de portraits
littéraires au XIXᵉ siècle*. Paris: Presses universitaires de France, 1997.

Dufour 2003
Hélène Dufour. "Portraits du prochain siècle: un recueil de
portraits littéraires en 1894." In André Guyaux, Loïc Chotard and
Sophie Marchal. *La Vie romantique. Hommage à Loïc Chotard*.
Paris: Presses de l'Université de Paris-Sorbonne, 2003, pp. 191–204.

Dumas 1997
Ann Dumas et al. *The Private Collection of Edgar Degas*.
Exhibition catalogue. New York: The Metropolitan Museum of
Art, 1997–98.

Dupont 2012
Christine A. Dupont. "Comment on devient peintre orientaliste:
Les voyages de Jean-Baptiste Huysmans (1856 et 1862)."
In Brogniez 2012, pp. 67–81.

Edelman 1989
Bernard Edelman. *La propriété littéraire et artistique*. Paris:
Presses Universitaires de France, 1989.

Eisenman 1997
Stephen F. Eisenman. *Gauguin's Skirt*. London: Thames & Hudson, 1997.

Eisenman 2007
Stephen F. Eisenman, ed. *Paul Gauguin: Artist of Myth and Dream*. Exhibition catalogue. Complesso del Vittoriano, Rome, 2007–08.

Elderfield 2017
John Elderfield et al. *Cézanne Portraits*. Exhibition catalogue. Musée d'Orsay, Paris; National Portrait Gallery, London; and National Gallery of Art, Washington, D.C., 2017–18.

Exposition des portraits des écrivains et journalistes du siècle 1893
Association des journalistes parisiens. *Catalogue de l'exposition des portraits des écrivains et journalistes du siècle (1793–1893)*. Exhibition catalogue. Galerie Georges Petit, Paris, 1893.

Exposition de portraits du siècle 1883
Société philanthropique. *Catalogue de l'exposition de portraits du siècle (1783–1883) ouverte au profit de l'œuvre, à l'École des Beaux-Arts, le 25 avril 1883*. Exhibition catalogue. École des Beaux-Arts, Paris, 1883.

Exposition de portraits du siècle 1885
Société philanthropique. *Catalogue de la deuxième exposition de portraits du siècle ouverte au profit de l'œuvre, à l'école des Beaux-Arts, le 20 avril 1885*. Exhibition catalogue. École des Beaux-Arts, Paris, 1885.

Fénéon 1888
Félix Fénéon. "Calendrier de février." Includes a section on the Salle des portraits de peintres au Musée du Louvre, 14 February 1888. Published in *La Revue indépendante de littérature et d'art* 6, no. 17, pp. 463–487.

Fénéon 1970
Félix Fénéon. *Œuvres plus que complètes*. 2 vols. Edited by Joan U. Halperin. Geneva: Droz, 1970.

Figura 2014
Starr Figura, ed. *Gauguin: Metamorphoses*. Exhibition catalogue. The Museum of Modern Art, New York, 2014.

Fonsmark 2007
Anne-Birgitte Fonsmark. "Gauguin Creates His World. The Object in a World of Myth and Dream." In Eisenman 2007, pp. 35–47.

Fréché 2012
Bibiane Fréché. "Les peintres belges en voyage: Un continent à explorer." In Brogniez 2012, pp. 141–155.

Frèches-Thory 1988
Claire Frèches-Thory. "Brittany, 1886–1890." In Brettell 1988, pp. 52–60.

Friedman, Herson and Walen 2014
Jane Friedman, Sharon Herson and Audrey Walen, eds. *Cézanne and the Modern: Masterpieces of European Art from the Pearlman Collection*. Exhibition catalogue. Ashmolean Museum of Art and Archaeology, Oxford; Musée Granet, Aix-en-Provence; High Museum of Art, Atlanta; Vancouver Art Gallery; and Princeton University Art Museum, 2014–16.

Fromentin 1981
Eugène Fromentin. *Un Été dans le Sahara*. 1874. Edited by Anne-Marie Christin. Paris: Le Sycomore, 1981.

Fromentin 1984
Eugène Fromentin. "Alger: fragments d'un journal de voyage." *L'Artiste* (26 July; 2 and 9 August 1857). Revised in Eugène Fromentin. *Oeuvres complètes*. Paris: Gallimard, 1984, p. 960.

Gamboni 2005
Dario L. Gamboni. "Mana'o tupapa'u: Jarry, Gauguin et la fraternité des arts." In Michael Einfalt et al., ed. *Intellektuelle Redlichkeit – Intégrité intellectuelle: Literatur, Geschichte, Kultur. Festschrift für Joseph Jurt*. Heidelberg: C. Winter, 2005, pp. 459–475.

Gamboni 2014
Dario Gamboni. *Paul Gauguin: The Mysterious Centre of Thought*. Translated by Chris Miller. London: Reaktion, 2014.

Gamboni 2016
Dario Gamboni. "Gauguin, Cats. 51–60, The Noa Noa Suite: 'Veiled in a Cloud of Fragrance.'" In Groom, Westerby and Solomon 2016.

Gamboni 2018
Dario Gamboni. "Gauguin and the Challenge of Ambiguity." In Broude 2018, pp. 103–127.

Gautier 1852
Théophile Gautier. "Salon de 1852, 10ᵉ article." *La Presse* (27 May 1852), unpaginated.

Gautier 1874
Théophile Gautier. *Portraits contemporains*. Paris: Charpentier, 1874.

Gill 1959
Austin Gill. "Le Symbole du miroir dans l'œuvre de Mallarmé." *Cahiers de l'Association Internationale des Études Françaises*, no. 11 (1959), pp. 159–181.

Girard 1894
Edmond Girard. "Portraits du prochain siècle (notre deuxième volume)." *Essais d'art libre* (August/September/October 1894), pp. 217–218.

Girard and Roinard 1893
Edmond Girard and Paul-Napoléon Roinard. "Portraits du prochain siècle (le livre)." *Essais d'art libre* (August/September/October 1893), pp. 124–126.

Goddard 2008
Linda Goddard. "'The Writings of a Savage'? Literary Strategies in Paul Gauguin's *Noa Noa*." *Journal of the Warburg and Courtauld Institutes* 71 (2008), pp. 277–293.

Goddard 2011
Linda Goddard. "'Scattered Notes': Authorship and Originality in Paul Gauguin's *Diverses choses*." *Art History* 34, no. 2 (April 2011), pp. 352–369.

Goddard 2018
Linda Goddard. "Gauguin's Alter Egos: Writing the Other and the Self." In Broude 2018, pp. 15–40.

Goddard 2019
Linda Goddard. *Savage Tales: The Writings of Paul Gauguin*. New Haven and London: Yale University Press, 2019 (forthcoming).

Van Gogh 2009
Vincent van Gogh. *Vincent van Gogh: The Letters*. Edited by Leo Jansen, Hans Luijten and Nienke Bakker. London: Thames & Hudson, in association with the Van Gogh Museum and the Huygens Institute, 2009. Online edition: http://vangoghletters.org.

Gott 1990
Ted Gott. *The Enchanted Stone: The Graphic Worlds of Odilon Redon*. Exhibition catalogue. National Gallery of Victoria, Melbourne, 1990.

Gray 1963
Christopher Gray. *Sculpture and Ceramics of Paul Gauguin*. Baltimore: Johns Hopkins Press, 1963.

Greub 2011
Suzanne Greub, ed. *Gauguin: Polynesia*. Exhibition catalogue. Ny Carlsberg Glyptotek, Copenhagen, and Seattle Art Museum, 2011–12.

Groom 2017
Gloria Groom, ed. *Gauguin: Artist as Alchemist*. Exhibition catalogue. Art Institute of Chicago and Grand Palais, Paris, 2017–18.

Groom, Westerby and Solomon 2016
Gloria Groom, Genevieve Westerby and Mel Becker Solomon, eds. *Gauguin Paintings, Sculpture, and Graphic Works at the Art Institute of Chicago*. Digital catalogue. Chicago: Art Institute of Chicago, 2016, https://publications.artic.edu/gauguin/reader/gauguinart/section/139805.

Hale 2002
Charlotte Hale. "Gauguin's Paintings in the Metropolitan Museum of Art: Recent Revelations through Technical Examination." In Ives and Stein 2002, pp. 175–196.

Halperin 1988
Joan Ungersma Halperin. *Félix Fénéon: Aesthete and Anarchist in Fin-de-Siècle Paris*. New Haven and London: Yale University Press, 1988.

Hargrove 2008
June Hargrove. "Gauguin's bust of *Meyer de Haan*: 'la nature à travers le voile de l'âme.'" In *La sculpture au XIXe siècle: mélanges pour Anne Pingeot*. Paris: N. Chaudun, 2008, pp. 330–338.

Hargrove 2010a
June Hargrove. "Les *Contes barbares* de Paul Gauguin." *Revue de l'art* 169 (2010), pp. 25–37.

Hargrove 2010b
June Hargrove. "Gauguin's Maverick Sage: Meyer de Haan." In Stolwijk 2010, pp. 87–111.

Hargrove 2017
June Hargrove. *Gauguin*. Paris: Citadelles and Mazenod, 2017.

Hellmich and Pedersen 2018
Christina Hellmich and Line Pedersen, eds. *Gauguin: A Spiritual Journey*. Exhibition catalogue. Fine Arts Museums of San Francisco, De Young Museum, 2018.

Hirsch 1893
Paul-Armand Hirsch. "Exposition des Portraits du prochain siècle." *L'art social* (October 1893), pp. 286–287.

Hobbs 1996
Richard Hobbs. "L'apparition du peintre-écrivain." In Keith Cameron and James Kearns, eds. *Le Champ littéraire 1860–1900: études offertes à Michael Pakenham*. Amsterdam: Rodopi, 1996, pp. 127–137.

Hobbs 2002
Richard Hobbs. "Reading Artists' Words." In Smith and Wilde 2002, pp. 173–182.

Holsten 1978
Siegmar Holsten. *Das Bild des Künstlers: Selbstdarstellungen*. Exhibition catalogue. Hamburger Kunsthalle, Hamburg, 1978.

Homburg 1992
Cornelia Homburg. "Affirming Modernity: Van Gogh's *Arlésienne*." *Simiolus: Netherlands Quarterly for the History of Art*, no. 3 (1992), pp. 127–138.

Homburg 2001
Cornelia Homburg, ed. *Vincent van Gogh and the Painters of the Petit Boulevard*. St. Louis/New York: Saint Louis Art Museum/Rizzoli, 2001.

Homburg 2003
Cornelia Homburg. "Vincent van Gogh and the Avant-Garde: Colleagues, Competitors, Friends." In Chris Stolwijk, Sjraar van Heugten and Leo Jansen. *Van Gogh's Imaginary Museum: Exploring the Artist's Inner World*. Exhibition catalogue. Van Gogh Museum, Amsterdam, 2003, pp. 113–122.

Huysmans 1857
Jean-Baptiste Huysmans. *Voyage en Italie et en Orient, 1856–1857: notes et impressions*. Anvers, 1857.

Huysmans 1865
Jean-Baptiste Huysmans. *Voyage Illustré en Espagne et en Algérie, 1862*. Brussels: C. Muquardt, 1865.

Ives and Stein 2002
Colta Ives and Susan Alyson Stein. *The Lure of the Exotic: Gauguin in New York Collections*. Exhibition catalogue. Metropolitan Museum of Art, New York, 2002.

Jénot 1956
P. Jénot. "Le premier séjour de Gauguin à Tahiti d'après le manuscrit Jénot (1891–1893)." *Gazette des Beaux-Arts*, 47 (January–April 1956), pp. 115–126. Translated as "Gauguin's First Stay in Tahiti." In Prather and Stuckey 1987, pp. 173–178.

Jirat-Wasiutyński 1978
Vojtěch Jirat-Wasiutyński. *Paul Gauguin in the Context of Symbolism*. New York and London: Garland, 1978.

Jirat-Wasiutyński and Newton 2000
Vojtěch Jirat-Wasiutyński and H. Travers Newton. *Technique and Meaning in the Paintings of Paul Gauguin*. Cambridge: Cambridge University Press, 2000.

Jouin 1879
Henry Jouin. *Exposition universelle de 1878 à Paris. Notice historique et analytique des peintures, sculptures, tapisseries, miniatures, émaux, dessins, etc., exposés dans les galeries des portraits nationaux au Palais du Trocadéro, par M. Henry Jouin*. Exhibition catalogue. Palais du Trocadéro, Paris, 1879.

Jouin 1888
Henry Jouin. *Musée de portraits d'artistes peintres, sculpteurs, architectes, graveurs, musiciens, artistes dramatiques, amateurs, etc., nés en France ou y ayant vécu, état de 3,000 portraits peints, dessinés ou sculptés, avec l'indication des collections publiques ou privées qui les renferment.* Paris: H. Laurens, 1888.

Jouin 1897
Henry Jouin. *Vus de profil.* Paris: Firmin-Didot, 1897.

Koerner 1993
Joseph Leo Koerner. *The Moment of Self-portraiture in German Renaissance Art.* Chicago and London: University of Chicago Press, 1993.

Kröger 2009
Jelka Kröger, ed. *Meijer de Haan: A Master Revealed.* Exhibition catalogue. Jewish Historical Museum, Amsterdam; Musée d'Orsay, Paris; and Musée des beaux-arts, Quimper, 2009.

Lafenestre 1888
Georges Lafenestre. *Notice des portraits des artistes exposés dans la salle Denon du Musée du Louvre.* Exhibition catalogue. Musée du Louvre, Paris, 1888.

Lang 2005
Paul Lang, ed. *Richard Wagner, visions d'artistes: d'Auguste Renoir à Anselm Kiefer.* Exhibition catalogue. Musée Rath, Geneva, and Musée d'art moderne et contemporain, Geneva, 2005–06.

Larson 2018
Barbara Larson. "Gauguin: Vitalist, Hypnotist." In Broude 2018, pp. 179–202.

Latour 2002
Bruno Latour. *We Have Never Been Modern.* Cambridge, MA: Harvard University Press, 2002.

Leclerq 1895
Julien Leclerq. "Exposition Paul Gauguin." *Mercure de France* (January 1895), pp. 121–122.

Lemonedes, Thomson and Juszczak 2009
Heather Lemonedes, Belinda Thomson and Agnieszka Juszczak. *Paul Gauguin: The Breakthrough into Modernity.* Exhibition catalogue. The Cleveland Museum of Art and Van Gogh Museum, Amsterdam, 2009–10.

Lobstein 2012
Dominique Lobstein. "Portraits du prochain siècle." In Pierre Sanchez, ed. *Les expositions de la Galerie Le Barc de Boutteville, 1891–1899 et du Salon des Cent, 1894–1903: répertoire des artistes et liste de leurs œuvres.* Dijon: l'Échelle de Jacob, 2012, pp. 28–40.

Loize 1961
Jean Loize. "The Real *Noa Noa* and the Illustrated Copy." In Gauguin 1961, pp. 57–70.

Loize 1966
Jean Loize. "Gauguin sous le masque ou cinquante ans d'erreur autour de *Noa Noa*." In Gauguin 1966, pp. 66–112.

Loti 1925
Pierre Loti. *Le Marriage de Loti.* 1880. Translated as *The Marriage of Loti.* Translated by Clara Bell. New York: Frederick A. Stokes, 1925.

Lübbren 2001
Nina Lübbren. *Rural Artists' Colonies in Europe, 1870–1910.* Manchester: Manchester University Press, 2001.

Mantz 1863
Paul Mantz. "Salon de 1863 (III)." *La Gazette des Beaux-Arts* (1 July 1863), pp. 32–64.

Mantz 1878
Paul Mantz. "Exposition universelle. Les portraits historiques au Trocadéro." *La Gazette des Beaux-Arts* (1 December 1878), pp. 857–882.

Martin 1897
Jules Martin. *Nos Peintres et Sculpteurs, Graveurs, Dessinateurs – Portraits et Biographies.* Paris: E. Flammarion Éditeur, 1897.

Mathews 2001
Nancy Mowll Mathews. *Paul Gauguin: An Erotic Life.* New Haven and London: Yale University Press, 2001.

Mauclair 1893
Camille Mauclair. "Portraits du prochain siècle." *Essais d'Art libre* (August/September/October 1893), pp. 117–121.

Maurer 1988
Naomi Margolis Maurer. *The Pursuit of Spiritual Wisdom: The Thought and Art of Vincent van Gogh and Paul Gauguin.* Madison, NJ: Fairleigh Dickinson University Press, 1988.

McGuiness 2015
Patrick McGuiness. *Poetry and Radical Politics in fin de siècle France: From Anarchism to Action Française.* Oxford: Oxford University Press, 2015.

Menard 1981
Wilmon Menard. "Author in Search of an Artist." *Apollo* 114, no. 234 (August 1981), pp. 114–117.

Merlhès 2001
Victor Merlhès. "Labor: Painters at Play in Le Pouldu." In Zafran 2001, pp. 81–101.

Michaud 1959
Guy Michaud. "Le thème du miroir dans le symbolisme français." *Cahiers de l'Association Internationale des Études Françaises*, no. 11 (1959), pp. 199–216.

Mirbeau 1993
Octave Mirbeau. *Combats esthétiques, vol. 1, 1877–1892.* Edited by Pierre Michel and Jean-François Nivet. Paris: Séguier, 1993.

Mittelstädt 1968
Kuno Mittelstädt. *Paul Gauguin: Self-portraits.* Oxford: Cassirer, 1968.

Monchoisy 1888
Monchoisy (M. Mativet). *La Nouvelle Cythère.* Paris: Charpentier, 1888.

Moran 2017
Claire Moran. *Staging the Artist: Performance and the Self-portrait from Realism to Expressionism.* London and New York: Routledge, 2017.

Moréas 1968
Jean Moréas. *Cent-soixante-treize lettres de Jean Moréas.* Vol. 1. Paris: Lettres modernes, 1968.

Morehead 2014
Allison Morehead. "Understanding and Translating: Gauguin and Strindberg in 1895." *Nineteenth-Century Art Worldwide* 13, no. 1 (2014), www.19thc-artworldwide.org/spring14/morehead-on-gauguin-and-strindberg-in-1895 (accessed 21 May 2018).

Morice 1905
Charles Morice. "Le XXᵉ Salon des Indépendants." *Mercure de France* (15 April 1905), p. 522.

Morice 1907
Charles Morice. "Art moderne: la grande querelle." *Mercure de France* (1 December 1907), p. 547.

Morice 1919
Charles Morice. *Paul Gauguin, l'art et l'artiste*. Paris: H. Floury Éditeur, 1919.

Munck and Olesen 1993
Jens Peter Munck and Kirsten Olesen. *Post-Impressionism: Ny Carlsberg Glyptotek*. Copenhagen: Ny Carlsberg Glyptotek, 1993.

Musée de l'Hôtel-Dieu, Mantes-la-Jolie 1998
Musée de l'Hôtel-Dieu. *Face à face: portraits d'artistes dans les collections publiques d'Île-de-France*. Exhibition catalogue. Musée de l'Hôtel-Dieu, Mantes-la-Jolie; Musée d'Art et d'Historie, Saint-Denis; and Musée Bossuet, Meaux, 1998–99.

Musée des beaux-arts, Quimper 1978
Musée des beaux-arts. *L'école de Pont-Aven dans les collections publiques et privées de Bretagne*. Exhibition catalogue. Musée des beaux-arts, Quimper, and Musée des beaux-arts, Nantes, 1978–79.

Nicholson 1995
Bronwen Nicholson. *Gauguin and Māori Art*. Auckland: Auckland City Art Gallery, 1995.

Nicholson 2011
Bronwen Nicholson. "Gauguin's Auckland Visit." In Greub 2011, pp. 250–267.

Norman 2014
Barnaby Norman. *Mallarmé's Sunset: Poetry at the End of Time*. London: Routledge, 2014.

O'Reilly and Teissier 1975
Patrick O'Reilly and Raoul Teissier. *Tahitiens: Répertoire biographique de la Polynésie Française*. Second edition. Publications de la Société des Océanistes, no. 36. Paris: Musée de l'homme, 1975.

Perelman 2017
Allison Perelman. "The Burning Yellow Atelier." In Groom 2017, pp. 64–71.

Pickvance 1998
Ronald Pickvance. *Paul Gauguin*. Exhibition catalogue. Fondation Pierre Gianadda, Martigny, 1998.

Piron 1865
Eugène Piron. *Delacroix, sa vie et ses œuvres*. Paris: Jules Claye, 1865.

Pointon 2013
Marcia Pointon. *Portrayal and the Search for Identity*. London: Reaktion, 2013.

Pollock 1992
Griselda Pollock. *Avant-Garde Gambits, 1888–1893: Gender and the Colour of Art History*. London: Thames & Hudson, 1992.

Prather and Stuckey 1987
Marla Prather and Charles F. Stuckey, eds. *Gauguin: A Retrospective*. New York: Park Lane, 1987.

Puget, Jaworska and Delouche 1989
Catherine Puget, Władysława Jaworska and Denise Delouche. *Gauguin et ses amis à Pont-Aven*. Douarnenez: Éditions Le Chasse-Marée / ArMen, 1989.

Rathbone and Robinson 2013
Eliza E. Rathbone, William H. Robinson, et al. *Van Gogh: Repetitions*. Exhibition catalogue. The Phillips Collection, Washington, D.C., and The Cleveland Museum of Art, 2013.

Rathbone and Shackelford 2001
Eliza E. Rathbone and George T.M. Shackelford. *Impressionist Still Life*. Exhibition catalogue. The Phillips Collection, Washington, D.C., 2001.

Redon 1987
Odilon Redon. *Critiques d'art: Salon de 1868, Rodolphe Bresdin, Paul Gauguin, précédées de Confidences d'artiste*. Edited by Robert Coustet. Bordeaux: William Blake & Co., 1987.

Rewald 1986
John Rewald, ed. *Studies in Post-Impressionism*. New York: H.N. Abrams, 1986.

Rewald 2002
John Rewald, ed. *Camille Pissarro: Letters to His Son Lucien*. Translated by Lionel Abel. Boston: Museum of Fine Arts, 2002.

Roinard 1893
Paul-Napoléon Roinard. "Les Portraits du prochain siècle." *Revue encyclopédique* (15 November 1893), pp. 641–648.

Roinard 1894
Paul-Napoléon Roinard. *Portraits du prochain siècle... Poètes et prosateurs*. Paris: E. Girard, 1894.

Rooney 2018
Brendan Rooney. "The Lure of Pont-Aven." In Benington 2018, pp. 18–21.

Schapiro 1968
Meyer Schapiro. "The Apples of Cézanne: An Essay on the Meaning of Still Life." *Art News Annual* 34 (1968), pp. 34–53. Reprinted in Schapiro 1978, pp. 1–38.

Schapiro 1978
Meyer Schapiro. *Modern Art, 19th and 20th Centuries: Selected Papers*. New York: George Braziller, 1978.

Séailles 1902
Gabriel Séailles. *Essai sur le génie dans l'art*. 1883. Paris: Alcan, 1902.

Séguin 1903
Armand Séguin. "Paul Gauguin." *L'Occident* (March 1903), p. 160.

Sérusier 1950
Paul Sérusier. *ABC de la peinture, suivi d'une Correspondance inédite recueillie par madame P. Sérusier et annotée par mademoiselle H. Boutaric*. Paris: Librairie Floury, 1950.

Shackelford and Frèches-Thory 2003
George T.M. Shackelford and Claire Frèches-Thory, eds. *Gauguin: Tahiti*. Exhibition catalogue. Galeries Nationales du Grand Palais, Paris, and Museum of Fine Arts, Boston, 2003–04.

Shapiro 2003
Barbara Stern Shapiro. "Shapes and Harmonies of Another World." In Shackelford and Frèches-Thory 2003, pp. 115–133.

Shiff 2001
Richard Shiff. "Apples and Abstraction." In Rathbone and Shackelford 2001, pp. 42–47.

Shiff 2004
Richard Shiff. "The Primitive of Everyone Else's Way." In Solana 2004, pp. 64–79.

Siberchicot 2011
Clément Siberchicot. *L'exposition Volpini, 1889. Paul Gauguin, Émile Bernard, Charles Laval: une avant-garde au cœur de l'exposition universelle.* Paris: Garnier, 2011.

Silverman 2000
Debora Silverman. *Van Gogh and Gauguin: The Search for Sacred Art.* New York: Farrar, Straus and Giroux, 2000.

Smith and Wilde 2002
Paul Smith and Carolyn Wilde, eds. *A Companion to Art Theory.* Oxford: Blackwell, 2002.

Solana 2004
Guillermo Solana, ed. *Gauguin and the Origins of Symbolism.* Exhibition catalogue. Museo Thyssen-Bornemisza, Madrid, 2004–05.

Solomon-Godeau 1992
Abigail Solomon-Godeau. "Going Native: Paul Gauguin and the Invention of Modernist Primitivism." *Art in America* 77 (July 1989), pp. 118–129. Reprinted in Norma Broude and Mary D. Garrard, eds. *The Expanding Discourse: Feminism and Art History.* New York: HarperCollins/Icon Editions, 1992.

Stanton 2009
Moyna Stanton. "Gauguin's Yellow Paper." In Lemonedes, Thomson and Juszczak 2009, pp. 109–117.

Stein 1986
Susan Alyson Stein, ed. *Van Gogh: A Retrospective.* New York: Hugh Lauter Levin Assoc., 1986.

Stolwijk 2009
Chris Stolwijk. "Devoted to a Good Cause: Theo van Gogh and Paul Gauguin." In Lemonedes, Thomson and Juszczak 2009, pp. 75–85.

Stolwijk 2010
Chris Stolwijk, ed. *Visions: Gauguin and His Time. Van Gogh Studies.* Vol. 3. Guest editor Belinda Thomson. Amsterdam: Van Gogh Museum, 2010.

Stotland 2018
Irina Stotland. "Paul Gauguin's Self-portraits in Polynesia: Androgyny and Ambivalence." In Broude 2018, pp. 41–67.

Sweetman 1995
David Sweetman. *Paul Gauguin: A Life.* New York: Simon & Schuster, 1995.

Tardieu 1895
Eugène Tardieu. "Interview with Paul Gauguin." *L'Écho de Paris* (13 May 1895). In Gauguin 1996, pp. 108–111.

Tcherkézoff 2013
Serge Tcherkézoff. *Tahiti 1768: Jeunes filles en pleurs.* Papeete: Au vent des îles, 2013.

Teilhet-Fisk 1983
Jehanne Teilhet-Fisk. *Paradise Reviewed: An Interpretation of Gauguin's Polynesian Symbolism.* Ann Arbor: UMI Research Press, 1983.

Thomson 1998
Belinda Thomson. *Gauguin by Himself.* Boston and London: Little, Brown and Company, 1998.

Thomson 2009
Belinda Thomson. "Gauguin Goes Public." In Lemonedes, Thomson and Juszczak 2009, pp. 29–72.

Thomson 2010
Belinda Thomson, ed. *Gauguin: Maker of Myth.* Exhibition catalogue. Tate Modern, London, and the National Gallery of Art, Washington, D.C., 2010–11.

Tiphereth 1893
Tiphereth. "Exposition des portraits du prochain siècle." *Le Cœur* (September/October 1893), p. 8.

Vermersch 1866–67
Eugène Vermersch. *Les Hommes du jour.* Paris: Madre, 1866–67.

Vollard 1914
Ambroise Vollard. *Paul Cézanne.* Paris: G. Crès, 1914.

Walter 1978
Elisabeth Walter. "'Le Seigneur Roy': Louis Roy (1862–1907)." *Bulletin des amis du Musée de Rennes* 2 (summer 1978), pp. 61–72.

Welsh 2001
Robert Welsh. "Gauguin and the Inn of Marie Henry at Pouldu." In Zafran 2001, pp. 61–80.

Welsh-Ovcharov 2001
Bogomila Welsh-Ovcharov. "Paul Gauguin's Third Visit to Brittany, June 1889 – November 1890." In Zafran 2001, pp. 15–59.

Wildenstein 1964
Georges Wildenstein. *Gauguin.* Paris: Les Beaux Arts, 1964.

Wildenstein 2001/2002
Daniel Wildenstein. *Gauguin: Premier itinéraire d'un sauvage. Catalogue de l'œuvre peint (1873–1888).* 2001. Translated as *Gauguin. A Savage in the Making: Catalogue Raisonné of the Paintings, 1873–1888.* 2 vols. Texts and research by Sylvie Crussard, documentation and chronology by Martine Heudron. Translated by Chris Miller. Milan/New York/Paris: Skira/Rizzoli/Wildenstein Institute, 2002.

Winnicott 1953
D.W. Winnicott. "Transitional Objects and Transitional Phenomena: A Study of the First Not-Me Possession." *The International Journal of Psychoanalysis* 34, no. 2 (1953), pp. 89–97.

Wright 2009
Alastair Wright. "Mourning, Painting, and the Commune: Maximilien Luce's *A Paris Street in 1871.*" *Oxford Art Journal* 32, no. 2 (summer 2009), pp. 223–242.

Wright 2010
Alastair Wright. "Paradise Lost: Gauguin and the Melancholy Logic of Reproduction." In Brown and Wright 2010, pp. 49–99.

Wright 2014
Alastair Wright. "Gauguin and the Dream of the Exotic." In Friedman, Herson and Walen 2014, pp. 186–197.

Wright 2015
Alastair Wright. "Fallen Vision: Gauguin in Polynesia." In Bouvier and Schwander 2015, pp. 167–179.

Wright 2018
Alastair Wright. "On Not Seeing Tahiti: Gauguin's *Noa Noa* and the Rhetoric of Blindness." In Broude 2018, pp. 129–156.

Wright and Brown 2010
Calvin Brown and Alastair Wright. *Gauguin's Paradise Remembered: The Noa Noa Prints*. Exhibition catalogue. Princeton University Art Museum, 2010.

Zachmann 2008
Gayle Zachmann. *Frameworks for Mallarmé: The Photo and the Graphic of an Interdisciplinary Aesthetic*. Albany: State University of New York Press, 2008.

Zafran 2001
Eric M. Zafran, ed. *Gauguin's Nirvana: Painters at Le Pouldu, 1880–90*. Exhibition catalogue. Wadsworth Atheneum Museum of Art, Hartford, CT, 2001.

Zola 1991
Émile Zola. *Écrits sur l'art*. Edited by Jean-Pierre Leduc-Adine. Paris: Gallimard, 1991.

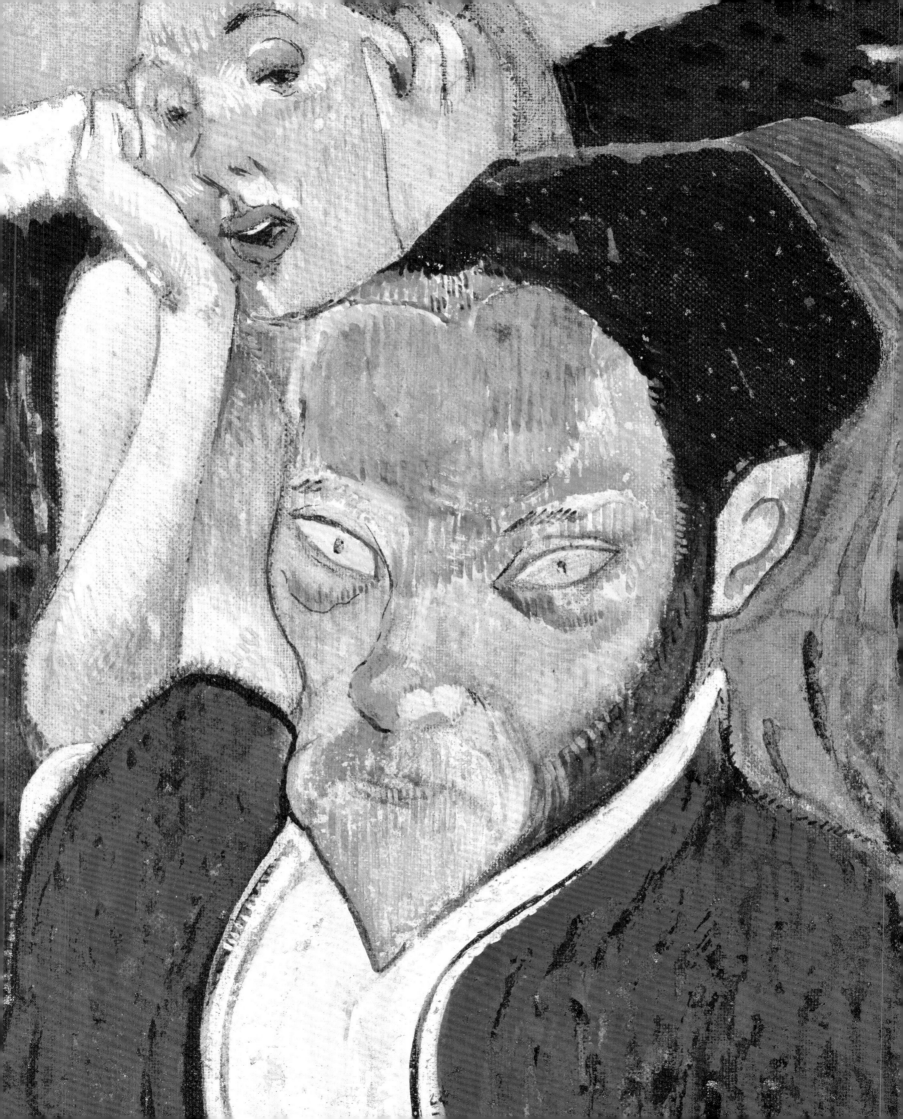

INDEX

About, Edmond 230
Andean pottery 121, 209
Andersen, Hans Christian 218
Annah la Javanaise 114
Anquetin, Louis 245, 246
Arosa, Gustave 19, 140
Association des journalistes parisiens 243
Astruc, Zacharie 229
Aubé, Jean-Paul 218
Auberge Gloanec 107
Aula, Paul 242
Aurier, Albert 61, 146, 190, 217, 244
Bakunin, Mikhail 244
Bambridge, Suzanne (Tutana) 134
Barbey d'Aurevilly, Jules 244, 247
Barc de Boutteville 68, 244
Basch, Victor 215
Baudelaire, Charles 61, 88, 94, 124, 175, 232
Baudry, Paul-Jacques-Aimé 241
Bazire, Edmond (Edmond Jacques) 242
Bentham, Jeremy 219
Berchère, Narcisse 181
Bernard, Émile 28, 31, 33, 37, 42, 44, 45, 62, 68, 78, 88, 105,
 171, 179, 189, 232, 245, 246
Bernard, Madeleine 28, 37, 171, 179
Blanc, Charles 229
Blanche, Jacques-Émile 244
Böcklin, Arnold 213
Bonnat, Léon 228, 237, 239, 241, 242, 244
Bouchot, Henri 243
Bougainville, Louis Antoine de 149
Boussod, Valadon & Cie 76
Breton, Jules 103
Bruyas, Alfred 35
Buddhist / Buddhism 19, 32, 94
Buffalo Bill 42, 179
Buvette de la Plage 35, 37, 84, 88, 92
Cabanel, Alexandre 238, 239, 241, 242
Carlyle, Thomas 88
Carolus-Duran 239, 240, 241, 242, 244
Carrière, Eugène 28, 190, 244
Castagnary, Jules-Antoine 229, 239, 240
Catholic / Catholicism 88, 94, 108, 137, 178
Cézanne, Paul 19, 73, 77, 88, 109, 130, 197, 210, 211, 212, 213,
 214, 245
Chaplet, Ernest 57, 73, 121
Chaplin, Charles 239, 240, 241, 242
Chassé, Charles 192, 193
Chennevières, Philippe de 239
Christian / Christianity 78, 79, 88, 94, 109, 140
Christophe, Jules 244
Collet, Georges 192
Cook, James 149

Corot, Camille 140
Comtesse de Nimal 110
Courbet, Gustave 19, 35, 76, 238
Dagnan-Bouveret, P.A.J. 103
Dante 37, 62
Daumier, Honoré 239
David, Jacques-Louis 232, 241, 242
Degas, Edgar 19, 76, 83, 110, 130, 132, 172, 210, 240, 247
Delacroix, Eugène 19, 179, 180, 181
Delaherche, Auguste 57, 121
Delaunay, Jules-Élie 241
Denimal, Thérèse-Josephine 110
Denis, Maurice 108
Deschamps, Léon 192
Diderot, Denis 61
De Haan, Meijer 19, 35, 65, 73, 84, 88, 90, 92, 94, 96
De Monfreid, Daniel 52, 59, 73, 79, 110, 134, 139, 167, 168, 171,
 172, 173, 234
Dolent, Jean 174, 175, 233, 246
Durand-Ruel 40, 46, 167, 171, 172
Dürer, Albrecht 37, 90
École des Beaux-Arts 239, 241, 242, 243
Ensor, James 37
Ericson, Ida 67
Ethnographical Museum of the Trocadéro 219
Exposition des portraits des écrivains et journalistes du siècle
 243
Exposition des portraits du prochain siècle 244
Exposition Universelle 42, 44, 45, 57, 104, 105, 235
Fatu / Fatou 57, 59
Favre, Claude Antoine Charles 66, 68
Fontainas, André 73, 171, 217, 238, 242
Fromentin, Eugène 181
Gauguin, Aline 179, 217, 218
Gauguin, Clovis 217, 218, 220
Gauguin, Jean 219
Gauguin, Mette 42, 108, 123, 134, 149, 209, 218, 220, 228
Gautier, Théophile 229, 233
Gérard, François 241
Gide, André 50
Girard, Edmond 244, 246
van Gogh, Theo 28, 76, 84, 88, 90, 109, 231, 232
van Gogh, Vincent 19, 27, 28, 31, 32, 35, 37, 42, 59, 65, 76, 77,
 78, 79, 83, 84, 88, 90, 92, 94, 96, 104, 105, 114, 121, 130,
 132, 202, 232, 237, 245, 246
Goupil, Jeanne (Vaïte) 143
Goupil & Cie 28, 134
Gourmond, Remy de 70
Hennequin, Émile 73
Hina 45, 153
Hirsch, Paul-Armand 245, 246
Holbein the Younger, Hans 247
Hugo, Victor 31
Huysmans, Jan Baptist 181
Ingres, Jean-Auguste-Dominique 232, 235, 236, 241, 242
Japanese / Japonisme 32, 33, 42, 76, 78, 88, 109, 132, 143, 247
Jarry, Alfred 70

Jénot, Paulin 129, 132
Jesus / Christ (figure of) 24, 37, 42, 174, 179, 189
Jewish / Judaism 84, 88, 94, 103
Jouin, Henry 233, 239
Jourdain, Francis 246
Kandinsky, Wassily 213, 214, 215
Kohler, Madame Alexandre 206
La Fontaine, Jean de 172, 173, 209
Lagadu, Marie 107, 108
La Tour, Maurice-Quentin de 237, 238
Laval, Charles 28, 65, 73, 83, 105, 206, 222, 228
Lawrence, Thomas 232, 242
Leleux, Adolphe Pierre 103
Leonardo da Vinci 146
van Leyden, Lucas 174
Lostalot, Alfred de 241
Loti, Pierre (Julien Viaud) 46, 48, 182
Louarn, Marie 108
Louvre 174, 175, 235, 236, 238, 239
Luce, Maximilien 246
Poussin, Pierre-Charles 103, 104, 105
Proudhon, Pierre-Joseph 244
Ma'ari a Teheiura 149
Mallarmé, Stéphane 27, 48, 50, 59, 70, 73, 124, 190, 193, 246
Manet, Édouard 19, 73, 131, 197, 210, 241, 242, 246, 247
Mani Vehbi-Zunbul-Zadi 33, 179
Mantz, Paul 229, 235
Maori 94, 147, 182, 219, 231
Le Marriage de Loti (The Marriage of Loti) 46, 48, 182
Martin, Jules 233
Marx, Karl 244
Marx, Roger 175
Mauclair, Camille 244, 245
Maugham, W. Somerset 149
Mirbeau, Octave 230, 240
Milton, John 88, 94
Molard, William 52, 66, 68, 76
Monet, Claude 33, 122
Moréas, Jean 19, 70, 158, 189, 190, 192, 193
Morice, Charles 45, 52, 70, 73, 171, 172, 174, 179, 182, 184, 190, 192, 197, 213, 233
Musée Fabre 237
Nemo, Ludovic 33
O'Connor, Marae 134
Oviri 57, 59
Paretenia 178
pareu 45, 153, 158, 202
Pau'ura a Tai (Pahura) 45, 140, 174, 178
Péladan, Joséphin 244
Peru / Peruvian 42, 44, 123, 209, 219
Petit, Georges 243, 244
Piron, Eugène 180, 181
Pissarro, Camille 27, 40, 66, 73, 122
Pissarro, Georges 40, 42
Poe, Edgar Allan 73, 179, 193, 231
Pomare V 134, 146, 147, 165

Pre-Columbian pottery 45, 209
Prud'hon, Pierre-Paul 153
Puvis de Chavannes, Pierre 83, 172, 202, 247
Raiatea 134
Rapa Nui rongorongo boards 153
Ranson, Paul 190
Rarahu 46, 182
Reclus, Elisée 244
Redon, Odilon 19, 73, 83, 190, 197, 202, 210
Rembrandt 227, 232, 235, 237, 240, 247
Renoir, Auguste 231, 233, 241, 242
Reynolds, Joshua 232
Rimbaud, Arthur 33
Roinard, Paul-Napoléon 244, 246
Rollinat, Maurice 23
Rossetti, Dante Gabriel 213
Roux, Paul-Pierre (Saint-Pol-Roux) 50
Roy, Louis 68, 70, 83, 206, 245
Salon 61, 103, 105, 197, 227, 235, 239, 240
Satre, Marie-Angélique 108, 109
Schuffenecker, Émile 42, 59, 65, 68, 121, 122, 123, 180, 189, 202, 222, 233
Schuffenecker, Louise Virginie 68, 121, 122, 123, 124, 202
Séailles, Gabriel 218
Segantini, Giovanni 213
Séguin, Armand 40
Sérusier, Paul 35, 105, 108, 192, 193, 228
Seurat, Georges 33
Signac, Paul 33, 193, 244
Sisley, Alfred 122
Ślewiński, Władysław 73, 76
Spitz, Charles 147, 152
Strindberg, August 172
Suhas, Aristide (Atiti) 137
Tehamana / Teha'amana / Tehura 45, 50, 132, 148, 149, 150, 152, 153, 155, 158, 165, 167, 168, 182
Tiphereth 245
Toulouse-Lautrec, Henri de 33, 44, 246
Tupapau 50, 52, 153, 154, 155
Valjean, Jean 31, 33, 37, 50
Vallotton, Félix 246
Valpinçon, Paul 210
Velázquez, Diego 227, 235, 237
Verlaine, Paul 46, 175, 193, 244
Vermersch, Eugène 233
Virgil 211
Vollard, Ambroise 40, 42, 59, 83, 139, 140, 197
Volpini exhibition (Café des Arts) 33, 68, 105
van der Weyden, Rogier 143
Whistler, James McNeill 246
Willumsen, Jens Ferdinand 44, 236
Zola, Émile 33, 227, 229, 230, 239

Jénot, Paulin 129, 132
Jesus / Christ (figure of) 24, 37, 42, 174, 179, 189
Jewish / Judaism 84, 88, 94, 103
Jouin, Henry 233, 239
Jourdain, Francis 246
Kandinsky, Wassily 213, 214, 215
Kohler, Madame Alexandre 206
La Fontaine, Jean de 172, 173, 209
Lagadu, Marie 107, 108
La Tour, Maurice-Quentin de 237, 238
Laval, Charles 28, 65, 73, 83, 105, 206, 222, 228
Lawrence, Thomas 232, 242
Leleux, Adolphe Pierre 103
Leonardo da Vinci 146
van Leyden, Lucas 174
Lostalot, Alfred de 241
Loti, Pierre (Julien Viaud) 46, 48, 182
Louarn, Marie 108
Louvre 174, 175, 235, 236, 238, 239
Luce, Maximilien 246
Poussin, Pierre-Charles 103, 104, 105
Proudhon, Pierre-Joseph 244
Ma'ari a Teheiura 149
Mallarmé, Stéphane 27, 48, 50, 59, 70, 73, 124, 190, 193, 246
Manet, Édouard 19, 73, 131, 197, 210, 241, 242, 246, 247
Mani Vehbi-Zunbul-Zadi 33, 179
Mantz, Paul 229, 235
Maori 94, 147, 182, 219, 231
Le Marriage de Loti (The Marriage of Loti) 46, 48, 182
Martin, Jules 233
Marx, Karl 244
Marx, Roger 175
Mauclair, Camille 244, 245
Maugham, W. Somerset 149
Mirbeau, Octave 230, 240
Milton, John 88, 94
Molard, William 52, 66, 68, 76
Monet, Claude 33, 122
Moréas, Jean 19, 70, 158, 189, 190, 192, 193
Morice, Charles 45, 52, 70, 73, 171, 172, 174, 179, 182, 184, 190, 192, 197, 213, 233
Musée Fabre 237
Nemo, Ludovic 33
O'Connor, Marae 134
Oviri 57, 59
Paretenia 178
pareu 45, 153, 158, 202
Pau'ura a Tai (Pahura) 45, 140, 174, 178
Péladan, Joséphin 244
Peru / Peruvian 42, 44, 123, 209, 219
Petit, Georges 243, 244
Piron, Eugène 180, 181
Pissarro, Camille 27, 40, 66, 73, 122
Pissarro, Georges 40, 42
Poe, Edgar Allan 73, 179, 193, 231
Pomare V 134, 146, 147, 165

Pre-Columbian pottery 45, 209
Prud'hon, Pierre-Paul 153
Puvis de Chavannes, Pierre 83, 172, 202, 247
Raiatea 134
Rapa Nui rongorongo boards 153
Ranson, Paul 190
Rarahu 46, 182
Reclus, Elisée 244
Redon, Odilon 19, 73, 83, 190, 197, 202, 210
Rembrandt 227, 232, 235, 237, 240, 247
Renoir, Auguste 231, 233, 241, 242
Reynolds, Joshua 232
Rimbaud, Arthur 33
Roinard, Paul-Napoléon 244, 246
Rollinat, Maurice 23
Rossetti, Dante Gabriel 213
Roux, Paul-Pierre (Saint-Pol-Roux) 50
Roy, Louis 68, 70, 83, 206, 245
Salon 61, 103, 105, 197, 227, 235, 239, 240
Satre, Marie-Angélique 108, 109
Schuffenecker, Émile 42, 59, 65, 68, 121, 122, 123, 180, 189, 202, 222, 233
Schuffenecker, Louise Virginie 68, 121, 122, 123, 124, 202
Séailles, Gabriel 218
Segantini, Giovanni 213
Séguin, Armand 40
Sérusier, Paul 35, 105, 108, 192, 193, 228
Seurat, Georges 33
Signac, Paul 33, 193, 244
Sisley, Alfred 122
Ślewiński, Władysław 73, 76
Spitz, Charles 147, 152
Strindberg, August 172
Suhas, Aristide (Atiti) 137
Tehamana / Teha'amana / Tehura 45, 50, 132, 148, 149, 150, 152, 153, 155, 158, 165, 167, 168, 182
Tiphereth 245
Toulouse-Lautrec, Henri de 33, 44, 246
Tupapau 50, 52, 153, 154, 155
Valjean, Jean 31, 33, 37, 50
Vallotton, Félix 246
Valpinçon, Paul 210
Velázquez, Diego 227, 235, 237
Verlaine, Paul 46, 175, 193, 244
Vermersch, Eugène 233
Virgil 211
Vollard, Ambroise 40, 42, 59, 83, 139, 140, 197
Volpini exhibition (Café des Arts) 33, 68, 105
van der Weyden, Rogier 143
Whistler, James McNeill 246
Willumsen, Jens Ferdinand 44, 236
Zola, Émile 33, 227, 229, 230, 239